THE COMPLETE IDIOT'S GUIDE® TO

D1404063

Cartooning

by Arnold Wagner and Shannon Turlington

ALPHA

A Pearson Education Company

International Standard Book Number: 0-02-864379-8
Library of Congress Catalog Card Number: 2002106341

04 03 02 8 7 6 5 4 3 2 1

Interpretation of the printing code: The rightmost number of the first series of numbers is the year of the book's printing; the rightmost number of the second series of numbers is the number of the book's printing. For example, a printing code of 02-1 shows that the first printing occurred in 2002.

Printed in the United States of America

Note: This publication contains the opinions and ideas of its authors. It is intended to provide helpful and informative material on the subject matter covered. It is sold with the understanding that the authors and publisher are not engaged in rendering professional services in the book. If the reader requires personal assistance or advice, a competent professional should be consulted.

The authors and publisher specifically disclaim any responsibility for any liability, loss, or risk, personal or otherwise, which is incurred as a consequence, directly or indirectly, of the use and application of any of the contents of this book.

For marketing and publicity, please call: 317-581-3722

The publisher offers discounts on this book when ordered in quantity for bulk purchases and special sales.

For sales within the United States, please contact: Corporate and Government Sales, 1-800-382-3419 or corpsales@pearsontechgroup.com

Outside the United States, please contact: International Sales, 317-581-3793 or international@pearsontechgroup.com

Publisher: *Marie Butler-Knight*
Product Manager: *Phil Kitchel*
Managing Editor: *Jennifer Chisholm*
Acquisitions Editor: *Mike Sanders*
Development Editor: *Lynn Northrup*
Senior Production Editor: *Christy Wagner*
Copy Editor: *Jan Zunkel*
Cover/Book Designer: *Trina Wurst*
Indexer: *Ginny Bess*
Layout/Proofreading: *Angela Calvert, John Etchison*

Contents at a Glance

Part 1: **The First Frame** **1**

 1 The Cartoon and the Cartoonist 3
Discover whether cartooning is art or literature—or just what the heck is cartooning, anyway?

 2 In the Beginning … Cartooning's Roots 9
Explore the beginnings of the ancient art of cartooning and how it has developed over the centuries.

 3 Specialization Enters the Picture 17
Follow along as cartooning grows up, branching off into new directions and taking advantage of technological innovations.

 4 Where Cartooning Is Headed 31
We climb into our time machine and guess what part cartooning will play in a future dominated by new computer technologies.

Part 2: **In the Toolbox** **37**

 5 Tools of the Trade 39
Pencils, pens, crayons, and brushes—what drawing tools do you need to get started?

 6 Working in Different Media 47
Putting your ideas on paper—we sort out inks, paints, paper, and computers.

 7 A Studio of Your Own 55
An artist needs a special place to work—how to outfit (and over-outfit) your studio.

Part 3: **1-2-3 Draw!** **59**

 8 A Little Exercise Can't Hurt 61
Let's start drawing! Here you'll get a review of the basics.

 9 Heads, Shoulders, Knees, and Toes 67
You can't draw a cartoon without characters; here's a lesson in drawing people and animals.

 10 Express Yourself 79
Give your characters "character" with facial expressions, body language, costumes, props, and action.

 11 Getting Perspective 87
Add some more dimension to your cartoons.

 12 Composition Basics 97
Learn to use balance, sequence, emphasis, and atmosphere to get your point across.

 13 The Elements of Style 109
You can't teach style, but we'll give it a try—or at least give you some meaty tips to chew on.

Part 4: **What's in a Genre?** **115**

 14 The Gag or Panel Cartoon 117
Become a stand-up cartoonist: How to come up with a gag.

15 The Strip 123
Cartooning goes horizontal: Learn the basics of the strip.

16 Editorial Cartooning 129
You're angry but in a funny way; welcome to the editorial page.

17 Comic Books 135
Superheroes and superpowers, babes and baddies—enter the underground realm of comic books.

18 Animation 141
Put your art into motion—this is the wild, wonderful, wacky world of animation.

19 Manga: East Meets West 149
Learn about the traditional Japanese art form of manga—and how it's taking the Western world by storm.

20 Illustration 161
It's not just for fine artists anymore; cartoonists can be illustrators, too.

21 Greeting Cards and Novelties 167
Hey, you've got to sell your stuff somewhere; here's how to get your cartoons into the stores.

Part 5: Where Do Ideas Come From? 173

22 The Gag 175
Yeah, but is it funny? The basics of writing the gag.

23 The Story 181
Drama, plot, conflict, and action: Here's how to make your cartoons exciting.

24 The Characters 187
Who are the people in your world? The basics of creating cartoon-y characters.

25 Polishing the Gems 195
Rewrite, revise, rework—it's not finished till you say it's finished.

Part 6: Getting into the Swing 201

26 Breaking into the Business 203
You've got a cartoon; now who's going to buy it? Get started selling your artwork.

27 Self-Promotion 211
You're in business now; sell yourself with portfolios, samples, and even your own website.

28 Legal Stuff 217
You've gotta know this stuff: the lowdown on copyright, licensing, contracts, and all the ways you can get paid.

Appendixes

A Glossary 225

B Bibliography 233

C Publications 239

D Professional Organizations 243

Index 245

Contents

Part 1: The First Frame 1

1 The Cartoon and the Cartoonist 3

What's in a Label? .. 3
But Is It Art? ... 6
What It Takes to Be a Cartoonist ... 6
Practice Makes Perfect .. 7

2 In the Beginning ... Cartooning's Roots 9

How It All Began (Probably) .. 9
From the Egyptians to the Renaissance: Early Cartoons 10
Print Takes a Bow .. 12
Two Visions: Hogarth vs. Töpffer .. 13

3 Specialization Enters the Picture 17

Lampooning Life: Editorial Cartoons 17
 The Earliest Editorial Cartoonists 17
 Editorial Cartooning Comes to America 19
The Birth and Growth of the Humor Magazine 20
See You in the Funny Pages ... 23
Bringing Cartoons to Life: The Birth of Animation 24
Comic Books Find the Superhero .. 27

4 Where Cartooning Is Headed 31

A Look Ahead .. 31
The Wide World of Digital .. 32
Programmable Paper and Electronic Ink 33
Print on Demand ... 34
Holography and Internet Animation .. 34

Part 2: In the Toolbox 37

5 Tools of the Trade 39

How Will It Look on Camera? ... 39
Making Your Mark .. 40
 Pencils and Crayons ... 40
 Pens ... 41
 Brushes ... 42
Other Tools, Fancy and Plain ... 43
 Rulers and T-Squares .. 43
 Cutting Tools ... 44
 Drafting Supplies ... 44
 Sharpeners .. 44
 Erasers ... 44
 Adhesives and Tapes .. 44

6 Working in Different Media 47

All About Inks ..47
 India Ink ..47
 Iron and Nutgall Ink ..48
 Aniline and Acrylic Inks ..49
 Colored Inks ..49
Wash and Watercolor ..49
Dry Media ..50
 Colored Pencils ..50
 Charcoal ..50
Mechanical Tints ..50
Computers and Other Media ..51
 Get Digital ..51
 What Else? ..52
Get It on Paper ..52
Protecting Your Work ..53

7 A Studio of Your Own 55

The Bare Necessities ..55
Setting Up a Studio ..56
Lighting Tips ..57
Keeping It Organized with … a Morgue?57

Part 3: 1-2-3 Draw! 59

8 A Little Exercise Can't Hurt 61

Fill Up That Sketch Book ..61
Be a Doodlebug ..63
Letting It Flow Naturally ..63
Mastering the Basic Shapes ..64

9 Heads, Shoulders, Knees, and Toes 67

Proportions 101 ..67
 A Few General Guidelines ..69
 Male and Female Figures ..69
Types of Anatomy ..70
The Head ..71
The Hands ..73
The Feet ..75
Balance and the Center of Gravity76
Animals and Anthropomorphic Figures76

10 Express Yourself 79

It's in the Eyes … and All Over the Face79
A Gesture Says It All: Body Language81
Dressing the Part: Costumes and Props82
Lights, Camera, Action! ..84

11 Getting Perspective **87**

Early Theories on Perspective ..87
How We Measure Perspective ...89
One-Point and Two-Point Perspective ..90
Putting Circles and Shadows in Perspective93
Worm's- and Bird's-Eye Views ...94
Atmospheric Perspective and the Use of Color95

12 Composition Basics **97**

A Balancing Act ..97
Keeping It in Sequence ..100
 Who's Talking? ..*100*
 On Your Mark ...*101*
 Space Between Panels ...*102*
 Dialog Balloons ...*103*
Adding Emphasis and Contrast ...104
Creating Atmosphere ...106

13 The Elements of Style **109**

What's Your Style? ...109
Style Influences ...112
Less Is Usually More ..112
The Danger of Extremes ..113
Fitting Your Style to the Genre ..113
Your John Hancock ..114

Part 4: What's in a Genre? **115**

14 The Gag or Panel Cartoon **117**

The Layout of the Gag Cartoon ...117
 How to Present the Gag ...*117*
 Publishing Gags in Trade Journals and House Organs*119*
 Coding Your Cartoons ..*120*
What to Use to Draw Your Gags ..120
The Basics of Writing Captions ..121
Sticking to a Slant ...121

15 The Strip **123**

Syndicates and the Strip Cartoonist ...123
The Three Kinds of Syndicated Features ..125
 Another Day, Another Gag ..*125*
 Another Day, Another Cliffhanger ..*126*
 Another Day, Another Panel ..*126*
Characters: The People (or Animals) in Your World127
Making Your Characters Talk: Lettering ...127

16 Editorial Cartooning **129**

Becoming an Editorial Cartoonist ...129
Figuring Out Proportions ...130

Conventions You Need to Know ...130
Drawing Editorial Cartoons ...131
Adhering to Editorial Policies ..132

17 Comic Books 135

The Comic Book Assembly Line ...135
Comic Book Genres ...136
Having Fun and Getting Work Done at Conventions137
Publishers and Self-Publishing ...138
 Getting in a Publisher's Door ...*138*
 Going It Alone ..*138*
The Comic Book Grows Up: The Graphic Novel139

18 Animation 141

From the Flipbook to the Computer ...141
Getting into Studio Animation ..142
 Getting Educated ...*142*
 Getting Your Foot in the Door ..*143*
 Creating an Animated Feature ...*143*
Animation Styles and Techniques ..144
Teach Yourself Computer Animation ..145
Playing with Computer Games ..146
Taking Animation Online ...146

19 Manga: East Meets West 149

Once Upon a Time … the Origins of Manga149
Manga vs. Western Comic Books ...152
The Basic Elements of the Manga Style.......................................153
Manga Anatomy 101: Drawing the Head and Other Features154
The Use of Calligraphy and "Sound Effects".................................159

20 Illustration 161

Developing an Illustration Style ..161
Your Job as Illustrator ..162
The Media You Choose ..163
Directories and Agents ...164
Drawing for Juveniles ...164
 Illustrating for Younger Children ..*164*
 Drawing for Older Children ..*165*

21 Greeting Cards and Novelties 167

Making It as a Freelance Card Artist ..167
 Round Out Your Repertoire: Types of Cards*168*
 Designing and Submitting Cards ..*169*
Wrapping Paper and Other Paper Goods170
Having Fun with Novelties ...171
Designing CD Labels or Music Posters171

Part 5: Where Do Ideas Come From? 173

22 The Gag 175

Gag Basics ...175

Putting the Gag into Words: Captions and Dialog 176

Take the Reader by Surprise 177

 Clichés: The Gag Cartoonist's Handiest Tool 177

 Dreaming Up Gags ...178

23 The Story 181

Here's What Happens: Plot 181

Conflict: The Source of Every Story 182

Take Action ...183

 Moving Things Along ..183

 Playing with Panels ...184

Continuity ..185

24 The Characters 187

Casting Call ..187

 Finding a Star ..188

 Rounding Out the Cast 188

Stereotype Shortcuts ...189

Character Traits: Making Your Characters Real 190

 Physical Attributes ...191

 Costumes ...191

 Props ..192

 Personality Traits ..192

 Occupations ...192

 Hobbies and Interests ..192

 How They Talk ...192

Repetitive Gags ..193

25 Polishing the Gems 195

Rework Captions by Reading Aloud 195

Changing Your Viewpoint 196

Using Identifiable Elements 197

Aging ..198

Part 6: Getting into the Swing 201

26 Breaking into the Business 203

Selling Your Gag Cartoons203

Selling to the Syndicates ...204

Exploring Other Markets ...205

 Selling Illustrations to Art Directors 206

 Greeting Cards and Novelties 206

 Stock Illustrations and Clip Art 207

Breaking into Comic Books 207

Breaking into Animation ...209

27 Self-Promotion 211

Preparing Your Cartoons for Submission211
Submitting a Batch of Gags212
Submitting a Strip Idea to the Syndicates213
Marketing Yourself with Mailers214
The Portfolio: The Artist's Main Marketing Tool214
Your Very Own Website215

28 Legal Stuff 217

The Lowdown on Copyright217
Myths and Misunderstandings About Copyright218
Copyrighting Your Cartoons219
Selling Your Copyright219
Your Rights and How to Sell Them220
Recycling Your Cartoons Through Reprints221
Making More Money Through Licensing221
No Rights at All: Work for Hire222
Contracts: Friend and Foe223

Appendixes

A Glossary 225

B Bibliography 233

C Publications 239

D Professional Organizations 243

Index 245

Foreword

When I was asked to write this foreword for *The Complete Idiot's Guide to Cartooning*, being a cartoonist and used to dealing primarily with visuals and very few words, my first instinct was to panic. Of course, my wife sent me off to the bookstore to hunt for *The Complete Idiot's Guide to Writing Forewords* (we cartoonists are a gullible lot) ... I guess having my studio at home gets to be a bit much for her.

The profession, or craft, of cartooning is a world filled with a number of benefits: the ability to live in practically any exotic place in the world that you desire as long as it's served by FedEx and the Internet; the lax dress code; and hanging out with rock stars, actresses, and supermodels, just to name a few. *The Complete Idiot's Guide to Cartooning* is your passport into that world. Having been in the business for close to 30 years, I was still able to learn even more about my profession from reading this book. (Why didn't anybody ever tell me about eraser shields?!) I discovered there were actually names for some of the things I had drawn many years ago (keep an eye out for "grylli").

Over the years a lot of people have asked me why I chose cartooning as a profession. My answer has always been, "I didn't choose cartooning, cartooning chose me." I think that's true for almost every cartoonist I know—with the exception of Bud Grace, who draws the comic strip *The Piranha Club*, formerly known as *Ernie*. Cartooning actually tried to keep him out, but he succeeded at forcing his way in anyway. For those of you out there who picked up this book, or were given it by someone you know, you most likely already feel that pull of being chosen for cartooning. You find yourself drawing in the margins of books or on notepads or just about anywhere there's a blank space—sometimes to the annoyance of teachers, parents, bosses, and spouses.

Just about every kid starts out drawing cartoons. That's the first and easiest way kids are able to depict the world in which they live. Usually something happens along the way that makes kids stop looking at the world that way and become more serious. Quite possibly, it's the realization that there's not much money in it. But while those kids drift away from cartooning as they age, there are a chosen few who don't grow out of it. I am one of those, and you probably are, too.

It is for us that *The Complete Idiot's Guide to Cartooning* was written. The authors have made sense of the varied fields in which cartoonists work. Like many cartoonists, I've worked in most of the fields discussed in this book. Arnold Wagner and Shannon Turlington have provided you with a well-structured look at a vastly complex form of art and a tremendous head start with a comprehensive nuts-and-bolts tool for beginning your career in cartooning.

It is for that reason I sit here in my boxer shorts in my studio seething with bitterness that you are being given an advantage that I never had. If I'd had *The Complete Idiot's Guide to Cartooning* when I started out 30 years ago, I'd be rich, retired, and lounging on a desert island somewhere by now. Hmmm, that gives me an idea for a cartoon ...

Rick Kirkman, co-creator of the comic strip *Baby Blues*

Introduction

Cartooning is so many things all at once: It's both art and writing. It's both silly and satirical. It's both funny and fun. Probably that's why cartoonists love it so much. Cartooning truly gives us the opportunity to stretch ourselves, to try new things, to experiment—and have a good time doing it. We cartoonists are in a class by ourselves. We're not exactly artists, yet we produce drawings that are either stark and simple or packed with delightful details. We're not exactly writers, yet we churn out stories ranging from the one-punch gag to complex graphic novels.

Cartoonists are a slippery lot. You can't pin us down or slap a label on us. As soon as you try to, we're attempting something new. And we're everywhere you look: in newspapers, magazines, and books; on television and in the movies; in the comic book store and hanging in art galleries; and now on the Internet.

There's always room for one more in our little group—so welcome. You don't need a fancy art school education to get into cartooning. You don't need a lot of expensive equipment. All you need is a passion for drawing and an offbeat way of looking at the world.

This book will help start you on your way to discovering a unique way of expressing yourself through cartooning. We'll give you all the basics to get started, whether you're looking for a lifetime hobby or hope to make a living at this someday, whether you're into strips or comic books or animation or all of them at once. We're sure you'll learn a lot, and here are the first lessons: Don't ever stop having fun with it, and don't ever be afraid to try something new!

What's Inside

This book is divided into six sections that start with the most basic question of what cartooning is, and take you all the way through to actually making a living doing what you love. Here's what you'll find inside:

Part 1, "The First Frame," attempts to define what cartooning is exactly. In that section, you'll find an overview of the history of cartooning, from its earliest roots to its branching out into such genres as the newspaper strip, the comic book, and the animated film. We'll also try to figure out where cartooning is headed in the future.

Part 2, "In the Toolbox," will help you outfit your studio so that you can get started drawing. You'll learn all about the different tools you can use, the various media you can work in, and the basic equipment you'll need to build a professional cartoonist's studio.

Part 3, "1-2-3 Draw!" finally gets you to put pen (or pencil or brush) to paper. You'll start with the basics and then learn all about drawing figures (human and animal), figure out perspective, and get the lowdown on composition. You'll also start developing your own personal style.

Part 4, "What's in a Genre?" takes a look at the many different forms cartooning can take. From the traditional genres of the panel cartoon, the strip, and the editorial cartoon to comic books and animation, you'll learn about working with them all. We'll also take a look at more commercial forms of cartooning, such as illustration, greeting cards, and novelties, as well as other genres you might not have considered, like video games and record labels.

Part 5, "Where Do Ideas Come From?" gets into the storytelling aspect of creating cartoons. In this section, you'll get help with coming up with gag ideas, and you'll learn what elements make a story dramatic and suspenseful. You'll also find out how to create memorable characters and how to revise your cartoons to produce polished, finished pieces.

Part 6, "Getting into the Swing," gives proven advice on breaking into this field professionally. You'll discover how to submit your stuff to magazines and syndicates, how to become a freelance illustrator, and how to land a job with a comic book publisher or animation studio. This section will also help you sort out the confusing details of copyright, contracts, and licensing deals, so that you can actually make money doing this.

The appendixes are a treasure trove of useful resources. They start with a glossary that explains technical terms used in this book. After that, you'll find a bibliography of books for your cartooning library, a selection of helpful periodicals and websites, and contact information for professional organizations you can join.

Friendly Advice

In every section of this book, you'll find many signposts to help you on your way in the form of these boxes:

'Toon Talk

Whenever we introduce a new term, we'll define it in one of these definition boxes. Be sure to also check the glossary in Appendix A for definitions of unusual terms.

From the Pros

Check these boxes for anecdotes and bits of interesting information about professional cartoonists. This advice "from the pros" provides helpful examples that you can emulate.

Red Ink Alert

These boxes warn you about common traps and potential pitfalls. Heed the advice in these warnings, and you'll keep yourself out of trouble as you launch your cartooning career.

Creative Inkling

These boxes provide brief but helpful tips and advice on the topic at hand. Check the tips for handy shortcuts, better ways of doing something, and inside advice.

Acknowledgments

This book is truly the result of a team effort. Many people helped to make this book a reality.

Thanks from Arnold: For whatever I managed to get right here, I owe thanks to Connie, who didn't snap back at a very grumpy husband, and to the very mixed crowd of cartoonists who claim the title of "Wisenheimers" under the leadership of the very talented Ted Goff. And last but hardly least, to my agent Jessica Faust, my editors Mike Sanders and Lynn Northrup, and my co-author Shannon Turlington for patience with someone who was in over his head.

Thanks from Shannon: First, I'd like to thank my agent, Jacky Sach, for bringing this project to me in the first place, as well as the editors, Mike and Lynn. I'd also like to thank Arnold Wagner for being such a cooperative collaborator. Finally—and as always—thanks to Marty for his patience and support all that time I was working nonstop.

Trademarks

All terms mentioned in this book that are known to be or are suspected of being trademarks or service marks have been appropriately capitalized. Alpha Books and Pearson Education, Inc., cannot attest to the accuracy of this information. Use of a term in this book should not be regarded as affecting the validity of any trademark or service mark.

Part 1

The First Frame

Everyone knows what a cartoon is, right? It's obvious. The problem is that we all have our own view of the obvious, depending on where we're viewing it from. There are lots of ways to start a heated debate among a group of cartoonists. Our favorites include these: "What is a cartoon?" "Is cartooning art?" and "Are cartoonists primarily artists or writers?"

There are few absolutes in cartooning, but in this section, we'll try to give you enough information to let you create your own view of what cartooning is and join the debate. The debate, even if just with ourselves, is a very important part of developing an individual style or voice. Part of the confusion is due to the variety of cartoons. We'll try to help you understand how different genres of cartooning developed and the directions it may evolve in the future. Then it's up to you to decide how you can best fit into the world of cartooning.

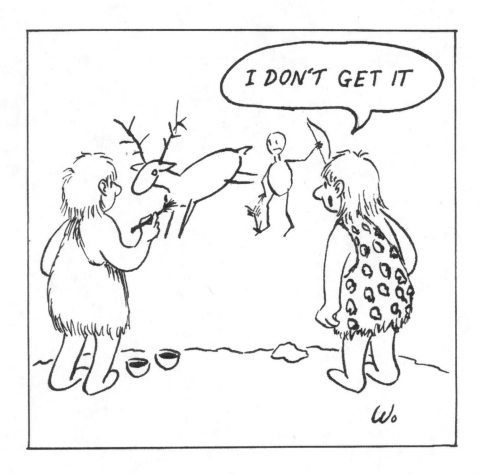

The Cartoon and the Cartoonist

In This Chapter

- ◆ What is this thing called cartooning?
- ◆ Cartoons as art or literature
- ◆ What does it take to be a cartoonist?
- ◆ Draw, draw, draw!

There's not much about cartooning that can be defined in an exact manner. It's certainly not a science, and the various arts only grudgingly recognize it as a family member. The illegitimate child of the arts, it's allowed into their society only if it promises to behave, something it seldom accomplishes. At times, it may court the approval of its parent arts, but it soon wanders off to do its own thing.

Describing cartooning is a challenge not only because of the broad spectrum the term covers, but also because our understanding of the label changes as rapidly as the technology's various forms of cartooning do. Nevertheless, that's the challenge we've accepted, so let's get started!

What's in a Label?

The label *cartoon* is borrowed, and like most borrowed things, the fit isn't all that great. William Hogarth (1697–1764) could be called the first professional cartoonist, but he would have rejected that label as nonsense. To him, and to other artists before him, cartoons were the detailed plans for frescos, murals, tapestries, or other elaborate works. Hogarth did satirical paintings and engravings.

The art of caricature—a portrait of a person with one or more exaggerated features, usually for the purposes of satire—reached the shores of England during his lifetime, but Hogarth rejected the narrow imported version of caricature and the label. "Grotesques" was another label in use, but also too extreme for Hogarth. He liked the label "character drawing," a term also favored by the American cartoonist Charles Dana Gibson (1867–1944) over a century later. (We'll tell you more about Hogarth's background and his vision of his art in the next chapter.)

Caricature dates from prehistory, but it was formalized by the classical artist Annibale Carracci (1560–1609) of Bologna. The term literally means a loaded or overloaded portrait. Originally a private and gentle amusement, the form of caricature that arrived in England about 100 years later was a vicious, and often malicious, social and political weapon that leaned heavily on anthropomorphism, which we'll discuss in more detail in later chapters. Caricature is still thought of as a loaded portrait, but the definition has evolved and in its broadest form could be applied to all forms of cartooning. We draw caricatures of persons, types, society, fashion, or just about anything else.

There are three overlapping definitions of what we call cartoons that seem to cover the entire field: humorous drawings, satirical drawings, and storytelling drawings. If all three definitions fit a particular cartoon, that's great, but any one or two of the three can work equally well.

Hogarth's illustration of the difference between character and caricature.

(© William Hogarth, 1743)

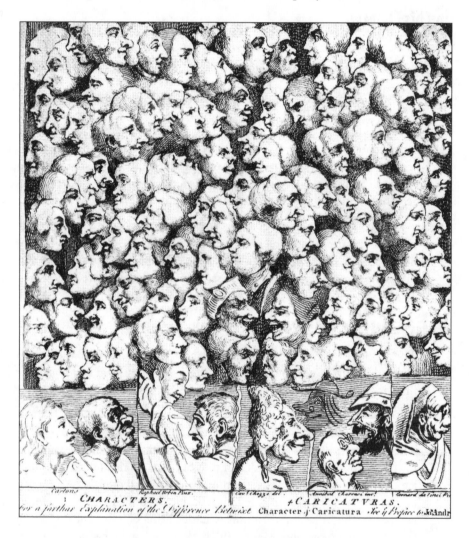

In 1843, an English competition and exhibition of cartoons was held to choose frescos for the new home of parliament. To some, the whole thing seemed pretentious and a waste of money that could be put to better use. The staff of the famous humor magazine *Punch* (which was then just two years old) was among those who held that opinion. They announced that they would hold their own exhibition of cartoons. To this end, John Leech drew a series of cartoons parodying the official ones. These were very popular, and the magazine

continued to label the large satirical drawings dealing with politics it published as "cartoons." The other drawings continued to be called caricatures, cuts, or big cuts.

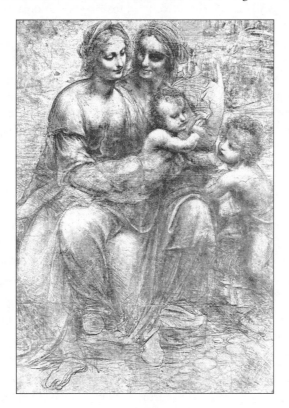

The original meaning of cartoon in formal art as used by Leonardo da Vinci.

(© Leonardo da Vinci, ca. 1499)

When young American humor magazines attempted to imitate the success of *Punch*, they used the term "cartoon" to apply to all their humorous or satirical drawings. This was a natural since most of the drawings they published were political in nature. In that period of U.S. history, the national sport was politics. (Baseball was yet to be invented.) In time this broader meaning became universally accepted, and even *Punch* adopted it.

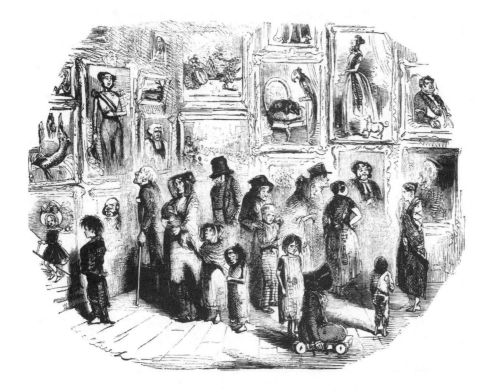

The first satirical drawing to be labeled a "cartoon," it criticized giving an art exhibit to the poor rather than food and other aid.

(© John Leech, Punch, the London Charivari, July 15, 1843)

Red Ink Alert

Even a one-panel gag cartoon usually tells a story. A simple illustration for a story, article, or advertisement should add something to the message and not just repeat the text. A cartoon always says something. It is never simply decorative.

As time passed, the distance between the artists' definition of cartoons and the popular definition grew wider, and seemed to be misleading to those of a purist tendency. Artists have tried many times to do away with the terms "cartoon" and "cartoonist," preferring more specific labels. Some of those labels have been adopted for particular specialties, such as animators and caricaturists, but "cartoonist" continues to be used to describe the entire field. Trying to replace it with another term is a nice hobby if you don't have anything better to do, but is ultimately doomed to failure. If you're creating work that fits into one or more of the three categories mentioned, you're a cartoonist. It's a varied, strange, and wonderful club. Relax and wear the title with pride.

But Is It Art?

Are cartoonists artists? Our highly personal opinion is that cartooning is an art, but not *art*—at least not in the sense that the works of Rembrandt or Titian are *art*. That art is classified as "fine art," a label that, if taken literally, doesn't make much sense. Not all work in the fine-art category is fine; some of it is decidedly *un*-fine.

Many examples of work in the "lesser" arts are very fine works. The use of any skill in a highly creative way is an art: the art of dance, the art of poetry, the art of flower arranging. Basket weavers who turn out traditional baskets of a high quality are craftspeople; if they turn out baskets that are creative originals, they are artists.

As a hybrid art, cartooning varies in the concepts and skills it borrows from other arts. This depends on the branch of cartooning the cartoonist is working in and on that cartoonist's individual style. Obviously, cartooning always requires some degree of visual art, but it may not be the dominant element.

Cartoonists often have as much, or more, in common with the playwright, the movie director, or the circus clown than they do with easel painters. As cartoonists, they often see themselves as entertainers, journalists, poets, or even philosophers. Creating pictures is not their primary goal; it's just a means to an end, a tool.

As cartooning became a viable occupation, artists who wrote their own material had an edge. Later some gag writers developed the rudiments of visual art to a level where they could work as cartoonists. If some degree of visual art is always a part of cartooning, then so is writing. Even without captions or dialogue balloons, the writing is there. Writing is the creation of mental images using words. Screenwriters write scenes without dialogue, but they are still writing, even when just describing a scene to a director or a machine. In cartooning, the drawing and the writing should morph into a whole that is greater than the sum of its parts.

Creative Inkling

Books like this one can make the process of becoming a cartoonist easier, faster, and less painful, but no one book can cover it all. This book will point you in the direction of other books and reference materials for further study. (The appendixes at the back of this book are a good place to start.)

What It Takes to Be a Cartoonist

If the art of cartooning seems a vague category, the education of a cartoonist is even more so. Art school is nice and can be helpful, but it's hardly a requirement. In going over a list of successful cartoonists, those who are self-taught easily outnumber those who attended art school, and the difference isn't always obvious. Courses in journalism or creative writing are also useful, but again, not required. If you have any aptitude at all for drawing and a strong desire to express yourself through cartooning, you can learn all you need to know on your own.

When professional cartoonists talk about education, they tend to mention broad areas of study, the perpetual observation of human nature and society, a varied life experience, and the habit of noticing details. It's hard to

imagine any learning that can't be applied to cartooning, and cartoonists are invariably people who are curious about the world around them. They comment on the passing scene—that's as good a description as anything of what cartoonists do.

The value of technical training does vary a bit depending on the type of cartooning you're interested in. In feature animation or mainstream comic books, for example, formal training tends to be much more important.

When we mention the habit of noticing details, we mean in a variety of ways: the basic construction of a chair, how costume defines the person, body language that points out character or traits, and human nature in general. Observing how other cartoonists, writers, performers, and movie directors solve these various communication problems is also important. Notice how ads work or fail to work in telling their stories. All forms of communication can teach you important skills that can be applied to cartooning.

From the Pros

Most cartoonists knew at an early age that they wanted to be cartoonists, but there are notable exceptions. Peter Arno (cartoonist for *The New Yorker*) was originally a jazz musician and bandleader. Bob Thaves (*Frank and Ernest*) and Dave Breger (*Mr. Breger* and *G.I. Joe*) earned degrees in psychology. Gardner Rea (cartoonist for *The New Yorker*) was a theater critic. Carl Anderson (*Henry*) was a cabinetmaker. Carl Ed (*Harold Teen*) and V. T. Hamlin (*Alley Oop*) were reporters. Shirvanian (cartoonist for *The New Yorker*) took his degree in English. The editorial cartoonist Rube Goldberg was an engineer. Stan Berenstain (*The Berenstain Bears*) and Lynn Johnston (*For Better or Worse*) were medical illustrators. Fred McCarthy (*Brother Juniper*) was a Franciscan priest.

Practice Makes Perfect

A vital element of becoming a successful cartoonist is that you draw constantly. Fill dozens of sketchbooks with relaxed studies and doodles. You should be drawing on napkins, envelopes, and any other surface that will hold an image at any time and any place. Don't bother with trying to produce finished drawings every time; the goal is to be able to put down rough images with the same ease as you write a grocery list or type an e-mail. Watch these sketches for little tricks that will help you communicate with your cartoons. That is not always the same as being a better artist.

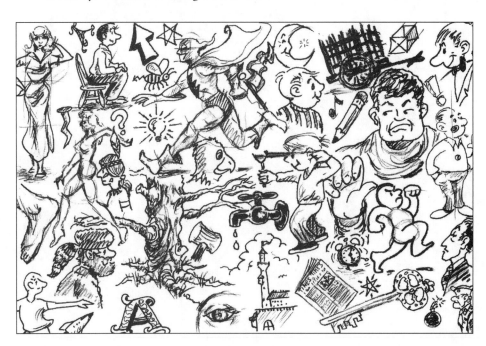

A section of one of the many pages of doodles Arnold fills at every opportunity. Obviously, no real thought, effort, or attempt at accuracy is made; the important thing is getting the ideas down on paper.

(© Arnold Wagner, 2002)

Without mentioning names, there are successful cartoonists who, in the eyes of most, seem to be poor artists. Often the cartoonists themselves admit to that. The catch is that if you study their backgrounds, you will usually find that they have a long history of using drawing to express themselves. They have developed a system of graphics that best communicates their ideas in their particular voices. It's the communication skills and not the technical expertise that make them professional cartoonists.

The Least You Need to Know

- No matter how you define cartooning, all cartoons are humorous, satirical, or tell a story—often all at once.
- Cartoons are much more than just drawings. Good cartoons are never merely decorative; they always say something.
- One needn't be a graduate of art school to be a successful cartoonist; having keen powers of observation into human nature and society are often more important.
- To develop an individual style and hone your skills, you must draw, draw, draw!

In the Beginning ... Cartooning's Roots

In This Chapter

- ◆ Cartooning's humble beginnings
- ◆ Humor through the ages
- ◆ Art and technology make their contributions
- ◆ Hogarth and Töpffer: two cartooning pioneers shape the medium

The early history of cartooning inspires a lot of debate. Some cite the exaggerated drawings of elderly or deformed faces by Leonardo da Vinci as examples of early cartooning, but others say there was no intent of humor or satire: They were merely studies in extremes, not cartoons.

It's actually easier to make the call on ancient Egyptian art, where we can separate the story and the humorous art from the beginnings of a written language. Cartoons aren't quite as easy to trace in other historical periods. In this chapter, we'll explore how the cartoon developed, from its earliest roots to the first modern cartoonists who set the stage for the cartoons we are familiar with today.

How It All Began (Probably)

Examples of graffiti and humor are found in all cultures. The seeds of cartooning were planted long before recorded history. Picture a group of primitive humans around a campfire. A large male takes a twig and in the dirt draws several stick figures. He points to the largest of the stick figures and grunts, "Grug!" He then points to himself and repeats, "Grug!" Everyone smiles and nods carefully. He points to the smallest member of the group and announces, "Oog!" Then he points to the smallest stick figure and repeats, "Oog!" This time everyone laughs, except Oog, of course.

But Oog begins thinking. This business of drawing in the dirt could give him a tool that doesn't depend on size or muscle. He can wield this tool as well as anyone. He practices, and soon he's much better at this new skill than his tormentor or anyone else in the clan. He invents little tricks of the trade, and he diversifies, drawing tales of hunts, battles, evil spirits, and ghosts. He

gains prestige and popularity with each new variation. Others bring him meat and berries. Nearby clans want their own cartoonist, and soon youngsters are traveling to his cave to learn from him.

From the Egyptians to the Renaissance: Early Cartoons

Like primitive humankind, the Egyptians demonstrated a strong, if basic, sense of humor. Surprisingly, nobles seemed to have been able to laugh at themselves, or at least to pretend they could. One hieroglyphic record shows a group of young nobles setting off on a hunting trip, complete with bearers to tote the game home. The hunting trip ends with the bearers returning, carrying not game, but their drunken masters.

Return of the hunters. This basic gag still shows up in many magazines and comic strips today.

(© Engraving of original by Frederick W. Fairholt, ca. 1865)

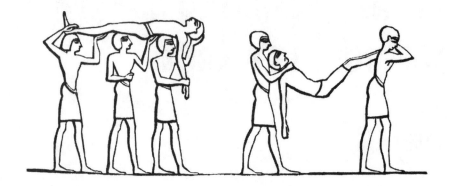

There are even ancient Egyptian comic scenes depicting situations we wouldn't expect anyone to laugh at. Some show funeral ships whose procession becomes a bungled disaster. Some scenes show animals burlesquing the roles of gods and humans. There's even a series of drawings on an ancient Thebes monument depicting a drunken party attended by nobility of both sexes; they reach a state where they need the aid of servants, with mixed results.

A noblewoman at this Thebes party loses the contents of her stomach before a servant can reach her.

(© Engraving of original by Frederick W. Fairholt, ca. 1865)

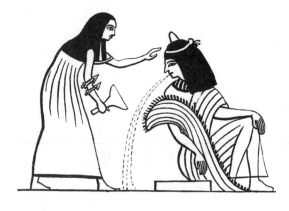

'Toon Talk

Anthropomorphic is the attribution of human appearances or traits to nonhuman objects or beings. Technically, it may apply to gods, animals, or inanimate objects, but in the cartooning world, it is most often applied to animals.

Anthropomorphic images are common to most cultures. Examples have been found from ancient Sumaria and in Egypt, Greece, and Rome. It seems to be a universal trait.

In ancient Greece, humor or satiric comment isn't seen much in sculpture, and we know very little about their paintings, but they delighted in using humor as decorations on their pottery and other household goods. Like the Egyptians, the Greeks were fond of anthropomorphic images, especially those of dog-faced monkeys. In fact, they probably borrowed the monkey image from the Egyptians. The Romans would in turn borrow images from the Greeks.

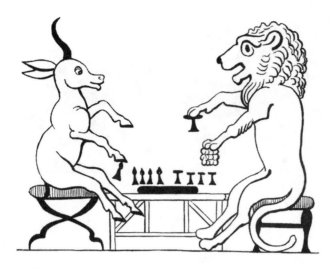

An engraving taken from an Egyptian drawing on papyrus showing a game similar to checkers, with the lion the victor over the unicorn.

(© Engraving of original by Frederick W. Fairholt, ca. 1865)

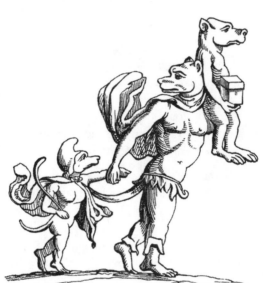

Intaglios of "The Flight of Aeneas from Troy" from Virgil's Aeneid, *and a burlesque on it using the dog-faced monkeys, taken from a Pompeii wall painting.*

(© Engraving of original by Frederick W. Fairholt, ca. 1865)

The Romans needed humor as much as anyone, and they became entranced by the Greek legends of a race of pygmies who were constantly at war with their archenemies, the cranes. They merged the concept with the dwarfs whom they often kept for entertainment. The result was a great many pictures of figures with large heads and small bodies, who were generally involved in common everyday activities. Many of these drawings have a relatively modern look.

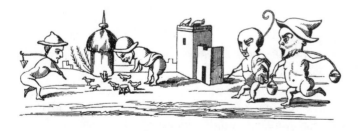

A Roman burlesque of pygmies in a typical farmyard from the walls of the temple of Venus at Pompeii. They were always scantily clothed.

(© Engraving of original by Frederick W. Fairholt, ca. 1865)

During the Middle Ages and the Renaissance, humorous images often took a more personal approach. The gargoyles on churches were at times made to resemble enemies of those in office and were often replaced when a new authority gained office. Tapestries might show the patron as wise and wealthy, with his rivals' faces placed on hounds fighting over scraps under the tables.

A rare scene shows the pigmy version of a Roman artist's studio. Note the mixing slab at the base of the crude easel, the assistant grinding pigments, and in the background, an apprentice paying more attention to what's going on around him than to his studies. This scene was found in a private home in Pompeii, in a state of rapid decay. It quickly perished upon exposure to air.

(© Engraving of original by Frederick W. Fairholt and Mazois, ca. 1865)

Print Takes a Bow

Graphic humor and story telling were still just the sidelines of a few artists and craftspeople. Each example was one-of-a-kind, which made them expensive and only allowed for very limited exposure to the public. What little the public did see was mostly in the form of crude woodcuts. Cartooning as a trade needed a way to mass-produce drawings so that they could be distributed and sold at prices that the less affluent could afford. Developments in the technology of engraving, and later, lithography, made this possible. With the marriage of images and print, all the elements were in place for the modern development of cartooning.

William Hogarth was the first artist to realize the commercial potential for quality prints of a humorous or satirical nature and probably the first to make a living solely from humorous art. His work quickly became very popular and inspired a host of imitators and plagiarists. While the plagiarists were active for many years, changes in copyright law—due in part to Hogarth's campaigning efforts—mostly put a stop to the problem. The print quickly became a legitimate and profitable medium for both the humorous artist and the caricaturist. There were shops that sold nothing but prints by Hogarth and other popular artists, which were displayed in the shop windows, and members of the upper class collected them. Print shops remained popular for well over 100 years, only fading with the rise of humor magazines.

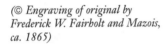

From the Pros _____

William Hogarth was the son of a schoolteacher and author who spent some time in debtor's prison, in part because his textbooks were pirated and distributed without payment to him. When the younger Hogarth's series of satiric prints, *A Harlot's Progress*, was later widely pirated, he campaigned successfully for extended copyright laws in England. In later years, he moved to producing more traditional oil paintings but continued to work to improve the conditions of all artists. He instigated the idea of public art exhibits in England and is generally credited with inspiring a great many social reforms. Prostitution, gambling, alcohol, medical quacks, and many more problems of his era were targets.

Technical problems delayed the use of drawings in periodicals. Engravings had to be printed separately and tipped into books and periodicals. Woodcuts were cut into the sides of planks. They could be planed to type high and were placed alongside assembled type. However, woodcuts tended to splinter with too much use, making long runs and detailed cuts nearly impossible. Still they were the best alternative until about 1817, when they were replaced with wood engraving. Wood engraving solved some problems by using the end surfaces of the wood for engraving the design across the grain. The only drawback was that large wood surfaces

were hard to come by, so often an illustration was made up of two or more blocks fastened together.

Cartooning spread to weekly papers, but the rise of daily papers was a step back for them. The technical problems for the high-speed presses the dailies used made even wood engravings inadequate. Not until photo engraving was developed in the 1870s could cartooning become a true form of popular art.

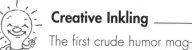

Creative Inkling

The first crude humor magazines were probably published in England. The concept soon spread to Europe, where they were developed to a high level in France and Germany, and then in that form, they were borrowed back by England. From there they spread to the United States and other parts of the world, even Japan, where there already existed a healthy native form.

Two Visions: Hogarth vs. Töpffer

The comics scholar Thierry Smolderen has divided the approach to graphic story telling into the approach used by Hogarth and the later one used by Rodolphe Töpffer (1799–1846). Hogarth sold his prints as single units, though in many cases they were a part of a series. Each print had to stand on its own and be complex enough to justify its purchase.

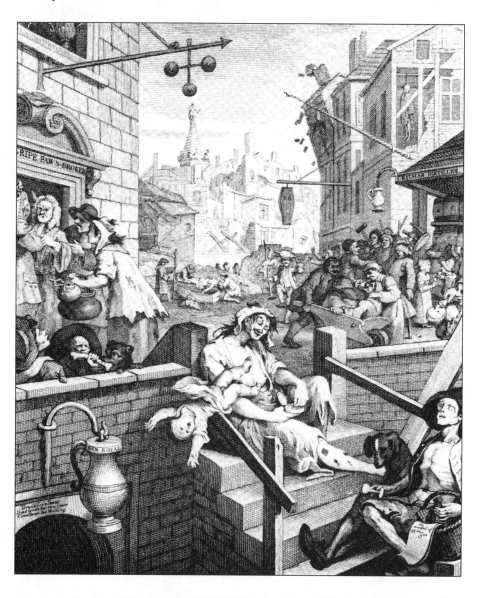

One of Hogarth's satiric prints on the evils of gin. Historians say the print wasn't all that exaggerated.

(© William Hogarth, 1750)

Hogarth's view remained the standard for some time, but as it became practical to print illustrations in books and publications, a new approach emerged with Rodolphe Töpffer as, perhaps, the major pioneer. He used panels, or individual pictures, to form a storybook. The individual drawings were simpler, unable to stand on their own, and relied on their sequence for value. The finished product looked quite a bit like the modern comic strip or comic book.

A sequence from Töpffer's
M. Jabot, a satire of
romantic courtship.

(© Rodolphe Töpffer, ca. 1837)

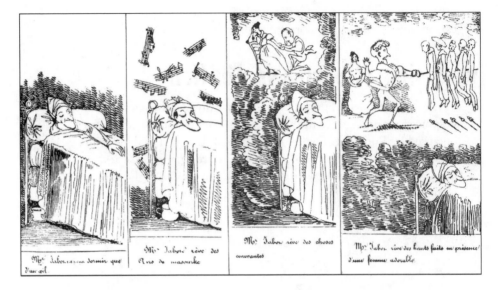

Töpffer published *Obadiah Oldbuck* in Switzerland in 1837. It was translated into English and published in the United States in 1842. It is considered by some scholars to be the first comic book printed in the United States.

Töpffer's multi-paneled version of the cartoon is now the dominant one, but even if Hogarth's one-panel model is not seen as often, it still exists. A century later, artist Richard Doyle was using it in the fledging humor magazine *Punch*. Doyle was an early mainstay at the magazine and designed the famous cover that the magazine used from 1849 to 1956. He was also the uncle of *Sherlock Holmes* novelist Sir Arthur Conan Doyle.

The Yellow Kid, the feature that made the comic strip business explode in the 1890s, was often drawn in a Hogarthian form. Gluyas Williams and Rea Irvin kept the one-panel cartoon alive in the pages of *The New Yorker*. We see a mild form of it in Billy's travels in the Sunday cartoon *Family Circle* by Bil Keane. *Mad Magazine* uses it frequently. The rigid layout of the "funny pages" in newspapers, designed to accommodate the familiar comic strip, has made the one-panel a rarity in that media, but it's often seen in calendars, posters, children's magazines, and advertisements. The children's puzzle feature *Where's Waldo* is a good example.

MANNERS · AND · CVSTOMS · OF · Yᵉ · ENGLYSHE · IN · 1849 ·

Yᵉ FASHONABLE · WORLDE · TAKYNGE · ITS · EXERCYSE · IN · HYDE · PARKE ·

The Least You Need to Know

♦ The practice of drawing funny pictures that tell a story or joke is probably older than recorded history.

♦ Humorous pictures are commonly found at all stages of recorded history, from ancient Egypt to the Renaissance period.

♦ Modern printing techniques put the cartoon on paper and made it a popular form of entertainment.

♦ Two basic forms of cartoons emerged early on: Hogarth's one-panel cartoon and Töpffer's multi-panel strip.

Specialization Enters the Picture

In This Chapter

- The rise of the editorial cartoon as a critical forum
- Humor magazines catch on in America, and then fade away
- The comic strip finds a home in the newspapers
- Before Saturday-morning cartoons: early attempts at animation
- Comic books and the first appearance of the superhero

As the market for cartoons grew, cartoonists began to specialize, playing to their strong suits. Technology met them halfway. As new media and publishing forums developed, they eagerly sought out those cartoonists who could best supply the kind of content they needed to please their audiences.

In this chapter, we'll fast-forward through the development of the major kinds of cartooning. These brief timelines are meant as a "you are here" orientation to various cartooning genres, showing how they have developed into present-day forms. We'll try to give you some perspective on cartooning's past so you can better judge how cartooning will fit into your future.

Lampooning Life: Editorial Cartoons

Cartoons generally examine the ridiculous side of life; in other words, they're a form of ridicule—gentle or vicious, broad or specific. When they deal with society, politics, and the prominent people involved in both, they are editorial cartoons.

The Earliest Editorial Cartoonists

We've already mentioned William Hogarth, who aimed his pen at social ills, championing general reform but avoiding politics and the individual. Those who came after him were different;

they stressed politics and weren't shy about attacking individuals. They took to caricature with a zest. Rowlandson, Gillray, Cruikshank, and Grandville were a few of those early giants.

For the most part, these early editorial cartoonists worked with prints. Engravings or the later *lithography* couldn't be printed on the same pages as text. As you learned in the last chapter, woodcuts had been around for a long time, but they weren't sturdy enough for mass production. Wood engraving, which used the end grain rather than the side grain of the wood, was developed around 1817 in England and could be used on regular presses alongside text.

'Toon Talk

Lithography is a printing process invented in 1796. The technique is based on the fact that oil and water don't mix. A pattern is drawn on a limestone slab with a greasy black crayon. The crayon interacts with the lime to form a soap that will accept printing ink and reject water. The stone is treated with water and then ink is applied, which only adheres to the crayoned areas. Printing requires a special lithographic press.

In France, Honoré Daumier (1808–1879) was the dominant cartoonist among a number of skilled artists. He had joined forces with cartoonist and publisher Charles Philipon. Between them, they developed the political cartoon and satirical magazine into a major social force in Europe. Although he died in obscurity, Daumier's work has never been out of print, and the power of his lithographs is still obvious.

An example of Daumier's power with a lithographic crayon.

(© Daumier, La Caricature, ca. 1831)

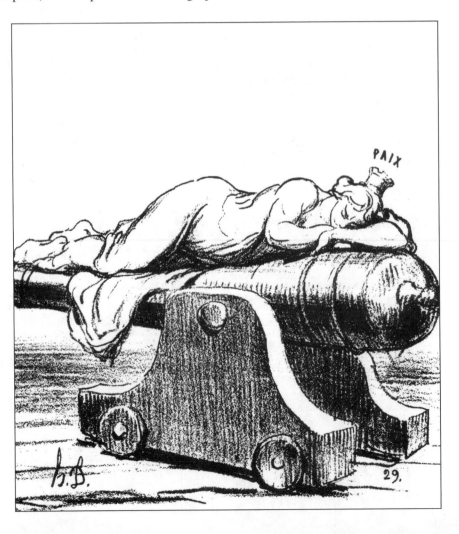

Editorial Cartooning Comes to America

In the United States, editorial cartooning got off to a slower start than in Europe and the United Kingdom. Without large urban areas, the market for prints was much smaller. There were far fewer trained artists or engravers, and the art of wood engraving took much longer to reach the Americas.

Benjamin Franklin created a few crude cartoons, the best known being the snake cut into pieces representing the Colonies, with the slogan "Join or Die" (see the following illustration). Another early U.S. cartoonist was Paul Revere. As a silversmith he had some skill in engraving. Still, both were amateurs, with limited skill and interest.

JOIN or DIE

One of Franklin's later versions of the "Join or Die" emblem. He used it a number of times, as did others, including Paul Revere.

(© Benjamin Franklin, 1775)

Another well-known early American cartoon was "The Gerrymander," which introduced a new word into the language. It came about when the Jeffersonian party redistricted a county in order to carry an election. Some said that the new district looked like a salamander. It was named for Governor Gerry who opposed the measure but signed it. There were other early cartoonists, but no major talent would emerge in the United States until Thomas Nast came along in the late 1800s.

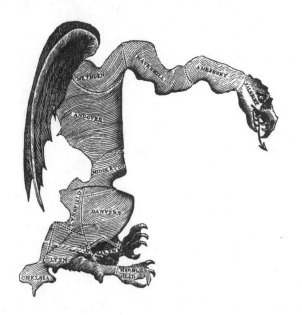

"The Gerrymander" was inspired by political redistricting in order for the party in power to win an election. It's credited to the engraver Elkanah Tisdale, but may have been drawn by the artist Gilbert Stuart.

(© Elkanah Tisdale, The Boston Gazette, *1812)*

In the United States, Thomas Nast (1840–1902) would develop the editorial cartoon into a force to be reckoned with. Nast immigrated to the United States from Bavaria at the age of six. He was an artist at *Leslie's* (a pictorial magazine) and the *New York Illustrated News*. His Civil War drawings for *Harper's Weekly* made him famous. He created the modern images of Santa Claus and the Republican elephant, and refined the images of the Democratic donkey, Uncle Sam, John Bull, and other symbols. Famous for his reform campaigns, Nast defended blacks and the Chinese but bitterly attacked the Irish and Italians as a result of his intense

hatred of the Roman Catholic Church. Bad investments forced him to accept a diplomatic post in Ecuador, where he came down with yellow fever and died.

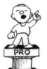

From the Pros

Thomas Nast is best known for his Christmas drawings, which mark the first appearance of the modern-day Santa Claus. Prior to Nast, Santa had appeared more as a religious figure. After reading Clement Moore's poem, "'Twas the Night Before Christmas," Nast was inspired to create a jollier, plumper Santa, complete with sleigh and reindeer. Nast produced 76 Christmas engravings, and his drawings brought Christmas to a wide audience. Christmas took on a more commercial, secular tone as stores used the new Santa in their ads. It became a national holiday in the late 1800s, and the custom of sending Christmas cards soon followed. So we have Nast's cartoons to thank (or blame) for how we celebrate Christmas today!

After Nast, a flood of talented cartoonists found an audience in the United States. They mostly published in magazines, since newspapers were not yet technologically capable of making regular use of cartoonists. The first major newspaper cartoonist of national reputation was probably Homer Davenport (1867–1912).

The Birth and Growth of the Humor Magazine

Humor magazines grew out of the English gossip sheets common in the late eighteenth century. They evolved into publications like *Scourge*, which published the work of George and Robert Cruikshank. None of them lasted long, but they inspired imitation, especially in France.

Cartoonist Charles Philipon (1806–1862) gained notoriety for his caricatures of King Louis-Philippe, which landed him in prison for a short time and made publishers leery of publishing his work. To circumvent this, he founded his own publication, *La Caricature*, in 1830. It became the leading critic of the regime until it was forced to close down in 1835. Philipon also established the milder publication *Le Charivari* in 1832, which lasted much longer. Philipon went on to start many other publications, becoming a model not only for reformers, but also for successful magazine publishers. He was only an adequate cartoonist; most of his power came from working closely with Daumier and other giants of the period.

Philipon's work inspired imitation, and the cycle returned to England with the founding of *Punch, the London Charivari* (the title was later shortened to just *Punch*). *Punch* then inspired worldwide imitation, including a Melbourne *Punch*, a Japanese *Punch*, a Canadian *Punch*, and several U.S. *Punch*es.

Humor magazines in the United States had an early but dismal start. Few lasted more than a few months. Some pictorial magazines like *Leslie's* and *Harper's Weekly* ran a bit of humor but weren't really humor magazines. Among the many attempts at humor magazines were titles like *The Wasp*, a New York publication, which lasted less than a year (later publication of *The Wasp* in San Francisco fared much better); *The Corrector*, which lasted a month; and *The Scourge*, which lasted six months. Most of these were highly partisan and abusive. Many were closed down for libel.

The first real American comic magazine was probably *The Tickler*. It ran from 1807 to 1813, stopping when the editor joined the Army. On his return, he founded the *Independent Balance*, which lasted about five years, but on his death it faded from sight.

After the Civil War, there were further attempts in the United States to found humor magazines on the European model. These didn't fare much better than their predecessors. The titles included Frank Leslie's *Budget of Fun*, *Wild Oats*, *Jolly Joker*, *Phunny Phellow*, and *Yankee Notions*.

Success finally arrived in the person of an Austrian immigrant, Joseph Keppler (1837–1894). He founded a successful German-language humor magazine, *Puck*, and a year later an English version was introduced.

IT MAKES HIM SICK.

Puck magazine.

(© Puck, 1880, author's collection)

The success of *Puck* was due not only to Keppler's talents as a writer and cartoonist, but also to his skill as a lithographer, which was still a rare skill in the United States. This enabled him to employ full color on his covers, full pages, and centerfolds. *Puck* was political but originally nonpartisan. In later years, its editorial slant leaned toward the Democratic Party. It lasted until 1918, when William Randolph Hearst bought it in order to acquire its cartoonist contracts. It then became a Sunday comics supplement.

In 1881, the magazine *Judge* was founded and attracted a highly talented group of cartoonists. In order to separate itself from *Puck*, *Judge* adopted a Republican slant. It outlasted its competitors, shutting down in 1939. To the end, it remained faithful to the "he said, she said" style of cartoon captioning. The captions, made up of two or more lines consisting of back-and-forth dialog between a male and a female character, were clumsy and tended to step on the punch line.

Creative Inkling

Judge had two editors who tried to phase out the "he said, she said" captions in favor of punchier, one-line captions. That was about the only thing they did agree on, and the top brass soon sent them on their separate ways. One was Norman Anthony, who founded the immensely popular *Ballyhoo*. The other was Harold Ross, the founder of *The New Yorker*.

Judge *magazine.*

(© Judge, 1898, author's collection)

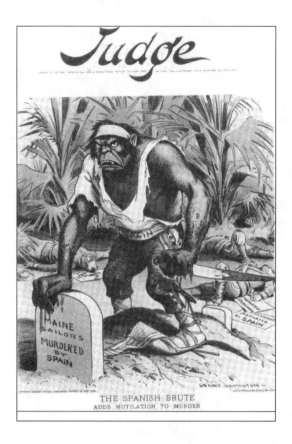

Life was the third of the major American humor magazines. Founded in 1883, it was published at a smaller size, with no color inside and with limited color on the cover. It avoided politics and was a gentler, more sophisticated publication than its competitors. Charles Dana Gibson was the giant among *Life*'s talented staff of cartoonists and writers. In later years, he ran the magazine. It lasted until 1936, when the title was sold to *Time* for their new photographic news publication.

Life *magazine.*

(© Life, 1899, author's collection)

During the period between the World Wars, magazine cartoons shifted from appearing in straight humor magazines to becoming an important part of broader publications, such as *Vanity Fair*, *The Saturday Evening Post*, *Colliers*, *Esquire*, *Look*, *Liberty*, and of course, *The New Yorker*. The reasons for the shift are debatable. The public may have tired of the partisanship of *Puck* and *Judge*. Tastes were changing, too; for example, the concerns of women were beginning to be heard, although women weren't yet a political force. The general magazines took that into consideration and aimed their content at the whole family, not just the men. In addition, advances in printing allowed the general magazines to not only use more color, but photographs as well. Thus, they were better able to compete against the expensive color lithography of the humor magazines.

College Humor and *Ballyhoo* were among the few humor magazines founded during this period. Both enjoyed success for a period and then faded. The humor was light and zany without the bite of the earlier humor magazines. In the 1940s and 1950s, humor magazines metamorphosed into mostly low-paying pulp magazines that published large numbers of cartoons, usually with some sex or cheesecake element thrown in.

See You in the Funny Pages

Newspapers were slow to use cartoons. They were pretty much limited to wood engravings, requiring highly skilled craftspeople, which took time to produce. As dailies became the standard, this became a bigger handicap. It wasn't until line photo engraving was developed in 1873 that newspapers could make important use of cartoons.

At first, newspaper artists did it all. They illustrated and reported the news as well as did general cartooning. The top artists tended to specialize. Editorial and sports cartoonists were popular. At times, the papers printed satirical or humorous drawings, especially on Sundays. As the color presses came into being, cartoons often used some color.

One of these artists was R. F. Outcault (1863–1828). He had been a top magazine cartoonist before joining Joseph Pulitzer's *New York World*. Outcault specialized in satirizing New York society using slum kids from the various back streets and alleys of Manhattan. He gradually settled on the title *Hogan's Alley* for his cartoons. A bald urchin in a yellow nightshirt kept showing up in the feature and finally became a major character referred to as the Yellow Kid. Outcault's cartoons were large one-panel affairs based on the Hogarthian model (discussed in the previous chapter).

When William Randolph Hearst invaded the New York publishing scene with his *New York Journal*, he quickly noticed the popularity of the feature and hired Outcault away from Pulitzer. Due to a lawsuit, the name was changed to *The Yellow Kid* in the *Journal* and continued as *Hogan's Alley* under a different artist in *New York World*. Comics became a major draw of newspaper readership, and Pulitzer and Hearst engaged in a "war" for readers, raiding each other's staff for talent. The public identified this competition with the legal battle over *The Yellow Kid*, and since both papers employed a sensationalist writing style, the term "yellow journalism" was applied to them and to all other newspapers publishing that sort of material. Today the term refers to all sensationalistic, melodramatic newspaper reporting.

The Katzenjammer Kids, patterned after Wilhelm Busch's *Max und Moritz* picture stories in Germany, was Hearst's second comic feature (Busch was a prominent German writer and cartoonist). The strip used separate panels and speech balloons, setting the standard for all later comic features. Before that time, color, panels, and speech balloons had all appeared in cartoons separately but hadn't been used together in the recognizable format of modern comic strips. This time Pulitzer hired away the artist, renaming the comic *The Captain and the Kids*. The two versions ran for years in the competing papers, with Rudolph Dirks drawing *The Captain and the Kids* for Pulitzer and Harold Knerr continuing *The Katzenjammer Kids* for Hearst.

The daily strip was slower to appear, and again the development was more by accident than design. Clare Briggs was an artist for a Hearst paper. With his editor, he created a cartoon feature for the sports page. It

involved a character named A. Piker Clerk who was always scrounging for cash to bet on the horse races. In the process, he made predictions on the next day's races. The feature became very popular, although Briggs was kept so busy with his other professional duties that he often couldn't draw it every day. The comic didn't come to Hearst's attention until it began using a Russian nobleman as a stooge. Hearst was friends with a great many members of the Russian nobility and had the feature killed.

A few years later, Bud Fisher used the identical idea with a character that looked a bit like Piker and was named A. Mutt. It too became popular and evolved into the *Mutt and Jeff* strip. Soon daily strips were everywhere.

The Yellow Kid.

(© The Yellow Kid, *the* New York Journal, *1877*)

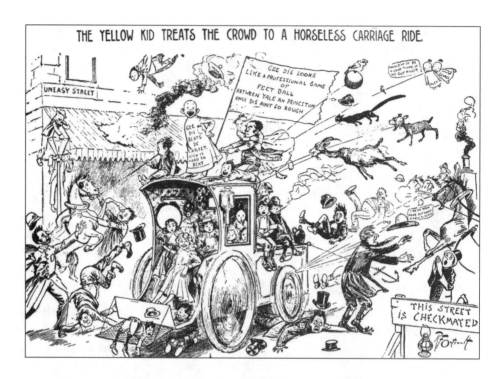

Panels from the two strips, A. Piker Clerk *and* A. Mutt, *with each gambler making a bet at the track.*

(© *Clare Briggs*, A. Piker Clerk, *1903;* © *Bud Fisher*, A. Mutt, *1907*)

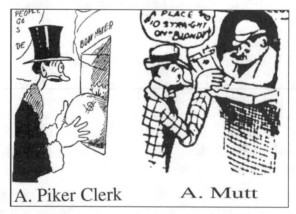

Bringing Cartoons to Life: The Birth of Animation

It seems like animation should be a more recent development than comic strips or humor magazines, but it isn't. Almost from the start, artists looked for ways to make their creations move and imitate life. In that sense, puppetry might be considered an ancestor of animation, especially the elaborate shadow puppetry introduced to Europe from China around 1760.

In 1645, Athanasius Kircher, a Jesuit scholar in Rome, published his work on the art of light and shadow, in which he described his invention: the magic lantern, a crude slide projector. Kircher later added a revolving glass disc with pictures painted on it to the magic lantern, creating a sequence that told a story but didn't provide the illusion of movement.

In 1735, Pieter van Musschenbroek of the Netherlands used the revolving discs to create the illusion of motion. Traveling show-people began to spread the entertainment devices starting around 1750. In 1801, these Fantasmagorie, or Phantasmagoria, reached England, and then New York City in 1803. Parents complained that their children stole money and stayed out late to attend the shows. Alas, the novelty didn't last. The figures had to be drawn small and then projected to many times their original size by a weak light source, and the result had severe limitations.

In 1820, Peter Mark Roget, of *Roget's Thesaurus* fame, published a paper documenting the theory of *persistence of vision*, a concept known since ancient times. This paper led to the development of numerous toys involving animation. The Thaumatrope (see the following illustration) was invented in 1825. It is simply a disc with drawings on both sides. When spun, the two images merge. The Thaumatrope demonstrates the persistence of vision, but not animation. Around 1830, the Phenakistoscope, or Fantoscope, was invented. It involved two discs spun together, or one disc spun in front of a mirror.

'Toon Talk

The ability of your eye and brain to retain a visual image for a short period of time (about ¹⁄₁₀ of a second) is called **persistence of vision**. Movies and animation are made up of single frames, which are played very rapidly on a screen. The eye retains the image of each frame long enough to give the illusion of motion, rather than the series of still pictures you're really seeing.

The Thaumatrope. When the disk is spun, the cage and the bird morph so that the bird appears to be in the cage.

(© Dr. Fitton, 1825)

The Daedalum, or Wheel of the Devil, was invented in 1834 but wasn't developed until the 1860s, when it was renamed the Zoetrope, or Wheel of Life, and became a very popular toy (as shown in the next illustration). In Paris, Emile Reynaud developed his Praxinoscope from the Zoetrope by adding mirrors, and then,

by combining it with a projector, he came out with his Théâtre Optique in 1892. He presented features of 10 to 15 minutes in length with color, electrically triggered music, and sound effects. It was enormously popular but, as only one person, he couldn't compete with the less sophisticated cinematic films being produced at the time, and by 1910 he closed up shop, throwing much of his film and equipment into the Seine.

The Zoetrope. Strips making a cycle of movement were placed inside the drum, the drum was turned, and the viewer looked through the slits in the drum.

(© Milton Bradley, 1868)

ZOETROPE OF WILLIAM LINCOLN.

In 1868, the simple kineograph, or flip book, was invented; it remains a popular toy and demonstration of persistence of vision. Thomas Edison took this concept a step further with a mechanical flip book called the Mutoscope. It, or variations of it, could still be seen in arcades as late as 1960.

In 1896 or 1897, the vaudeville act of Reader, Smith, and Blackton was inspired by Edison to organize the Vitagraph Company, which would become one the major film studios of the silent era. James Stuart Blackton (1875–1941) was a newspaper and stage cartoonist, and developed many of the studio's special effects as well as some early animation, but most of his energy went into regular Vitagraph films.

In Europe, Emile Cohl was doing important work in developing animation, but his interest was more scientific than artistic.

In the United States, Winsor McCay (1871–1934) was the next major influence in animation. With only a minimal amount of formal art training, McCay went to work producing posters, signs, and woodcuts for vaudeville. Despite his lack of training, he was a master of perspective and color. He created at least seven comic strips, drew editorial cartoons, and was one of the pioneers in the animation field.

McCay developed many of the techniques, made important films, and publicized the medium with fellow cartoonists and the public. His first film used his newspaper strip, *Little Nemo.* He then took his next film, *Gertie the Dinosaur,* to vaudeville, where the animated Gertie and the real-life McCay seemed to interact: Gertie obeyed commands and appeared to eat food that was tossed to her.

The animation field was exploding. Studios opened and closed, merged, and split. They were all small operations with no strong financial stability. Animators jumped back and forth between studios as opportunities presented themselves. New animation techniques were developed almost daily. J. R. Bray saw early on that animation would have to be a production-line operation, and set about developing and patenting devices, as well as appropriating devices developed by others who'd neglected to patent them. Fortunately, most of the patents entered the public domain in 1932.

Newcomer Walt Disney made the next leap forward in animation. He barely scraped by until he came up with a mouse named Mickey and added some limited sound to a feature titled *Steamboat Willie.* Animation as we know it had arrived. (We'll talk more about modern-day techniques in Chapter 18, "Animation.")

Comic Books Find the Superhero

Comic books are another medium that can trace its family tree back a long way. They have the same antecedents as the comic strip. The works of Europeans like Töpffer and Busch could qualify as either comic strips or comic books.

In Japan, the word manga, meaning "comic book," was coined in the late eighteenth century. The Japanese comic book rested on a long tradition of humorous art, going back to the animal scrolls of the twelfth century, which told narrative tales using anthropomorphic figures. They had limited distribution but in the seventeenth century, woodblock printing made the tales accessible to the Japanese public. In the mid-nineteenth century, Japan was opened to world trade, and Western cartoons influenced Japanese cartoons, resulting in the modern Japanese form called manga. (You'll learn more about manga in Chapter 19.)

A small section of one of the animal scrolls. Some are 80 feet long!

(© Kozanji Temple, twelfth century)

England developed what has a claim to being the first comic strip or comic book as well. The ne'er-do-well Ally Sloper was introduced in the magazine *Judy*, a *Punch* clone, in 1867. It was collected into a book in 1873 and given its own publication, *Ally Sloper's Half Holiday*, in 1884. A number of artists worked on the feature over the years, and the magazine ran in some form until 1923, with several one-time shots after that. *Comic Cuts* and *Chips* were two of the many comic weeklies that followed *Ally* onto the scene. *Chips* introduced *Weary Willie* and *Tired Tim* in 1896.

The figure in the panel at the right is Ally. He's a bit like the Dickens character Micawber, W. C. Fields, and Andy Capp all rolled into one.

(© Ally Sloper's Half Holiday, 1884)

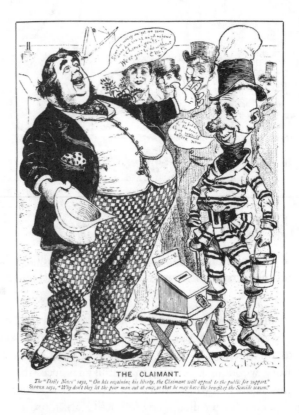

THE CLAIMANT.

The popularity of the new color comics in the United States ensured that some would be reprinted in collections. William Randolph Hearst was the first to do it, publishing collections in 1902. They were in full color with cardboard covers. The price was 50 cents. The publisher Cupples and Leon began about the same time

and soon dominated the field. Their books, of about 48 pages, featured popular strips without color, although the cardboard covers were printed in red and black. They were 10 by 10 inches in size and sold for 25 cents. They and numerous imitations were sold at newsstands and train depots.

One of the early Cupples and Leon books, featuring the comic strip Bringing Up Father.

(© Cupples and Leon, 1919, author's collection)

In 1934, H. I. Wildenberg and M. C. Gaines of Eastern Color Printing began publishing reprints in the modern comic book format as premiums for various companies. They were a hit, and they began marketing them to the public as *Famous Funnies.* The success was enough to inspire numerous imitations, mostly reprints, but eventually some original material began to appear. Sales continued to climb, and the stories separated into genres: funny animals, Westerns, teens, romance, crime, a bit of everything.

In 1938, to the horror of its publisher, a new feature was slipped into the premiere issue of *Action Comics.* It featured a bizarre hero named Superman. Sales of the comic book skyrocketed. The publisher, Harry A. Donenfeld, thought the concept too fantastic and ridiculous. He ordered the editor to at least keep Superman off the cover. That lasted five issues; then it became obvious why the book was breaking sales records, and Superman returned to the cover to stay. The superhero had arrived, and comic books would never be the same.

The Least You Need to Know

- Editorial cartoons began by pointing out social problems, but now more frequently lampoon politics and politicians.
- During their heyday, humor magazines were primary outlets for publishing cartoons, but they are no longer very popular.
- With new printing techniques, comic strips made an appearance in newspapers and even spawned a new term: "yellow journalism."
- Surprisingly, animation is a very old form of cartooning; from the start, artists have been searching for ways to make their creations move.
- Comic books began as reprints of comic strips in book form, but they gradually evolved into different genres and introduced the first superhero.

Where Cartooning Is Headed

In This Chapter

♦ A look into the future

♦ Comics and the Internet

♦ The new technologies of programmable paper and electronic ink

♦ Print on demand—and what it means for cartoonists

♦ Moving into *Star Trek* territory: holograms

We've taken a look at where cartooning has been. That's important, but if we don't want to get caught inventing a new and improved buggy whip, then we also need to keep an eye out on where cartooning may be going.

At one time, many cartoonists made at least part of their living performing, but vaudeville is dead, and the quick-sketch or chalk-talk artist is nearly so. These artists specialized in combining a rapid-fire patter with a drawing technique where the images at first looked like one thing, but as lines were added became something else. Books listing various chalk-talk tricks were good sellers for publishers.

The category of sports cartoonist on a newspaper's staff has also nearly disappeared. The number of editorial cartoonists on local staffs has shrunk, with more papers relying on syndicated material. These are trends that may get worse, or they may reverse themselves. A crystal ball would be nice, but since we don't have one, the best we can do is look at trends and developing technology, and make some educated guesses. That's what this chapter is about. We've included some of what we think are the most interesting of the new trends.

A Look Ahead

The magazine and newspaper industries are in a state of flux as they develop more of an online presence. The online content of magazines and newspapers is often very different from what is printed. Desktop publishing continues to expand.

There's always the chance that we can become the pioneers in a new area of cartooning. We just need to keep an eye on trends and emerging technologies, and try to figure out how we can make the best use of them. Cartooning isn't about a technology; it can adapt to wherever we want to use it.

Creative Inkling

One new trend, graphic novels, is gaining more acceptance. These can be found in more and more traditional bookstores. Graphic novels are essentially book-length comic books that tell a complete story instead of continuing from issue to issue (you'll learn more about them in Chapter 17, "Comic Books").

The Wide World of Digital

The word *digital* covers a lot of territory, but for the moment, we'll stick to how it relates to computers and the Internet. Not long ago American cartoonists would probably have avoided working for a client in Europe or Asia because of the time and cost involved in sending material by overseas mail. That limitation no longer applies. Communication by e-mail is quick and cheap. With a scanner and a fast modem, we can send cartoons to any part of the world faster than we can send them to a local client by traditional mail. With a web page, clients anywhere can look at samples of our work and contact us right away.

The web promised to be of huge benefit to cartoonists. That is still true, but it may not be in the way that we first imagined. For a time, cartoonists were busy supplying content for various dot-com firms, but then the bottom dropped out, and there were more cartoonists than markets. That will change but exactly how is questionable and bears watching. While there may be some, at the moment we can't name anyone who is making a living solely from cartooning on the web. Electronic greeting cards were a very profitable market for some cartoonists, but some of the firms buying them have dropped out. It is still a market worth watching though, and will probably make something of a comeback.

Web comics have, at this time, not proven to be much of a market for the professional, but new concepts and technologies may change that. Some experiments are being done with publishing comic books online. These "e-comics" may be in the traditional format or may involve limited animation and even sound. There are a lot of amateur strips on the web—some very good ones, but more that are very bad. Still, like it has been said of small comedy clubs, we need somewhere to start, even if it's bad, if we're going to improve. There are also professional-level cartoons that are published only on the web, though not very many.

From the Pros

One of the better web cartoonists is Bill Holbrook. He's also one of the busiest cartoonists we can think of. He has two nationally syndicated strips distributed by King Syndicate: *On the Fast Track* and *Safe Havens.* Both are dailies. He also produces one of the most popular strips syndicated on the Internet, *Kevin and Kell.* That's 18 strips a week! Bill has a very offbeat sense of humor that many find addictive. *On the Fast Track* is set in the business world. *Safe Havens* started with kids in daycare, but they've aged and are now in high school. *Kevin and Kell*—well, you need to see it. Check out Holbrook's work at www.kevinandkell.com/index.html.

What is certain is that the web provides a great many opportunities for cartoonists. Websites offer a unique way of showing your wares to potential clients. Some artists have built up a considerable business displaying low-resolution art online that can be ordered at a quality suitable for publication (check out Chapter 27, "Self-Promotion," for details). Some cartoonists offer only limited free access to part or all of their sites. Access to all the cartoons published online is by password for paying subscribers. Generating revenue is the main problem on the web, especially as there is so much free material there. It takes some marketing skill, but that's true of all professional cartooning.

For the amateur or hobby cartoonist, the web is an ideal way to share your work with a worldwide audience. That is something that has never before been possible. The drawback is that the web is huge, and it's all too easy to get lost in the crowd.

Programmable Paper and Electronic Ink

Two developing technologies seem to be merging and may revolutionize the publishing business are programmable paper and electronic ink. The technology of *electronic ink* is currently being researched and developed. The ink can be programmed to be one of two colors. Turned off it is the same color as the background (invisible); turned on it takes on the second color, such as black. If you blow up the pictures or letters on your computer screen, you'll notice that they are made up of tiny black squares. Electronic ink works in the same way. So far multiple colors are impossible, but that will probably change. This means that newspapers, magazines, and even books can be updated without needing more paper. It would allow the print media to compete on a level playing field with the Internet and, to some degree with television.

Electronic ink works by coating a sheet of paper-like material with the "ink." The ink capsules are about the diameter of a human hair. These capsules can be turned on (charged) or turned off electronically. That's basically all our computers are: millions of little switches that are turned on or off, speaking a language made up of only ones and zeros. The surface stays set until the user changes it by programming or downloading a new design, and it doesn't require any additional power, so it doesn't have to be plugged into a power source.

'Toon Talk

Electronic ink is a technology currently under development that enables electronic "ink" capsules to be placed on a paper-like surface. The ink can either be turned off (made the same color as the background) or turned on (made a different color). This enables images and printing to be changed with just the push of a button.

Another technology that combines with electronic ink or works on its own is programmable paper. This is simply a very thin sheet of plastic transistors that are flexible and transparent.

It's too early yet to tell exactly what direction these technologies will take, but because they involve imagery, they will provide opportunities for cartoonists. At the moment, practical application is limited to onsite signs at places of business. These can be purchased or leased but are still expensive. They are capable of limited flashing and animated effects. They have the appearance of a cardboard sign, but besides the animated effects, they can be changed quickly and easily. They run on batteries, using about the same power as a wall clock. JCPenney and the Arizona Republic have experimented with versions of this technology. Motorola and Hearst are among those financing research in the area.

Signs and billboards are the first electronic-ink applications being developed, but programmable books, newspapers, clothes, and even wallpaper are also being worked on. Imagine a T-shirt on which you can change the design merely by plugging it into a device for a few seconds. No need to buy a lot of T-shirts; just purchase the designs you want and change them to whatever fits your mood. When the kids outgrow the wallpaper design in their room, you simply purchase or download a new design and install it. Posters are another potential use. Newspaper strips and editorial cartoons could be animated with electronic ink or to save space, rotated like a slide projection presentation. In these cases, the demand for a variety of images and designs should provide an expanding market for images of all kinds, including cartoons.

Creative Inkling

For more information on electronic ink and programmable paper, check out www.eink.com, www.parc.xerox.com, and www.lucent.com.

Resolution is still the primary problem. Some of the large signs are using only 2 or 3 dots per inch (dpi), but one firm has claimed a

resolution of 200 dpi (your computer monitor generally only has a resolution of about 72 dpi). Like early video recording formats, it's hard to tell what the final standard will be, but all will offer a medium for those of us working in graphics.

Print on Demand

Currently, "print on demand" refers primarily to a new approach to self-publishing. The publisher has on hand digital files of the work and prints them up as copies are ordered, shipping them to the purchaser. Print on demand eliminates the cost of printing books that are never sold and also allows the book to remain perpetually in print.

The envisioned model would place machines in bookstores with digital files of the books on hand. A customer would come in, order the book, and within minutes, have a copy in his or her hands. Bookstores and publishers would avoid having a stock that isn't moving and could instead stock books that would normally go out of print.

The technology has its limitations, however: no color, paper covers, and a limited number of pages. The machines have been placed in a few stores on an experimental basis, but until the technology improves, sales are not apt to be large enough to justify the expense of the printers. The technology will be developed, though, because economic motivation is strong. When it does arrive, it should revolutionize the book-publishing business.

Until then, for those who can benefit from self-publishing, printers offering print on demand are an important alternative. Self-publishing is a risky undertaking, though. It involves the outlay of cash and a lot of work. It seldom shows a profit, except for niche books. Books of local interest or on highly specialized subjects that wouldn't justify a major publisher's investment can make self-published books best sellers. For cartoonists, works of a general nature haven't done well, but collections or comic books with a tight theme can sell if you work at promoting them. Cartoonists have had success in the past with self-published books about a particular locale, a specialized hobby, or where the cartoons have developed a following but not one large enough to justify a major publisher's interest. Ace Reid self-published book collections of his *Cowpokes* series for years, which made it possible for him to keep the Draggin' S Ranch in the black.

Holography and Internet Animation

Holographic technology hasn't yet reached a stage where the average cartoonist can make any practical use of it. It is too expensive and too complex for use in any but a limited, controlled situation. You'll find examples of it at Disneyland in the haunted house and other places.

'Toon Talk

A **hologram** is a three-dimensional image created with photographic projection. At its simplest form, the 3-D image is recorded on a static two-dimensional surface, such as paper. Holograms are made up of very fine grooves that bend light in an encoded pattern. This produces a 3-D or animated picture if viewed at the right angle.

Holography's time will come. Animators should keep an eye out for breakthroughs. In the meantime, simulated and simple forms of holographs may be of interest to those who want to look into the technology. Holographs can now be printed on paper, though the thickness and cost are still drawbacks. *National Geographic* has used several holographs on its covers, and comic books have experimented with it. Holographs make for interesting novelty items, and cartoonists have always found novelty items to be profitable. Cartoon holographs can be placed on ceramics, business cards, and a number of other novelty items.

Animation on the Internet is hardly news, but it is still limited in length and complexity. As processors get faster, the amount of available computer memory increases, and software becomes more sophisticated, this will change. Fewer and fewer people are needed to create lengthy animated films. Technically, an animator could produce feature-length animation

alone, but it would take quite a while and would be costly. Winsor McCay did it about 80 years ago with no technology to speak of. Learning the basics of computer animation is a wise move if you want to go this route or produce animation for Internet distribution. (Turn to Chapter 18, "Animation," to further explore the worlds of Internet and computer animation.)

The Least You Need to Know

◆ Cartoonists need to keep up with changes in the field in order to take advantage of new trends.

◆ Cartoonists can use the Internet now to promote themselves, sell their work, and cultivate a wider audience.

◆ The developing technologies of programmable paper and electronic ink offer new forums for cartoonists.

◆ Print on demand may give cartoonists and comic book artists a cost-effective way to self-publish their work.

◆ Holographic cartoons and feature-length Internet animation may be a reality sooner than you think.

Part 2

In the Toolbox

Time to get to the here and now. First you need the tools to work with. What you wind up with depends on what kind of cartooning you're doing and what works best for you. There are no magic bullets. The right pen, chair, or ink won't make you a better cartoonist.

What works best for you—that bears repeating. The way to find that out is to experiment. In order to do that, you need to know what's out there, and this section will be your guide. The necessities are pretty simple; beyond that, it's a matter of convenience and preference. We feel it's worthwhile to master the traditional tools and materials, even if you move on to something more contemporary later. After all, the more skills you have, the better off you are.

Tools of the Trade

In This Chapter

- ◆ Determining what tools you need—and others you might want
- ◆ How well will your work reproduce on camera?
- ◆ The basics: pencils, crayons, pens, and brushes
- ◆ Other handy helpers to include in your toolbox

It's easy to get caught up in worrying about having the right tools in order to turn out professional work. A lot of cartoonists are tool junkies, but if you don't have some special tool, don't let that stop you from working.

There are a few simple things you need to know for your work to be usable, but after that, what tools you use is a matter of preference. Most of the stuff mentioned in this chapter isn't a necessity. It's helpful to experiment to see what works best for you, and that takes trial and error. All the tools we mention here are available at artist-supply or office-supply stores. Shop around and see what appeals to you!

How Will It Look on Camera?

When drawing for print media, all you have to worry about is how well the work will reproduce on camera. If the work isn't in color, then you need an image that the printer's camera will see as black and white. This type of camera won't see light blue.

Many artists use nonphoto blue pencils to make rough drawings. A nonphoto blue pencil is a pencil that draws light blue, a color that won't be picked up by cameras. Cartoonists often use these pencils to draw rough first versions of their cartoons because the pencil lines don't need to be erased from the final drawing. They eliminate the need for erasing and speed up the process, but the messy look drives some cartoonists up the wall. The blue is also used on preprinted forms, and both the pencils and the forms are popular with comic-book artists. Back in the days when letterpress was the rule, a benday tint (which we'll discuss in Chapter 6, "Working in Different Media") was often indicated by a blue wash, but you had to be careful not to make it too dark. Some artists use the laundry product Mrs. Stewart's Liquid Bluing, which most stores carry in the laundry section. It makes a great blue watercolor when diluted.

If your black isn't a true black, then the printer's camera may give it a muddy look. Yellows, even light yellows, are unpredictable, and they may not register at all or register as a muddy gray. Light greens are iffy. Red will usually register as very black.

If you are pasting elements into the work, be careful about the edges. The camera uses a very bright light, which may cast a shadow that registers as black. Scraping, heavy erasing, or too much pressure on a pencil may leave marks that leave a shadow for the camera to see.

Making Your Mark

The most basic tools for any artist are paper and something to draw with. We'll discuss paper in the next chapter, but for now let's consider what tools you should choose to draw with. Most cartoonists have a selection of pencils, crayons, pens, and brushes on hand, so the perfect tool is always nearby, and so they can play around with the different "looks" produced by a variety of drawing tools. Still, we always tend to gravitate toward our favorites. We'll discuss your choices and make some recommendations, but nothing can substitute for your own experience, so be sure to play around to figure out what works best for you.

From the Pros

The famous British cartoonist, Ronald Searle, was taken prisoner by the Japanese early in World War II. During his years of confinement and forced labor, he produced drawings on scraps of paper he managed to scrounge, using a pen made out of reeds with furniture polish for ink. Even under the worst of circumstances, he turned out drawings that make other cartoonists turn green with envy!

'Toon Talk

Wooden **graphite pencils** were developed in the early 1800s. There are two types of grading. The Conte system is the everyday pencil and uses only numbers. The Brookman system is the one used for art pencils. A number-2 pencil is about the same as an HB or F pencil. Unmarked general pencils may fall somewhere between a 2H and a 2B pencil.

Pencils and Crayons

Most cartoonists use *graphite pencils* of some kind. The exceptions are if you do all of your drawing on the computer, use a nonphoto blue pencil, or are one of those brave souls who starts right off with pen, brush, or marker. The plain old number-2 pencil you used in school works fine, but you might want to try artist's pencils to see if they work better for you. They are a mixture of graphite and clay encased in wood. The higher the ratio of clay to graphite, the harder the pencil is.

Artist's pencils come in grades, 9H (the hardest) to F and HB in the middle, and then to 9B (the softest or blackest). Some brands don't make the extremes, since there's not much demand for them. The harder grades are better for blocking out a cartoon before inking, if you don't bear down too hard. They erase more easily and are less apt to smear. The B grades are great for sketching. The bolder line encourages simplicity and expression. For experimenting, we recommend the grades between 2H and 4B.

Two types of automatic pencils are commonly used by cartoonists. The standard .5mm or .7mm pencils work well, though some prefer the .9mm, which may be harder to find. They don't require sharpening, and the line is fine enough to make erasing easy. It's harder to find a variety of grades in lead pencils; most are HB or an equivalent. The second type is the older clutch-type drafting pencil. Most use a lead of about 2mm, though we've seen quarter-inch pencils and lead. The various grades of lead are generally easier to find for clutch pencils, and the thicker lead makes a bolder line for sketching. If you're using a graphite pencil for reproduction, the softer grades are much better, but they do tend to smear, and they usually have to be shot as halftones, not line work.

There are any number of specialty pencils on the market. You can find pure graphite sticks or pencils. You may choose to keep the softer grades of these handy for applying thick lines to the back of drawings. This is a technique used to transfer a drawing to a new surface, similar to carbon paper (see the following Creative Inkling sidebar). Pencils of greater black than regular graphite usually have at least some lampblack or other

pure carbon added and may be labeled as carbon pencils. Some of the names are Black Prince, Black Beauty, Black Magic, Ebony, and Negro. Graphite is also available in powdered form.

> ### Creative Inkling
>
> Most art stores sell transfer sheets, thin paper coated with graphite so it's erasable. It's generally easier and cheaper to make them yourself. Apply graphite to the backs of your drawings using a broad, soft lead. If there's a lot of detail, simply scribble lines over the whole area, and then with a bit of solvent, smooth the graphite out to an even layer. The solvents are Benzine or Naphtha (Ronson lighter fluid works great).

In graphic arts, when crayon is mentioned, we're usually talking about the lithographic crayon. Currently, they aren't used as much as they once were. They were designed to draw on lithographic stone and have a waxy, greasy texture. At one time, many editorial cartoonists used them to emulate the style of nineteenth-century French cartoonist Honoré Daumier. Several *New Yorker* cartoonists have used lithographic crayons, and the syndicated cartoonist George Lichty used them in his *Grin and Bear It* syndicated panel.

Used on a textured surface, such as the pebbled surface of a Ross or Coquille board, lithographic crayons produce a shaded, half-tone effect that can be shot as line art, rather than needing to be screened like a wash or other solid gray. They come in square or round sticks, and may be used in crayon holders. The leading brands are Korn and Stone's. The grades run from 0, very soft, to 5, copal hard. A grade of 3 or 4 seem to be the most popular with cartoonists. Large black areas should be filled in with ink, as the crayon will smear.

Some other tools work in the same manner. The plain black Crayola crayon or china marking pencils work. The Prismacolor black pencil is very similar to a harder lithographic crayon and is a popular sketching tool. Rick Kirkman uses the Prismacolor black to draw his cartoon *Baby Blues*. He doesn't use it to shade with, just to draw a solid black line. He likes it, but wishes it wasn't so brittle.

Pens

The pen is a very old tool, going back to the reed pens of Egypt. They advanced to quill pens, usually goose quill, and then to the steel dip pen, which became common in the late 1820s.

There is a dip pen for every possible use and taste, though they are getting harder to find. Stores selling calligraphy supplies are the best sources. Many people find the need to keep dipping them into the ink a nuisance. While it takes a little practice to handle them, they are flexible, and you can easily get a varied line by changing the amount of pressure you apply. Many cartoonists find the varied line more interesting in appearance, and the only other way of producing one of any quality is with a brush. Most modern pens leave a very uniform mark.

India ink doesn't work well in modern pens, but it is light-fast—which means it won't fade in sunlight—and many of the modern inks aren't. For that reason, many cartoonists continue to use the dip pen with India ink (you'll learn more about inks of all types in Chapter 6).

Speedball pen points are manufactured by Hunt and are basically lettering pens, but a number of cartoonists use the B and D styles for general drawing. They come in six to eight sizes; the higher the number, the finer the point. They also make each style in a flicker pen, where the reservoirs are hinged for easy cleaning.

(© Hunt Manufacturing Company, 1960)

Red Ink Alert

Dip pens are usually sold with a fine coat of oil, which interferes with the ink flow. The old fix for this was to hold the pen briefly over an open flame. That method may ruin the temper of the pen, though, and unless you prefer that, it should be avoided. Wiping the pen with a cloth dampened with alcohol is much better.

For dip pens, the leading brands are Gillott and Hunt. They come in points that fit standard holders, while the crow quills have a tubular barrel and need a smaller holder. The most popular sizes seem to be the Gillott 303, 290, and 170. For the Hunt brand, they're the 107 and 512.

If you're trying dip pens, don't limit yourself to these suggestions; a variety of pen points are out there. The globe-bowl type is one of the other popular types.

You can use fountain pens if you don't need a variable line, and you can try technical pens that are simply a fine wire inside a tube. The disadvantage of technical pens is that you have to hold them vertically for the ink to flow. You can even use some of the better ballpoints, as well as those pens with a fiber tip.

If it makes a clean, black line without digging into the paper, it will work. If you're fussy, you may worry about how light-fast or acid-free the ink is in the disposable pens. The problem is, no one knows.

Brushes

If you want to master the brush, then don't settle for second best. The round watercolor Red Kolinsky sable, shown in the following illustration, is the top-grade brush for cartoonists. You need a brush that will hold a good quantity of ink, will keep its shape, and will have enough spring to make variation of line easy. The shape of the brush should be symmetrical, and the widest portion of the brush, the belly, should be at or near the ferrule, the metal section connecting the brush to the handle. The wider the belly, the more medium it will hold. There shouldn't be a concave shape to any part of the brush.

Scan of Winsor-Newton Kolinsky sable brush series 7, number 3.

Belly

(© Arnold Wagner, 2002)

For large black areas, any brush will work. Some cartoonists don't even bother with a brush; they use a cotton swab to fill in large areas. If you want to experiment, you might try some of the brushes that have a blend of natural hair and synthetic fibers. Some very good synthetic fibers have been developed recently. The Kolinsky sable brush usually starts at about $20 and goes up from there, depending on the size of the brush. Regular red sable is less expensive.

Another type of brush to experiment with is the Oriental brush. Most have bamboo handles, and they handle very differently than Western brushes. Some examples are the Japanese hake brush and the Sumi brush, pictured in the following illustration. (Arnold is fond of the latter.) Oriental brushes come in a wide range of sizes and prices, so shop around.

Scan of Sumi brush.

(© Arnold Wagner, 2002)

Cartoonists generally use India ink with the brushes. Because the carbon in the ink is an abrasive and can damage the brush, the brush should be cleaned after each use with warm, soapy water or with a commercial brush cleaner and then rinsed, and set out to dry with the tip up and not resting on anything. Being especially careful to clean near the ferrule is important. Never leave the brush sitting in water with its tip touching the bottom of the container. It will ruin the shape.

Brushes are numbered according to size. The numbering system varies considerably between different types of brushes and even between brands, to a degree. There are no standards, so you just have to experiment to find out what works for you. The number 2 or 3 are the favorites among cartoonists for general work. We suggest number 1 for fine work and number 5 or 6 for filling in.

Other Tools, Fancy and Plain

All of the tools suggested here are just that: suggestions. Of course, cartoonists tend to haunt artist-supply stores and pick up any tools that catch their fancy or for which they can imagine a use. As long as it doesn't bust your budget, there's nothing wrong with that. We've tried to include tools here that are fairly inexpensive and which you'll find many uses for. Still, don't stress if you don't acquire all of these tools right away. Pick them up as you find a need for them (and if you find you don't need them, that's okay, too).

Rulers and T-Squares

A variety of rulers is nice to have around. A plain old 12-inch school ruler is fine, especially if it has a raised metal edge for ruling with ink. A strong metal straight-edge is good for cutting, especially for heavy stock paper. Rulers marked in both inches and centimeters may be needed, and those with printer's measures— points, picas, and agates—are good if you're planning to publish in newspapers.

T-squares should be long enough to reach all of your working area, but not so long as to knock stuff over. The kind with a wooden center and clear plastic edges is best. The wood should be a bit thicker than the plastic, giving you a raised edge. Check to make sure that the two parts of the T-square are very well fastened together so that they won't allow wiggle after they've been used a while.

The circular proportional scale, shown in the following photo, is also a handy tool to have. If you're working with layout, it is almost a requirement. It's an easy way to tell how much you'll need to reduce a cartoon to fit a given space, or the reverse.

Creative Inkling

In mastering the brush, try to keep your hand relaxed, and move your whole arm more than your wrist. Holding the brush in a nearly vertical position will give you better control. Avoid overloading the brush with ink, and experiment with a dry-brush technique, using very little moisture or wet media (this technique is mostly used with watercolor or India ink).

The circular proportional scale is a handy artist's tool.

Cutting Tools

You'll need cutting tools for all of the following tasks, and dozens more:

- Cutting preprinted elements that you want to glue onto artwork (logos, special type, and so forth)
- Making corrections
- Redrawing a section and gluing it on the original
- Cutting protective mats and overlays
- Using plastic tinting sheets

> **Creative Inkling**
>
> Cutting mats are a great time saver, especially the transparent, self-healing ones that can be used on a light table. You can cut through whatever you're cutting easily, without worrying about damaging the surface below. Some cutting mats come with graphs and rulers so that you can measure as you go.

A simple craft knife with disposable blade sections works fine. We have X-Acto blades of various shapes, such as angles for cutting and round for scraping off errors. You might also want a frisket knife with the same types of blades, a scalpel, and/or single-edge razor blades. You should also invest in a variety of scissors and shears. Another handy cutting tool is a guillotine-type paper cutter or a trimmer with a round blade.

Drafting Supplies

Compasses of various kinds, ruling pens, and dividers are more niceties. You can find fairly cheap sets sold in most art stores, and compasses are often sold separately. Triangles, protractors, and lettering guides can also come in handy.

Sharpeners

The old hand-cranked pencil sharpener is still a basic. If you use an electric version, the vertical models where you insert the pencil at the top are considered the best. The small handheld sharpeners never seem to work well, not even the expensive ones. Lead pointers are needed for the automatic clutch pencils where you only need to sharpen the lead. These work by a grinding process. Some small handheld ones work well, as do the heavier desk models. A sandpaper block also works. Of course, you can always fall back on the knife or razor blade for sharpening regular pencils.

Erasers

If the world were perfect, we wouldn't need erasers—but then we wouldn't need cartoonists, either. The primary erasers are the white plastic types (our favorite is the Magic Rub) and the kneaded erasers that can be shaped to touch odd spaces without bothering what's next to them. Gum erasers are very gentle but messy. Then there's the old standby, the Pink Pearl, which works well. Try to avoid the ink erasers, because they are too hard on the paper. The refillable-pencil plastic erasers are very good, and if you want to spend the money, electric erasers are labor savers. Along with these, a good eraser shield can save your nerves.

Adhesives and Tapes

Rubber cement is the old standby for paste-ups, although it is messy. Spray adhesives are popular, but for health reasons you might want to avoid them, due to their toxic fumes. The glue sticks sold in most office-supply stores work quite well for small areas.

We don't advise the use of masking tape in the studio, in most cases. It could tear or mark your work, or leave residue when removed, and it ages badly. You can find artists' or architects' tape that is far superior for

your purposes. It's usually white, but not always. Many cartoonists also keep some varieties of Scotch tape around. The double-sided kind is handy at times.

The Least You Need to Know

- ◆ Trial and error is the best way to learn what tools will work best for you and to determine how well your work will reproduce on camera.

- ◆ When drawing for print media, you need to take special note of how well the work will reproduce on camera.

- ◆ Before you can draw, you need something to draw with; keep a supply of pencils, crayons, pens, and brushes around, and keep trying new tools to experiment with different "looks."

- ◆ Any cartoonist's studio will have a variety of tools lying around, but they're not necessary to be a working cartoonist; look for inexpensive, handy helpers that you'll use often.

Working in Different Media

In This Chapter

◆ What you need to know about ink types

◆ It's a wash: watercolor

◆ Dry media: colored pencils and charcoal

◆ Using mechanical tints

◆ Using the computer and other media

◆ Paper issues and how to archive your work so it lasts

The word *media* has two meanings in cartooning. In one sense, media refers to where and how the material will be published. That might be magazines, newspapers, film, videotapes, digital formats, books, advertising, or some subdivision of those. The other definition of media has to do with the materials you're producing the work with: pen and ink, watercolor, gauche, acrylic, pencil, crayon, charcoal, oil (unusual but not unheard of in cartooning), or any of dozens of others. In this chapter, we'll primarily discuss this latter type of media.

How the tools, the various media, and the surfaces react to each other can be surprising, and surprises can be unpleasant. It helps to know something about each medium. What we'll try to do in this chapter is outline the basic nature of the main media used by cartoonists.

All About Inks

Ink is a dye, not a paint: It stains rather than covers, and because of that, it is never totally opaque. India ink is the exception, though it can easily be thinned to a gray wash. The colored inks you see in art stores won't cover a mark made by any other media.

India Ink

Ink is a very old medium. What we call India ink was invented independently in China and Egypt around 2500 B.C.E. or a bit earlier. The Egyptians had two kinds of ink. The first was the same as India ink: carbon and gum dissolved in water, making a deep black. The other kind was made of green vitriol and nutgall dissolved in water.

The Chinese made ink production into an art. True India ink (also called China and Japan ink) comes in the form of a stick; bottled ink is a modern invention. Makers have their own secret formulas and processes that are handed down through the years. The sticks are usually marked with the maker's name and location. Quality sticks may also carry the date—the older, the better.

Red Ink Alert

Ink ground from an ink stick must be used before it dries out. If you try to reconstitute the dried ink with water, it will usually flake when dry. It's best not to grind more than you need at one time.

The ink is prepared for use by grinding the stick in water on a fine whetstone or shallow mortar. A lot of effort is involved, which is probably why stick ink is not popular in the West. Experts believe that even the way the stick is rubbed on the stone affects its character. In washes, the tonal values from stick ink is superior to the modern bottled inks. You can buy the sticks and the stones for grinding them in most art-supply stores, but they are expensive and they may not be worth it to you.

Bottled India ink is basically the same as ink sticks, allowing for secret recipes and processes as well as modern shortcuts. A mixture of carbon, alkali, and a weak gum is the basic formula. Waterproof ink usually has some form of shellac added. As you'll recall from Chapter 5, "Tools of the Trade," the carbon found in India ink is abrasive. Add to that the effects of even a mild alkali, and you have a substance that's rough on brushes and pens. Tools need to be cleaned after each use.

You can dilute bottled India ink for a wash, but the quality is inferior to the ink stick or watercolors. It may have a brown or reddish tint.

India ink comes in waterproof and water-soluble forms. Permanent generally means waterproof, not light-fast as many think. So that "permanent" ink may still fade over time, especially if exposed to direct sunlight. Sumi ink is generally waterproof.

Different types and brands of India ink vary greatly. You should try as many kinds as you can until you find one that works best for you. One brand may stress an easy-flowing quality, while the next one may stress density, and the next the undertones. There are high-density inks, ink for use on film, opaque inks, inks for technical pens, etc. These have special ingredients, and the warning about cleaning tools is doubly important. India ink should never be used in fountain pens or the refillable technical pens. It will damage them, and it seldom flows well anyway. Some cartoonists use an embossing ink for all kinds of pens, because they say it flows better. You also might want to check out the inks used in calligraphy.

Before using any India ink, gently shake the bottle. The pigment has a tendency to settle to the bottom. Inks are traditionally transparent dyes, while India ink is an exception: The pigments (or coloring agents) are in suspension, not dissolved, so they can separate. India ink can go out of suspension if it's too old or if it has been exposed to extreme temperatures. Add a few drops of alcohol, a pinch of borax, and then shake; let it set a bit and it will probably go back into suspension.

Even with shaking, the ink may seem a bit weak when new. Some cartoonists will open a new bottle of ink and let it age for a few days before using it. That allows some evaporation, making it thicker. If you forget and leave it uncapped for too long, it may become too thick or dry out altogether.

'Toon Talk

Nutgall is a nutlike growth found on some trees or plants near the leaf stem, caused by an insect laying its eggs there. It's rich in tannic acid. The quality varies depending on the plant. The Oriental oak is generally considered the best.

Iron and Nutgall Ink

Originally made from iron salts and *nutgall*, iron and nutgall ink is now made synthetically. Iron and nutgall ink used to be called "blue-black ink." When new, it is pale in color, so a blue or black dye is added. Over time, exposure to air and light causes a chemical reaction, and it darkens to a true black. In part, that's because the ink actually burns into the paper. If the quality is poor, the color may fade to pale amber, like a scorch mark, or

it may burn right through the paper. But normally it is permanent. This kind of ink is not as common as it once was, but it will work in fountain pens.

Aniline and Acrylic Inks

Aniline and acrylic inks are becoming popular. Aniline dyes have improved but still tend to fade in light, although the color is very intense when first applied. Acrylic inks are usually opaque because they tend to remain on the surface rather than acting like a dye, but the ratio of acrylic to pigment affects that. Their long-term permanency is still unknown, but the pigments used for color are probably more important than the fact that they're acrylic.

Colored Inks

Colored inks are dyes. Therefore, they are almost always transparent, and few dyes are light-fast. With some, there have been some health concerns due to the fumes. With others, there is little odor, and they are probably quite safe. Whenever possible, we prefer to use watercolor, but some colored inks are waterproof, and at times that is important.

Red Ink Alert

Many of the materials we use can be bad for us. This is especially true with the items that are sprayed, like fixative and adhesives, but it can also apply to the solvents and medium in some paints and inks. Check the labels, and if you have to use those that are suspect, make sure you are working in a well-ventilated area.

Wash and Watercolor

Though not waterproof, watercolor makes the best washes. There are a number of names for black watercolor. The standard is lampblack, made from burning gas under controlled conditions where the soot is collected on glass plates. There are also various kinds of vegetable blacks made from twigs, basically the same way that charcoal is made. The most expensive type is bone or ivory black. (It's no longer true ivory, of course.) The quality is good, but it does have a flat bluish undertone that some people dislike.

Markers are also available in various shades of gray, both warm and cool, that can be used for washes, although getting the variation of tone is difficult.

Watercolors are great for coloring drawings once you master the technique. They aren't waterproof, but that can be an advantage at times. They are more apt to be light-fast, though it depends on the pigment used. You get what you pay for, and if you want them to last, buying name brands is advisable.

From the Pros

As a rule, avoid color names that are too simple; no paint is simply red, blue, or green. And fancy made-up names are gambles: They may be good, or they may be worthless. "Grass green," "sky blue," "electric blue"—these descriptions don't really tell you anything. The names may be a marketing ploy, or they may be named that because they don't want to tell you something. Look for colors that name the source of the pigment or are well established, such as cerulean blue, cadmium yellow, alizarin crimson red, or burnt ochre.

Pigments are generally divided into two kinds: organic and inorganic. The organic pigments include those that come from vegetable sources, such as gamboge, indigo, and madder. Animal-matter pigments include cochineal and Indian yellow. Artificial organic colors include alizarin and the anilines. The anilines are seldom light-fast.

Inorganic, or mineral, pigments include native earths like ochre and raw umber. Calcined native earths like burnt umber and burnt sienna are another group. In artificial mineral pigments, like cadmium yellow and zinc oxide, the pigments are apt to be very stable.

Dry Media

This category includes a broad range of materials, but cartoonists seldom use most of them. Colored pencils and charcoal are the main ones that we haven't covered in Chapter 5, so let's take a look at them here.

> **Creative Inkling**
>
> The surface you are working on makes a big difference. Pencils don't do well with paper that has a smooth finish. They need a bit of texture. If your surface is textured, it will show, which will add its own character to the work.

Colored Pencils

Colored pencils have become more popular for commercial work in recent years. The rule for all media also applies here: Quality costs money, and they may not be light-fast. Aside from quality, colored pencils come in various kinds. Some work much like any pencil, while some are water-soluble. Some have a chalk base and are similar to pastels. Others have a wax base and are more like a crayon. Mixing them with other media can achieve interesting effects. With watercolors, those that are not water-soluble retain a distinct character, while the soluble ones can be blended into the watercolor.

Charcoal

Several of the classic *New Yorker* cartoonists worked in charcoal. It can be used, carefully, on a textured surface that automatically breaks it into black dots and can be shot as line art. Alternatively, it can be blended like a wash, and the printer can screen it down into dots, just as they do with photos. In cartoons, charcoal is usually combined with ink.

When buying charcoal sticks, you'll see natural forms and compressed forms, which are made from powdered charcoal. The natural sticks are sold according to thickness: thin, medium, and thick. The compressed sticks are sold in grades from very soft to very hard. You can also buy the powdered kind for use with a brush or stump. The pencils come in the same grades as the compressed sticks. You'll want stumps or tortillons for blending. They're cheap and available at almost any art-supply store. Your fingers also work.

Mechanical Tints

Mechanical tints are patterns of dots, lines, or other small units that give the art a gray tone. The original mechanical tint was Benday, named for its inventor, Ben Day. The process he invented allowed the photo engraver to add a flat gray area to an area of an engraving. This is seldom seen now.

> **'Toon Talk**
>
> **Mechanical tint** refers to a tint that consists of a dot or line pattern. The mechanical tint can be laid down on artwork before or during processing for reproduction. **Benday tint** is another name for mechanical tint.

Benday refers to shading sheets. The sheets are patterns printed on acetate. They come in various patterns of different dots or lines per inch and percentages of black. The computer has cut into the demand for this technique, but it is still called for under some circumstances. Letraset still makes some varieties, as does Grafix. These shading sheets (also referred to as "stack") come in two types. With one you cut and burnish sections of the sheet onto the art where you want the tint. It uses a waxy adhesive.

The other is a dry-transfer process. You simply lay the printed sheet over your art and rub the sheet with a burnisher to transfer the pattern to where it's wanted. This second type allows a lot more freedom and control but

can also be damaged easily. In the example of the jester shown in the following illustration, Arnold has added excessive amounts of tint to show what it does—use it sparingly in your own work. The lightest area is a 10 percent screen from a pressure-sensitive sheet. As you can see, this type of mechanical tint allows you to put dots in places too small to try to cut a sheet to fit. The pattern on the jester's suit is a line pattern instead of the usual dot pattern. Another layer of the same pattern is then laid down at an angle over one part to produce a darker area.

Benday techniques.

(© Arnold Wagner, 2002)

Besides the shading tints, you can use color sheets and lettering sheets. All of these are getting harder to find.

There is also a special paper that has invisible patterns imprinted on it. Brushing a developer on the areas where you want a tone will immediately bring it up. It comes in several designs, with one or two patterns on a sheet. The primary manufacturer now is Graphix, which makes Duoshade and Unishade. Duoshade has two shades: a light shade at about 25 percent, and a dark shade at about 50 percent. You use one developer for the light and another for the dark. Unishade has only the light shade. The boards, usually a three-ply Bristol, come in varying lines per inch from 24 per inch to 42 per inch. This allows for the art to be reduced by 50 percent or a bit more. In cartooning, the technique is now primarily used by editorial cartoonists. In the era of the adventure comic strip *Roy Crane*, it was used very effectively in *Buzz Sawyer*.

Computers and Other Media

This subject involves way too much to cover here; it needs—and will undoubtedly get—a book of its own. We'll just take a quick overall peek.

Get Digital

There are some very good graphics programs out there (Adobe PhotoShop is one) which enable you to edit your art and color it. There are also drawing programs that allow you to create art from scratch on the computer. If you already use Adobe PhotoShop and Adobe PageMaker, you might opt for Adobe Illustrator as a drawing program. This keeps things compatible, but there are other good drawing programs available. Some cartoonists are using drawing pads that allow them to produce their cartoons entirely on the computer. Some use the computer merely to change the size of the cartoon, add color or lettering, or correct minor mistakes.

More and more often, cartoonists are delivering their art to the client by modem. Then there is art that is intended for display on the Internet, perhaps as part of a web page. Art on the web has a fairly low resolution; about 72 dpi is about as good as most monitors can handle.

Unless you're doing all your drawing on the computer, you will need a good scanner so that you can get your art into the computer. Graphics suitable for print result in big files. Some artists have gone the CD-burner route and are sending graphics on CD-ROMs. Zip drives also work, but the 3½-inch floppy isn't of much use.

What Else?

If you can draw or paint with it, some cartoonist somewhere has used it, but most of these mediums are too rare to consider the norm. Producing cartoons in oil has been done, but there's very little call for it. Considering the time and effort put into such mediums, the return is very small.

One area we haven't touched on is the plastic mediums. Some of that falls under the discussion of animation, but there are cartoonists doing illustrations in clay, sculpted paper, papier-mâché, and various other materials. These can be photographed and used as illustrations. Cartoonists working in this area can also produce stereotypes for novelty items, toys, or three-dimensional displays.

Get It on Paper

Most of us need paper at some point. That's true even if we work mostly on the computer, film, or with plastic items. What kind of paper you need depends on the tools and media you're using and how you intend to use the finished drawing. (We will mention the paper used for the specific kinds of cartooning in the chapters devoted to them.)

When working with dry media like pencil or crayon, you need a surface with a little "tooth" that will grab the pigment. With watercolor and some markers, the paper may buckle and warp if you are covering a very large area. If you want a smooth line, a textured surface is not the best choice. For wet media, you need paper that won't bleed.

Coated papers have a filler of pigment and binder applied to one or both sides. They can handle fine detail and vivid colors well. The character of the coating can vary greatly. It may or may not be absorbent. It may have a flat surface or a very glossy one. It can be very hard or relatively soft.

Uncoated paper may be uncalendered, calendered, or supercalendered ("calendering" involves rollers that press and smooth the paper at the paper mill). The smoothness increases greatly as you move up from uncalendered paper to supercalendered. The general levels of smoothness in uncoated papers are antique, eggshell, vellum, smooth, and lustre. Coating, which involves adding material to the paper to give it a particular trait, will make the paper even smoother. Some textures, like linen, tweed, and pebble, are embossed onto the paper at a later stage.

> **Creative Inkling**
>
> Embossed paper, usually pebble, works well with crayon or dark pencil that will be shot as line art. Ross and coquille board are both popular for this purpose.

The basic weight of paper as measured in the United States is highly confusing. It is the weight of 500 sheets, one ream, of the paper in its basic size. The problem is that there are different sizes for different styles of paper. Book paper is 25 inches by 38 inches, writing paper is 17 by 22 inches, cover paper is 20 by 26 inches, and so forth. This means that two kinds of paper labeled as the same weight may not seem the same weight at all. Don't buy 24-pound book paper thinking it is the same as 24-pound writing paper. If you are using the paper for wet media, it has to be heavy enough not to buckle easily. In most countries now, the weight of paper is measured by grammage: grams per square meter.

Protecting Your Work

A great many cartoonists couldn't care less about yesterday's work. If it disintegrates in 30 days, it won't bother them. Then there are those who fuss about this a lot. We have drawings on our walls by friends and idols from 50 years ago that still look as good as the day they were drawn. Several factors are involved in keeping cartoons in that condition: paper with a low acid content, light-fast pigments, and placing drawings where they're not exposed to harmful elements like direct sunlight.

The acid content of the paper is what will cause it to deteriorate. The pH factor is important. It's measured on a scale of 0 to 14, with 7 being a neutral value. Above that, it has an alkaline value. Below that, it has an acid value. The more acid, the shorter the life span of the paper. For direct mail, newspapers, and flyers, this is unimportant, but for books and documents, it is crucial. In order to be called permanent, the pH value shouldn't be less than 5.

Storage is also important. Naturally, it's best to store or display the work where it won't be exposed to extreme temperatures, too much dampness, or direct sunlight. The one thing that gets missed is what you store the work in. Wrap a drawing done on quality paper in newspaper or in most envelopes or folders, and the acid from those sources will affect the drawing and shorten its life.

If the life expectancy of your work is important to you, you may want to check out the supplies offered at comic book stores. We feel some collectors tend to get carried away and for all practical purposes, put their collections in a time capsule. Our own small comics collections are meant to be read. But collectors are responsible for the fact that we can buy acid-free plastic bags and backing cardboard, which is archival quality.

The Least You Need to Know

- Ink is an old medium and a popular one; India ink is the most widely used kind.
- Watercolor is a good medium for washes in both black and color.
- Dry media is a broad category, but cartoonists typically limit themselves to colored pencils and charcoal.
- Mechanical tints enable you to easily add shading to your drawings.
- The paper you choose depends on the media you're using and the final purpose for the cartoon.
- If you care about preserving your work, the paper you use and how you store your work are the most important considerations.

A Studio of Your Own

In This Chapter

- ◆ The bare necessities: a drawing surface, paper, pencil, light, and you
- ◆ Adding to your studio
- ◆ The importance of good lighting
- ◆ Why you need a morgue

As in most of this book, we try to give you as many options as possible. That's because there are no hard and fast rules in cartooning, only general guidelines. In the long run, you will choose your own path, but you want to be as well informed as possible in order to avoid learning the hard way.

Having art training, fancy tools, top-of-the-line materials, and a spouse or partner who is filthy rich can help, but they won't guarantee your success. There are plenty of cartoonists who make it without much in the way of any of these. They simply have some talent and a lot of persistence, sometimes called stubbornness or obsessive behavior. With this or any other book on cartooning, take what you need and forget the rest.

The Bare Necessities

Cartoonists who haven't been at this for very long seem to always be fretting over not having this or having that, sure that if they just had the right stuff, fame and fortune would quickly follow. Arnold has most of that stuff now, but it was because of what he did before he had it.

Arnold and another cartoonist discovered that a well-known cartoonist was living in a town about 60 miles away. They called him and were invited up for a visit. On arriving, they sat in his living room and talked shop—about markets, editors, and agents. They passed around examples of their work, and finally they asked to see his studio. He smiled and took them into the bedroom, a very nice and immaculate room. He pulled out a 20- by 26-inch drawing board and T-square from under the bed, swung a chair around to one side of his night stand, opened a drawer, leaned the board up against the night stand, and said, "That's it. I guess I'm just a neatness freak."

From the Pros

Mort Walker, creator of the cartoon *Beetle Bailey*, has said that even after he had a studio, he often wound up with his drawing board propped against the kitchen table. He seems to be one of those people who works well with other people around him.

Unless you draw technical details in your work or you're working in animation, that's about all you really need: a surface to draw on, paper, something to draw with, and adequate light. Many cartoonists have had a highly successful career without much more. You might want to add a T-square, two triangles, a ruler, a compass, a couple of erasers, and some white-out, and expand your drawing tools to a few more pencils, a dip pen, and a brush or two. Throw in a ream of 20-pound bond, maybe some two-ply Bristol, and some scrap paper, and you're in business.

Expand on that as your needs dictate, not just because you think it's the thing to do. Stick with what you really need and really want, and avoid the doodads that sound nice but only gather dust (we wish we'd follow our own advice!). If you can't make it with this much, then you probably can't make it.

Setting Up a Studio

The biggest advantage to having a fancier setup may be just psychological—it makes you *feel* more professional. Some items in your studio can make the work go easier and faster, but it probably won't make it better.

If you're part of a family, setting aside a room where you can be alone to work is a big help. It doesn't have to be much, but having a door you can shut is a big plus. Depending on the family, a lock may also help. If you work on a computer or will be using the Internet, the room will have to be a bit larger. Make sure the room has a phone jack as well as electrical outlets so that you can plug in your computer and any other machines you might need, such as a printer.

Red Ink Alert

Make sure your studio has good ventilation. You're almost sure to be working with solvents, thinners, fixatives, or other substances whose fumes can be harmful and flammable. A window or vents and a fan will make life a lot safer. Keep a working fire extinguisher handy, too.

Putting things on the wall can help inspire you: your work that you're proud of, the work of other cartoonists and artists whom you admire, things you find funny, and maybe parts of projects you're looking forward to. A shelf for some reference works and a cabinet of some sort for supplies are handy additions. File cabinets, card files, and bulletin boards help to keep stuff organized.

You might want to keep a stereo and a collection of CDs or taped radio programs handy in your studio to keep you relaxed and upbeat while you're working. Some cartoonists can't work with music going, some can only listen if there's no vocal, and some listen to stuff that would drive us up the wall. It's a personal thing; if it helps you, go for it. We know cartoonists who listen to talk shows while they're drawing. They say they get a lot of gag ideas that way. All we'd get would be a migraine.

An adjustable drawing table is a plus. Working at the right height is less tiring, and being able to adjust the angle to one that's parallel to your line of vision keeps you from hunching over the board, which can usually cause your muscles to cramp up after a while. Anything that helps eliminate a strain on muscles makes a big difference when you're working several hours straight. The same applies to the chair: You'll spend a lot of time in it, and the wrong chair will become a torture device.

Having a separate table where you can spread stuff out, get packages ready to mail, and do general sorting can be a time saver. It isn't absolutely needed, but it can make life easier.

One of the biggest aids is a light table for tracing and adjusting drawings. It can be simple or deluxe. Some cartoonists just tape their work to a window, and some have a piece of clear plastic or glass handy that they can prop between them and a light source. The commercial light tables are expensive, generally starting at

around $80. Some cartoonists who have a knack for that sort of thing make their own light tables. If you go that route, two fluorescent tubes are the best light source, covered by a frosted piece of plastic. A good size is 16 by 14 inches. (At a local auction, Arnold found an old panel that had been used to study x-rays in a medical building that was torn down. He paid $3 for it.)

What else should you add? Here are some ideas:

- Lots of lights—good lighting is a must (see the following section)
- A mirror for making faces in
- A taboret (a fancy artist's stand with drawers to hold supplies and tools)
- Several kinds of pencil sharpeners
- An old paper cutter capable of do-it-yourself amputations
- A coffee maker—a necessity for most of us
- A hair dryer—used to speed the drying time of some projects
- A couch for when you burn out and need a short nap
- A phone (although you may regret putting that in when the telemarketers interrupt a good drawing streak)
- A compressor and airbrush that you'll probably never find the time to master
- Anything else you like and that makes you feel more professional

There's a lot more stuff that you can get (until there's no room left in your studio for you), but you get the idea. Most cartoonists definitely don't need most of this. Try to put off purchasing these extras as long as is convenient.

Creative Inkling

Arnold has four or five drawing boards in his studio, which enables him to switch between projects—a necessity when one job is just not going right. Keeping a project handy that you can switch to is a big advantage. We've all gotten to a point where we're just spinning our tires. Our minds just won't focus on the job anymore. A change of pace usually helps.

Lighting Tips

Good lighting, as we've said, is very important. The old bit about artists and northern light isn't usually valid for cartoonists. The idea there was to get as much daylight for as long and as even as possible. What is important is the right light to avoid eyestrain. We suggest a combination of fluorescent daylight tubes overhead and an adjustable incandescent lamp on the drawing table. The balance works, and it keeps colors fairly true.

Keeping It Organized with ... a Morgue?

Your studio should also include a *morgue*. This is nothing morbid, just an old journalism term borrowed by commercial artists.

A few years ago, Arnold had a client who needed a cartoon of a steeplechase horse and rider making a jump. Because it was cartoon, it didn't need to be perfectly accurate, as long as it wasn't obviously wrong. Her readers were people who rode in steeplechases. The last artist she'd worked with got a lot of complaints about form.

He went to his morgue and checked the sports and animals files. He managed to find about a half-dozen photos that applied. He did some quick studies to get the details down—the rider's form was the

'Toon Talk

A **morgue** refers to old files and photos of people and things that may be of use at some later date. Usually, a librarian in or near the newsroom keeps track of all the old files. At one time, newspapers kept a large staff of artists and cartoonists who also used the morgue, so it was natural that they would take the term with them when they left.

big item—and then he started boiling them down into cartoon form. The client was happy with the result and called back later to say that her readers had raved about it, and were convinced that Arnold was one of them.

Keep a stack of old magazines, newspapers, junk mail, or whatever. Catalogs of all kinds are handy. Even real-estate folders have good pictures of various kinds of houses. When you have time, go through it all, clipping anything that looks useful and filing it. You can fake the details of a motorcycle, but you can't put in something that's wrong. You will get caught.

> **Creative Inkling**
>
> In setting up your morgue, start with the broadest possible categories. It will save reorganizing later when you have to break the folders down into smaller groups.

Divide your morgue into folders for anatomy, places, animals, automobiles, airplanes, farms, waterfalls, ships, weapons, etc. Break down each category into subfolders as they fill up. In a separate morgue file, save photos of well-known people who you may want to do caricatures of or to use as a base for a character you're developing. It's a good idea to keep a separate folder of website addresses that have good reference pictures you can download.

The Least You Need to Know

- You don't need everything you think you do. A drawing surface, paper, something to draw with, and adequate light are all you really need to get started.

- Setting up a studio that includes a light table, filing cabinets, supply cabinets, multiple drawing boards, and other items can make you feel more professional and help your work go more smoothly.

- The right light gives your eyes a break and keeps the colors in your work true. Make sure you invest in good lighting for your work space.

- Set up a morgue to organize files of miscellaneous information, pictures, and other reference materials you may need someday.

Part 3

1-2-3 Draw!

Now comes the fun part. If you aren't someone hooked on drawing, you probably wouldn't be looking at this book anyway, right? Cartooning has a lot in common with other areas of visual art and a lot that runs counter to the other forms.

Drawing cartoons isn't necessarily easier than painting the Last Supper, just different. Most of us don't really need to know the difference between the tibia and the fibula, or how to stretch a canvas. We aren't apt to worry about the various qualities of lake colors, or even to care what a lake color is. We do need to know about problems with dialogue, gags, story lines, and sequence—things other artists don't concern themselves with—and we will obsess and sweat blood over our problems just as much as the rest.

We'll start with the basics and work up to more advanced concepts like composition and style. The basics are so basic that all of us tend to gloss over them, and even those of us who have been at this a while can stand to go back and get a few reminders.

A Little Exercise Can't Hurt

In This Chapter

◆ Getting in the habit of sketching all the time

◆ Generating ideas through doodling

◆ Loosening up first

◆ Using shapes to get started on a drawing

Basics are one thing; gimmicks are another. You won't find any stick figures here, and no instructions on turning the written word *dog* into a cute picture of a dog. We went through a lot of books like that as youngsters, and the only thing we learned was how to draw copies of what the author drew for us to copy.

This chapter is about getting comfortable with your tools and with drawing, and staying that way. We'll give you some tips for how to get started drawing on a regular basis, but you're going to draw what you want to, not what we tell you to. Drawing what's in your head and drawing regularly are the two keys to finding your own personal style, as opposed to imitating someone else's.

Fill Up That Sketch Book

Blank sketch books should be a part of your life; having boxes of them always on hand is a good idea. Your sketch books don't have to be fancy or large; they just have to be full. You should have sketch books for every occasion: Large ones are best for when you don't need to worry about an audience; smaller ones are more appropriate for when you're sketching in a public place. The main thing is for the paper to have some tooth so that it will take a pencil line well.

Sketching is an art in itself. In art school, the figure-drawing class is often a challenge at first. The first hurdle is getting over the embarrassment of sitting in a crowded room with a nude model. (Some get over that a lot faster than others.) Then there are the two kinds of poses: the long ones, an hour or so; and the short ones, maybe five minutes. With the long poses, most new students have problems getting the basic pose right. If we didn't get that right, then whatever we did after looked cockeyed, like a house built on a crooked foundation.

Creative Inkling

Try sketching while watching television, as Arnold often does. You may find that you get a variety of ideas down on paper from watching TV that you're not apt to get any other way.

Red Ink Alert

When sketching out in public, keep a low profile. Try to look like you're jotting down notes. Having an audience will pretty well defeat the purpose of the sketching, and if you're sketching a person, he or she may become uncomfortable under your scrutiny.

With the short poses, we were hung up on drawing a picture. At the end of five minutes we'd just be starting to get the head well defined, or we'd be fussing over a proportion or angle that didn't seem quite right. Once we got it through our heads that five-minute poses weren't supposed to result in masterpieces, just quick notes about the major points of the pose, we started to improve. As we got better at those short poses, we started noticing the basics of the action, lighting, and structure. We began getting the foundation for the longer poses right. Sketching is like learning conversational skills in a foreign language. It makes the formal mastery of the language much easier and richer.

Developing your sketching skills will enable you to capture the spirit of a moment and perhaps use it to create a more detailed drawing later. It's visual note-taking. That's especially important for cartoonists who deal with life boiled down to the basics. The point is not to obsess over details or accuracy. With practice, the sketches will get better, but they should never be complete drawings. Drawings and studies are different animals than quick sketches. When you're sketching out in the real world, even five minutes is probably too long. You'll probably only have seconds. Notes are all you'll have time for, which is fine.

The following illustration shows sketches from some of Arnold's old pads. As you can see, they're like shorthand notes, taken quickly without worrying about details or technical points.

Sketches from old sketch books.

(© Arnold Wagner, ca. 1980–1990)

The following illustration shows a composite sketch dug out of one of Arnold's old pads, done many years ago. It's of a street in Anchorage, Alaska, during January. Arnold was killing time in a nice warm restaurant, watching people go by. It takes more than a second to do even rough sketches of a group, and people aren't going to stop and pose for you. He just added in any figure who passed and looked interesting. The entire composite was probably sketched over a period of 30 or more minutes and dozens of people. Composites are a basic tool. A nice landscape needs a human element, so you add an old building from a sketch made at a different place and time.

Composite sketch of a street scene.

(© Arnold Wagner, 1954)

With drawings, you have a purpose—you sit down, start, and hopefully wind up with a finished drawing that you like. A study is usually a number of sketches of a subject you need to master. You may make drawings of details, lighting, and various angles, and keep at it until you're comfortable enough with the subject to improvise. You can work from life, photos, or both.

Be a Doodlebug

Doodles are different than sketches or drawings; they are a creative process. Any line you put down on paper can be turned into an image of some kind: a face, an animal, an airplane, something. Don't work at them or feel that you have to make a particular line or wiggle work. The artist Paul Klee referred to his drawings as taking a line for a walk. That's a good approach. Just relax and let your hand and mind roam. Doodling is also a great way to generate ideas.

Letting It Flow Naturally

When we try too hard, we tend to get a death grip on whatever tool we're using. We hunch down and draw very slowly, usually very small. Enough of that and our hand may start hurting or shaking. It's a sure thing that the finished drawing will look forced.

Before you start, and any time you feel yourself tightening up, try some exercises to loosen back up. The practice will also help you master your tools, so that you no longer have to think as much about the tool and can concentrate on the drawing.

Don't make it too rigid. The following illustration from Arnold's collection uses lines two inches high, working fast with a series-7, number-3 brush. Arnold just drew lines and shapes as they came to him, without caring about neatness.

Loosening-up exercises.

(© Arnold Wagner, 2002)

Do this with all the tools you use regularly. Half circles, S shapes, and wavy lines let you work without pressure. If you want a more practical routine, put some straight lines in between the groups of squiggles, horizontal lines, vertical lines, and diagonals. Then do some cross-hatching. Just keep moving as quickly and as freely as you can. These exercises will be easier to do some days than others.

You can do the neatness thing at other times to achieve control, but not to loosen up. Even then, keep your movements large enough so you don't clamp down, mentally or physically. To help relax your hand, try changing your grip on whatever you're drawing with and sketching out some shapes. Move your hand back from the tip of the pen or pencil. Try doodling while holding a pencil or brush like a fencing foil.

In addition to these drawing exercises, physical exercise can loosen you up and ease tension. Don't sit at the drawing board too long without a break. Get up and move around, do some calisthenics, stretch, take the garbage out. Break the pattern. A 15-minute nap can also do wonders. Get some fresh air, even if it's just by opening a window. Take a few deep breaths. Singing can also get some oxygen into your lungs, as long as the neighbors don't complain.

Mastering the Basic Shapes

If you have trouble with a drawing, try breaking it down into geometrical shapes. There are only a few basic shapes—the square, rectangle, triangle, circle, and oval are just about it—and with these you can build a rough outline of just about anything.

Basic geometric shapes.

(© Arnold Wagner, 2002)

If we round out the triangle or squash the oval a bit, we have an egg shape. If we add depth—a third dimension—we can build globes, tubes, cones, and cubes. When you're having trouble with the perspective of a complex shape, this can help: Break the complex shape down into the basic forms, then choose a *vanishing point*, draw lines from it, and place the basic forms into the area formed by the lines to the vanishing point. If the complex shape is made up of curves, try blocking it out in rectangles, which are easier to put into perspective.

You can do this with even very complex shapes, whether an animal or a human-made object. The latter is easier, of course, and there's a limit to how much time you want to spend breaking the object down. This is supposed solve problems when you're stuck, not be a technique to make drawing easy.

'Toon Talk

In perspective, the **vanishing point** is the point at which parallel lines appear to meet in the distance. The vanishing point is most often at eye level, but not always.

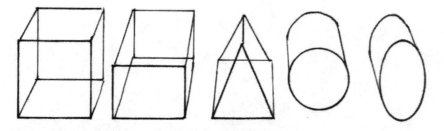

Basic three-dimensional shapes.

(© Arnold Wagner, 2002)

In the following illustration, Arnold used the shapes as a guide on the dog, being careful to include lots of irregular lines, like the shaggy bits of hair. Don't follow the geometric shapes too closely. If he had wanted to show the dog in a three-quarter view, he might have first drawn a rectangle in perspective to enclose the dog and to use as a guide for correct proportions.

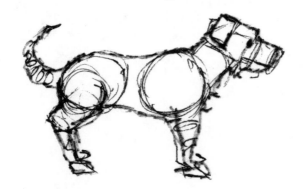

Drawing a dog with geometric shapes.

(© Arnold Wagner, 2002)

The Least You Need to Know

- The sketch book is a cartoonist's best friend; carry one with you always.
- Idle doodling often generates good ideas you can use later.
- As with any exercise, you have to loosen up first, so stretch out your drawing "muscles" before you start.
- Breaking down an object into its fundamental shapes can help when you're stuck.

Heads, Shoulders, Knees, and Toes

In This Chapter

- ◆ Keeping your characters in proportion
- ◆ Types of bodies for all occasions
- ◆ Putting a face on it
- ◆ The hands and feet
- ◆ Keeping figures in balance
- ◆ Anthropomorphic and real animals

If you're planning on a career drawing superheroes, you're going to need more anatomy than a book covering the overall subject of cartooning can give you, though this is a good place to start. If you're not planning on that sort of illustrative cartooning, then you may not see the need for knowing much about anatomy. It's true that you don't need to be an expert, but you do need to be able to figure out what's wrong when a figure just won't come out right, or when you want a special look for a character but aren't sure how to achieve it.

It's not whether you break the rules that matters—it's *how* you break them. That's what this chapter is about. Don't panic; we won't bore you with the Latin names of muscles, bones, or organs. You'll learn just enough so that you know how to distort the human form intentionally, rather than by chance.

Proportions 101

Like a lot of things in the arts, the Greeks set the basics of anatomy. The sculptor Polycleitus started it. After some research, he set the artistic standard at being $7^1/_2$ heads high, or the height of a person being $7^1/_2$ times the length of their head. Polycleitus wanted realism in his art, but along came another sculptor named Lysippus. He wanted a heroic look, so he upped it to 8 heads for his statues. It stayed that way until Michelangelo wanted an even more heroic look and went to an $8^1/_2$ head standard in his art.

From the Pros

Hal Foster always used $7^1/_2$ heads for his characters. If you can find one of Foster's early *Tarzan* strips, compare it with the heroic form. (Foster drew *Tarzan* in the 1930s.) Burne Hogarth took over the strip until the mid-1940s and became the classic *Tarzan* artist, not only using heroic proportions of $8^1/_2$ heads, but also adding muscles no human has ever had and showing the apeman in poses impossible for people to achieve. He called his approach "dynamic anatomy," and it influenced a lot of comic book artists. Milton Caniff used a less-obvious heroic proportion of eight heads in both *Terry and the Pirates* and *Steve Canyon*—somewhere between the realism of Foster and the fantasy of Hogarth.

The two standards, realism and heroic, remained the canon until the modern era. Fashion artists may have started the more extreme standards. They generally draw their figures at least 9 heads high, and we've seen 12. Cartoonists are used to playing loose with anatomy, and with the advent of the superhero, they've upped the heroic proportions a bit more. Eight and a half is still seen, but 9 and 10 heads are more common.

Remember, this is the length of the head in proportion to the whole body. It has nothing to do with actual height. Generally a tall person also has a longer head and a shorter person has a shorter head, so the proportions remain the same for both. Changing the proportion changes the character of the drawing, not always the height.

If a larger ratio of heads to body means a more imposing look, fewer heads means a less imposing look, as with children. This is something that has been used by cartoonists as far back as cartoons go. In the following illustration, you can see the normal male figure at $7^1/_2$ heads, the superhero at $8^1/_2$ heads, and a fashion model at 9 heads. The heads are all the same size so that the proportion controls how tall they appear.

The realistic $7^1/_2$ heads, the heroic $8^1/_2$ heads, and the extreme 9 heads used for the heroic look and fashion drawings. The heads are all the same size.

(© Arnold Wagner, 2002)

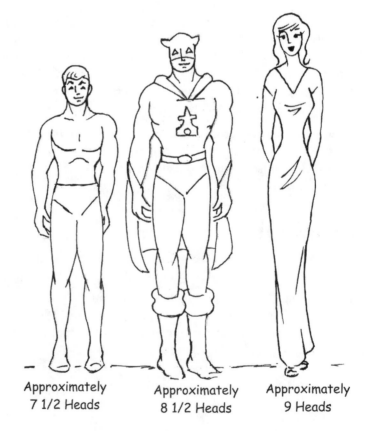

Approximately
7 1/2 Heads

Approximately
8 1/2 Heads

Approximately
9 Heads

In the next illustration, the drawings are in arbitrary sizes. The tallest figure has the largest head, as he would in real life, and the fashion model has the smallest head, but the proportions are still the same.

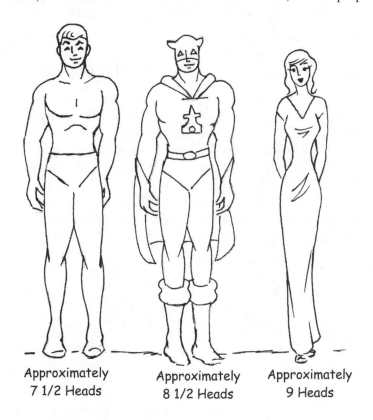

Here the height is reversed to show that height and proportion aren't necessarily connected.

(© Arnold Wagner, 2002)

Approximately
7 1/2 Heads

Approximately
8 1/2 Heads

Approximately
9 Heads

A Few General Guidelines

You probably don't want or need a detailed chart of proportions. Instead we'll outline some rules of thumb that can be helpful when the figure looks wrong, but you can't figure out why.

From the top of the head to the top of the hips or the crotch will be about the halfway mark of a figure's total height. That allows some leeway that can alter the look and yet not look wrong. The halfway mark you choose for your figures will affect the length of their legs. In real life, the legs of most people are a bit shorter than what are drawn in idealized figures.

If we start at the pit of the neck—the hollow where the neck meets the clavicle—we can divide the body into thirds. From the pit of the neck to the top of the hips equals one third, hips to knees another third, and knees to ball of the foot is the final third.

If the arm is hanging down the side of the body, then the hand, in the normal relaxed, cupped position, will reach to a point about halfway between the top of the hips and the knee. Changing that is another important element in indicating the personality type. If the arms are too long, they impart an apelike appearance; if too short, they can give the impression of a character without dexterity. The elbow comes at about the same point as the lower part of the rib cage.

Width doesn't depend as much on bone structure as it does on muscle and fat, so there aren't as many guidelines, but it does symbolize character more.

Male and Female Figures

The differences between the female and male figures are generalizations, with a lot of variance from person to person. There are books that say to make the female figure fewer heads in length, but women are the

same proportion as men. In a survey of 350 adult women, the average proportion came to 7.5009 heads. The use of proportions less than that for women in illustrative cartooning is intended to make female characters more childlike and easier to cope with. (Did we mention that most cartoonists are male?)

The exception comes with the female superhero, who generally has the same heroic proportions as the male superhero but may be shorter in height. That can change depending on the personality of the character. In recent years, some comic book heroines have become quite aggressive, and their appearances reflect that.

Creative Inkling _____

In drawing female and male figures, the basic rule is simple but very effective: Use short angular lines for men, long curves for women, and curves for young children.

There are some guidelines for drawing women, but as with men, there are no absolutes. There's the bust line, for one, and the thing to remember there is that if the figure is well endowed, gravity will have an effect, so the nipples will be a bit lower. Women don't have Adam's apples, and ideally, we make the neck a bit longer; however, the pit of the neck tends to be a bit higher on the female figure, so while on a male figure the clavicle forms a line from shoulder to pit of the neck that is V-shaped, the pit of the neck on a woman tends to be a bit higher in relationship to the shoulders, and therefore the line formed by the clavicle is nearly a straight line.

Male and female clavicles.

(© Arnold Wagner, 2002)

In the male figure, the waist is at the top of the hips, while in the female figure, the waist is generally halfway between the bottom of the rib cage and the top of the hip. The widest point of the body tends to be lower on women and forms a more constant curve. The female pelvis is generally shaped a bit differently than the male, being tilted, which will throw the buttocks into more prominence.

Red Ink Alert _____

The waist is probably the most variable measurement in human anatomy. Watch the waist if you want to portray a tomboy or a woman who competes with men in the business world. Halfway between the hips and the rib cage, the waist looks very feminine; if it is lowered toward the hips, it takes on a more masculine look, in part because the waist can't be as narrow.

The Greeks used Venus as the ideal for female beauty, but they also had other standards of what was considered the ideal. The waist was variable, but the width of the shoulders and the hips at their widest point were the basics. Venus, the ideal beauty, was $1^1/_2$ head-lengths wide at the shoulders and $1^3/_8$ heads wide at the hips. Juno—earthy, sexy, an earth mother—was $1^1/_4$ head-lengths wide at the shoulders and $1^3/_4$ heads wide at the hips. Diana—athletic, aggressive, and competitive—was $1^3/_4$ heads wide at the shoulders and $1^3/_4$ heads wide at the hips.

Types of Anatomy

Cartoonists working with humor seldom use figures that are anywhere near the same proportions as seen in real life. Most of the figures will have larger heads and smaller bodies. In Chapter 2, "In the Beginning … Cartooning's Roots," the figures of the pygmies show an early example of that. These look more childlike and less threatening, and so are easier to laugh at.

The proportion in children is less. A newborn baby is about 4 heads in length, which increases until about age 12, when they reach the normal $7^1/_2$ heads. In cartooning, we make them smaller for effect, but how much smaller depends on the style. Even in semi-illustrative cartooning, a newborn baby will probably only be $2^1/_2$ heads long. They aren't usually shown at $7^1/_2$ heads until they're at least 16 years old.

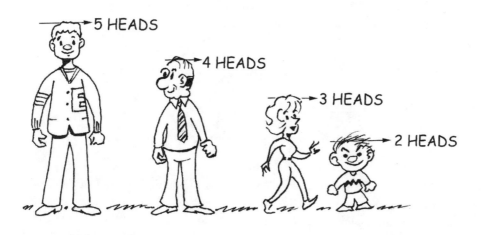

These figures range from 5 heads to 2 heads. Cartoonists also frequently use 6 heads and sometimes 1¹/₂ heads.

(© Arnold Wagner, 2002)

Here's how some popular comic strips stack up:

♦ The characters in *Peanuts* run between 2 and 2¹/₂ heads.

♦ *The Wizard of Id* and *Andy Capp* vary a bit, but the characters in each are mostly 3 heads.

♦ In B.C., the male characters run 3 heads, while the female characters are closer to 3¹/₂ heads.

♦ In *Calvin and Hobbes*, Calvin was 2 heads, Hobbes was 4 heads, and the parents were about 5 heads.

♦ Hagar is 3¹/₂ heads, but his daughter, Honi, is 5 heads.

♦ In *Dennis the Menace*, the parents are 6 heads, while Dennis is 2¹/₂ heads.

♦ Blondie and Dagwood are both 5 heads.

♦ In *Baby Blues*, the parents are only 2¹/₂ heads, while the children are 2 heads. This strip shows how much difference in size you can use while still working with similar proportions.

Grylli (gryllos in the singular) are a lot of fun to draw. They are simply heads with limbs—no bodies. In extreme cases, they are even less than that—a nose or eyeballs with limbs. Unfortunately, there aren't too many opportunities to use grylli. They supposedly appeared in an unlikely strip, *Tarzan*, and walked on their hands, but we haven't seen that sequence. Al Capp used them in the form of the Bald Iggle, and Grog in B.C. is one.

From the Pros

E. Sims Campbell, famous for his drawings of gorgeous women, drew a lot of showgirls, giving them power over men, the long-legged look of the chorus, and yet the shorter sexpot look. He made them 8¹/₂ heads in length, but the upper body was proportioned at 6 heads, and the rest was legs. This became the standard look for the cartoon showgirl.

Examples of grylli.

(© Arnold Wagner, 2002)

The Head

As cartoonists, we don't often pay much attention to the shape of the normal skull. We tend to use circles, ovals, triangles, squares, or some combination of shapes to form the head. We don't need to know things like how many bones are in the head (29, if you count the 6 ear bones but don't count the 32 teeth). For reference, here's a skull inside a head and the rough form frequently used to approximate it in semi-illustrative drawings.

The skull and its relation to the head.

(© Arnold Wagner, 2002)

As with the previous chapter, we'll stick to the basics here. The following illustration shows front and side views of a head divided into fourths. The eyes are set in the middle of the head, the top of the lip is at the three-quarter mark, the brow at about three-eighths, and the nose starts at about the level of the eyes and extends to two thirds of the way down the head. The tops of the ears are placed just slightly higher than the eyes, and at the bottom, they are almost even with the tip of the nose. The illustration shows the basic fourths in a front and side view.

Proportions of the head and face.

(© Arnold Wagner, 2002)

Of course, both the nose and the ears vary greatly, even in real life, and they also change with age. Generally, the ball of the nose and the earlobes get bigger over the years and make good age indicators for cartoonists—they are usually large in the elderly and small in the young.

From the front view, the eyes are about one-fifth the width of the head. They're one eye-width apart and one eye-width from the side of the head. This is another good way to indicate character. Eyes set close together or above center imparts a brutish and less-than-intelligent look; moving them farther apart and lower results in a bright, innocent, young look. The width of the mouth is another big variable, but there's a rule of thumb that helps. If you draw a somewhat vertical line down from the center of the eye, running parallel with the form of the side of the face, it will cross the line of the mouth at a good width for that face. The width of the head is approximately three-fourths the length of the head.

> ### Creative Inkling
>
> Hair is another variable that varies greatly, but in laying out a head, we don't count it. It gets added as one of the last details. A good rule of thumb is that the hairline in front will hit at about the one-quarter mark. Bangs will lower it, and of course it can be raised until it doesn't exist at all.

The following illustration shows several cartoon heads. Most violate the rules of anatomy in order to achieve an effect. Study them to see why they have the result they do. Notice that some stay very close to the norm. Also notice the varying facial planes in the profiles; they may be straight, curved, concave, convex, or slanted. Facial planes can also be a combination of these. They might be slanted at the top half and straight or even concave at the bottom of the head.

Draw a few pages of heads yourself, trying to indicate as many personality types as you can. In real life, we aren't supposed to judge people by how they look, but in cartooning, it's required. Stereotypes are a basic tool of the cartoonist, and personality has to be reflected in a character's face.

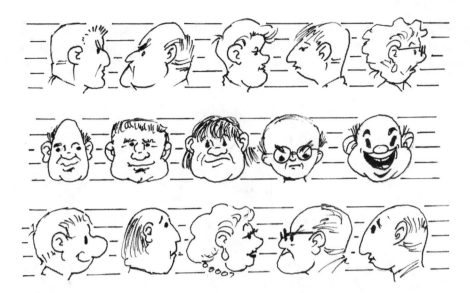

Basic head shapes and facial planes.

(© Arnold Wagner, 2002)

The Hands

Hands are almost as important as the face in expressing emotion. They are also a part of the anatomy that give a lot of cartoonists a problem. Beginning cartoonists often skirt the issue by drawing a lot of characters with their hands in their pockets or behind their back, or they only show the figure from the waist up, with the hands out of sight. Don't think editors don't notice! They do and mark the cartoonist down as a beginner.

The hand is made up of two primary sections: the palm and the fingers. These two sections are about the same length. Each finger is a different length, but not as much as you might guess. They seem to vary more than they actually do because they are connected to an angled or curved part of the palm. Because the area between the fingers angles from front to back, your fingers will look longer palm-up than palm-down. The joints of the fingers also seem closer to the tips of the fingers at the back of the hand than when palm-up.

The joints of the fingers are at an angle, top to bottom. The fingers taper slightly toward the middle finger. The extended thumb will reach to just short of the first joint of the index finger. The little finger reaches to the third joint of the third finger.

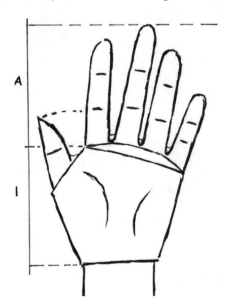

The hand, palm up.

(© Arnold Wagner, 2002)

Side view of the hand, showing the angle at which the fingers join the hand.

(© Arnold Wagner, 2002)

The hand is larger than most beginners draw it. It's about three-fourths the length of the head, or the distance from the chin to the upper quarter, where the hairline begins on the average person. It is also about the same measurement as the width of the head at its widest point.

Comparison of the length of the hand and the length of the face.

(© Arnold Wagner, 2002)

Despite the legends, the three-fingered hand of animation has nothing to do with imitating the three toes of animals, nor is it a way of cutting back on ink. Instead, it is based on the fact that the middle and the third finger generally move together, so only three units are seen much of the time. It is also a simpler form, which aids in creating natural movement.

You need to draw hands. There's no getting around it. Start with more or less realistic-looking hands, and boil them down into cartoon hands. Study the hands drawn by various other cartoonists. Fill pages of studies, like the hands shown in the following illustration, until drawing hands starts to come naturally.

Hands drawn in a variety of styles.

(© Arnold Wagner, 2002)

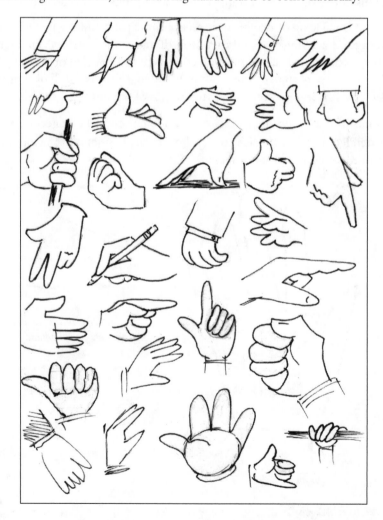

From the Pros _____

Virgil Partch (*Vip or Vipper*) drew hands that sometimes looked like Medusa on a bad-hair day, and the number of fingers was random. But when hands could add to the drawing, there they were. He once said that he thought his hands of many fingers were a rebellion after years of drawing three-fingered hands while at Disney Studios.

The Feet

The feet aren't as vital for expression as the hands, but they do contribute, and they are even more important for providing support for your characters. The feet have to look like they are supporting the body. The most common mistake in drawing the foot is to eliminate the heel, as shown in figure A of the following illustration. Figure B is correct, and as you can see in figure C, there is a heel bone that adds stability.

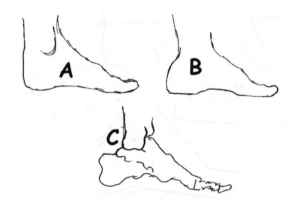

The basic structure of the foot.

(© Arnold Wagner, 2002)

The foot has quite a bit in common with the hands. It is of about the same length, three-fourths the length of the head, same as the hand. The weight is usually centered on the balls of the feet. Generally, cartoonists make the female foot smaller than it is in reality, and the male foot larger.

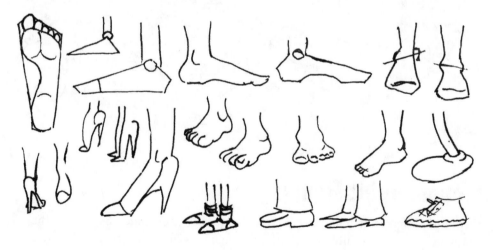

Examples of feet in different styles.

(© Arnold Wagner, 2002)

The foot isn't too hard to master, but what you need to be aware of are the different kinds of footwear. Like the hands, you should fill pages of various kinds of feet and shoes from different angles, until you feel comfortable with them.

Balance and the Center of Gravity

Any figure you draw will either be balanced or out of balance. In other words, if they take no further action, they will either remain standing or they will fall over. If they're not supposed to be moving, then they had better be in balance and not look like they are going to fall. If they are moving, then they are probably out of balance to some degree. Walking is simply throwing oneself off balance, falling forward, and then recovering balance, repeated. There are positions so extreme that there's no way the body could recover balance, but that's allowed under our cartooning license.

Notice in the following illustration that some of the figures are out of balance. The *center of gravity* isn't in the center of the mass, so the figure can't maintain the pose.

Action and the center of gravity.

(© Arnold Wagner, 2002)

Animals and Anthropomorphic Figures

Animals aren't put together much different than humans. The basics are there: the spine, the ribcage, the neck, and the skull. The proportions are a bit different. The legs on four-legged animals may look different than the legs on people, but if you imagine that they are walking on their toes, the same bones are there.

A dog's leg looks like it bends differently than a human's, but notice that dogs don't have feet—their paws are toes—and that if we were to place their leg in the position it is when they are sitting, the lower section of their leg becomes foot-like, right down to having the heel bone at the back.

A comparison of a dog's rear leg and a human's; notice the heel bone.

(© Arnold Wagner, 2002)

There are a few other things to remember. Predators tend to have eyes in the front of their heads, as humans do, giving them bifocal vision, which makes it possible for them to judge distance. Grazing animals tend to have eyes at the side of the skull, enabling them to spot any movement in a wide field that might indicate danger.

In cartoon animals, we use eyebrows and mouths to express emotion. Neither is there in real life. This is a mild form of anthropomorphic art, one we often convince ourselves that we actually see.

As you'll recall from earlier chapters, an anthropomorphic figure refers to anything that isn't human but that we portray as having human traits. Most often we think of anthropomorphic figures as being animals, but it's not that limited. An anthropomorphic figure can be any type of living form, including plants. It can be a talking car that prefers a particular brand of gasoline or any other mechanical object. It can be an abstract concept, such as Lady Liberty, Uncle Sam, or Father Time. It can be a deity or other supernatural form, such as Cupid or a ghost. It can also be an inanimate object: Dolls, toy soldiers, houses, wind, bombs … all of these have been used.

Some examples of anthropomorphic figures.

(© Arnold Wagner, 2002)

The Least You Need to Know

◆ When determining a figure's anatomy, figure out the number of heads it should have—in other words, the length of the head in proportion to the height of the entire body.

◆ Cartoon figures don't often reflect real-life anatomy and proportion; the size of a cartoon character's head can help establish its personality.

◆ How you draw facial figures will also give your audience important clues about your characters' personality traits.

◆ You can't get around it—you've gotta draw hands, so practice until you get them right.

◆ Feet are often overlooked but still important; practice drawing them bare and shoed.

◆ If your figures are standing still, be sure they are balanced.

◆ Don't limit yourself to human characters; anthropomorphic forms, such as talking animals and "living" inanimate objects, are a staple of cartoons.

Express Yourself

In This Chapter

◆ Conveying expression through the eyes, eyebrows, mouth, and position of the head

◆ How the body "talks"

◆ The importance of costumes and props in cartoons

◆ Actions speak louder than words

We covered some anatomy basics in the last chapter, so now we have a figure, but it's just stiffly standing there in an anatomical pose, deadpan, looking like a deer caught in the headlights. Beginners often wind up using figures like this. They don't work. It's the equivalent of a comedian standing stiffly and delivering lines in a monotone. The reader has to identify with the cartoon, and it's difficult to identify with a zombie.

You may have seen examples of basic expressions in how-to books for children that were labeled "happy," "sad," "sleeping," and so forth. Those are okay as a starting point. Just remember that human emotions are seldom so simple that they can be described with a single word.

It's in the Eyes ... and All Over the Face

You've probably heard the saying that the eyes are the windows of the soul. That's a bit of an exaggeration. They aren't really capable of that much emotion. They can be opened wide, closed tightly, or fall somewhere between those extremes. The following illustration shows a few of the basic ways that eyes can be drawn. Because the eyes alone don't show much emotion, the expressions may seem bland.

Some basic types of eyes.

(© Arnold Wagner, 2002)

There are almost as many ways to draw eyes as there are cartoonists. You can, and should, fill pages experimenting with eyes and all of the following elements.

Added expression using open, closed, and half-closed eyes.

(© Arnold Wagner, 2002)

Fortunately, as cartoonists we aren't limited to what the eyes can actually express in real life. Symbols for eyes can say a lot. The variations are almost endless. The following illustration shows the classic cross mark, indicating that the character has been put out of commission by some means. You'll often see this convention combined with birds chirping or stars circling the head. The hearts and the stars are self-explanatory. The next one with the circles around the eyes may indicate lack of sleep, a hangover, fatigue, or shock. Tear-shaped pupils tend to look slightly sad. The meaning of the dollar sign, of course, is obvious.

Symbols used to express different emotions and states.

(© Arnold Wagner, 2002)

The faces are still pretty bland, but when we add eyebrows, we increase the potential combinations many times over. Eyebrows don't really have much more range than eyes since they are really only capable of being raised or lowered, but for some reason, they do add a lot to faces. Combine eyes and eyebrows, and you begin to get a much broader range of expressions. The following illustration shows some basic eyebrows, but doesn't include the finely drawn female eyebrow, the bushy eyebrow that shades the eyes, the eyebrow that runs clear across the bridge of the nose forming a single unit (some call it the "unibrow"), or any of numerous other possibilities.

Eyebrows are more expressive than eyes.

(© Arnold Wagner, 2002)

 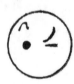

Creative Inkling

It's a good idea to keep a mirror near your drawing board so that you can try out expressions and then sketch them.

The final expressive element of the face is the mouth, and it is also the element with the widest varieties of expression. It can be twisted in an endless number of shapes, and that's without even opening it. The top row of the examples shown in the next illustration are very generic; on the lower row, you'll see a character with mixed emotions, one who is bombed out of his skull, one who just sucked on a lemon, one talking tough, and the standard laugh.

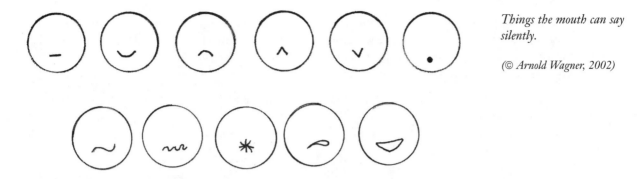

Things the mouth can say silently.

(© Arnold Wagner, 2002)

The position or movement of the head also adds to the expression of the face. This may be as simple as a nod, a head shake, or tilting the head at an angle. The change in meaning might be subtle, but it's the subtle differences that can make or break a cartoon in many cases. In the next illustration, notice that the face holds the same expression, but the meaning of the expression is slightly different in each case.

Conveying meaning with a tilt of the head.

(© Arnold Wagner, 2002)

Blood flow is another element of facial expression. We don't know of a case where turning pale or having a face go white has been used effectively in a cartoon, but the blush certainly has. It can be a bit of a challenge to show blushing, depending on your style and the medium you are using.

All of this is pretty basic stuff. The multitude of combinations possible from the examples given here will leave you with some formulaic expressions. They make for good practice, but when you sit down to draw a character, put yourself into that character's mind. How would they be reacting and what would their face look like if they were performing a comedy skit? Draw that expression.

Red Ink Alert

In some cases, you'll want to keep expressions and personalities somewhat generic. In gag cartoons, information not basic to the gag will detract from it. Avoid overly dramatic expressions, poses, or unusual costumes that aren't pertinent. In cartooning, everything plays second fiddle to the gag or story. Because gag cartoons are too short to allow character development, your cast will often be made up of John and Jane Does. Your characters should be natural, not stiff and lifeless; on the other hand, you don't want them overacting. It's a fine balance.

A Gesture Says It All: Body Language

Our whole body takes part in communicating with others. Sometimes it's intentional, while other times it's an automatic response to the situation. Noticing body language is part of observing and sketching. Sketching people in bus depots, airports, and other public places gives you a lot of good poses. Does his posture close him off and keep strangers at arms' length, or is it open and friendly? Does her body language seem timid, aggressive, impatient, exhausted, eager, nervous—or does it convey some other emotion?

The value of sketching while watching television is that you can study how professional actors handle their roles: their facial expressions, gestures, and body position. Getting onstage or in front of a camera may not

be your idea of fun, but studying acting techniques can be a big help to the cartoonist. Watching comedians perform can be especially useful. Studying what works for them visually is very helpful, but watching what doesn't work is equally important. (Unfortunately, sketching while watching television means they usually have to be even quicker studies, since television has to keep moving to hold its audience's attention.)

In the following illustration, notice that while the face and hands play an important role, the arms, shoulders, and feet all add to the overall effect.

Body language.

(© Arnold Wagner, 2002)

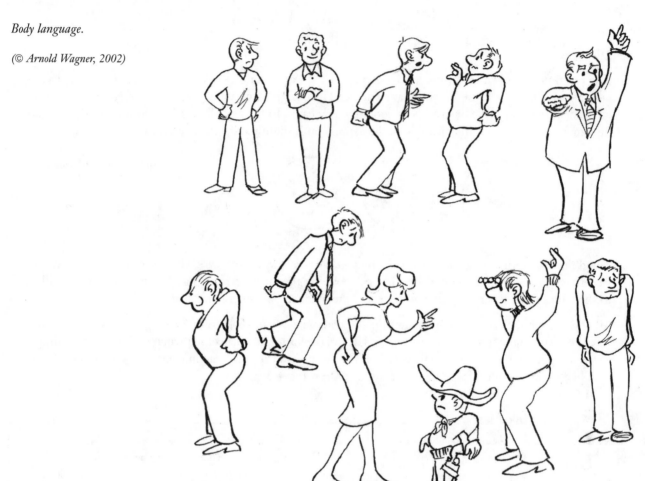

Dressing the Part: Costumes and Props

Police officers, firefighters, and military personnel aren't the only people who wear uniforms. We all wear them in some sense. Our clothes say something about us. The clothes we like usually reflect how we see ourselves and how we want others to see us. A few of us don't pay any attention to what we wear, but that says something about us, too. Then there are the rebels, those who choose costumes that are designed to get a negative response. It's all important in deciding how a character will look to the audience. Something as simple as how a baseball cap is worn can send a variety of messages.

Anything about a person that can be altered or designed can be categorized as costume. For that reason, we're calling hair a costume. It's one of the major ways we try to tell others how we want to be seen. Baldness isn't something we can control, but there are wigs. We can dye our hair and style it various ways. Men can add facial hair in the form of sideburns, moustaches, and beards. Our characters may wear headbands, hair clips, or ribbons in their hair. In *Hagar*, his beard, Helga's braids, and Honi's long flowing hair all say something about their character. If we gave Snuffy a full head of hair or Blondie a page-boy cut, we probably wouldn't recognize them. Same thing if we slicked down Dagwood's, Dennis's, and Calvin's hair.

If your character is participating in a profession or activity that isn't identifiable from the clothes, you have to try *props*. That generally means tools or equipment. Props are related to accessories, which are of less importance. An *accessory* may help identify the setting or set a mood but isn't strictly necessary to the premise. Accessories can be the moon, a street lamp, a sofa, a stove, litter on the street, anything—but they do need some justification in order to be in the cartoon. That they reflect reality isn't enough. It is all too easy to overdo accessories.

Props can also tell who the character wants to be. If we use a brand-new Ferrari as a prop, we get different impressions depending on the characters we drop into it. Try a young professional, a portly middle-aged CEO, a teenaged male, and a frail grandmotherly looking female. We come to very different conclusions about these people because of the association with the automobile.

'Toon Talk

A **prop** is any inanimate object needed in the drawing to enhance, clarify, or act as a necessary element in the concept. Anything can be a prop: a shoe, an apple, a hat, a match—but it should be vital to the gag or story. An **accessory** is any element that isn't part of the primary idea or necessary to the premise but in some way supports it.

Red Ink Alert

Although sometimes tobacco use might be justified in a cartoon, try to avoid it, if possible. It will offend some, and it looks dated. It helps if only the bad guys smoke.

Props also act as identifying objects. In *Peanuts*, Snoopy's doghouse becomes a vehicle for many of his fantasies. We also immediately identify Linus's blanket and Schroeder's piano; in many cases, they become the basis for running gags. In *Beetle Bailey*, Beetle's cap pulled down over his eyes or Killer's cap that wiggles when he sees an attractive female are props that identify the characters and their traits. In the following illustration, tobacco, a clipboard, and an axe are used as props along with costumes.

Some examples of costumes and props.

(© Arnold Wagner, 2002)

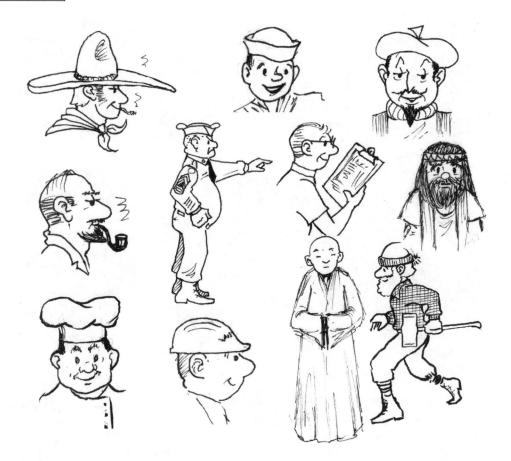

Lights, Camera, Action!

Most cartoons need action. The action doesn't have to be anything major or even very physical—just shutting or rolling your eyes is an action. Action can even be implied: something that is happening just off camera, has already happened a moment before, or is about to happen. Action simply means that the characters seem to be interacting with someone or something. The important thing is to avoid the zombie look mentioned at the beginning of this chapter.

Action as used in cartoons can also be passive: Dagwood sleeping on the sofa or Beetle Bailey lying in a mangled heap on the ground is a kind of action.

The following illustrations show first a mild reaction to what may have been a sound. Next, there is a confrontation between man and beast. Neither party is moving, but there is action—lots of it. And finally, we have what we generally think of when we say "action."

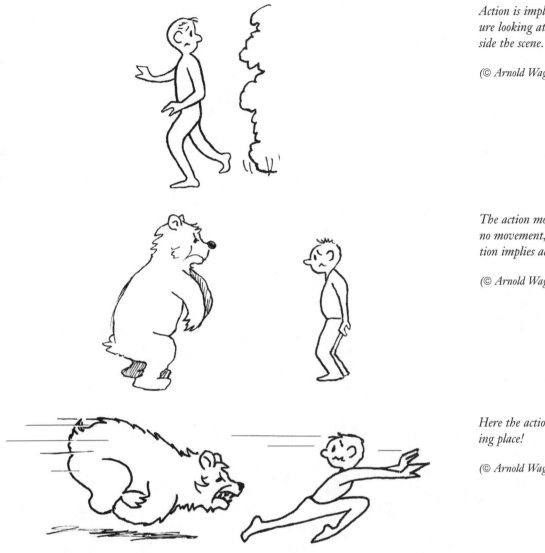

Action is implied by the figure looking at something outside the scene.

(© Arnold Wagner, 2002)

The action moves up a notch: no movement, but confrontation implies action.

(© Arnold Wagner, 2002)

Here the action is finally taking place!

(© Arnold Wagner, 2002)

The Least You Need to Know

♦ The eyes don't say it all; you have to use the entire face to convey facial expressions well.

♦ We don't just express ourselves with our faces, but with our bodies as well; studying real people can help you bring your cartoon characters' bodies to life.

♦ We've all heard that the clothes make the man; in cartoons, this is literally true, as costumes and props are essential tools in defining character.

♦ Action simply means doing something—anything! Action can also be implied—something that has just happened or is about to happen. Action injects energy into your cartoons and captures readers' interest.

Getting Perspective

In This Chapter

◆ The science of perspective

◆ How we see perspective

◆ One-point and two-point perspective

◆ Shadows, circles, and perspective

◆ Look up, look down: worm's-eye and bird's-eye views

◆ Atmospheric perspective: reality and illusion

When we speak of perspective, we're talking about the proportion of the various parts of a drawing to each other, depending on their distance and angle from the viewer and each other. If that sounds complicated, it can be. For some it becomes a life's study. In most cases, cartoonists can get by with freehand perspective—drawing the illusion without aid of a ruler, vanishing points, or horizon lines—once they understand the principles involved.

However, there will be times when freehand perspective just isn't enough. One example is if you want to use a particular viewpoint, such as from a very high or low position, but are having trouble setting it up. Laying it out in perspective with vanishing points and an eye level can solve the problem. At other times, something about the perspective will just look wrong, and you can't seem to correct it. Then it's also time to get out the T-square and triangles.

In this chapter, we'll try to give you what you'll need in most cases, and avoid the complicated stuff that will only be forgotten if not used constantly.

Early Theories on Perspective

It's unclear just when the science of *perspective* started. Probably it was like most sciences and arts, and started very gradually. The Greeks mentioned it in their writings, but we have no knowledge of how advanced their knowledge of it was. The Romans used one-point perspective (which we'll discuss a little bit later in this chapter) but nothing more. We can't judge by example alone; some cultures that knew something of perspective ignored it in their fine art, preferring the look of the simpler form.

During the Renaissance, perspective was reinvented, and many artists experimented with it. Some used glass panes marked off in a graph; by sketching through these, they could study the illusion of perspective and foreshortening. This is the origin of the picture-plane concept in perspective, the invisible surface between us and the object on which we imagine the object is drawn.

'Toon Talk

Perspective is the illusion of three dimensions created on a flat surface. We normally separate perspective into linear perspective—the illusion that parallel lines converge in the distance—and aerial, or atmospheric, perspective—the illusion of distance caused by detail, color, and contrast rather than by converging lines. The cartoonist generally thinks in terms of linear perspective, but atmospheric is more important than it is given credit for, and both need to be taken into account.

It's easy to make some bad mistakes in perspective, and it was even easier to in earlier periods. In 1754, William Hogarth saw so many "false perspective" mistakes in the works of his fellow artists that he did a satire based on it.

A satire on false perspective: "Whoever makes a design without the knowledge of perspective will be liable to such absurdities as are shown in this frontispiece."

(© William Hogarth, from his engraving titled Satire on False Perspective, *1754)*

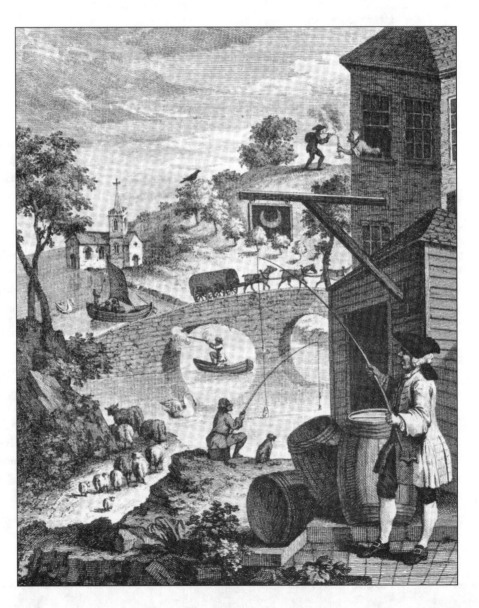

How We Measure Perspective

Our eyes see in a cone of vision. Peripheral vision varies, but the cone normally is between 45 and 60 degrees. This means that if an object is close to our eyes, it takes up most of our field of vision, while the same object at a distance occupies a much smaller part of our field of vision.

If you're sketching a live scene or model, laying out horizon lines and vanishing points isn't usually convenient. The horizon line is set at a point where your line of vision meets the picture plane. In other words, it's a line running horizontal to your line of vision, and it changes as you look up or down. The vanishing point is where parallel lines meet at this horizon line.

Cone of vision.

(© Arnold Wagner, 2002)

We've all seen the picture of an artist squinting at his or her thumb, shown in the following cartoon. It's not very useful in real life, but if we add a pencil, brush, or some other long straight object, it can be very useful. By holding your arm straight out so that the distance between your eye and hand remains constant, you have a measuring tool. You can judge the angle of an object from the vertical or horizontal. You can move your thumb up the pencil to mark the length of some element in the scene and then use that to judge the comparative lengths of other objects.

Rule of thumb.

(© Arnold Wagner, 2002)

Another illustration of why things look smaller in the distance also introduces us to the picture plane. This is an imaginary version of the pane of glass mentioned earlier. It represents your paper. The picture plane always remains at a 90-degree angle to your line of vision. If you are looking down, it tilts downward; if you are looking up, it tilts in that direction. The distance between the picture plane and the object you are drawing determines the difference between the actual size and the visual size. If the object is parallel and up against the picture plane, then the actual length of the object and the length on the paper will be the same. As the distance between the picture plane and the object increases, the less length it will have in your drawing. The picture plane and the line of sight determine the horizon line.

Red Ink Alert

If you use the thumb-and-pencil technique, remember to keep your arm fully extended. That ensures that the distance between your eye and the pencil remains constant. If the distance varies, the measurements will be inaccurate.

The picture plane.

(© Arnold Wagner, 2002)

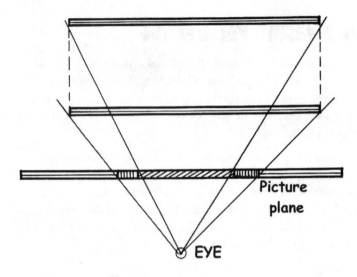

One-Point and Two-Point Perspective

When two sets of edges of an object are parallel to the picture plane and a third set is perpendicular to the picture plane, the result is one-point, or parallel, perspective. This can be subdivided into horizontal, vertical, and oblique perspective. Oblique and inclined-plane perspective are not the same. Oblique perspective uses the same vanishing points, so it works as a base or a top at an angle, but not as a tilted ramp or roof. Those are attached to structures using the normal vanishing points but have their own vanishing point.

Viewpoints in one-point perspective from various angles and relationships to the eye level.

(© Arnold Wagner, 2002)

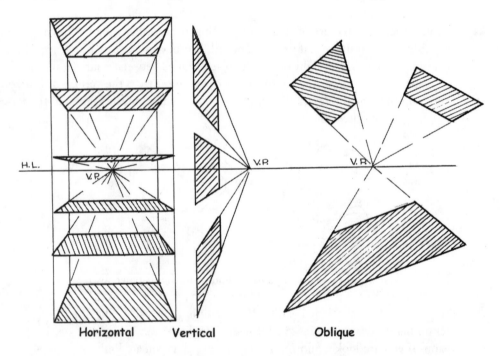

Notice that the back and front edges are parallel to the picture plane and to the base of the drawing. They don't angle away from the viewer. These are the two sets. They are easy to manage in vertical and horizontal views, but in the oblique view, it takes a bit more care to keep them parallel to each other.

A situation that often causes confusion is the inclined plane mentioned earlier. The following illustration shows nine cubes in one-point perspective. CV is center of vision, HL is horizon line, and VP is vanishing point. On the cube at the lower left, we want to place a pitched roof. Since the inclined plane recedes from us, it needs a vanishing point, and the central one would just make it look flat. We find the center of the side by diagonal lines and then extend a vertical line up to whatever height we want the pitch to be. By running a

line from the front-right corner of the cube through the point for the peak of the roof and extending it until it crosses the center of vision, we have a new vanishing point. If the inclined plane were on the side of a cube rather than the top, we'd use the same method to find a vanishing point along the horizon line. We may have numerous vanishing points in this manner, and yet, because each element uses only one vanishing point, it is still one-point perspective.

In two-point, or angular, perspective, only one plane is parallel to the picture plane. No surface faces the picture plane; the objects are at an angle to it. In the illustration on the following page, we start with the horizon line (HL) or eye level (EL). From the center of that line, draw a semicircle. The station point (SP) will always be somewhere on that arc. Where the arc intersects, the horizon line will be the left and right vanishing points. Pick a spot near the center, but not necessarily at the center, for the center of vision (CV). You can place the station point anywhere on the arc. Here we've placed it vertically from the center of interest. Lines from the SP to the vanishing points will form a 90-degree angle.

> **Creative Inkling**
>
> Experiment with using numerous vanishing points in a drawing. The labels one-, two-, or three-point perspective refer to the number of vanishing points needed to form that single element of the drawing, but there is no limit to the number of vanishing points you can use. You can even mix the types of perspective.

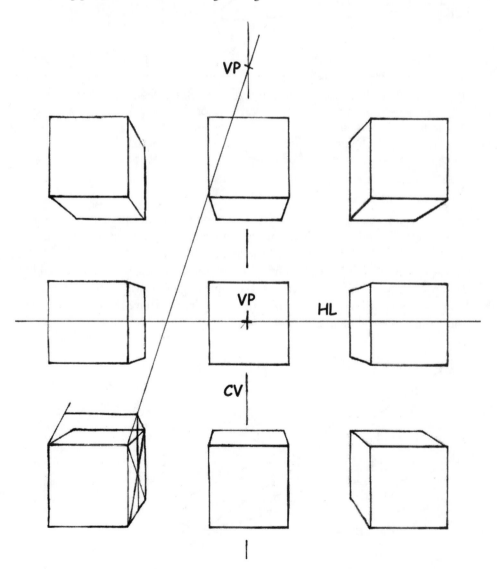

Cubes in relationship to vanishing point and eye level in one-point perspective, and a vanishing point for an inclined plane.

(© Arnold Wagner, 2002)

Two-point perspective.

(© Arnold Wagner, 2002)

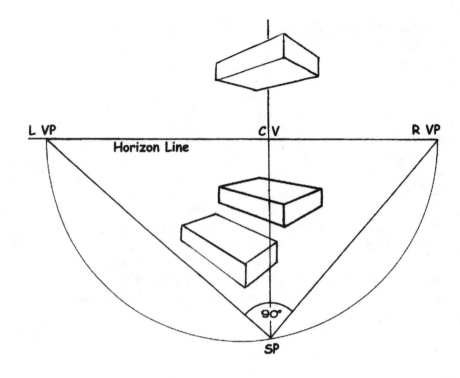

Red Ink Alert

The 90-degree angle is important. That's the distance where the angles of the perspective will be the most accurate. If you just guess and put two vanishing points on the horizon line, it can be trouble. If the angle is more than 90 degrees, say 120 degrees, some of the angular perspective is lost, and the item looks flat. If less than 90 degrees is used, then you increase angles, and the object may look warped. This is one of the ways the perspective of an object looks wrong, yet you can't find an error.

Inclined planes aren't any more difficult in two-point perspective than in one-point perspective, once you get used to knowing when you need them. Extend vertical lines through the left and right vanishing points, so that with the horizon line you have a giant *H*. Then determine the high and low points of your inclined plane in the same way as in one-point perspective. Extend a line through these two points to the vertical line at the side, and you have one vanishing point. On the other side, the vanishing point will be the normal one. That rule will hold true: On one side you will have a new vanishing point directly above or below the normal one, and on the other side the normal one will be used.

Inclined planes in two-point perspective.

(© Arnold Wagner, 2002)

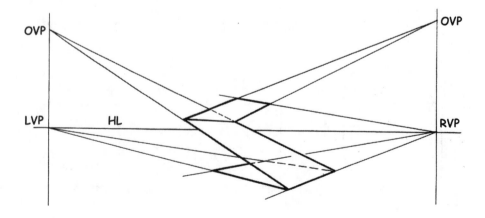

Putting Circles and Shadows in Perspective

There are a number of ways to put a circle into perspective, some far beyond what a cartoonist is going to need. A circle is nothing more than a large number of points all equal distance from a common center. If all you're trying to do is draw a plate on a table or a wheel on a car, you don't want to spend an hour laying out the perspective. For most purposes simply drawing a square in perspective, using diagonals to find the center, and then adding vertical and horizontal lines will give you a pattern of four points in which you can draw the circle as an ellipse.

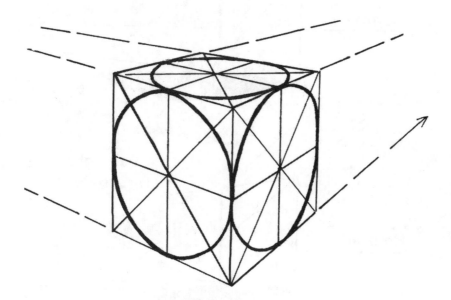

Circles sketched in using a square in perspective.

(© Arnold Wagner, 2002)

If you're still having a problem, there's an easy way to double the reference points. Divide the measurement of one side of the square by two, use that to measure out from the center along the diagonals in all four directions, and it will give you four corners of an inner square. The corners will be points on the circle midway between the four primary ones.

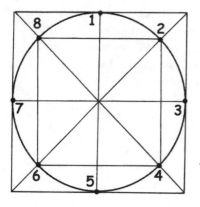
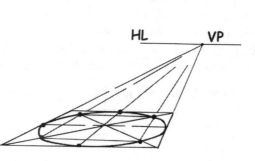

Sketching in a circle on a square using eight points.

(© Arnold Wagner, 2002)

The main thing to remember about shadows is that there are two basic types, depending on the light source. There is natural light, like the sun, and artificial light, as in lamps. The light from the sun originates from so far away that the cone of light is immense and the beams are parallel for all practical purposes. With artificial light, the source is much nearer and we have diverging lines of light.

The result is that the shadows from artificial light tend to be larger than the light from the sun or moon. If the light source is very near you, then your shadow will be much larger. That's an easy experiment to try.

Shadows in perspective.

(© Arnold Wagner, 2002)

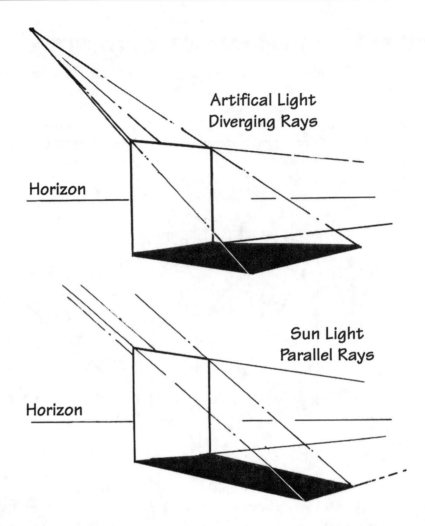

Worm's- and Bird's-Eye Views

What we call the worm's-eye view and bird's-eye view are used only when an exaggerated effect is wanted, as in looking up at a high object (the worm's-eye view) or looking down from a great height (the bird's-eye view). These effects can be achieved in one- or two-point perspective (or in three-point perspective, which we don't discuss here). City scenes are used in the following illustrations, and that's what we usually think of with the two views, but cartoonists use them for many dramatic effects; for example:

♦ Looking up at tall trees from the forest ground

♦ Looking down to the ground from the top of a tree

♦ Looking up at a giant

♦ Looking up or down a long flight of stairs

♦ Looking up or down an elevator shaft

♦ Looking down from a flying carpet

♦ Looking up from the bottom of a well

If you're interested in how cartoonists make good use of perspective, we can suggest a few likely places to look: Bill Watterson's *Calvin and Hobbes* and Pat Brady's *Rose Is Rose* are the two modern champions, but the all-time champion is an old strip, Winsor McCay's *Little Nemo*. Fortunately, you can still find examples of this strip in anthologies and reprints. A lot of editorial cartoonists have copied McCay's style for its dramatic impact.

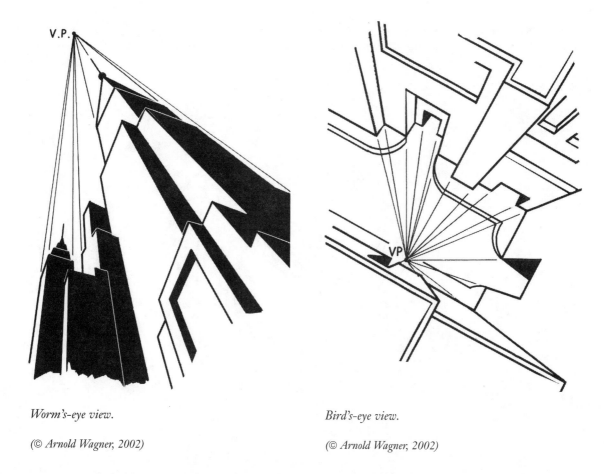

Worm's-eye view.

(© Arnold Wagner, 2002)

Bird's-eye view.

(© Arnold Wagner, 2002)

Atmospheric Perspective and the Use of Color

No lines or bothersome vanishing points here. All perspective—all cartooning and all art—is to some extent an illusion, but atmospheric perspective is both reality and total illusion. In linear perspective, the lines don't really converge, but in aerial perspective, the atmosphere really does change the appearance of objects at a great distance.

If you use color in your cartoons—and it's becoming more common all the time—you need to be aware of the effects of color on how near or distant things appear. Cool colors like blue, green, blue-green, and blue-violet give the impression of receding, or distance. Warm colors like red, orange, and yellow give the impression of advancing, or nearness.

You can observe the effect in nature: The distant hills and mountains take on a bluish tone and lose brilliance and intensity, so they appear a grayish blue. In your backgrounds, grayed blues, blue-greens, and blue-violets are effective, but avoid reds and yellows. On the other hand, using warm colors like reds and yellows in the foreground will help to emphasize that part of your drawing.

In cartoons, black and white is still used more often than color, but atmospheric perspective remains important even then. Showing less detail in far-away backgrounds is a natural tool and has the added advantage of stressing the elements of the cartoon that are important. The same is true of another technique. The lines on the primary elements of the cartoon are bold, and finer, even broken, lines are used

Red Ink Alert

Aside from color, detail is quickly lost at any distance. Too often you see paintings by amateurs where the background is vivid and full of detail. It rings false and tends to make the entire picture take on a sameness that may make it seem boring.

in the background. Another trick that throws the background forward is the halo effect. White space surrounds the foreground elements, while none of the lines of the background touch the objects and people in the foreground.

Highlighting important objects by leaving a white space around them.

(© Arnold Wagner, 2002)

"Dropped my watch..."

The Least You Need to Know

◆ It's difficult to determine when perspective was first understood scientifically, but artists throughout history have experimented with it.

◆ The main thing to remember about perspective is that objects look smaller when they're farther away.

◆ The most commonly used forms of perspective in cartooning are one-point and two-point perspective; which one you use depends on how many dimensions are parallel to the picture plane: two in one-point perspective and one in two-point perspective.

◆ Two types of perspective tend to seem harder than they are. Remember that shadows change depending on the source of the light, and circles always fit into squares.

◆ If you want an exaggerated effect, consider a worm's-eye or bird's-eye view.

◆ Color, detail, lines, and the halo effect are all common tricks used in conveying atmospheric perspective.

Chapter 12

Composition Basics

In This Chapter

- Balance: how to arrange your elements
- Sequence: going from start to finish
- Emphasis: focusing on the important stuff
- Creating mood and atmosphere

Composition is very different for the painter and the cartoonist. They have different problems and different goals. The cartoonist is usually working with dialog, and they are always working with sequence. A beginning, middle, and ending are there, even in the single-panel cartoon. The ending may be implied, but it's there. The cartoonist's work will be reproduced in a commercial media. They won't be concerned with frames, lighting, or the height at which the work is hung. They will be concerned about immediate public reaction, and how well the work reproduces.

We keep coming back to comparing cartoonists to those working in stage, film, or television. It's an important point—one that will get even more play in this chapter.

A Balancing Act

The drawing has to look like a unit. There are some general rules, and as usual, they come with exceptions. Let's start with the Greeks again. They came up with what they thought was the ideal proportion, or ratio, to achieve beauty. They called it the *golden section* (also called the "golden mean" or "divine proportion"). It's a proportion that many artists and builders have come up with instinctively. In the arts, it is rounded out as a ratio of 3:5. The idea is that the smaller unit will be to the larger unit as the larger unit is to the whole. The goal is to have all elements of an object in proportion to each other, although that isn't always practical.

In order to achieve balance, we attempt to coordinate all the parts in a work so that they are connected, both in sequence and in emphasis. If you have an element that isn't connected, then the work is out of balance. If there is an element that has a false emphasis or seems more important than it is, then the work is out of balance. A bit harder to notice, but equally true, is that if a primary element doesn't have the emphasis it should have, then the work is also out of balance.

Because cartoons are a narrative form, balance in them is a bit different than in paintings. Develop the habit of noticing what you see first when you look at a cartoon and how your eye travels through the cartoon. Are there detours? Blank spots? You want a smooth and rapid path, unless misdirection is the point of the gag.

'Toon Talk

The **golden section** is a numerical constant that comes out to 1.618 … and is represented in mathematics by the Greek letter *phi*. Divide a line into two segments: A (the longer segment) and B (the shorter segment), so that the ratio of segment B to segment A equals the ratio of segment A to the length of the whole line AB. If the length of segment A is 1, then the length of the line AB is the golden section. (You can calculate this if you want, or take our word for it.)

Very early in history, artists figured out that some works seemed like a whole, and others didn't. They worked out a system of organizing them along a symmetrical pattern. We now use symmetrical and asymmetrical as the primary forms of composition. Symmetrical is primarily used in decorative works. It has a static, peaceful, and formal look to it. In a symmetrical design, the area is divided equally from its center, and each section has equal weight and emphasis. The perfect example of symmetry is a circle centered exactly in the middle of the composition.

In asymmetrical balance, we divide the area into unequal parts and achieve balance and unity by giving unequal emphasis to the elements. It's somewhat like balancing a large and a small child on a teeter-totter. Asymmetrical compositions are more interesting, and tend to represent action and emotion.

This is as simple a symmetrical division as we're apt to find. The two halves, horizontal or vertical, should be equal in weight.

(© Arnold Wagner, 2002)

The Greeks discovered the value of asymmetrical design early on and developed the golden section as the ideal foundation for it. You can measure it in their architecture.

3:5 Ratio approximate of Golden mean

Spending time and effort to adhere closely to this form of composition in cartoons isn't productive, but it's a good rule of thumb to keep in mind and to use as a general guide. Placing your center of interest in the exact center of a drawing is seldom a good idea. Few painters use the golden section that formally. They approximate it, and some favor a ratio of 2:3, as shown in the following illustration.

There are exceptions. Leonardo da Vinci's painting, *The Last Supper,* is a major one. It is in one-point perspective (see Chapter 11, "Getting Perspective") with the vanishing point at Christ. If not really an example of symmetrical composition, it approaches it.

In the following illustration, we've blocked in examples of symmetrical and asymmetrical balance. The lines marked A are in the center of the drawing. The lines marked B form a golden section. Notice that in the asymmetrical example, both divisions work.

Symmetrical and asymmetrical balance.

(© Arnold Wagner, 2002)

Creative Inkling

Exceptions to formal balance occur when the imbalance carries an emotional impact. A single figure might be at the lower left looking out at a vast wasteland; a female might be at the far right, looking back at an empty panel and realizing her date has deserted her. In such cases the emptiness itself takes on form.

In the symmetrical layout, any movement or action is played down. There are three elements, forming a triangle; none of the sections are too empty, and all three are connected by eye contact and the gesture of the central figure. The requirements for balance have been met, but it is a bit dull. In the asymmetrical panel, there are only two elements because the lower two people are grouped together. The composition forms a diagonal from the upper left to the lower right, while the background forms an opposing diagonal. This is a much more dynamic balance.

Keep the negative or empty areas varied and interesting in shape. Unless accessories are vital to the story or gag, don't let them upstage your players. Keep your elements connected, whether they are people, animals, or props. This can be done by eye contact, gesture, action, or indirect means using vanishing points leading to a central point, common colors, or dialog balloons.

Keeping It in Sequence

Because we are talking about cartooning, we are talking about sequence: Something is happening; time passes. Sequence accounts for many of the exceptions to formal balance. It also adds its requirements to balance. What we'll stress here is the single panel, since even a graphic novel is just a large number of single panels.

Westerners read from left to right, top to bottom. Ingrained habit results in our looking at pictures in the same way, especially if they are cartoons where we expect some form of direct communication. It throws us for a second if something interferes with this. It breaks the spell, the rhythm, and may spoil the story or gag. The exception is when breaking the flow is the whole point of the gag. The double take, the non sequitur, and puns often break the rhythm.

Who's Talking?

With the single-panel magazine cartoon, the dialog usually takes the form of a legend, or caption, at the bottom of the page. The first question this brings up is, Who is doing the talking? One character should have his or her mouth open, or be gesturing in the manner people use when talking, or some combination that shows who is speaking the caption. That's not a problem—or at least it shouldn't be—with dialog balloons. This also means that other characters in the scene should have their mouths closed and not look like they are talking, unless by other means it is made clear that they are not the primary speaker.

On Your Mark

Next we need to set the stage and give our actors their marks to stand on. As our eyes follow the pattern from left to right, it usually helps if we notice the person instigating the action first and the person reacting last. But that's a decision that should be thought about.

In the following illustration, artist Jack Schmidt started at the upper left by setting up the location, a supermarket's frozen-food section. The strong black of the trousers pulls our eyes diagonally. We move on to the shopper, whose mouth is open, but her expression and hand gesture indicate shock, not speech. So then we move to the clerk, whose mouth is open and doing the talking. Note that the black base of the freezer unit pulls our eyes back to the shopper and the clerk. The shopper sees trousers, assumes the worst, and reacts, and we close with the clerk's explanation of the wrong assumption.

From the Pros

Harold Ross, the founder of *The New Yorker*, was a major influence in modernizing the gag cartoon. He was always asking the question, "Who's talking?" Cartoonists from an earlier era didn't bother about that much. They let the reader figure it out or used labeling in the caption to clarify it. But by clarifying who was speaking in the drawing itself, the cartoonist ensured that the punch line didn't get walked on.

Example of eye control for sequence.

(© Jack Schmidt, 2002)

"IT'S ALRIGHT MAM - HE'S FIXING THE FREEZER."

In the next illustration, artist Ted Trogdon sets the scene as taking place in a bathroom at the start by using a mirror and a basin. The black trousers are emphasized, and they pull our eyes down to the dripping hands, which set us up for the connection with the towels and the payoff. Notice that there is no surplus of images to draw our eyes away from the sequence as Ted wanted us to see it.

*Another example of sequence
and eye control.*

(© Ted Trogdon, 2002)

Space Between Panels

In a series of panels, an important factor to remember is that the *gutter,* or actual space between the panels, represents a time period. It may mean time passing in the same scene, or it may mean a change in time and place, as in a change of scenes. The following panels show unrelated scenes, so the time element doesn't apply, but we have divided those panels into three and four areas using a simple line. That tends to indicate little or no time change. In the upper left-hand panel, we use the lines to show two scenes at once, with a sequence. The first character announces the approach of the second character, who is shown doing just that in the middle section, and in the third division we have the third character reacting and calling for them to hide.

'Toon Talk

The space between panels in a multipanel cartoon or comic book is called the **gutter.** It is also referred to as the "alley."

In the upper right-hand panel, we have just one character searching for an object. By using the line division in one panel, we compress the time element as well. In the lower left panel, we again have just one character, but this time we have divided the panel into four parts, which slows the action down just a bit. In the lower right-hand panel, we're back to three characters, or two scenes shown at one time.

Study the four panels in the following illustration carefully. Notice what your eyes see first and the order in which they take in the elements in the rest of the drawing.

Examples of rapid or simultaneous sequence within a panel.

(© Arnold Wagner, 2002)

Dialog Balloons

Dialog balloons are another way sequence is expressed. It's nice if the first speaker is at the upper left and the second speaker is at the lower right, but that's not always convenient.

The solution is to move the balloons around so that they are in the right sequence, regardless of where the characters are positioned. In the first panel of the following illustration, notice that the figures are in the same order as they are speaking, from left to right. This is strengthened by the technique of having the first balloon overlap the second one, so that the first balloon is in the front and the second balloon is behind it.

In the second panel, the speakers are right to left, but the balloons are in the proper left-to-right position, so we simply used the pointers to identify the right speakers. There are a variety of ways this can be varied. Study different comic strips and watch how the artists handle this, and how well it works or confuses.

Examples of sequence with speech balloons.

(© Arnold Wagner, 2002)

Adding Emphasis and Contrast

Emphasis is often connected to sequence. It helps control what we notice first and what we notice last. That can be vital in a gag or story plot. As with sequence, where you place a character or object in the panel can indicate how much emphasis you want it to have. But there are a number of other ways to emphasize a particular element. The simplest is just to place the center of interest in or near the center of the drawing, and to use one-point perspective with the vanishing point on whatever is forming the center of interest.

A mistake many beginners make is using overemphasis in both the drawing and captions. They may have too many points of interest or end too many sentences with exclamation points. The result is a jerky flow that interrupts the timing and is distracting for the reader.

In the next illustration, artist Lo Linkert has kept the drawing as simple as possible to emphasize his central character. He underlines that by keeping his lines well away from the central figure, throwing it into the foreground and in effect shining a spotlight on it. He takes it a step further by using one-point perspective with the vanishing point at his central figure.

The main figure is centered, with perspective lines drawing the eye to it.

(© Lo Linkert, 2002)

A similar technique, but one that is less noticeable, also involves a spotlighting effect. In the next illustration, notice how the lines of the background stop before touching any of the major figures in the foreground. That throws the foreground into more prominence. The only other emphasis used there is the black in the doctor's mouth, the line of his vision, and the black on the fruit.

"UNFORTUNATELY IT'S NOT PRUNING SEASON."

Contrast is important in emphasizing the parts of a drawing you want to stand out. In a line drawing with little detail, small touches of black are sufficient. Small spots of color are equally effective. In a dark drawing, light areas will stand out.

Black will be stronger than white when used as a contrast. In Chapter 11, we mentioned that warm colors advance and cool colors recede. Black is about as warm as you can get, since it absorbs all the light rays. White reflects all the light and thus is cool. White on black will often seem like a hole in a black surface.

You can see this in the 10 panels shown in the following illustration. In panel 1, the two foreground silhouettes frame and accent the silhouetted figure in the background. The perspective of the mountain trail also adds to the effect. In panel 2, the two silhouetted figures in the background are further accented by being framed by the foreground figure. In panel 3, the foreground figure frames the background figure and accents it, although it is small and without any accent of its own. Panel 4 uses the same approach but with a dramatic viewpoint, plus the aid of converging lines to the vanishing point at the distant figure.

Panel 5 illustrates the white silhouette on black, emphasizing the mountains more than the figures; because the white recedes, it seems a bit jarring. Panel 6 shows the same effect, but the detail in the light lessens the result. Panel 7 is yet another example of framing. Panel 8 makes use of black to indicate something out of our view, making it more dramatic and adding to the action. In panel 9, the dark and light tend to accent the distances. The mountains loom, yet the plain recedes into the background, and the building stands out against it. In panel 10, the hand is accented by being in silhouette, but because there is no detail, our eye follows the form to the *X* on the map that wouldn't stand out as well otherwise.

From the Pros

New Yorker cartoonist Peter Arno was a master at using light areas for emphasis. In his drawings with dark washes, the faces of those speaking or reacting are often lit up, as if someone with a baby spotlight was nearby, training the light on their faces. Stan Hunt was another *New Yorker* cartoonist who did this very well.

Examples of how silhouettes can emphasize an element or frame the main element.

(© Arnold Wagner, 2002)

Creating Atmosphere

Atmosphere is a difficult area to define. Some cartoonists create an atmosphere that exists in most, if not all, of their cartoons. It's a prime element in their message. Cartoonists Milton Caniff, Fred Harman, Bill Mauldin, Harold Gray, George Price, Koren, and the United Kingdom's Emett and Sprod are all good examples, and their work is well worth studying.

In comic books, the contrast between *Superman* and *Batman* is a good example of differences in atmosphere. *Batman* uses a lot of dark colors, which stresses the mystery and sinister undertones of the main character. *Superman* uses brighter colors, leaning more toward the primary shades, which stresses the idealism and wholesomeness of the hero. In the classics *Terry and the Pirates* and *Little Orphan Annie*, the dark colors and shadows convey a sense of mystery, exotic flavor, and danger. *Ziggy* often uses a bright array of colors, which can indicate a peacefulness at times, or at other times underline Ziggy's insignificance in the grand plan of things.

In other cases, atmosphere is used only as needed. A mood or emotion is evoked not as a part of style, but if it's required for a particular situation. Props and settings are important in these cases. Viewpoint is another element. Are we looking up at something imposing or down on something of little significance?

> ## Creative Inkling
>
> In cartoons, deserts and the Arctic have a similar look: large white areas, strong contrasts, and small but dense shadows. The image is generally small on a large canvas, to emphasize the scale of the environment.

An obvious example of a cheerful or gloomy atmosphere expressed by trees.

(© Arnold Wagner, 2002)

Sharp angles and diagonals give an atmosphere of action, conflict, unrest, and violence. They also tend to be masculine. Straight, even, vertical and horizontal lines indicate a static, stable, dignified, strong, quiet, steady, and boring atmosphere. We tend to think of curved lines as feminine, beautiful, peaceful, and sensuous.

In all cases, the length of the line or curve is also a strong factor in what it conveys. Length of line adds stability, power, smooth motion, purity, and balance. Short lines give a feel of action, confusion, instability, impatience, and a lack of structure.

The Least You Need to Know

◆ Balance is an important element of cartooning, but always stress communication of the idea over making the drawing look pretty.

◆ All cartoons tell a story, even single-panel gags, so they need to read in sequence from left to right, just like a page of text.

◆ Make the most important elements of the cartoon stand out by emphasizing them, but don't clutter things up with unnecessary accessories.

◆ Atmosphere is difficult to define but still crucial: The appearance of the cartoon should reflect the mood of the message.

The Elements of Style

In This Chapter

◆ Some basic types of style

◆ The difference between studying and copying

◆ Why less is usually more in cartooning

◆ The risk of going to extremes

◆ Fitting style and genre

◆ Signing your work

Beginners tend to worry too much about style. Style should evolve, not be designed. If you look at the early work of any well-known cartoonist, it will look a lot different from what they produce a few years later. The changes don't happen overnight; they happen as a result of constant drawing. They aren't really different, just a more evolved, refined version of the original style. It's like refining crude oil into any of the many petroleum products.

You already have a style. You can't avoid that. It's a natural result of a number of things: your way of looking at the world and your influences filtered through the tools and media you choose to work with, and adapting all that to the media you are working in.

What's Your Style?

We can break style down into categories, though there's a lot of overlapping. In the basic drawing, there's the illustrative style. That would include the heroic figures like *Superman* and *Spiderman*, and the more realistic ones like *Prince Valiant*, *Mary Worth*, and *Apartment 3-G*. Next are the less realistic ones like *Brenda Starr*, *Dick Tracy*, *Rex Morgan*, and *For Better or For Worse*.

We'll call the next group the illustrative-caricature style. This category includes the strips *Sally Forth*, *Funky Winkerbean*, *Crankshaft*, *Tank McNamara*, and *Gasoline Alley*, as well as such magazine cartoonists as Peter Arno and Dedini.

Variations on style, from heroic to big foot.

(© Arnold Wagner, 2002)

The caricature-illustrative group is just a half-step more and includes the strips *Beetle Bailey, Blondie, Hi and Lois,* and *Zits,* and the magazine cartoonists Chon Day and George Price.

A caricature category would include *Baby Blues, Foxtrot, Garfield, Peanuts, Dilbert, Ziggy,* and *Cathy.*

The categories and what fits where is open to debate, of course, but the concept is that we are moving from the realistic to the abstract. The style and the subject matter limit each other to some extent. Switching the styles between *Apartment 3-G* and *Baby Blues,* for example, would be disastrous for both features because the audience would have trouble identifying with the drama and glamour of *Apartment 3-G* if it were drawn in the broad style of *Baby Blues,* while *Baby Blues* drawn like *Apartment 3-G* would lose the spontaneity and informal atmosphere it needs for the humor to shine.

Media is another way to divide up styles, though there are even more exceptions. Generally, the single-panel or gag cartoon will have a looser, more immediate look than a strip. The syndicated single panel will usually be somewhere between the strip and the magazine cartoon. Magazine cartoons don't usually depend on continuing characters, so the characters in them are more generic, less developed—John or Jane Doe. The syndicated strip will have to be designed in a manner to be reduced to a very small size and still be easy to read.

'Toon Talk

In animation, **cels** are transparent sheets of cellulose acetate on which drawings are placed, usually in several layers, to make one or more exposures of film. It takes a great many cels to make even a short animated sequence. Cels have become collectible items, and firms selling them can be located on the web.

Animation styles are changing with computer animation, but some general trends hold up. The anime look imported from Japan is a popular subcategory of animation that has caught on in the United States. It grew out of imitations of Disney animation and the Japanese culture's tales told in manga, the long-established Japanese comic books that we first mentioned in Chapter 3, "Specialization Enters the Picture." The characters tend to be very young-looking, with large eyes. The plots stress fantasy and science fiction rather than humor. But anime retains the strong outlines that make the characters easier to animate. Styles like those of *Blondie* or *Zits* have been used in animation but haven't been very successful. Animation likes rubbery joints, for one thing, because joints are difficult to animate. Most animation favors simple forms that are easy to reproduce from *cel* to cel. Standard animation styles have had some limited success in newspaper syndication but almost none in gag or editorial cartooning.

"You cats are all alike."

In successful comic books, the styles usually encompass exaggerated action and expressions. Good comic book artists sometimes have trouble adapting to newspaper strips. It's a little like the differences between acting on the stage and on film.

Tools are also an element of style. There are the lush or bold brush lines; the precise or sketchy pen lines; the mechanical half tones and rich washes. There are markers, pencils, crayons, charcoal, watercolors, and, of course, the computer.

The minimalist look shown on the left is getting more popular as cartoons are published at smaller and smaller sizes.

Style Influences

Some teachers will tell you not to copy other cartoonists. Other teachers tell you to study the styles of those cartoonists you admire. *Copy* is the key word. At one time, most of the adventure strips around looked like they'd been drawn by Milton Caniff (*Terry and the Pirates* and *Steve Canyon*) on a bad day. There are hundreds of Gary Larson clones around that mimic his style in *The Far Side*. None of Caniff's clones came anywhere near his success, and so far the same is true of the Larson clones.

> **Red Ink Alert**
>
> Copying a cartoonist's style in the literal sense—drawing it line for line, focusing on the small details—is not helpful. You will lose the big picture and gain little from the exercise, except to get practice with your tools. Instead, try to reproduce the drawing in spirit. Try getting the same setting, expressions, perspective, anatomy, light, and shadow. Focus on the larger elements, not the detail, unless it's as a separate study of that detail. Doing this kind of analysis will help you learn a lot more than simply copying the style line for line. (Of course, this is just an exercise for practice; don't ever try to sell or publish anything but your own original work.)

The advice to study the work of cartoonists you admire is good, but we'd go a bit further: Study the work of all the successful cartoonists you can. They all have something that gave them the edge and won them an audience. Chester Gould (*Dick Tracy*) wasn't the world's best draftsman, but he had a natural flair for dramatic composition that give some of his panels a gorgeous look and helped make *Dick Tracy* a hit.

There's another advantage in studying the work of a great many cartoonists: You'll pick up what you need or want from each and discard the rest, and not fall into the clone trap.

You don't need to copy the whole drawing as a rule. Check out how the cartoonist sets up the scene, and how she handles the perspective and anatomy. What does she include, and what does she leave out? Change things around. Does it help or hurt the cartoon? That's studying, not copying. Another good approach is to choose one subject—hands, feet, eyes, cars, desks—and study how a variety of cartoonists handle that subject.

Various styles of hands, from illustrative to spaghetti doodles and minimalist outlines.

(© Arnold Wagner, 2002)

Less Is Usually More

In concentrating on style, it's easy to start adding in all kinds of detail and fancy technique that will, in most cases, prove to be detrimental. It's tempting to throw in everything we like and have mastered from the drawing styles of our favorite cartoonists. That's showing off our skill, and readers couldn't care less. If they notice at all, it will probably be in irritation.

Except for the delayed-reaction type of gag, cartoons work best with fast and total comprehension. Style has to do with the meaning and point of the cartoon as much, and maybe more, than the drawing itself. Keep reminding yourself that everything you put into a cartoon must be justified. In many cases, the success of a cartoonist has as much to do with skill at editing the work as it does with creating it in the first place.

The Danger of Extremes

Frank and Ernest, The Far Side, Doonesbury, Boondocks, and *The Piranha Club* are all fairly extreme features. They look nothing like any other feature around. They are radical in appearance.

Extreme is not necessarily bad, but it is a handicap that has to be overcome. Both editors and the public tend to be slow in accepting extreme styles. It's also true that just because someone succeeds at a particular type of extreme style doesn't mean it will be easier for anyone else to follow in that cartoonist's footsteps. Often it's harder. Extreme styles are identified closely with one cartoonist. Extremes succeed because a cartoonist is doing his own thing, something that is very much a part of that cartoonist, and he is in the right place at the right time for the public to accept it. Others trying to adopt a similar style will be seen as imitators, second best.

Don't work at being controversial; it's neither a good nor a bad thing in itself. It's either you, or it's not you. Either way, it has to be important enough to you for you to risk rejection. If you like to climb out on limbs, then you can't complain if the limb doesn't hold your weight. If the fruit growing out there is something you want badly enough, then the risk is worth it, but know the risks going in, and accept them.

Creative Inkling

Whatever media you are primarily interested in, you need to keep up on it so that you can avoid things that have become overdone or for some reason looked at in an unfavorable light. But in doing so, don't try to cash in on what seems hot at the moment unless you have a very fast turnaround time. Normally, by the time you can develop material related to a new trend, the time has passed, and the work is seen as dated.

Fitting Your Style to the Genre

If you love the style of Alex Raymond (*Flash Gordon* and *Rip Kirby*), for example, given enough time and work, you could probably come up with a fair imitation of it. The problem is that it wouldn't be *you*; it would never result in a natural and confident look. It would be slow, tedious, and forced labor. Worse, what would you do with it? There's no longer a market for it. Adventure strips as a genre are pretty much dead in newspapers, the style is too labor intensive to make the deadlines of comic books, and trying to adapt it to animation is even less practical.

Style is related to the genre or media you want to work with in the following ways:

- In animation, you need figures that can be animated easily and made to look natural without a lot of labor or time.
- In newspaper features, your work needs to look good at the postage-stamp sizes in which most newspapers are reproducing cartoons.
- In comic books, the style has to enable you to produce a lot of pages in a very short period.
- Editorial cartooning works with very short deadlines due to being topical.

Deciding what kind of work you want to do will affect how your style evolves. That doesn't mean you can't work in more than one media. But your basic style will be based on one media and adapted to the others.

From the Pros

Style is like a stew: You add things and let it simmer slowly so that the flavor is richer. It is possible to sit down at the drawing board and manufacture an artificial style in a few days. At best, the style will evolve as you use it, just as your natural drawings would. At worst, it will lock you into a way of drawing that becomes a real pain a few years down the pike because it's not you. The problem is that it is an artificial style, so it may have traits that resist evolving into a natural style, and if you are successful, you may be trapped into drawing in a manner you're not comfortable with.

Your John Hancock

Your signature is a part of your style, and again, it is something beginners tend to get hung up on. The consensus among cartoonists is that your signature should be readable and easily seen, but not so conspicuous that it detracts from your work. Fancy signatures are often more of a problem than a help. What's important is that your signature becomes part of your drawing, not a headline, and becomes a part of your identity as a cartoonist, along with the rest of your style.

In the following illustration, the first signature in the upper left-hand corner works, while the one in the lower right-hand corner is harder to read. The rest are too busy.

Some examples of excessive signatures.

(© Arnold Wagner, 2002)

Should you sign your real name or not? It's better to go with your real name unless you have a strong reason to do otherwise. There are enough exceptions to that view to prove that it's nowhere near being a rule. Virgil Partch (*Vip or Vipper*) is probably the most familiar signature that isn't a real name, and he developed it into a valuable property. Revilo and Baloo are among the other familiar pseudonyms around now. Peter Arno was born Curtis Arnoux Peters but changed his name when he organized a jazz band playing speak-easies to avoid embarrassing his prominent family. George Gately is really George Gately Gallagher but adopted a pseudonym to avoid confusion with his brother John Gallagher, a prominent gag cartoonist.

Don't use a pseudonym simply because it sounds cool. It can be a headache in dealing with checking accounts, copyrights, and other business factors. Of course, there are also valid reasons to use a pseudonym. At one time, a number of female cartoonists used pseudonyms because they feared that being a woman might hinder their success. You may also want to use one to avoid confusion with other cartoonists, to keep two careers separate, or to protect relatives from embarrassment.

The Least You Need to Know

- There are a wide variety of styles, and they are affected by the subject matter, media, and tools you choose.

- Study other cartoonists but don't copy them exactly; instead look at their successes and failures to determine what works and what doesn't, and adapt what you learn to your own style.

- The number-one mistake of the beginning cartoonist is to throw in all sorts of extraneous details and fancy technique just because they can. In cartooning, the rule is less is more.

- Your style must be natural and evolve out of the kind of work you genuinely want to do—don't be different just to be different.

- Different genres demand specific drawing approaches; don't lock yourself into one style that just doesn't work for the genre you've chosen to work in.

- Don't overdo your signature; keep it readable and make it a part of your style.

Part 4

What's in a Genre?

This section is a survey of the major areas, or genres, that provide a market for cartoonists. Any one of these fields could easily justify a book all by itself. Obviously, this can't be an exhaustive survey, but we hope it will lay the groundwork and give you a starting point for further exploration.

There are a vast number of minor markets we haven't mentioned, and new ones are developing nearly every day. With a little imagination and incentive, you might latch on to some markets no one else knows about yet. It's increasingly true that most cartoonists need to diversify if they want to make a good living. Check out all the genres and see which ones fit your style and interests best, but always be on the lookout for new and unusual opportunities as well.

Chapter 14

The Gag or Panel Cartoon

In This Chapter

- Laying out the gag or panel cartoon with magazine submission in mind
- Choosing a media for drawing gag cartoons
- How to caption your gag cartoons
- Selling gags with a slant

Gag cartoonists are a bit like stand-up comedians as compared to actors in a sitcom. They don't normally have repeat characters, a regular paycheck, or a contract like most syndicated cartoonists. They are always looking for their next gig, and if they quit, not many will even notice.

Gag cartoonists work almost exclusively on speculation. They send batches of cartoons to publications that they know, or hope, will be interested in the material. The editors may or may not purchase anything from them. Some cartoonists have submitted hundreds of cartoons before making their first sale, and the giants in the business still get batches back with rejection slips.

The upside is that they are free to do any kind of material they want to do. They don't have deadlines, unless you count the stack of bills that arrive every month. Not many make a full-time living at gag cartooning, but there are a few. Most also do other types of cartooning or even hold totally unrelated jobs.

The Layout of the Gag Cartoon

Gag cartoons are always one-off cartoons. Because they're not part of a strip or other ongoing series, they need to be handled in a slightly different way. There are some significant differences in how gag cartoons are drawn and how they are submitted to magazines for publication.

How to Present the Gag

The gag cartoon is generally drawn on an 8½-by-11-inch sheet of paper. The specific kind of paper is a matter of choice; pick the kind that works best with the tools you use. Twenty-pound

Red Ink Alert

Multi-panel cartoons are one-time cartoons in strip format—often pantomime gags with no or limited dialog. Spreads are series of cartoons on a closely connected subject or theme, such as a list of computer terms with illustrations providing humorous definitions. Some publications use multi-panel cartoons or spreads, but you should know that they publish that type of material before submitting it, because it isn't the norm.

This cartoon is ready for submission to a magazine.

(© Elmer R. Parolini, 2002)

bond is the old standard. Some gag cartoonists use copy or printer paper if they draw with markers or pens that won't bleed or spread on that kind of paper. If you're working with watercolor or washes, you need to use a more substantial type of paper.

Always leave space around the drawing for the editor to make notes and for the printer to use as trim space. Most cartoonists generally allow a minimum of a half-inch, but a bit more is better.

Most publications print cartoons in a more-or-less square format. Using a proportion that is too vertical or horizontal can hurt your chances of a sale, unless you find a publication that makes a habit of using that format.

The following figure is a cartoon by Elmer Parolini that is ready for submission to a magazine. Notice that he has hand-lettered the caption well below the cartoon. Most publications prefer to set the caption in a house typeface, so leave room to do that.

"DID YOU HAVE TO MENTION THEIR OLD CIRCUS ACT?"

Leaving the publication as many options as possible is just good business. This also means that the best policy is not to enclose your cartoon in a box unless there's a strong reason to do so or unless the publication's submission guidelines state that you should. Publications have a carefully developed format and may prefer to use a specific type of box, or none at all.

Copies—never original artwork—are submitted to publications in batches of between 8 and 15 cartoons. Copies can be made quickly and fairly cheaply either by using a photocopier or a computer—much easier

than redrawing the cartoon when it gets mangled or has coffee spilled on it at the publication's offices. Just make sure that the copy is good enough to be published as is. (For more on preparing your gag cartoons for submission, turn to Chapter 26, "Breaking into the Business.")

Publishing Gags in Trade Journals and House Organs

Some gag cartoonists draw on a half-sheet, or 5½-by-8½-inch paper. This works well if the publications you generally submit to are *trade journals* or *house organs*, which typically print cartoons at a small size. (Using smaller paper also saves on postage.)

There are trade journals for almost every imaginable job. Trade journals usually want cartoons of particular interest to the audience they are serving. A journal for fast-food franchisers will only consider cartoons about the fast-food business, for example, while a TJ aimed at motel operators won't look at cartoons that aren't connected to the travel industry.

House organs are published by companies or organizations for an even narrower audience. There are two basic kinds: Interior house organs are published for employees, agents, and others involved in the day-to-day business; exterior house organs are aimed at clients, potential clients, stockholders, the press, and others who are interested in what the company is doing. Some house organs are a combination of these two types. Like TJs, house organs generally only use cartoons that are of special interest to their audiences.

Between trade journals and house organs, these publications make up a market that the general public seldom sees, but a potentially very lucrative market for the cartoonist who can turn out material suited to their specialized needs.

The following figure is an example of a trade journal cartoon done on a half-sheet in a minimalist style. The cartoonist, Alvin Bloodworth, opted to specialize in these small publications, which pay very low rates. Due to that, he had to find ways to mass-produce cartoons and keep expenses as low as possible.

'Toon Talk

Trade journals, or TJs, are publications aimed at people working in particular trades or professions. **House organs** are newsletters and magazines published by companies or organizations. There are two kinds: interior house organs, published for employees and others involved in the day-to-day business; and exterior house organs, published for clients, stockholders, and others outside the company who are interested in what the company is doing.

A typical trade journal cartoon, done on a half-sheet.

(© Alvin Hale Bloodworth, 2002)

Coding Your Cartoons

Put your address and a code for each cartoon anywhere on the back of every copy you submit—this is a must. If the cartoon gets separated from the rest of the batch, the editor will still know who drew it—very important if you want to complete the sale. With any luck, one or two of your cartoons will get separated from the rest. If the editor likes the cartoon, it may be placed in a stack of cartoons for further consideration, or it may passed around the office for comment by other staff members.

Creative Inkling

If you're going to be producing a lot of gag cartoons, it's a good idea to invest in a rubber stamp with your name, mailing address, and phone number. (They're not very expensive.) Get in the habit of stamping the back of each copy of every cartoon.

If the magazine decides to hold or buy the cartoon, they need to refer to the submitted drawing when contacting you. They may describe it or identify it by quoting the caption, but it's easier for them to just use the code number. That means you need to keep a separate record of all code numbers and what cartoon they each belong to.

Coding systems come in all kinds. They are basically just a bookkeeping item, but some things need to be considered. Numbers smaller than in the thousands indicate a beginner, something you may not wish to announce. Starting with number 1,001 isn't any better. You also may not want to announce that this is a cartoon you drew several years ago, so you don't want the date to be too noticeable.

One system we've developed is to indicate the month the cartoon was created by the letters A through L, followed by the last two digits of the year and a number indicating how many cartoons completed that month so far. (If you use gag writers, it may help to include the identity of the gag writer somewhere.) The code number H0128, for example, tells us that the cartoon was the twenty-eighth cartoon drawn in August of 2001. There are endless methods of assigning code numbers; develop one that fits your particular needs.

Some cartoonists add marks or code to the back of the cartoon to indicate where the cartoon has been submitted so far. This code may be just a dot over or under a particular letter or number in the return address, or some short code marked in a corner. We don't advise this for two reasons: First, if you lose the copy, then you've lost the record of where it's been. Second, most editors aren't total idiots. They can figure out that a lot of little code marks means that the cartoon has been around and rejected by a several other editors. It tends to have a negative influence.

What to Use to Draw Your Gags

We've already mentioned paper in the previous section. Pen or brush and India ink are still the standards for drawing gag cartoons, but nearly anything is acceptable. You should know enough about the publications you submit to that you're aware of whether they use color or washes, or prefer simple line art. You also need to know how much reduction is typical and any other details that may affect the way your work is reproduced.

Red Ink Alert

If you use a computer, it's wise to keep backups, but don't save them in JPEG format. That compresses the file by eliminating detail that isn't important. However, it compresses the file more each time it's saved, and the file loses quality. Keep a backup in a format like TIFF, and then if you need to send it to someone, make a copy in the JPEG format.

Computers are becoming a more important part of the cartoonist's equipment. If we aren't yet submitting electronically, we are often doing at least a part of the production work on the computer. Some cartoonists do all of their drawing on the computer; some only use the computer to do touch-up and perhaps to add color, lettering, or patterns. A good scanner, a drawing program like Adobe Illustrator or Corel Draw, and Adobe PhotoShop are the basic tools.

PhotoShop teamed with a good scanner is especially valuable to the cartoonist. If you spill ink, coffee, or food on a cartoon, it is much easier, faster, and safer to correct a digital version than the original drawing.

If you aren't using a computer to work on your cartoons, then it is still advisable to submit only copies of your artwork and to develop a working relationship with a copy center that keeps its machines capable of producing quality copies. Copy machines in these centers take a beating, and if management isn't careful, the quality just isn't adequate for reproduction.

The Basics of Writing Captions

Captions for gag cartoons are usually dialog. That is true even if the speaker is a voice-over narrator. An example would be, "Harold was beginning to suspect that elephants weren't great house pets." Avoid having more than one speaker in the caption. He-said, she-said captions only work if you are spoofing old-fashioned cartoons.

Write the caption well below the gag in pencil, and if it is dialog, enclose it in quotation marks. Some magazines use cartoons that put the dialog in speech balloons like those used in comic strips, but you need to be aware of what the publication's policy is on word balloons.

'Toon Talk

In gag cartooning, the **caption** refers to the text that appears below the single panel. Gag captions almost always take the form of dialog.

What cartoonists call a "caption" is technically a legend; a true caption is a heading or title, rather than dialog of any sort. If a true caption is used, then don't enclose it in quotation marks. Examples might be, "A Cold Day in Hell," "Wintertime Picnics," or "Shootout at the So-So Corral."

Keep a dictionary handy. Editors, as you might expect, tend to be picky about spelling. Words and their proper use are very important to editors, and a misspelled word will be jarring enough to spoil the punch line for them. The caption should be natural and conversational rather than formal English, but avoid unfamiliar language or the overuse of dialect. Reading the caption aloud helps to catch errors and determine whether the caption sounds natural.

Beginners often like to use all the exclamation marks they can cram in. Exclamation marks don't make the gag any funnier. It's like shouting the punch line. Overuse of them is the mark of a beginner and should be avoided. Use them where they are needed, but restraint is advised.

Red Ink Alert

Despite the fact that more and more publications are using color, it's not wise to send a color cartoon to a publication unless you know they use it. Color is fairly easy to add if it's wanted; it's not so easy to remove from an otherwise acceptable cartoon.

We've just touched on the basics of writing captions here. For a more thorough explanation of writing captions, turn to Chapter 22, "The Gag."

Sticking to a Slant

Slant is one of the biggest secrets around in selling cartoons to publications. In cartooning, slant refers to the subject matter of your cartoons. It's almost as important as the humor itself. Developing a series of gag cartoons centering on a particular slant can help you sell those cartoons to a niche market, like a trade journal or house organ.

Always remember that you are selling a product. Trying to sell suspenders at a nudist colony is not a great business move. Both the buyer and the seller wind up frustrated. If you're going to spend the time, effort, and postage to mail a batch of cartoons to a publication, you need to do a little basic research first. Taking at least a glance at a copy of the publication is suggested. The more study you do, the better your odds are.

If you've completed a bunch of cartoons with a religious theme, for example, sending them off to every religious publication you can find isn't good enough. You have to get even more specialized. The Baptist publications aren't going to find cartoons featuring nuns and monks of interest, and Roman Catholic publications aren't going to buy cartoons involving baptism by immersion.

You also have to be careful how your cartoons portray the subject matter, whether negatively or positively. Publications dealing with banking aren't going to buy cartoons dealing with embezzlement. Journals for those in the medical profession will write you off if you send them cartoons dealing with malpractice or other subjects that tend to show the profession in a bad light.

Think about who the readers of a publication are and how you would appeal to them if you were the editor. If you see a publication listed as wanting cartoons, pay attention to what they say they want, and pay even closer attention if they mention what they say they won't buy. Then look at what they're actually publishing. There may be a difference—send them both what they say they want and what they are actually publishing. The important thing is not to send what they say they don't want and what is not in the their best interest to use. Sending material to an editor that the publication can't use results in their viewing any future submissions from you cynically, if they look at them at all.

From the Pros _____

If you want to know how top professionals are going about marketing their gag cartoons on the Internet, these two cartoonists are about as good as they get:

- Randy Glasbergen: www.borg.com/~rjgtoons/cpub.html
- Ted Goff: www.tedgoff.com/safe

Study their examples and turn to Chapter 27, "Self-Promotion," for more tips on marketing your particular slant of gag online.

Publications also have slants beyond just subject matter. This is another reason to study what they actually publish. The editor may hate puns, or may have a weakness for them. The publication may lean toward drawing styles that are clean with lots of white spaces, or they may like dark washes, or a sketchy look.

Check out Chapter 26 for tips on locating markets. You'll also find a lot more information about preparing your gags for submission and targeting markets in Chapters 26 and 27.

The Least You Need to Know

- Draw your gags to the standard size and format used by most magazines to increase your sales potential.
- You can use traditional media to draw gags, but the computer is becoming a much more important tool.
- Captions are almost always dialog, so treat them that way.
- Coming up with a common slant for your gags can help you sell to specialized markets.

The Strip

In This Chapter

- What's a syndicate, and why do strip cartoonists need them?
- The two types of strip, and one panel
- Coming up with characters that readers care about
- There's no way around lettering

When most people think of cartoons, they think of comic strips. In other words, they think of the cartoons they see most often: the strips published on the "funnies" page in their local newspapers. This is probably the format that most beginning cartoonists aspire to as well, believing that a successful strip will automatically bring them fame and fortune.

This chapter is titled "The Strip," but we're including the syndicated panel here, too, since it has more in common with the strip than it does with the typical gag cartoon. It usually has a title, continuing characters, and a common setting, or at least an ongoing theme.

Syndicates and the Strip Cartoonist

The majority of strips are distributed by large syndicates, which are the agents that represent strip cartoons to the newspapers and magazines that publish them. A few strips are self-syndicated, but that takes people willing to work extremely long hours, and requires that they be well organized and dedicated beyond reason. It also demands that they give up any ideas of wealth or leisure.

The relationship between the cartoonist and the syndicate is basically a partnership. The cartoonist provides the creativity and the basic product. The syndicate kicks in the startup capital, the sales team, and promotion. They take the drawings and make proofs, and then distribute the final product to the client papers. They provide the clout of a large corporation that an individual can't supply. If it works, it's a win-win situation.

Before submitting a feature for possible syndication, you need to do a lot of preparation. Syndicates receive thousands of submissions a year, and they generally only accept three or four. To have a chance of acceptance, you need to put in a lot of hours developing your strip's concept and characters, coming up with original gags, and producing samples so that you can select only the very best to include in your strip proposal.

'Toon Talk

A **pica** is a printing measure made up of 12 points. There are six picas to an inch. We've used inches in all the dimensions here because not all readers will have rulers marked in picas. The standard method of stating dimensions of strips is picas wide and inches high, so a strip might be 38 picas by 2 inches.

Red Ink Alert

Whenever you send anything out, always send quality copies—not your original artwork. Also mark each piece with your name, return address, and any other contact information you want to provide, such as a phone number, e-mail address, and/or website address.

Using diagonal proportioning to enlarge panels.

(© Arnold Wagner, 2002)

How big to draw the strip is a common question. It's not important as long as the proportions are right so that when reduced, it will come out with the correct dimensions. At this time, the syndicates are distributing strips at about $6^7/_{16}$ inches wide. (The standard units of measurement aren't inches, though, but *picas*.) The height varies more; that runs from $1^3/_4$ inches to $2^1/_8$ inches high.

You can use a proportional scale or the diagonal proportioning method to enlarge the reproduction size to a size you're comfortable drawing in. Your samples should be reduced to the proper size though.

See the following figure for an example of the diagonal proportioning method. We simply drew a diagonal from the lower-left corner of the panel that we want to enlarge, extending it through the upper-right corner until it reaches a height that we feel is right for drawing the original. Then it's just a matter of running a vertical line from that point to the baseline and a horizontal line from the top to the left boundary.

Sunday strips are far more complicated and may be offered in a variety of formats, though no one feature is apt to use all of them. For submission purposes, we suggest using a size that reduces to a printed size of 13 inches wide and 9 inches high, divided into nine equal panels, three panels high, and three panels wide. The first two panels should be designed so that they can be eliminated without losing the sense of the strip as a whole. Colors should be flat with as little variance as possible.

There are a lot more details than this that you'll have to keep in mind when preparing a strip proposal for submission to the syndicates; turn to Chapter 26, "Breaking into the Business," to learn more.

The Three Kinds of Syndicated Features

There are basically three kinds of syndicated comic features: the gag-a-day strip, the continuity-adventure strip, and the syndicated panel. Each has its own conventions and limitations.

Another Day, Another Gag

The gag-a-day strip is just what it sounds like: a new gag every day. Most strips published in the newspaper are of this type. To come up with a successful gag-a-day strip, you need to have a sense of humor that can work even after spending time at the dentist getting a root canal. You can't wait for inspiration, and writer's block just isn't an option.

If you're producing a daily feature, that's six cartoons a week, 312 a year, or 1,560 cartoons in 5 years—and that is about the time they may quit calling your feature the "new strip." If you also do a Sunday feature, that's 52 more cartoons a year. Sundays are a lot more work, since they're in color and there are a lot of different formats you'll need to consider.

You may or may not use some degree of story line in your gag-a-day strip. Even if you don't tell an ongoing story, you're almost sure to employ some degree of continuity. In *Peanuts*, a few strips might be built around the Little Red-Haired Girl or Snoopy and Schroeder at the piano, but there's never a full story. Running gags like Lucy holding the football for Charlie Brown or Dagwood napping on the sofa are a form of continuity, but are more character driven than story plot. (Story elements, plot, and continuity are covered in much more detail in Chapter 23, "The Story.")

Creative Inkling

Some cartoonists have had layout forms printed on Bristol board in nonphoto blue, which eliminates the need for almost all measuring. These forms outline the overall size, show the divisions for two, three, or four equal panels, and have ruler markings along the side and bottom. When doing them yourself, it saves time to lay out several at a time using nonphoto blue pencil.

What the syndicates look for in gag-a-day strips are characters or themes that will connect with the reader on a personal level. Characters that readers love—or love to hate—are apt to be winners. The beginner tends to stress originality, and syndicates look for that, but not always the same kind. It's true that there has never been a strip where the lead character was an IRS agent. It's an original concept, but not apt to impress syndicate editors. They will look for originality in the little things. They want original characters and ideas that come from you, not from what you *think* the editor wants to see.

The syndicates also worry about whether the situation and characters provide enough material to support the feature over the long haul. They will want to know whether the cartoonist can maintain the quality and can consistently meet deadlines, especially over a run of years. Other considerations may involve how well your artwork will reproduce and what problems may arise in selling the feature. In that regard, if the syndicates are interested, they usually go to their sales staff and ask them for input on how difficult it would be to sell the proposed feature.

In your samples, show as wide a variety in gags as possible, and provide conflict and interaction between the characters that will generate humorous situations. You want your cast of characters to be as varied as possible, but not too large in number. They need to be developed beyond the stereotype level and to seem real to the reader. You'll find more advice on creating comic strip characters in Chapter 24, "The Characters."

Another Day, Another Cliffhanger

The other kind of comic strip is the story strip, which tells an ongoing story that continues from one day to the next—think *Mary Worth* or *The Phantom*. During the 1930s and 1940s, the story strip—also known as the continuity-adventure strip—flourished, and was widely popular. Now continuity-adventure strips are nearly extinct. The shrinking size of newspaper strips and competition with television have sealed their fate. If you are dreaming of creating a new version of *Buck Rogers*, *Dick Tracy*, or *Steve Canyon*, you have some major problems to overcome. Dramatic or soap strips like *Mary Worth*, *Judge Parker*, and *Apartment 3G* have fared a bit better, but no new ones have been successfully launched in quite a while, and the list of ones dropped is long.

> **From the Pros**
>
> The soap opera strip isn't as old as you might think. Allen Saunders (1899–1986) invented it in its modern format. He was a cartoonist and writer who gradually dropped the drawing part of his career in comic strips. With Elmer Woggon, Saunders created *Big Chief Wahoo*, which became *Steve Roper*. Then, in 1940, the syndicate asked him to take over the writing on *Apple Mary*. He gradually changed it from a humorous strip to its present format as *Mary Worth* in a conscious imitation of the daytime radio serials so popular with women. He also had a hand in developing the strips *Rex Morgan, M.D.*, and *Judge Parker*. Saunders retired in 1979.

If it sounds like story strips are dead, that isn't quite the case. A type of story strip has made a comeback, but it's a type that was almost extinct a few years back. This kind of feature combines the gag-a-day format with a story line.

This type of story strip used to be common. *The Gumps*, *Barney Google*, *Wash Tubbs*, *Popeye*, and a host of others had both an ongoing story and daily gags. With the rise of the adventure strip and then the soap opera strip, the gag-story strip went out of style. But as the adventure strips died and the soap strips faltered, some gag-a-day cartoonists began experimenting with the form. Strips like *For Better or for Worse*, *Luann*, *Curtis*, *Funky Winkerbean*, and others began sneaking the ongoing story back in.

These strips are popular, but syndicates and newspapers are still leery of the format, and there's no sign that the straight story strip is going to make a comeback. In today's market, each strip has to work on a daily basis as well as furthering any ongoing story line it uses.

Another Day, Another Panel

The syndicates find panels harder to sell than strips. That seems to be more of a problem with fitting them into a layout than with popularity or other concerns. The syndicated panel often has continuing characters like the strips (and unlike the freelance gag cartoon). There are *Dennis the Menace*, *Marmaduke*, *Callahan*, *Family Circus*, *Herman*, and *The Lockhorns*, to mention a few.

Syndicated panels with continuing characters are more common than strips without them. Those that don't have continuing characters usually have a strong theme or format to tie individual cartoons together. *The Far Side* and its clones are prime examples.

In size, the daily panels distributed by the syndicates run at about three inches wide. As with the strips, the height varies, with most running between $3^1/_2$ inches and $4^1/_4$ inches high. An even four inches seems to be the most common height. The drawings are nearly square in proportion. The title and the caption at the bottom of the panel, if one is used, make up for any differences in the height.

If a syndicated panel has a Sunday version, it is either several cartoons in the daily format with color added, or it moves to a strip format.

Characters: The People (or Animals) in Your World

Characters can make or break a strip, which is why the syndicates place so much importance on them, and why it's worthwhile for the cartoonist to spend a lot of time and effort developing them. We can think of one or two features that have made it without strong characters, but that's extremely rare and, in most cases, the characters are replaced by strong themes.

Interaction between characters is usually the source of *humor* in strips, which generally holds up better than just gags. In *Calvin and Hobbes*, the opposing personalities of the characters Calvin and Hobbes provide a lot of the appeal. In *Baby Blues*, the sibling relationship between the kids effectively shows two very different but very believable personalities interacting. The *Peanuts* gang is made up of characters that we know as well as we would if they were our own kids. It's a good idea to create your characters as a group, designing the personalities with enough depth so that you know exactly how they will react and interact if thrown into any given situation.

In gag cartooning, we use a lot of stereotypes because they are easily recognizable and they form a visual shorthand. There's no time to develop personalities in the one-shot gag panel. So we use the symbolic stereotype.

In strips, we usually start with stereotypes and then develop them to greater depth. We let characters develop conflicting traits: the villain has some good points, while the lead displays some human faults. It's hard to care about a character who doesn't seem real, but even severely flawed characters can gain our sympathy if they seem human. It's even better if they seem to be like someone we know. (Turn to Chapter 24 for a lot more discussion on developing lovable, recognizable characters.)

'Toon Talk

The term **humor** derives from a primitive medical theory that proposed that human behavior was controlled by the presence of body liquids called "humors," each one controlling different personality traits. Both Johnson and Shakespeare used this theory to create exaggerated characters for their plays. The term eventually came to mean the caricaturing of the oddities of human nature.

Making Your Characters Talk: Lettering

A lot of strip cartoonists are not thrilled by the chore of lettering. Some cartoonists farm out the lettering to underpaid assistants; others have taken to employing computers to do the lettering for them.

Even fonts that imitate handwriting have a mechanical aspect. In most features, that isn't an advantage. In a few strips, the formality of computer fonts actually sets off the humor. We favor hand-lettering; you can adapt it to individual situations easier and with more subtlety than you can a computer font. Walt Kelly was a master at hand-lettering. Studying his lettering is well worth your time.

The main thing to remember when doing lettering is to keep it readable. In the majority of cases, an informal style of lettering fits better with the humor of the strip.

The first thing to do is to get an Ames lettering guide and practice using it to draw guidelines. The space between the lines of lettering should be just a bit over half the height of the letters. For several reasons, most lettering in comic strips is all uppercase.

Letters in which the rounded sections are at the top guideline or at the baseline are just a hair larger, with the curve just barely crossing the guidelines. These letters are *C, G, J, O, Q, S,* and *U.* Crossbars are drawn so that they rise slightly from left to right. These letters are *A, E, F, H, L, T,* and *Z.*

Practice your lettering until it's consistent and legible. Lettering should make your strip easier to read, not distract the reader from the basic idea.

The Least You Need to Know

- Strip cartoonists partner with syndicates, agents who sell their features to newspapers.
- The three kinds of syndicated features are gag-a-day strips, continuity-adventure strips, and syndicated panels; of these, gag-a-day strips are currently the most popular.
- Characters can build both gags and humor, but humor may be better than gags in the long run.
- At minimum, lettering has to be easy to read, but it can add more than what the words say.

Chapter **16**

Editorial Cartooning

In This Chapter

◆ Breaking into the field of editorial cartooning

◆ Standards for laying out editorial cartoons

◆ Using and overusing symbols

◆ The tools and materials that save time and get your views across

◆ When to compromise your opinions, and when not to

There's a long-running tradition of using cartoons to make comments on the events or politics of the day, or the social mores of our time. This tradition has evolved into the modern-day editorial cartoon. Editorial cartoons are too "highbrow" for the funnies page of the newspaper; instead, they're found on the editorial page alongside editors' and readers' opinions.

Because of their satirical nature, editorial cartoons are allowed a lot more room for experimentation in form and subject matter than strip cartoons. Readers almost expect editorial cartoons to be offensive, whereas strip cartoons are anything but. That's one reason why it's so difficult to break into this specialized genre, and why rich and famous editorial cartoonists are so few and far between. Still, if you have strong opinions and a knack for presenting them in caricature, this may be just the genre for you.

Becoming an Editorial Cartoonist

Editorial cartooning is probably the hardest area of cartooning to break into currently. It's extremely rare for a new position for an editorial cartoonist to be created. There aren't many new newspapers starting up, and not many small papers are becoming large newspapers. Every year a few newspapers that have traditionally had editorial cartoonists on staff decide to eliminate the position and depend on syndicated editorial cartoonists as a cheaper alternative.

The reasons for this are varied: the rising cost of newsprint, the static level of circulation for most dailies, the lack of competition in one-newspaper cities, the loss of advertising revenue to television, and the corporate ownership of chains whose stockholders are made nervous by controversy. Stockholders are definitely more interested in dividends than in Pulitzer Prizes.

At one time, nearly every syndicated editorial cartoonist worked for a home paper and was syndicated as a sideline. Now for many cartoonists, syndication is their sole source of income, which

means they cover national issues and have no outlet for regional issues. Some editorial cartoonists have felt an economic squeeze, and this has resulted in a number of them trying their hand at syndicated comic strips, either in addition to their editorial work or by dropping the editorial work entirely.

'Toon Talk

An **editorial cartoon** is a cartoon that comments on politics, current events, or society, usually in a satirical way.

If you want to break into this field, start early by taking classes in civics, political science, history, journalism, and economics. After that, your best bet is to work for a small daily or weekly, or start out in the art department of a larger newspaper. Build a portfolio and get some experience, and then begin to submit to the syndicates. If you can't find any of these positions, you might try freelancing editorial cartooning to regional papers.

Another good idea is to subscribe to or borrow the weekly *Editor & Publisher* and watch their help-wanted ads (see Appendix C, "Publications"). Not many openings for editorial cartoonists are listed, but it does happen. Another plus is that there are articles on editorial cartoonists at times, as well as related articles that may be of interest and keep you up-to-date on the industry.

If you can make contact with cartoonists working in the field, that can be a big plus. This sort of networking can often let you know when a paper will soon be looking for someone to fill an editorial cartoonist's slot, and you can get a jump on applying for the job.

You do need to be aware that it's going to be an uphill battle. You're competing with a lot of very talented people for a very limited number of jobs.

Figuring Out Proportions

In the United States, the earliest editorial cartoons tended to use a horizontal proportion, the width being larger than the height. For some reason, the trend changed to favor the vertical format. In recent years, the horizontal format came back into favor—not for any strong reason except that Patrick Oliphant used it, and he was the strongest influence that editorial cartooning had seen in a long time.

A popular size to work in seems to be about 15 inches wide and 9 inches high. Borders or boxes are not in style, and it's best to avoid them. Most editorial cartoons seem to be distributed at a size between 6 and 7 inches wide and from 4 to 5½ inches high, with 4½ inches being the most common height. Color is still unusual. The trend has also been toward fewer figures in a drawing and a cleaner, more open look in general.

Red Ink Alert

Traditionally, newspapers use screens in halftones at about 65 dots per inch (dpi). Even with good presses and quality camera work, 85 dpi is pushing their luck. The combination of fast presses and cheap paper doesn't encourage fine detail.

Allowances have to be made for reduction, and that can vary a lot with syndication. This is harder to gauge with the litho crayon, which can smudge—one of the reasons it isn't used as much as it once was. Of course, some of the same problems arise with extensive cross-hatching.

Mechanical tints are usually about 32 dots or lines per inch. If you are working at double the final size, that's a 64-line-per-inch tint when reproduced. With the variables between presses and production quality among newspapers, that gives you a fairly safe margin.

Conventions You Need to Know

At one time, editorial cartoons used a multitude of symbols. They became so overused that a reaction set in, and cartoonists began to avoid them. Uncle Sam, John Bull, and other national personifications are seen a lot less than just a few years ago. The Greek and Roman gods have been almost totally retired, even Mars. Columbia seems to be fully retired. Only the Statue of Liberty has made a comeback with the September 11 disaster.

Other symbols are still seen, if less than before. The Republican elephant and the Democratic donkey are probably the most common symbols still in use. Others include the dove of peace, Cupid, Father Time, Justice, St. Peter, and the Star of David.

Labels and identifying tags are held in even less regard than symbols, and editorial cartoonists have found ways to limit their use. This isn't to say that symbols aren't still used very effectively or that labels aren't necessary at times. It just means cartoonists are less apt to use them as a crutch.

From the Pros

Humor in editorial cartooning began with Homer Davenport (1867–1912), who replaced Thomas Nast (1840–1902) as the nation's top editorial cartoonist, and whose use of humor was in sharp contrast to Nast's grim, angry cartoons. In moving from magazine work to newspapers, Frederick Burr Opper (1857–1937) followed Davenport's lead and let his sense of humor off its leash. He was not only a formidable editorial cartoonist, but one of the pioneers of the strip. Humor lost some ground during the Depression and World War II. When Patrick Oliphant arrived in the United States in 1964, the nation's cartoons were pretty staid. The country was ready for the revival of humor he inspired. The trend has gained so much momentum that some complain that editorial cartooning has become just an extension of the comics page. Others point out that humor has always been more convincing than anger.

If this field interests you, you'll need to learn about the symbols and other conventions of the trade. The best way to do that is to study editorial cartoons of the past and present. Plenty of books are available (see Appendix B, "Bibliography"). Check your library, the web, and as many newspapers as you can.

Drawing Editorial Cartoons

Honoré Daumier (1808–1879) and others in France used lithography to create powerful editorial cartoons. In England and the United States, editorial cartoonists used a style based on the old wood engraving, even after the era of wood engraving ended.

Around 1910, Boardman Robinson (1876–1952) began using the lithographic, or grease, crayon in an attempt to capture the power and look of Daumier. Robert Minor (1884–1952) and Daniel Fitzpatrick (1891–1969) followed suit with such powerful cartoons that the use of the *litho crayon* became the standard in the United States.

An example of a cartoon drawn with a lithographic crayon.

(© Arnold Wagner, 2002)

'Toon Talk

A **litho crayon** is a greasy crayon used on kid or rough, pebble-like surfaces. It is still available in art-supply stores, since lithography is a fine-art medium. The two leading brands are Korn and Stones. China markers and Prismacolor's black pencils make acceptable substitutes.

Creative Inkling

Because they deal with current events, editorial cartoonists normally work with very little lead time. In most cases, their cartoons are published within 24 hours. Litho crayons and Duoshade allow shading without the time and effort needed for detailed technique. A lot of editorial cartoonists still do an immense amount of detailed hatching, though. Even with long practice, that has to require some fast work.

Editorial cartoonists liked the litho crayon because it has a sketchy immediacy that implies power. It comes in various forms, including cakes and liquid, but cartoonists most often use it in square or round sticks of about two inches in length. The round sticks are often inserted in holders. Litho crayons come in grades of hardness from 0 to 5. Grades 3 and 4 are the most popular with cartoonists. Litho crayons shouldn't be used to fill in black areas because of their tendency to smear.

The litho crayon remained popular until the arrival in 1964 of Patrick Oliphant, who inspired the switch to mechanical shading like Duoshade and to the horizontal format. The litho crayon is still used by a few cartoonists, but it is a rarity now.

Coquille, Glarco, and Ross board were the standards for paper among editorial cartoonists. Currently, the most popular paper is a smooth-surface Bristol board. It comes in various thicknesses—one- to three-ply are common—and it also comes in several finishes.

Grafix makes the special chemically treated type of Bristol board made popular by Oliphant. It has invisible shading screens embedded into a three-ply Bristol. There are two types. The most popular is called Duoshade, which has two screens embedded in the Bristol board: a light shade, which is about 25 percent black, and a dark shade, which is about 50 percent black. The shades come in a variety of dots and lines per inch.

You simply draw your cartoon in ink on the Bristol board and then brush on a developer to the areas you want to tint. There are two developers: one for the light tint and one for the dark tint. The tint does tend to fade after a time if exposed to the light.

The second kind of mechanical shading is Unishade. It is exactly the same as Duoshade, except that it has only one tint embedded.

Enlarged detail of a Duoshade tint.

(© Arnold Wagner, 2002)

Adhering to Editorial Policies

During the early period when periodicals hired cartoonists to do nothing but editorial cartoons and made them important staff members, the cartoonists still had little or no freedom of expression as a rule. What they chose to defend or attack had to be in agreement with the views of their employer. That was true of even the mighty Nast. Editorial cartoonists had three choices: they found an employer whose views were close enough to their own to enable them to work with a clear conscience, or they drew cartoons on the

issues in agreement with the views of their employers, regardless of their own views, or they went into another line of work. Very few cartoonists were trusted to follow their own judgment.

As the syndicates grew and distributed the work of these cartoonists, the syndicates had little interest in or motivation to concern themselves with the views of any one cartoonist—either they sold well or they didn't. Syndicates placed almost no limits on the cartoonists, and the cartoonists often drew separate cartoons for the syndicates. The freedom was intoxicating.

Many editorial cartoonists began to resent the restrictions placed on them by their local employers. In some cases, they rebelled. This gave the publishers one more reason to dump staff cartoonists and go with the cheaper syndicated material. The syndicates offered a variety that could satisfy the demands of any one newspaper.

At the same time, newspapers began a move to making fewer and fewer strong stands. Where once newspapers openly identified themselves with one or the other political party, they now strove to be seen as impartial. With television costing them advertising dollars and readers, newspapers tended to be a bit paranoid about losing subscribers. Times were tough for print.

A person applying for a position as an editorial cartoonist should be someone who knows his or her own mind on most current issues. The person needs to sit down with a prospective employer and try to find some common ground on which they can lay down ground rules both sides can live with. We think it's reasonable for cartoonists to insist on not being required to draw cartoons in opposition to their own views. Equally, the newspaper should not be under any obligation to publish a cartoon that doesn't agree with its own editorial position.

This sort of agreement isn't all that unusual, and works quite well. Problems arise when one side changes its views to such a degree that agreement on cartoons becomes the exception. That happens more often with large newspaper chains, because editors and publishers move around, and viewpoints change with a change in management.

Other areas that prospective cartoonists may want to ask before accepting a job include the following: Work space—will they be allowed to work partially or entirely at home? Will they be invited to editorial board meetings, and how much, if any, input will they have there? And whom will they have to clear material with?

The Least You Need to Know

- ◆ It's become harder than ever to land a steady gig as an editorial cartoonist.
- ◆ You have to draw to proportion, but the styles are always changing.
- ◆ Know the conventions of editorial cartooning and use them, but keep track of the trends, too.
- ◆ Editorial cartoonists search out the best tools to get their points across and draw fast.
- ◆ When your opinions clash with your editor's, a little communication goes a long way.

Comic Books

In This Chapter

♦ The assembly-line model of producing comic books

♦ Understanding the different types of comic books

♦ Networking at the comics conventions

♦ Getting into print: How to approach publishers or go it alone

♦ The graphic novel, the newest member of the comic book family

Technically, the comic book genre began a long time ago, but in the form we think about as being the standard in the United States, they're relatively new. At the time of this writing, some of the pioneers of the industry are still alive. *Famous Funnies*, the first modern-format comic book, was introduced in 1934. It was made up entirely of reprints of newspaper comic strips, inspired by the success of comic-strip reprints used as advertising premiums. Because neither it nor its imitators used any original material, they provided no income for cartoonists.

These comic-book reprints were popular and sold well. Around 1936 some original material began to show up in some of them, and that meant employment for cartoonists, if on a very limited scale. Then in 1938, Superman made his appearance, and suddenly everything changed. The "golden age" of comic books had arrived. New publishers sprouted up everywhere, and those with the capital or the credit set up their own staffs on an assembly-line model. When they still couldn't meet demand, they used the independent shops that sprung up to service the publishers who couldn't afford their own staffs. These shops also used an assembly-line model.

Today, comic books are enjoying another renaissance, as the genre now targets a young adult audience with more money in their pockets. Comics now tackle adult themes, including graphic sex and violence, and they have moved far beyond the superhero genre spawned by *Superman*. Comic books and graphic novels are sold in legitimate bookstores, are collected avidly by fans, and regularly inspire multimillion-dollar films.

The Comic Book Assembly Line

The assembly-line model proved to be the approach that worked best for the major comic book publishers. It's still around today, although exceptions to the model have developed over the last few decades.

This model came about naturally. Publishers needed to turn out a set number of pages per day. One artist could lay out and pencil a large number of pages each day, but slowed when it came time to ink them, and slowed even more when doing the lettering. Another artist was slow at the penciling but sped through the inking. This cost both the artist and the shop owner money, since they were paid by the page. They needed to increase their income—meaning their production—so they passed the pages around, each doing their specialty: penciling, inking, or lettering. Everyone was making a better living.

Creative Inkling _____

Comic book covers must show the title, issue number, date, Comics Code Authority or other seal, price, teasers, bar code, and corporate logos. As a cover artist, you need to leave space for these, so they can be added without interfering with the meaning of the art. Most of these elements are placed at the top of the page.

This model worked so well that it was expanded. Some artists specialized in layout, color, or backgrounds. As the genre evolved and demand grew, other specialists were hired to do just covers and splash pages. (The splash page is generally the first page of a comic book. It usually shows a large, action-packed, introductory image.)

Covers are dramatic, sometimes far more so than the contents. They also need to be colorful in order to compete on the shelf, and no large areas of black should be used if it can be avoided.

Splash pages, or title pages, are usually, but not always, the first page. Sometimes they use the gimmick seen in movies and television programs, where a scene of action is the first thing shown and then the title appears. Like the cover, splash and title pages are dramatic, and they have to leave room for other elements. That includes the book title, story title, credits, and, at the bottom of the page in very small print, the indicia, which gives subscription, mailing, and copyright information.

The artist works on paper that is about $11^1/_2$ inches wide and $17^1/_2$ inches long. The image, or working area, is normally 10 inches by 15 inches. Gutters are typically set up a quarter of an inch wide, but this can vary for effect. The dialogue is usually lettered at the equivalent of 18-point type.

If your goal is to work for one of the major comic book publishers, then you will probably enter by way of specializing in a particular skill—penciling, inking, backgrounds, lettering, or coloring—or a position that has nothing to do with art, such as writing or even working in the mailroom. It's much easier to establish yourself or branch out from the inside.

Red Ink Alert _____

Comic books are team efforts; keep your ego under control. The talented penciler who is willing to do lettering, ink backgrounds, or pitch in wherever needed in a pinch is someone the publisher will want to keep around. Prima donnas they will put up with only as long as absolutely necessary.

In any case, specialization is the key to making a living in the comic book industry. Pick your strongest area and build your portfolio around that. The assembly-line model is going to stay with us for the major titles. The deadlines and complexity of putting out regular issues of a book are too demanding for any other solution.

That doesn't mean you should ignore the other skills. At some point, you may want to work in a different area, and you'll need those skills. It's also true that on any team, the player who can handle more than one position when necessary will be considered a very valuable member. (Turn to Chapter 26, "Breaking into the Business," for more advice about breaking into the comic book industry.)

Comic Book Genres

During the golden age of comics, the primary genres were superhero, Western, science fiction, romance, crime, horror, funny animals, jungle, war, and teens. Some of these were broken down even further. War comics, for example, were separated into naval, ground soldiers, and air corps (the Air Force didn't exist yet). Superheroes had team titles that were a subgenre in themselves.

All these genres are still around, and more besides. There are books that target an older audience and ones marketed to various minority groups. Fantasy and science fiction are much bigger than they were in either the golden or silver ages of comics.

Even if you are a true genius, the odds are that you won't be able to walk into Marvel or DC and land a job. You'll need to start at one of the smaller companies. Even there the competition is stiff. Besides your skill specialization, think about the genre you would like to work in. Then head for a local comics shop and find out what's being done in that genre. Check out any publishers with titles you'd like to work on and aim at developing samples for them.

You should also check out the alternative or underground comics, especially if your work is a bit offbeat. They cover most of the genres, but in a very different way.

> **Creative Inkling**
>
> If you dream of working in one of the genres where the characters and sets are fairly lifelike, such as any book in the superhero genre, you'll probably need some formal training in anatomy and perspective. It would be a good idea to start with Burne Hogarth's *Dynamic Figure Drawing* (see Appendix B, "Bibliography").

Having Fun and Getting Work Done at Conventions

Conventions are enormously important for the cartoonist who hopes to break into comic books. Attend as many as you can. Introduce yourself to as many professionals as possible and have a portfolio ready to show. Don't waste time running around showing your portfolio to anyone who is willing to look at it, though. Pick those artists and writers whose work you admire or those who are working in an area you're interested in. Those are the people who can give you the most valuable feedback. Feedback from a pro whom you don't know anything about is hard to evaluate, and feedback from someone who works in an area you have no interest in is apt to have little value for you.

Make a point of showing your portfolio to editors and their assistants as well as to artists and writers. If anything, these people in management can give better feedback than the creative talent. These are the people who assign the work and sign the checks. Chapter 27, "Self-Promotion," has a lot more information about preparing and showing portfolios.

The portfolio is important, but don't make the mistake that so many beginners do: Don't fill it full of impressive action poses and special effects. Make sure you have lots of layouts featuring continuous stories. That's what comic book editors buy, and that's what they want to know if you can supply.

Beyond showing your portfolio, you'll want to learn as much as you can about the business. Spend some time talking to retailers and vendors—and anyone else working in comic books or related fields. Ask questions and show an interest in what they do. They will remember someone who was pleasant and interested in them. Then if your work is good, they are more apt to recommend you to others. You are also apt to learn inside information that you wouldn't otherwise find out, perhaps tips that most other artists don't know. The people who manage and work at the conventions are also important. Lend them a hand when you can. You never know when a favor will be repaid.

> **Red Ink Alert**
>
> Socialize and network at the convention, but don't try to butter people up. Especially don't try to butter them up by knocking their competition. They will immediately wonder what you're saying about them to their competitors. Be polite, interested, and enthusiastic, but don't gush.

Remember that anyone you meet at these conventions may later be someone you work with or for. They may be retailers who sell your stuff or even just people who are fans because they remember meeting you before you were anyone. Attitudes simply say that you're not a team player, and comic books can't be made without teamwork.

Publishers and Self-Publishing

Comic book publishers come in all sizes and flavors. There are Marvel and DC—the "big two"—and then there are the dropouts who have managed to put out a few titles by maxing out a dozen credit cards and borrowing from all their relatives. They talk big, promise bigger, but will be gone next week. There is also, unfortunately, the occasional con artist.

There are also the publishers of comic-type publications that aren't a part of the normal structure. They may cover educational or training concepts. They may be advertising, promotional, or propaganda comics. Gaming books are also closely related.

Getting in a Publisher's Door

Do your homework. Haunt the local comic book shops. Read all the trade publications you can, search the web, and take notes at conventions.

Because a publisher is small or new is no reason to avoid them, especially if you're just beginning yourself; you just want to be sure that they'll be around long enough to get a project on the stands and that they are reasonably honest. The small publishers are more apt to take a chance on you and be less intrusive. You may not make a bundle, but getting published is a big benefit.

> **Creative Inkling**
>
> Most comic book publishers have websites, and they usually post submission guidelines there. Check them out but also write for guidelines as well. The printed and electronic guidelines are frequently different.

If you think you would match up well with a particular publisher, then work up some samples for a submission package. You're trying to get your foot in the door, so don't send them samples of everything you do. Concentrate on your strong suit. You can branch out after you're on the payroll.

As with the portfolio, send continuous pages (unless you're going for a job lettering or coloring). Don't send what one pro calls "pin-ups": samples that might make attractive covers or splash pages but don't say anything about your ability to draw actual comic book pages. Editors want to know you can do the work, so show them the work you do (more on this in Chapter 26).

Going It Alone

We haven't heard of anyone getting rich by going the self-publishing route or starting up his or her own small, independent publishing firm. Some make a modest profit; others lose their shirts. Look carefully into all aspects of the whole operation carefully before trying this. The art and story part is the least of it. You need to understand production, color separation, copyright laws, and how the distributors and the retailers work. Profit or not, self-publishing can be a very satisfying experience if well planned.

Count on it taking about four months, if you've done your homework and are well organized. It's almost a given that the first few issues will lose money—be prepared for that. You gain sales primarily by word of mouth, and that takes time. Things will become far more complicated than you imagined. It's wise to have the first two issues ready to go to the printer before you start.

> **Red Ink Alert**
>
> Your book should be the traditional size: 6 ¾ inches by 10 inches. Unusual sizes will tend to hurt orders, and even when ordered, may not be displayed well.

With your first attempt at self-publishing, the best format may be a black-and-white, 32-page book. Check current prices in the comic book stores, but $3 seems to be an average cover price. The cover is not included in the page count, and it should be in color. You may want to include a Canadian price on the cover, so check current exchange rates.

Remember, unlike regular magazines, comics are sold on a direct market concept. That means the retailer can't return the unsold copies for a refund. As a result, retailers tend to be conservative when ordering from small outfits, especially from new publishers. Tour every comic book store and convention you can get to. Give retailers special deals and even a free copy to put on the shelf. If you can turn the retailer into a fan, it will pay off. Trade ads and push mail-order coupons in your own publication. With mail order, you get to keep the cover price. Comics have a high pass-around ratio, so an order coupon may get good response.

The Comic Book Grows Up: The Graphic Novel

The *graphic novel* is a relatively new approach to comics. Graphic novels are really books, not periodicals. This is still a very experimental area.

Probably the best-known example is the two-volume work by Art Spiegelman, *Maus, a Survivor's Tale*. It tells the story of Spiegelman's relationship with his father and the experience of getting his father to talk about his survival in the Nazi concentration camps of World War II. It uses an anthropomorphic device: The Jews are depicted as mice, and the Nazis are cats. If you haven't seen it and think you might be interested in the graphic novel concept, you should get hold of a copy of this work.

> **'Toon Talk**
>
> A **graphic novel** is a book-length comic book that contains a complete story. Graphic novels often have higher production values than comic books. They may have hard covers and dustjackets, for instance, as well as heavier paper and more color.

Graphic novels are much longer than comic books. *Maus 1* is 160 pages long, and *Maus 2* is 138 pages long. They often have hard covers or come in the larger trade-paperback size, and they are generally printed on heavier paper. As a result, graphic novels tend to look better and last longer than the monthly issues. Probably because of this, graphic novels are beginning to find their way into bookstores that wouldn't normally carry anything in the comic book field.

Will Eisner, a pioneer of early comic books and creator of *The Spirit*, has written two works important to anyone interested in creating graphic novels: *Comics and Sequential Art* and *Graphic Storytelling and Visual Narrative* (see Appendix B for publication information). Eisner is also the author of about a dozen prime examples of the graphic novel, including *A Contract with God*, *The Building*, *The Dreamer*, *City People*, *Invisible People*, and *Dropsie Avenue*. Anyone interested in the graphic novel should also study Eisner's contributions to the field.

The Least You Need to Know

- In the big leagues of comic book publishing, specialization in one aspect of assembly-line production is a must.
- Studying the genres can help you to decide where you want to specialize.
- Make the conventions and network, network, network—but don't be a geek.
- Landing a job with a big publisher can be tough; self-publishing is an option, but it's not for the timid.
- The graphic novel may let you say what a comic book can't.

Animation

In This Chapter

- How animation works and the implications of modern technology
- Breaking into the animation field
- Styles and techniques you should know
- Training yourself to be a computer animator
- Breaking into the computer games market
- Animation finds a new home on the Internet

Animation always seems to be going through some sort of revolution. Currently, several revolutions seem to be going on at once, though all of them seem to be tied into the larger computer revolution.

The first animation revolution was the early technical experiments, which amazed the public. Then came the genius of the great McCay, who revolutionized animation by marrying science to art. Next came showmen like the Fleischers who made animation a major entertainment media. Disney revolutionized things yet again with the feature-length animated film, while the wild crew at Warner Brothers responded with madcap humor. UPA found its niche by bringing art, design, and intelligent themes to animation. Television doomed the theater short feature, but Jay Ward, Hanna-Barbera, and others developed techniques that allowed for the fast and cheap production needed by television because of the way it swallowed up material.

Computers are now revolutionizing animation on at least two opposing fronts. The large studios are turning out big-budget films that draw crowds with their novelty. But complex, three-dimensional computer animation calls for a lot more in the way of equipment and technicians, and gets more complicated all the time. The lone artist with a home computer is also designing animation for the Internet and software, and is learning how to create animation faster and better as a one-person firm, resulting in a more original product.

From the Flipbook to the Computer

We covered the early history of animation back in Chapter 3, "Specialization Enters the Picture," so turn back if you need a review. Animation is based on the idea that communication

between the eye and the brain will only work so fast. If you take a penlight into a dark room and move the beam back and forth fast enough, there seems to be a line of light, not the moving dot that really is there. The same principle is true whether you're dealing with flipbooks or computers.

Computers by their very nature are animation devices. When you scroll around a page, you are using animation; when you zoom in or out, that is animation. The same is true for moving the cursor with the mouse.

Computer animation produced by the studios for mass-media entertainment involves huge amounts of memory and extremely fast processing. It builds views of an object from various angles and at different sizes, depending on the data entered. Modern computer animation techniques enable the animation studio to create effects that would have been impossibly expensive a few years ago, but it remains an art that requires the skills of a great many people. It is very much a team effort.

'Toon Talk

Computer animation is animation created entirely on the computer, rather than being hand drawn. It is generally three-dimensional in appearance, and requires lots of computer memory and fast processors.

Animation commonly found on the Internet is an entirely different animal. It is usually the product of just a few individuals, or often of just one person. It can be produced on the average personal computer with fairly simple software. It's a far more personal art form—one you should try experimenting with.

In both cases, the technology is still new enough and novel enough that the science dominates the art. Special effects still overshadow the story.

Getting into Studio Animation

If you're planning to enter the film or television animation field, then you're going to need formal training, both in art and in animation. You're also going to need on-the-job training in order to break in.

Getting Educated

No matter where you live, there's probably a school near you that offers college-level courses in animation. It would be wise to get a good grounding in both traditional and computer-generated animation.

Computers are the wave of the future in animation—no doubt about that. But in concentrating on what they can do with the computer, the animators too often forget the subtle touches developed over the years in camera animation that made it an art form. In time, the two forms will merge, and the animator who can work in the new world with the skills of the old will have a big edge.

One of the techniques too often skipped in computer animation is "squash and stretch," which gives weight to objects.

(© Arnold Wagner, 2002)

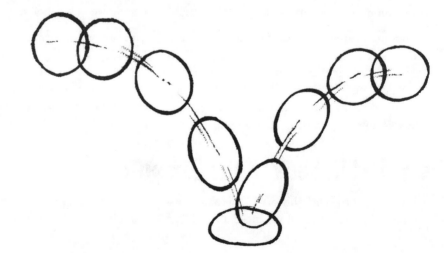

In the meantime, read books on animation, and watch examples of the various kinds, including experimental forms. You'll see many of these on cable television.

Getting Your Foot in the Door

When you're ready, the next step is to get a job in an animation studio—any studio, doing anything. Formal education is fine, but on-the-job training can't be duplicated in the classroom. (Turn to Chapter 26, "Breaking into the Business," for more advice on landing a job at an animation studio.)

In the drawn, or cel, animation studios, the main jobs include the following:

Creative Inkling

A few books that are invaluable for anyone planning on a career in animation include *Cartoon Animation* by Preston Blair, *Animation from Script to Screen* by Shamus Culhane, and *The Encyclopedia of Animation Techniques* by Richard Taylor. See Appendix B, "Bibliography," for publication information.

- The **director** oversees the whole project: writing, character development, sound, animation assignments, and checking the final work.
- The **director's assistant** handles the pesky details and keeps track of everything.
- The **writer** creates plots and gags.
- The **storyboard artist** works closely with the writers and with the director, as well as with the animators, to lay out exactly what happens.
- The **character designer** creates characters, which requires special skills and an ability to work in a number of styles.
- The **layout artist** designs the characters in the sets; this person is responsible for the look of the feature.
- The **animator** must be a good drafter and know a good deal about acting and camera work. This person is also responsible for assistant animators and in-betweeners.
- **Assistants** and **in-betweeners** handle the steps missing from the animators' drawings. (Animators' assistants and in-betweeners almost always intend to move up and become animators. While clean-up work can be tedious and boring, these jobs provide great opportunities for breaking into the business and learning the field.)
- The **background artist** has to be a skilled artist capable of working in a variety of media, and able to design almost any kind of set or background.

Other openings for computer animators are to be found in the video game industry and a number of software firms. The electronic game field is sophisticated enough that you probably need formal training in computer graphics and animation. Software companies often need simpler animation effects.

Creating an Animated Feature

Each studio operates a bit differently, but we can make a few generalizations about the process:

1. In all cases, you start with an idea and then a storyboard.
2. Next, the sound is recorded and then broken down into time or frame sequences.
3. In drawn animation, the scenes are laid out, and the movement and timing are planned.
4. Backgrounds are painted.
5. The animated drawings are made and tested.
6. The animated drawings are traced onto cels, colored, combined with the backgrounds, and filmed.

7. The film is processed. Then both the film and the soundtracks are edited, and the sound is dubbed onto the film.

8. From there, the completed film may be sent to theaters or transferred to videotape for use on television.

With computer animation, the process varies more because of the rapid development of technology in this field. Once the drawings have been made and tested, they are scanned into the computer. The coloring and animation are done on the computer. The sound is added digitally. The finished product is put onto videotape, which may then be transferred to film or sent out directly for broadcast.

Studio animation traditionally involves less variety of technique, and the drawings tend to be more simplified. Despite a number of different animators working on the same project, the characters will maintain the same appearance. With computers, that doesn't change—in part because the programming can get extremely complex otherwise, and in part because the computer just copies.

Animation Styles and Techniques

We'll list a fair amount of styles and techniques here, but the list is endless, and you can undoubtedly come up with a number of them that we've skipped.

The basic animation styles are Disney, Warner Brothers, UPA, and the more grotesque styles that are unique to television. The imported *anime* style from Japan is a natural outgrowth of the Japanese manga, or comic book, which we discussed in Chapter 3. The characters generally look very young and have very large eyes. (We have to wonder if they began as a caricature of Westerners.) There are also many unique styles that can't really be categorized. Most of them are the result of trying to find faster and easier ways to churn out animation.

'Toon Talk

Anime refers to Japanese animation, which has gained an immense following in the United States over the past few years—witness the popularity of Pokémon, for instance. Anime has very distinct characteristics that set it apart from American styles.

Techniques and styles can blend. Stop-motion techniques have played a major role in animation right from the start. Then there's puppet animation, clay animation, cutout animation, shadow animation, sand-and-glass animation, live-action animation, cartoon and still photographs combined, drawings etched directly onto the film, animation using colored pencils, and at least one case where pounded nails were used. An old standby done live on early television was dancing letters: white letters laid on black cloth and moved about by a crew wearing black gloves.

Another technique often missing from computer animation: A few people walk without a rise and fall in height, mostly military personnel and professional models. The rest of us have some up-and-down movement to our stride. We don't glide over the ground.

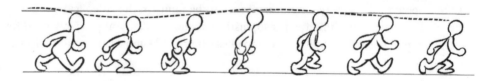

(© Arnold Wagner, 2002)

Rotoscoping also needs to be mentioned here. The rotoscope is a device invented by Max Fleischer (see the following illustration). It uses a film shot of live action, and by projecting it a frame at a time onto a screen, enables the animator to trace the action, resulting in more lifelike animation. Fleischer used this technique for his clown character KoKo in the *Out of the Inkwell* series. He dressed up as a clown and was filmed

doing the routines himself. The technique was licensed to Disney for some of *Snow White*'s dance routines, and Fleischer also used it for his *Gulliver's Travels*.

A page from Max Fleischer's patent, granted to him in 1917.

(© Max Fleischer, 1917)

Rotoscoping has been used off and on since Fleischer's time, most noticeably by Ralph Bakshi, who used it in several projects, including his *Lord of the Rings*. The critics weren't fond of the experiment, though.

Teach Yourself Computer Animation

The machines used by major animation studios are not only state of the art, but are often custom-designed with immense amounts of memory. The subject of computer animation is far too complex to get into here. Even a thick book might not do justice to the complex technique of creating wire-frame construction for 3-D animation. (See the "Animation" section of Appendix B for some helpful books.)

For the person wanting to learn the basics of computer animation, there are much simpler ways to get started. A bit of searching on the Internet will turn up a great many programs that create animation with *bitmapped graphics*. These programs are often free or can be licensed for a small fee, and they are easy to learn and a good place to start.

Two more areas that are of interest to computer animators deal with ray-tracing and fractal generation. These subjects have a sharper learning curve but can be very useful, and there are plenty of free and shareware goodies on them around as well.

'Toon Talk

Bitmapped graphics are those that create graphics a pixel at a time. This can result in detailed photographic images, but if expanded they will begin to show jagged edges. Vector graphics describe shapes by mathematics. There are no jagged edges, no matter how much the images are enlarged, and the files are smaller. For animation, the vector-type program is superior because of the smaller files, which will load faster, and because the animator is able to scale the figures up and down.

Flash animation is a favorite choice for low-end animation. Macromedia Flash is a vector program, so it can produce high-quality work. You'll find examples of Flash animation all over the Internet, and a search will turn up a tremendous amount of information about it.

Playing with Computer Games

Back in the early 1980s, when many of us got our first computers, we amazed our friends with "great" computer graphics and animation. We didn't expect as much of our computers back then. Most games required between 8K and 16K of memory; a complicated game might go as high as 32K.

Computer games are much more sophisticated now, in both action and appearance. If you're thinking about working in this area, the first thing to do is get yourself into a good animation school, one where you can master the fine points of anatomy, perspective, weight, and motion, as well as animation itself.

Not all computer game graphics are animated, though. Someone has to design the packaging, illustrate the documentary, and make up the advertising. Even on the actual animation, the backdrops need to be done. But openings in these less technical fields are limited, and with games that realistically imitate the NFL or the NBA, you'll need all the training you can get.

Until you can get into a good animation school, you'll just have to train in the best way you can. Here's the secret: Spend long hours playing every computer game you can find. Sure, it's hard work, but somebody has to do it!

Creative Inkling

Two magazines that can keep you up on what's happening in animation are *Animation Magazine* (www.animationmagazine.net) and *Animation Blast* (www. animationblast.com). Check Appendix C, "Publications," for subscription information.

Taking Animation Online

If they haven't begun to show more than a hint of their potential yet, both the Internet and computer animation are old enough to make it clear that there is a huge future for animation online.

You see animation everywhere online, from icon-size images cycling through simple animations to features lasting six minutes or more. Animated greeting cards are sent via the Internet daily.

As software improves, faster computers are sold, and modems evolve, the use and appeal of animation can only grow. Animation can add punch and content to a website and make an Internet ad more effective. There is definitely market potential for online animation.

The Least You Need to Know

◆ Computer or film animation is still a frame-by-frame illusion.

◆ Major-league animation requires formal education and on-the-job training.

◆ There are as many styles and techniques as there are animators; why not develop your own?

◆ Computers are rapidly changing animation in both big and small ways; start teaching yourself with low-cost software tools.

◆ Computer games are big and getting bigger; they offer lots of opportunities for cartoonists who can master the complexities of computer animation.

◆ The Internet promises to be a major market for small, independent animators.

Manga: East Meets West

In This Chapter

◆ The origins and development of manga

◆ How manga differs from comic books of the West

◆ Defining the manga style

◆ Manga conventions in drawing heads, hands, feet, and body

◆ The use of calligraphy and onomatopoeia for special effects

Like many things adopted by societies from cultures different than their own, Western manga is different than the version seen in Japan. Depending on your viewpoint, that's a good thing or a bad thing. Purists insist that, by definition, narrative art not created in Japan can't be manga. Others feel that they are just two variations of the same thing. One way to circumvent that is by labeling the adaptations in cultures outside of Japan as being manga-like.

Besides the need to adjust manga to American tastes, there are several very good reasons for the difference. One is that in moving from the printed page to anime (which, as you'll recall from Chapter 18, is the Japanese manga style of animation) certain changes had to be made. That's always true in adapting print to the screen. But manga was introduced to the United States primarily by means of anime.

There were quite a few problems with translating the printed version into Western languages. Manga is laid out to be read from right to left, which means that the panels would need to be changed around in order to be read easily in the West. Even then there are composition problems created by moving the panels around. Using ideographs (forms of writing much closer to pictures or pictographs than to an alphabet) in the background as sound effects and merging the symbols into the design of the panel create other translation problems. The problems aren't insurmountable, but it has resulted in anime being more popular than manga in the West.

Other factors are the economics and conventions of comic books in the West. In the United States, 32 pages is about the norm for mainstream comic books; they are all in color and are primarily sold only in specialty shops. Traditional manga won't fit into that format. We'll explain that as we go along.

Once Upon a Time ... the Origins of Manga

Caricature and cartooning started early in Japan. Examples of skilled, graffiti-like drawings have been found in old temples dating back to as early as the sixth century, and the tradition of graphic

storytelling probably began shortly after that. In the twelfth century, Japan developed its first master of satirical and narrative art. He was a Buddhist priest known as Bishop Toba (1053–1140). He created picture scrolls, sometimes 80 feet long, using anthropomorphic animals that played at being Buddhist monks. Many of these Chojugigia, or Animal scrolls, have an almost Disney-like look. (An example of Toba's animal scrolls is shown back in Chapter 3.)

Buddhist priests in Japan have always displayed a broad sense of humor in their art and customs, and that includes poking a bit of fun at themselves, sometimes by using anthropomorphic figures, and sometimes by using figures that looked a good deal more like them.

Chinese art was imported and influenced Japanese art, but Japan retained its own sense of humor, one broader than usually seen in Chinese art, and added that to the mix. When Zen Buddhism spread to Japan, it strengthened the element of satire and added a simplicity of line that is still a trademark of *manga*. No person or group was safe from the ridicule of the Japanese artist except the royal household. Targets included priests, religious ceremonies, warriors, and important rulers. Japanese satiric art has also always had strong scatological and erotic elements.

'Toon Talk

In the United States, the term **manga** (pronounced *man-ka*) has come to refer to reprints of Japanese comics sold in this country, as well as to home-grown comics that are strongly influenced by the Japanese artistic and storytelling style. There's some disagreement over its literal meaning, but the word comes from two Chinese ideographs with the general meaning of foolish and drawing.

As in most cultures, humorous art was restricted to the upper classes for a long time. This was simply due to it being very expensive to produce and therefore too expensive for the lower classes to purchase or be exposed to it. The technological improvement in woodblock printing in the seventeenth century made humorous or satirical art much cheaper and faster to produce, making it available to all of the population. It quickly developed in several directions and spread throughout the empire, becoming extremely popular among all classes.

In 1853, the American Admiral Matthew Perry (1794–1858) arrived in Japan with an armed fleet and, by intimidation, opened the hermit nation to the outside world. This marked the beginning of the next major era of development in Japanese satiric art. It came in the form of immigrants from the West. In 1857, the Englishman Charles Wirgman (1835–1891) was sent to Japan as a reporter for the *London Illustrated News*. He decided to stay, and adopted many of the Japanese customs. He wed a Japanese woman, and in 1862 began publication of the *Japan Punch* a British-type humor magazine published for other Westerners residing in the country.

A cover from Wirgman's Japan Punch.

(© 2002, author's collection)

In 1882, George Bigot arrived in Japan from France to teach art to army officers. He, too, decided to stay, and he adopted local dress and wed an ex-geisha girl. In 1887 he published a French-style humor magazine for Westerners and titled it *Tôbaé*, after Bishop Toba. He used panels at times, rather than a continuous scene that the Japanese had continued from the era of the scrolls. He drew with a pen instead of a brush. So, two more new concepts were quickly adapted by the local artists, and they altered the nature of manga greatly.

The cover of George Bigot's biweekly humor magazine Tôbaé, *published in Yokohama. It contained 13 pages.*

(© 2002, author's collection)

In the early 1920s, a number of Japanese students were sent to the United States to be educated. The livelier American comic strips were very popular with them, and they brought examples back to Japan when they returned. The strips were also a big hit in Japan. American humor was more in tune with the native sense of humor than the more reserved English or French products. At first, a few strips like *Bringing Up Father, Mutt and Jeff,* and *Felix the Cat* were translated into Japanese, but the Japanese artists soon began creating their own strips in the general style of the American comic strips.

One of the major differences between American and Japanese comics was already developing. Most of their strips were appearing in magazines, and Japanese newspapers never developed comic pages in the way papers in the United States did. The magazines used longer strips, many of them serialized, and the most popular of these were collected into book form. In time, some of these books included original works as well as reprints from magazines.

In Japan, World War II started in 1937 when they invaded the mainland. Manga took on a serious, nationalistic, and military tone. Patriotism and the art of war were featured. Gone were the light satire and comic touches.

The development of manga would be put on hold for the duration. At the end of the war, one man's talent and new ideas quickly dominated both the manga and the anime art forms, making them over in his own image.

Osamu Tezuka (1926–1989) produced his first comic strip while still a student at Osaka University in 1946. The next year saw his first comic book, followed by dozens of titles. In 1961, he formed Mushi Productions, and in 1963 released *Tetsuwan-Atom* (*Astroboy*) and repeated his manga success in anime. Nearly all modern manga and anime is based on the work of Osamu Tezuka. He has defined the terms. His art is a combination of traditional Japanese art and Western cartooning, primarily that of Disney.

Manga vs. Western Comic Books

Before getting into the differences in style between manga and Western comic books, there are physical and marketing differences between the two that need to be covered.

Manga is divided up into a multitude of genres, and is aimed at almost every imaginable segment of Japanese society. The books are printed on recycled paper, not normally of the best grade, and some of it may be in color. Generally, only the cover and the first few pages are printed in full color. The rest of the book is printed in one color, not necessarily black. Many of the titles are weeklies and biweeklies. Many are still collections of popular strips or serials from magazines, but others are original in book form.

From the Pros

Unlike the Western version, manga is a true book. It is square-backed, and usually runs at least 300 pages in length, often many more. It may carry a dozen or more stories.

Manga are sold everywhere in Japan. You can buy them in train depots, airports, subways, bookstores, newsstands, regular manga shops, vending machines on the streets, and various other stores. There are even manga cafés where people gather to read manga! Nearly two billion copies are published annually, and they are purchased by every element of society. Part of the popularity may be due to the fact that many Japanese spend long hours commuting to and from work or school.

A manga-style action layout.

(David Hutchinson for Idea + Design Works, LLC, 2002)

The Basic Elements of the Manga Style

In talking about style and the conventions of any genre, remember that we are talking in generalities by necessity, and there will be a great many exceptions. We can't cover all of the elements of manga in one chapter. A good-size book might find it difficult. We'll skip the basic elements of anatomy, and the other things that have been covered in earlier chapters, that aren't significantly different in manga. We'll limit ourselves to those things that make manga different from its Western cousin.

Despite the large number of pages, manga is a quick read. Osamu Tezuka developed his own version of manga's cinematic style. The visual is stressed in such a way that there is far less need for lengthy dialog. What might be covered with one or two panels in a Western comic could take a half-dozen pages or more in manga. This allows for greater subtlety and emotional impact. Manga uses panels in a much more developed manner than they are generally used in the West. That may be simply a matter of cost.

The passage of time can be stressed by simply repeating the same panel with very slight differences several times. By making only slight changes in a drawing, the impression of slow motion can be achieved, which can heighten the emotional impact, and show elements of the action not normally easy to notice. Subtle changes in body language, facial expression, or even background can add immense depth and layers to the story.

The use of panels.

(David Hutchinson for Idea + Design Works, LLC, 2002)

An example of slowed action in the manga format.

(David Hutchinson for Idea + Design Works, LLC, 2002)

Pans and zoom shots can be very effective, and in the manga format you have room to use whatever you need. They may add to tension or suspense. They can indicate isolation, vastness, or a sense of being trapped. The possibilities are endless, and can convey a wide range of emotions.

The dramatic use of symbolism is another trait of Japanese manga. The scene may suddenly cut away from the action to show a flower rising from the pavement, a bird on wing, or an insect caught in a spider web.

These types of scenes can also be stretched to a number of panels for effect, when called for. This type of slowed action is seen in manga as a change of pace, and that change, made possible by their greater length, is a big part of manga's appeal.

Manga stresses the simplicity of line, composition, and technique. Cluttered drawings don't work well and aren't needed when, rather than trying to get too much into a panel, you can use as many panels as it takes to achieve your purpose.

Slowly zooming in on a motionless figure to set a mood.

(David Hutchinson for Idea + Design Works, LLC, 2002)

An example of a symbolism sequence.

(David Hutchinson for Idea + Design Works, LLC, 2002)

Red Ink Alert

Cinematic techniques such as alternating from long shot to close up, slow pans, trucking in or out slowly to emphasize the point, or cutting to an extreme close-up to show a small detail in a dramatic way can be very effective. But any of these tricks can be easily overdone. Use them only when they add meaning to the story, never just for the sake of using them or to show off your skill. In addition to studying the manga version of the cinematic technique, you may want to take a look at the American version. It can be seen at its best in the work of Milton Caniff or Will Eisner. Browse through your local library or bookstore for some examples.

Manga Anatomy 101: Drawing the Head and Other Features

In any form of cartooning, the head and face are vital in showing character and identifying individuals. That's true in manga, too, but there are differences. In manga, the convention is to use a childlike head placed on a mature body. In Western cartooning, the mouth is the most expressive part of the face. In manga, the eyes dominate the face and are used to show emotion. That is achieved in part by keeping the nose and mouth small by comparison.

A close-up side view of an anime head.

(David Hutchinson for Idea + Design Works, LLC, 2002)

The placement of the eyes on the head is another factor. In the normal drawing of a head, the eyes are centered at a midpoint between the crown and the tip of the chin. In cartooning, that may be varied for the purpose of caricature. The type of face we generally associate with manga places the lower edge of the eye at a point three quarters of the way down the head. In the case of very large eyes, the upper edge may nearly reach the halfway mark. This gives the face a very childlike appearance.

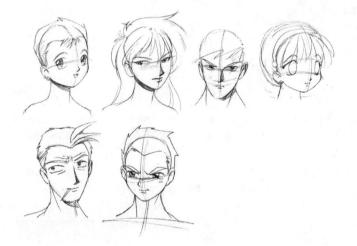

Series of heads showing variations of eye placement on manga faces.

(David Hutchinson for Idea + Design Works, LLC, 2002)

Manga eyes generally have a lot of contrast. Shadow and highlights are strong. Lines are well defined. The light source is indicated by reflections. The most common manga eyes are the large round eyes, but more realistic-looking eyes aren't too rare. For males, the eye may be nearly a rectangle. Manga figures lean toward pronounced eyebrows that accent the eyes and add expression.

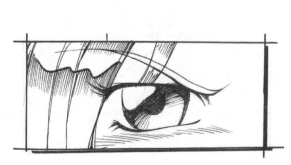

Details of a manga eye.

(David Hutchinson for Idea + Design Works, LLC, 2002)

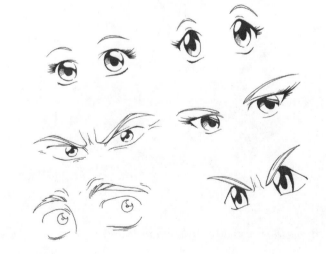

A collection of manga eyes.

(David Hutchinson for Idea + Design Works, LLC, 2002)

Hair is also a more important item in creating characters for manga than in Western cartooning. There is seldom any attempt to suggest separate hairs by using a lot of lines or technique. Units or broader strands are used. Hair is more frequently seen in longer or shorter styles than is the norm in Western cartooning. The strands often take on shapes that resemble flames to some degree. They may be short, jagged, and broad strands, or thinner and spike-like strands. Curves are the most common look, ranging from thin to broad and short to long. They may have a single curve or some degree of an "S" shape. Varying the curve with each strand will give a more interesting look and lend an illusion of depth. The strands may also take on a twisted or folded look. The curves are usually more pronounced toward the lower end of the strand.

Examples of the various kinds of strands of hair.

(David Hutchinson for Idea + Design Works, LLC, 2002)

In designing a hairstyle, make sure it fits the head. This is even more important with the exaggerated hair-styles common to manga. With any new style or character, it helps to draw the skull and then add the hair to it. Decide where on the forehead it will start, and how far down the back of the neck the hair will grow. This varies with every individual. By knowing where the hair is coming from on various parts of the head, it makes it easier for you to keep it looking like hair and not a strange hat. Drawing the base head or skull in three dimensions is also a good technique, because then you will have to curve the hairlines to match the curve of the head, which is another major factor in making it look like hair. It's usually advisable to keep the strands or units of hair all the same general shape, not exactly the same, but not radically different. Thick hair is the most common, but it may or may not be a heavy mass. In romantic scenes it may almost float.

Examples of various hairstyles fitted to a head.

(David Hutchinson for Idea + Design Works, LLC, 2002)

Ponytails and braids of various kinds and in various styles are common to both sexes in many of the manga genre.

(David Hutchinson for Idea + Design Works, LLC, 2002)

Manga is always dramatic, and one of the ways it achieves this and, at the same time, accents the action is by the movement of the hair. Frequently the hair almost seems to take on a life of its own. The movement may be due to wind, speed, or a sudden movement of the head, but it adds an element of dramatic design and indicates action even when very little else does. Even where only the head is shown, the action becomes obvious. The hair doesn't always all move to the same degree or in the same direction. That may be a matter of sequence where one part of the hair is just beginning to move while another part has moved as far as it can, and is rebounding. One part of the hair may be less sheltered and more affected by air currents than other parts.

Varied studies of hair in motion.

(David Hutchinson for Idea + Design Works, LLC, 2002)

There aren't any significant differences in the way the body, hands, or feet are drawn in manga. Costumes may be unusual at times, but that would depend on the story more than on the fact that it was being drawn in manga. There is, of course, a greater probability that you'll need a samurai or ninja costume, or any of the other traditional Japanese dress. The same is true of props and settings. The only thing that is important is that the lines and composition must be kept clean and relatively simple, and yet have a dramatic flair.

Examples of manga characters.

(David Hutchinson for Idea + Design Works, LLC, 2002)

Some typical manga costumes and props.

(David Hutchinson for Idea + Design Works, LLC, 2002)

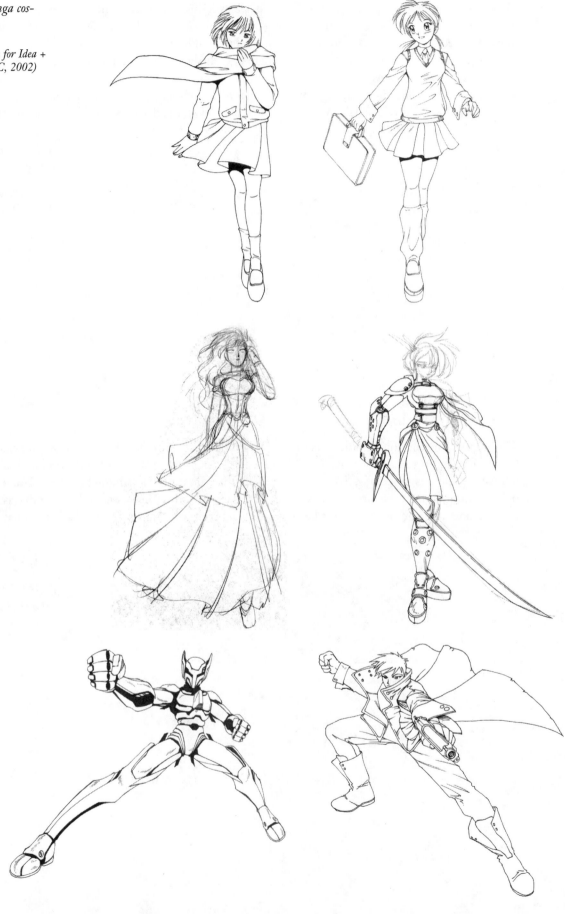

The Use of Calligraphy and "Sound Effects"

Dialog may or may not be enclosed in a balloon, but, in either case, it is usually typeset in Japan. Despite that, calligraphy is a well-established art in Japan and has a role in manga. The Japanese are very fond of *onomatopoeia* effects to convey sound. Sounds and other special effects are often indicated by traditional Japanese calligraphy. This form of writing is drawn rather than written, and is more likely to be seen as a part of the design than typeset characters.

Using Japanese ideographs, these "sound effects" can be made a part of the panel design quite easily, but it's not too much harder using words formed by the alphabet in the same manner. At times they can be combined with symbols. In older Western strips, a simple version of this could be seen in the sawing of a log for snoring, birds singing for a stunned character, halos, or the idea lightbulb above the character's head.

'Toon Talk

Onomatopoeia is the term for words that imitate natural sounds of objects or actions. *Bang, tinkle, buzz, swish, boom, splash,* and *growl* are common examples. In cartooning and slang, coined words are also common, such as *wham, whap, atchoo, kablooey,* and *bzzzt.*

An manga action sequence that conveys sound.

(David Hutchinson for Idea + Design Works, LLC, 2002)

Manga is as much an attitude as a drawing style, and both must be mastered. By visiting a local comic book shop, you'll find a great many examples. Larger bookstores will have a section for graphic novels, and there will be more examples there. You'll also find some good examples of manga on television shows for children or in video stores.

The appeal of manga is in the characters.

(David Hutchinson for Idea + Design Works, LLC, 2002)

As with any form of cartooning, study and more study is required to master the genre. The Western forms of manga and anime are still evolving, and in turn will affect the evolution of the Japanese forms. If you feel this is the area of cartooning for you, work at it until you are no longer imitating the style, but doing your own thing within the overall format of manga.

The Least You Need to Know

- Manga, a traditional Japanese art form with its own conventions, is very important in Japanese culture and is becoming popular in the West also.
- Manga is a more developed and complex form than the Western comic book. One might compare the Western comic book to an hour-long television show, and manga to a full-length movie in a theater.
- The childlike head on a mature body is a standard style of manga, but in all cases there is a dramatic simplicity with clean lines, with drama stressed over action.
- The eyes are the most expressive feature in manga. This can be indicated by the shape of the eyes and by strong eyebrows. Body language reinforces the message of the eyes.
- Symbolism is important in all Japanese art, and in manga it may take the form of conveying sounds and special effects indicated by the imaginative use of traditional calligraphy.

Illustration

In This Chapter

- ◆ Coming up with your own style (or two or three)
- ◆ The relationship between author and illustrator
- ◆ Selecting the right media for your illustration work
- ◆ Listing your work in a creative directory or with an agent
- ◆ Breaking into the children's illustration market

There are lots of illustration jobs, ranging from the relative glamour of magazine and book illustration to the relative drudgery of advertising and corporate work. Illustration may be your favorite or your least favorite cartooning job—more likely, it's somewhere between those extremes. Most cartoonists prefer creating their own material from scratch, and while illustrating someone else's work can be—and usually is—a blast, now and then it's a nightmare. We've all learned the hard way that some assignments just aren't for us.

Illustration jobs won't come to you; you need to hunt them down. That means business cards, sample sheets, postcards, query letters, and, when practical, making appointments to show your portfolio in person. (Turn to Chapter 27, "Self-Promotion," for more tips on how to promote yourself.)

Developing an Illustration Style

It's probably not smart for most of us to try to show just how many styles we can work in (even if we can imitate several). Despite being able to do them, we're probably not as comfortable or as fast in most of them. We can find ourselves up to our neck in a bog, unhappy with what we're producing, and all too aware that the client is equally unhappy.

Choose two styles that you are most comfortable with and that you can work in quickly and confidently, and limit yourself to those to start. You can update later if your tastes and skills change. You might add a third style for spots—small illustrations used as filler in magazines—but the comfortable-and-fast rule applies even more in that case.

Creative Inkling _____

Don't try to do it all with one mailing. Periodical mailings work better, and highlighting one or two aspects of what you do will get more attention and will be remembered longer. Some cartoonists keep several different kinds of mailers on hand, rotating them through and retaining some special mailers suitable for specialized clients. Chapter 27 will tell you more.

The other thing you need to have a handle on is the style of the publication or publisher you're querying. If the publication's style leans toward the literary, and its illustrations tend to look like Beardsley's or Peter Max's while you're more a Garfield person, then cross it off your list. If a book publisher's list seems primarily made up of books on automobiles, aeronautics, and warships, and you never could draw machines, then that's another one you shouldn't bother with.

Preliminary design for a book cover; note the space at the top for the title and other text.

(© Arnold Wagner, 1999)

Your Job as Illustrator

In illustration, part of style is doing the job you are given. You're not the star; you're the pianist accompanying Barbra Streisand. Your job is to make her sound good.

Stay with the author's mood. You should add to the value of the book and give depth to the story, but you must not—intentionally or otherwise—change the author's intent or mood. Not even slightly. Your job is to highlight the author's message—that's all.

The illustrator who decides to go solo—and whom the author isn't happy with—may not be asked to illustrate any more books for that publisher, and certainly not for that author. That's the case no matter how good the illustrations are. The test is not how well you draw; it is how well you do your job, and your job isn't to upstage the author.

From the Pros _____

The relationship between author and illustrator can be great or it can be painful for all concerned. John Tenniel refused to work with Lewis Carroll after the two *Alice* books, and Carroll claimed that Humpty Dumpty was the only one of Tenniel's drawings that was satisfactory. L. Frank Baum and his first illustrator on the *Oz* books, W. W. Denslow, started out more as collaborators than author and illustrator but wound up bitter enemies. On the other hand, Mark Twain and E. W. Kemble, who illustrated *Huckleberry Finn*, became close friends. A. A. Milne and E. H. Shepherd worked hard at getting the work on *Winnie the Pooh* right and remained admirers of each other's work.

Illustration from Where Did All the Dragons Go?

(© Arnold Wagner, 1999)

If you feel you can't do a particular author justice, turn the assignment down. Everyone will be happier, including you.

The Media You Choose

Whenever possible, take note of the media the magazine or publishing house you'd like to work for tends to use. In this day and age there are few technical limitations. Halftones and color are within the reach of just about any publisher.

That doesn't mean they will use them. They may place budget restraints on art, preferring to spend the money on some other area of production or promotion. Perhaps that means a larger page size or a better grade of paper; it might mean taking out a few more ads in literary magazines or offering the retailer a better markup. They may also feel that certain media just has a better aesthetic or marketing value for their type of product.

Next, figure out what media you work best in. That may seem like an obvious question, but it's amazing how many artists will try working in a medium they don't have much expertise in. They may do it in hopes of more money or more prestige. A bad job will have a negative effect on both.

More and more publishers are accepting work electronically, which is a big plus for the cartoonist able to handle it. Electronic submission is fast, which means you can finish the work today and the publisher can have it tomorrow, despite the fact that they are a few thousand miles away.

It also means that if the work is ready to go, and you're eating ravioli at the drawing board and have an accident, you don't have to convince the publisher that lightning struck your drawing board. You can simply scan the drawing, bring it up in PhotoShop, correct the problem, and e-mail the finished work to the publisher, hoping they never ask to see the original.

This is a good place to mention the Internet. If possible, a website is a great tool in this era. It gives you an online portfolio, a place where you can send potential clients to see samples of your work. You can go all out or get by with a small free site. There are a number of programs that will help you to design a web page, and HTML isn't all that hard to learn.

Red Ink Alert

If you plan on sending and receiving graphics that are suitable for reproduction over the Internet, make sure you have a fast modem and an e-mail service that can handle the large sizes of your attachments.

We do advise that you spend some time planning your site, though, and studying what others have done. A poorly designed site may be worse than none at all. It's also true that if you master the skills needed to design a web page, then you have added web design to the list of your marketable skills. Web design is a growing field, one that the cartoonist can use as a sideline. Learning the various programs used in designing a web page—Macromedia DreamWeaver is our program of choice—plus the basics of HTML, frames, and a few other programming skills is a must, but these are relatively simple languages. Obviously, if you plan to bill yourself as a website designer, your site had better be good!

Directories and Agents

Creative directories and artists' representatives are two subjects where cartoonists often disagree. We've talked to cartoonists who have spent big money to be listed in a number of expensive directories and have used them over a period of years, and never had a nibble. On the other hand, we've heard others say that they got their first assignment almost immediately after being listed, and it more than paid for the cost of the listing.

The same seems to be true of artists' representatives, or agents. Some swear by them; others swear at them. Most agree that one person you *do* need is a lawyer who works with artists and writers, one who understands copyright and other intellectual property laws (as discussed in Chapter 28, "Legal Stuff").

Drawing for Juveniles

The children's market isn't all that different from the adult market, depending on the age group. When drawing for the very young, there are a number of pitfalls to avoid. The older the group, the closer to adult tastes you can and should get. That should be obvious but isn't always.

Illustrating for Younger Children

For the primary ages—say, from three to eight years of age—violence is taboo. Base your concepts on a single concept. The illustration is about a particular incident; don't bring in side issues or complex reactions. Keep the illustration tightly focused.

There is a progression even here. Under six years of age, children are being read to, and the books are picture books. The pictures have to carry at least half the story. The children should figure out most of what is happening without knowing what the words say. Concepts are even simpler, colors and images bolder. If you are using color, keep it closer to the primary colors. Be careful about picturing situations that might be dangerous if the child tries to imitate them. At the upper levels, some danger and suspense is possible, but no real images of violence.

Rough sketches for a story book, A Windy Day.

(© Arnold Wagner, 2000)

Unless abstract concepts are explained in the text, don't use abstract symbolism. Coloring a jealous child green, for example, won't work unless the text clearly states that the child was green with envy.

Children in this age group will be more aware of the art than adults will be. They will look at it more carfully, so give them something to look at. It's important that the drawing be interesting; children want something to be happening. Mood pieces won't get their attention; pretty won't do much better. They want action of some sort.

Drawing for Older Children

For children from about 9 to 13 years old, you need to make the pictures more dramatic, more exciting, and with more physical action. Older children are more interested in their world and less interested in the adult world than younger children. They are more aware of their identity. Emotion is more a part of their world. Some limited levels of violence are acceptable. Think *Tarzan, Nancy Drew, Treasure Island,* and the *Oz* books.

Once into the teens, the lines blur. The same things that appeal to adults in good writing will appeal to teens. They now appreciate artistic touches in the illustrations. Mood and emotions are more interesting, though they still want action, and they still focus on their world more than the world of adults.

The Least You Need to Know

- ◆ Stick with the styles you do best; don't try to do it all, even if you think that will get you more work.
- ◆ Your job as an illustrator is to enhance the author's text, not to upstage it.
- ◆ Know which media you work best in, and which media the magazine or publishing house you'd like to work for tends to use.
- ◆ Whether you list your work in a creative directory or employ an agent is a personal decision; however, one person you should work with is a lawyer who understands copyright and other legal issues.
- ◆ Drawing for children is a little different, but it's still the quality of the artwork that counts.

Greeting Cards and Novelties

In This Chapter

◆ Getting gigs as a greeting card freelancer

◆ Designing wrapping paper and other paper goods

◆ Selling to the novelty market

◆ Designing CD labels and other music-related items

Greeting cards are big business—more than $12 billion per year—and a great many cartoonists make extra income from designing and writing them as freelancers. The field is a natural for cartoonists, and many card companies prefer to do business with a person who can create both the idea and the art.

If you want to get into this business, start by trolling your local card shops. Some judicious market research will tell you the types of cards that are being marketed, the styles that are selling, and the companies that produce cards in styles similar to your own. But don't just limit yourself to the traditional outlets. Also consider whether your cartoon creations would sell as electronic cards or novelty products. Paper products, coffee mugs, T-shirts, and pins are all areas that may pay off for you. (Turn to Chapter 26, "Breaking into the Business," for even more hints.)

We'll round out our discussion by talking a bit about designing CD labels or other music-related items. This is specialized work, to be sure, and it can be a difficult business to break into, but who knows—you might get lucky! And if you're a cartoonist who loves music, it's a natural fit.

Making It as a Freelance Card Artist

As a freelancer, you have the freedom to work when you want to. To freelance means that you work for yourself rather than for an employer. Freelancers are generally paid by the hour, by the page, or by the project, and don't receive benefits or have taxes withheld from their paychecks. The typical freelance cartoonist works for several different companies, often across a wide range of industries. You come up with the ideas, package them, and solicit them to the greeting card companies according to your timetable, not theirs—which leaves you more time for "real" cartooning. Many companies rely on these outside submissions to round out their lines.

Some companies have become gun-shy about looking at unsolicited submissions, however. By the nature of the business, there is bound to be some duplication, although many freelancers refuse to believe that anyone else could have come up with the same brilliant gems as they have. These firms have opted to insist on having the artist sign a disclosure waiver before they will look at freelance submissions. They may not even open the envelope without one. This isn't a con game or extreme paranoia. They do have a problem, and it's unfortunately a common practice with some very reputable companies.

Your best approach is to ask for submission guidelines before sending in your unsolicited ideas. A listing for the company in a marketing list probably means that they accept unsolicited submissions, but if in doubt, send an introductory query letter first. Again, Chapter 26 will help you to negotiate the minefield of tracking down markets and sending submissions.

Round Out Your Repertoire: Types of Cards

Greeting cards are broken down into two types: seasonal and occasion cards. The top 10 holidays for buying cards are as follows:

1. Christmas
2. Valentine's Day
3. Mother's Day
4. Father's Day
5. Graduation
6. Thanksgiving
7. Halloween
8. Saint Patrick's Day
9. The Jewish New Year
10. Hanukkah

> **Creative Inkling**
>
> Two publications that serve the industry are also online: *Party & Paper Retailer* at www.partypaper.com and *Greetings Etc.* at www. greetingsmagazine.com (also see Appendix C, "Publications"). *Greetings Etc.*'s site has a good list of greeting card companies as well as related outfits. Both magazines are good sources for what's going on in the greetings field.

Other popular holidays include Passover, Grandparent's Day, Secretary's Day, National Bosses Day, and April Fools Day.

All greeting card companies work far ahead on seasonal material. Six months is the shortest lead time we've heard of, and some companies are working over a year in advance.

The occasion cards ranked in order of popularity are as follows:

1. Birthdays (these cards account for 60 percent of all occasion card sales)
2. Friendship
3. Get well
4. Sympathy
5. Congratulations
6. Weddings/anniversaries
7. New baby

> **Creative Inkling**
>
> Most e-cards feature Flash animation, so that skill may be necessary to make any money from them. To learn more about this type of Internet-based animation, turn back to Chapter 18, "Animation."

Electronic greeting cards, or e-cards, are a fast-growing part of the greeting card industry. Business slowed a bit with the dot-com bust but is now slowly rebounding, and the survivors tend to be good businesspeople. If you check out the popular e-card websites, you'll find that most have submission guidelines.

Designing and Submitting Cards

The industry standard for greeting cards is $4^5/_8$ inches by 7 inches. We see a lot of exceptions to that, but that's the size we'd submit in. Leave space at the top of the card for text.

Card design, which originally had a color overlay on the cheese.

(© Robert Johnson, 2002)

In designing cards, pay particular attention to the top third of the card. Due to the way the cards are displayed in stores, that may be all that the customer sees. Also remember that appealing to women is a must; they buy the most cards by a huge margin (between 85 and 90 percent).

The normal procedure for breaking in is to send three to five samples with a very short cover letter. Don't misunderstand—this isn't submitting material for publication, though it might result in that. You are sending samples that they may keep on file. As with most markets, don't sent original artwork, make sure that each card is clearly marked with your name and address, and enclose a self-addressed, stamped envelope if you want the samples back. Wait a few months and then try the company again.

If you make a sale, the company may buy the whole card, just the idea, or just the art. Fees vary quite a bit depending on the size of the company. As a rough estimate, anywhere from $50 to $300 per card idea is possible. Some companies pay royalties, or a percentage of all sales. If you can come up with a line of cards, the pay goes way up.

A number of cartoonists work as full-time employees at greeting card companies while freelancing as gag cartoonists. It's a part of the "diversify or die" policy you've been reading about throughout this book. You aren't going to get rich working for these outfits, but with income from your other cartooning efforts, it can provide a good living, and the work is something you already know you love doing. If you're just starting out and you live near a major greeting card firm, then landing a permanent job might be worth looking into.

Red Ink Alert

Greeting card companies have traditionally wanted to buy all rights to artwork and ideas, but some have become willing to negotiate that. Trying to negotiate can't hurt, and you may want to ask for more money if they insist on all rights. Chapter 28, "Legal Stuff," will guide you through the confusing world of negotiating rights.

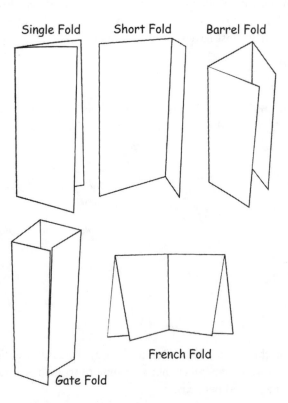

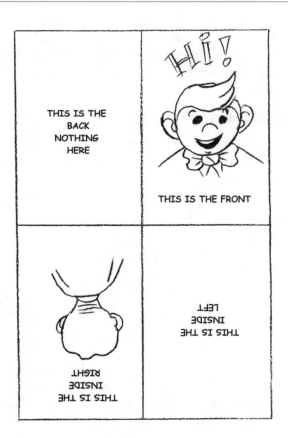

Card folds ranked in popularity are single fold, French fold, gate fold, barrel fold, and short fold.

(© Arnold Wagner, 2002)

Layout for a French fold card.

(© Arnold Wagner, 2002)

Wrapping Paper and Other Paper Goods

There aren't many standards in this area. In general, you submit samples and ideas in the same manner as to greeting card companies. Check the listings in books like *Artist's & Graphic Designer's Market* (see Appendix C) for each company's guidelines and needs, and be sure to send a *query* first.

> **'Toon Talk**
>
> A **query** is a letter, no more than one page and usually only a couple of paragraphs long, that you send to a company to gauge their interest in unsolicited ideas before sending artwork or samples. Many companies prefer queries, because that enables them to quickly respond only to submissions they are truly interested in, without having to handle artwork. Check the company's guidelines to find out if they prefer seeing queries or samples.

Keep in mind that an idea that doesn't work as a card may do well in some other category, so don't limit yourself. Remember that designs on wrapping paper have to repeat. Think about other paper goods where your designs might work, such as shopping bags, stationary, notepads, diaries, recipe cards, and the like. Party goods also fit into this category and include napkins, paper plates, banners, and party favors. Become a regular at the card and gift shops to come up with even more ideas.

Having Fun with Novelties

The novelty industry overlaps with the greeting card and paper products categories. This field includes pretty much every product sold in gift, card, and novelty stores: Balloons, T-shirts, calendars, mugs, stickers, personal checks, and games are the biggest categories.

It's not too difficult to get into designing and selling novelties yourself, without going through the middleman. They aren't all that expensive to produce, and many novelty goods can be marketed locally. T-shirts often have a local tie-in, for instance. A number of businesses that don't already do so might benefit from selling T-shirts, mugs, bumper stickers, and other novelties based on your artistic creations, especially if they have a local flavor that isn't available from the national corporations. Check your local Yellow Pages, especially the advertising specialties section, for sales ideas.

From the Pros _____

A number of firms hire cartoonists to develop toys. We're not talking about robotic dogs here. These toys are pretty much glorified Cracker Jack–type prizes, the kind of things fast-food places give away with their cheeseburger kiddie meals. Toy design is a natural for cartoonists, who tend to put little eyes, feet, and other features on inanimate objects to create strange little creatures. We think of it as three-dimensional doodling, and we suspect a lot of cartoonists do it. If that idea appeals to you, the toy market may be right up your alley.

Designing CD Labels or Music Posters

For reasons we don't understand, many cartoonists are also musicians. It seems like with all that crossover, more cartoons ought to be used in the music field. It's a natural match, and the material is out there.

Every compact disc has a front and back cover, both about five inches square. Often a small brochure is packed inside the jewel case as well. This isn't much space compared with the old 12-by-12-inch album covers, but it still has potential. In addition to drawing labels, there are posters, store displays, concert T-shirts, and other kinds of promotional devices that you can have a hand in creating.

If you're into music, this idea should be gold. You may already have the contacts to break into this typically tough field. The big recording companies like to do things on a grand scale and typically work through large ad agencies. If you don't have a "name," you may have a hard time making contact. However, there are a lot of small, independent recording studios around, and they are very approachable. They are also often hungry for the breakthrough that will put them up there with the big kids. The same is true of the musicians and bands that have gotten a start and are working steadily but can't seem to break through to the next level. Convince them that you can give them a cover for their next CD that is entertaining and that people will remember, and you may just land your next gig.

The Least You Need to Know

◆ Greeting cards are big business and a good way for the freelance cartoonist to make some extra money.

◆ Don't just rely on greeting cards for selling your designs; they might fit on any number of paper products.

◆ If you have a good idea and are willing to hit the bricks, you can sell a good novelty idea yourself, particularly if it has a local tie-in.

◆ If you're interested in music, designing CD labels, music posters, or other items is a natural fit.

Part 5

Where Do Ideas Come From?

There is probably one question cartoonists hear more than any other (besides "How do you get syndicated?"), and that's "Where do you get your ideas?" It's also the question that most cartoonists hate to have to answer, because there really isn't any way to answer it. There's no secret idea bank that only successful cartoonists know about. Ideas come from everywhere: in the office, at home, from headlines in the newspaper, from overheard conversations, from observations of everyday life. Cartoonists need to always be on the lookout, because you never know where your next winning idea is going to come from.

That being said, this section should help you with the process of searching for and refining new ideas. In this part, we'll go over the basic elements of every cartoon—the gag, the story, and the characters—and help you come up with ideas for each. We'll also give some tips on editing and polishing your cartoons to give them that all-important finishing touch.

The Gag

In This Chapter

- ◆ Understanding what makes a gag
- ◆ Writing a caption with punch
- ◆ The humor in clichés
- ◆ Delivering the twist and making it funny

If you ever want to see your cartoons in print, you can't just be a fabulous cartoonist. Even the most beautifully drawn cartoons will never sell if the ideas aren't there. In gag cartoons, the idea is much more important than the quality of the drawing. That's why the gag, or the idea, usually comes first, and the drawing second.

We may not be able to tell you where ideas come from, but we can help you tap into the plethora of ideas in your personal world. The trick is to train yourself to be aware of everything around you all the time, and to recognize when some seemingly ordinary thing can be transformed into a great gag.

Gag Basics

There are three basic kinds of gag cartoons:

- ◆ The single-panel captionless gag, also called the *sight gag*
- ◆ The single-panel gag with caption
- ◆ The multi-panel gag-a-day strip

The captionless cartoon may be the purest form of the gag cartoon because the action, conveyed entirely through the artwork, provides the whole joke. What is *seen* delivers the idea. At first glance, the cartoon may seem to be just a familiar scene, one the reader has seen a thousand times before and instantly recognizes. But after a second, the reader realizes that something is off, twisted in an unexpected way—and that's what makes the cartoon funny.

How the elements of the cartoon are arranged within the frame affects how readers get the joke. When you read, your eyes move from left to right. So even in the captionless cartoon, the reader will look at the drawing from left to right. Use this to your advantage by composing the cartoon so that the visual punch line comes last. Arrange the elements within the frame so that the setup is on the left and the gag is on the right. To understand this, study the captionless cartoons of your favorite cartoonists. Imagine that the elements are reversed; is the cartoon as funny?

Add some words to the single-panel cartoon, and you've got a captioned cartoon. The punch line is often found in the caption, which the reader typically looks at last. We'll get more into caption writing in the next section, but for now, understand that the caption adds to the cartoon—it doesn't duplicate it. Never say the same thing in the caption and the cartoon, or you'll give away the gag.

> **'Toon Talk**
>
> A **sight gag** is essentially a cartoon without a caption. The humor is conveyed entirely through the artwork. Some cartoonists consider the sight gag to be the purest form of the cartoon.

All the elements of the single-panel gag cartoon are present in the strip cartoon as well, but in the strip, you have an added dimension: time. This means you can build up to the punch line in the final panel by setting up the gag in the first two or three panels. Without the setup, the gag in the final panel would be meaningless.

Remember that the gag in a strip cartoon can be visual as well, even if there is dialog in the preceding panels. Often a silent punch line is funnier than a spoken one, so if you can deliver the gag in the picture, do so—and don't repeat it in dialog.

> **From the Pros**
>
> Charles Addams specializes in the single-panel gag cartoon, but he has said his personal challenge was to come up with scenes that speak for themselves. According to Mort Gerberg's *Cartooning: The Art and the Business* (see Appendix B, "Bibliography"), Addams's personal favorites of his own captionless cartoons include the classic scene of a skier going around a tree, with the ski tracks passing on either side of the tree, and the one where his Addams family is preparing to pour a cauldron of boiling oil on some Christmas carolers below.

Regardless of what type it is, all gags have one goal: to communicate a funny idea to the reader quickly, often in a single glance. That means that every element of the gag cartoon—every character, every prop, every detail of the setting, every word of the caption (if there is one)—must contribute in some fundamental way to delivering the gag.

As we've mentioned, beginning cartoonists often make the mistake of putting too much into their cartoons. Excessive, irrelevant details and wordy captions distract the reader and keep them from quickly reaching that magic moment when they "get" the gag. The most fundamental rule of gag cartooning is "when in doubt, leave it out." (Of course, some gag cartoonists positively wallow in details, but if you study their work, you'll find that every element still contributes to the overall gag. Besides, you have to master the rules before you can successfully break them.)

Putting the Gag into Words: Captions and Dialog

Most single-panel gags have a caption underneath that delivers the punch line set up by the cartoon. Writing captions is an art form in itself. The shorter the caption, the better the gag, so strive to keep your captions as short as possible. Twelve words or less is a good goal.

Because captions are so short, every word in the caption must contribute directly to the gag. Once again, the rule is "less is more." Choose the most precise words possible, and never use three words when one will do. Keep trying to pare the writing down in each rewrite (but stop if you start to lose the meaning or the impact of the words).

You not only have to worry about which words you choose, but also about how you put them together. As you probably have picked up from watching stand-up comedians and comic actors in action, humor comes as much from how a joke is delivered as from the joke itself. You don't want to give away the joke too early; the key words of the punch line should come at the *end* of the caption, not at the beginning. This delayed effect serves to surprise the reader, which is part of what makes the gag funny. Also pay attention to the rhythm of the caption: Does it flow naturally so that the emphasis, or the beat, falls on the funny part?

Red Ink Alert

Never say something in your caption that you've already shown in your drawing. Unnecessary repetition or explanation will undermine the surprise of the idea and ruin what might have been a funny gag.

Strips don't have captions; they have dialog that appears in balloons above the characters' heads. Though there is usually a little more text than in single-panel cartoons—since the text can be stretched out over several panels—the principles of writing dialog for strips are the same.

You don't have a lot of space to work with in those panels, so you want to keep the dialog to a minimum: 18 words or less. After all, if you have too much text, you'll obscure the art, and then you don't really have a cartoon at all. In a strip, pay as much attention to writing the setup lines as you do to writing the punch line. Don't bury the setup; the most important words should always come at the end of the line.

Rhythm and pacing are also important in strips. The dialog should flow naturally, and the emphasis should naturally fall on the punch line. Cartoonists employ many tricks to achieve the best rhythm. One such trick is to insert a silent reaction shot that adds a beat and varies the pacing, breaking up the predictable flow of the dialog. A silent panel also allows two panels for a setup line to register with the reader, instead of one.

You learn the art of writing captions just as you learn the art of cartooning: through practice and by studying what others have done before you. As an exercise, read through some of your favorite cartoonists' works, paying particular attention to the captions or dialog. In your mind, listen to how the captions sound; read them out loud if you like. Notice the specificity of the words, the rhythm and timing of the entire line, the length of the caption, and how the "pay-off" invariably comes at the end.

Creative Inkling

One way to write captions is to imagine the entire conversation leading up to the gag. Play it in your mind like a movie, freezing on the moment that is depicted in the cartoon, the one that makes the gag. The line of dialog spoken at that moment—and nothing else—naturally becomes your caption.

You'll find as you start creating your own gags that you're not just a cartoonist; you're a writer, too. Get used to the idea that you're going to have to write and rewrite your captions—often several times over—until you get them just right.

Take the Reader by Surprise

What makes a gag funny is the element of surprise. The gag specializes in presenting the familiar, the safe, the comfortable—and then adding an unexpected twist. It's the twist that makes the gag funny.

Clichés: The Gag Cartoonist's Handiest Tool

Gags rely on clichés for their humor. A cliché is anything that's so familiar that we automatically accept it. A cliché can be an object or situation we see every day: Slow—Children at Play signs; a police officer directing

traffic; a person running to catch a bus. It can be a phrase repeated so often that it's lost its meaning: "Let's do lunch"; "Looks like rain"; "Your call is important to us"; "The check's in the mail." It can be a scene from a well-known story, film, or even a legendary historical event: Romeo wooing Juliet beneath her window; Charles Foster Kane whispering, "Rosebud"; Custer's last stand. You can probably think of hundreds more.

One reason a cliché is the basis for almost every gag is because clichés are so familiar that they can easily be conveyed in the small space of the single-panel or strip cartoon. Using clichés makes the cartoonist's job that much easier. Gag cartoonists don't have to explain the situations of their cartoons to their audience; the situations are familiar and instantly recognizable. In the single-panel gag, you only have a second to communicate your idea to the reader. Clichés help achieve that instant communication.

Gag cartoonists also employ clichés because they're easy to twist. We've seen these clichéd situations so many times that they've become ingrained. So when the cartoonist twists a cliché in an unexpected way, that's surprising—and often funny.

You can twist a cliché in many ways:

- Combine two clichés, such as clowns throwing pies in a Wild West showdown.
- Substitute an unexpected object, person, or action for a familiar one, such as replacing bumper cars with tanks in an amusement-park ride.
- Put in something or someone that is out of place, such as a gigantic beast as a family pet in a suburban household.
- Use extreme understatement, such as a street bum telling a millionaire he likes his car.
- Add a hidden element that the viewer sees, but not the cartoon character, such as a jumbo jet looming behind Superman.

> **Red Ink Alert**
>
> Watch out for those clichés that have been used so many times in one gag after another that they have become cartooning clichés in themselves: the psychiatrist's couch; the desert island; cannibals cooking dinner; lover's leap. Those gags have all been done to death by cartoonists before you, so you should probably avoid them—unless you truly have a fresh new take, that is.

These are just a few suggestions on how clichés can be twisted to get to the gag. Study the cartoons of Gary Larson, Charles Addams, Sam Gross, or any of your favorite gag cartoonists, and notice how they are continually coming up with new ways to twist an old cliché and produce a fresh gag.

Dreaming Up Gags

Gag cartoonists specialize in violating and questioning clichés, turning them around and upside down. They look at ordinary situations from strange angles and points of view. They question what everyone else takes for granted. They are always asking "What if?" and that's how they come up with their ideas. As an aspiring cartoonist, you need to get into this habit, too.

How you come up with your own twists is up to you. There's no right way to do it, and you're not going to do it like any other cartoonist does. But sometimes it's difficult to get yourself to look at things in that skewed way that leads to the great gag. Here are some exercises to try when you start brainstorming:

- Jot down a common word or phrase. Then write the first thing that comes into your mind. What does that remind you of? Keep writing until something sparks an idea for a gag. Alternatively, you could write down one word, and then write everything you can think of that's connected to that word.
- Sketch out a familiar situation. Now change something in it just a little. You could reverse an aspect of the situation, distort it, or exaggerate it. You could substitute something unexpected for an element of the situation. You could even combine two clichéd situations in one. Keep playing with it until a good gag or two jumps out at you.

◆ List some standard phrases, ones you hear all the time. Now insert those phrases into situations where you don't normally hear them. How do the new situations change the meanings of hackneyed phrases?

◆ Doodle a familiar object. Now try drawing unusual variations of it. Think about how the meaning of the object changes when you alter its look. What if it were much larger or smaller? What if it replaced something that looked like it? What if it were plopped down in a place where you don't normally see it?

◆ Draw a table of three columns. In the first column, write down as many people, animals, and things as you can think of. In the second column, list an equal number of actions. And in the third column, list settings. Try randomly combining one word from each column. Do any gags jump out at you?

Creative Inkling

Get in the habit of keeping a notebook or sketchbook with you at all times for jotting down or doodling ideas as they occur to you. You never know when you'll see or hear something that will generate a great gag, and if you don't make a note of it right away, you'll probably lose it.

At first, you may have to consciously do one or more of these exercises to generate some worthwhile gags. But with practice, this constant searching for the twist will become second nature to you, and you'll develop your own method of finding ideas, one that works best for you. That's the only way to tap into your unique voice and all the material that's trapped inside your head. Once *your* distinctive ideas start coming out, they'll become part of your personal style. That's your ultimate goal: to come up with a style of cartooning that's yours and yours alone.

The Least You Need to Know

◆ All gags have one goal: to communicate a funny idea quickly.

◆ Captions should be as short and precise as possible, and the punch should always come at the end.

◆ The humor in gag cartoons comes from twisting clichés into something unexpected and surprising.

◆ While gags rely on clichés for their humor, watch out for those gags that have been done so often that they've become cartooning clichés in themselves.

The Story

In This Chapter

- Figuring out plots, or what happens
- Introducing conflict, the heart of the story
- Spicing things up with action
- Keeping continuity from beginning to end

All cartoons have a story, even the single-panel ones. After all, a series of events had to have happened to get to that one freeze-frame moment when the gag is delivered. The story is only slightly more complicated in the gag-a-day strip, whereas continuity-adventure strips, comic books, and animated films have fully evolved story lines with plots, subplots, and a large cast of characters.

So, guess what? You're not just a cartoonist; you're a writer, too. Regardless of what genre of cartoon you want to produce, you're going to have to master the basic elements of story. This chapter will lay 'em out for you.

Here's What Happens: Plot

Plot is the most basic building block of the story. At its essence, plot is what happens, all the events of the story. In the single-panel gag, plot encompasses everything that moved the scene to the freeze-frame point shown in the cartoon. In the multi-panel strip, plot is composed of a few events—usually small ones—which set up the gag in the final panel.

Consider this brief story:

- A general walks out of a movie theater to find a long disorderly line of people waiting to buy tickets.
- The general stops and barks an order at the ticket-buyers.
- The general marches on, leaving a straight, military-style line behind him.

Creative Inkling

Unless you plan to write a continuity-adventure strip, comic book, or animated film, don't be overly concerned with the intricacies of plot. If you do want to tackle those genres, invest in one or two good books on the craft of writing novels and short stories (the principles are the same). You'll find plenty in the writing section of your local bookstore.

'Toon Talk

The **break down** is the process of splitting up the events of a strip's story, or the plot, into separate frames to tell the story and set up the gag in the most effective way.

This is a simple story, just enough for a three-panel strip. Notice how each event proceeds logically from the last and leads naturally to the next. Everything happens for a specific reason, all leading up to the gag. When you sit down at your drawing table, you will probably find it helpful to map out the plots of your strips in this way. Roughing out the events of the story beforehand should give you a general idea of what needs to happen in each panel to get your readers to the gag.

So how do you come up with a plot? It usually starts with the gag—the end of the story—which we discussed in the previous chapter. Then you need to figure out how to get the characters to that point in time. Those events are the plot of your strip.

The next step is to decide how to split up the events into panels. This is called the *break down*. How you sequence the events frame by frame will affect how readers get to the punch line, or the gag, and so it pays to play with the break down until you achieve the best effect.

As your strip evolves, you may want to experiment with plot. For instance, many strips have ongoing plots that continue from one day to the next. While each single strip stands on its own as one gag, the sequence of strips forms a complete story with a beginning, middle, and end. You don't have to know everything that happens in the middle—in fact, most writers don't when they start a new story—but it's helpful to know how you want the story to end so that the events of the story lead naturally to that point.

Conflict: The Source of Every Story

Conflict is at the heart of every story. Without conflict, you don't have a story—you have a slice of life, and let's face it, that can be pretty boring. Conflict creates drama, an essential building block for any successful story.

Consider this sequence of events:

- A woman wakes up.
- She makes coffee.
- She sits at the kitchen table to read the newspaper.
- She looks at her watch, realizes she's late, and rushes off to work.

Things are happening, sure, so you could say you have plot. But do you have a story? Are you at all interested in what happens next?

Now, consider this:

- A woman realizes she is late for work and rushes around, getting ready.
- Her dog, not wanting her to go to work, hides her car keys. (Hey, this is a cartoon; dogs can do stuff like that.)
- The woman finds the keys, but the dog has snatched her presentation …

Do you want to know what happens next? Now we've got a story cooking.

What's the difference? For one thing, we've introduced a second character: the dog. Each character wants different things. The woman wants to get to work on time, and the dog doesn't want her to go to work at all,

probably because it doesn't want to be left home alone all day. What each character wants leads directly to what they do: The dog hides the car keys, the woman searches for the keys, and so on.

The source of conflict is your characters, both human and otherwise. Conflict happens whenever one character wants one thing and another character wants the opposite. Once you introduce a conflict, questions will automatically spark in your readers' minds: Who will get their way? Who is right? What will each character do to get what they want? Conflict naturally creates drama and suspense for your readers.

Unless you're writing a traditional comic book, you don't need to create a superhero and a supervillain fighting over the fate of the world. Conflicts and the stories that result from them are often more interesting to readers when they can recognize in them events from their own lives. We all experience minor conflicts all the time; the course of a normal day is littered with them, from a clash with the boss, to a run-in with a store clerk, to a quarrel at home over whose turn it is to take out the garbage. A conflict as minor as a squabble over where to eat dinner can become the basis for a strip's story, and a funny gag.

Conflicts occur all the time between friends, siblings, husbands and wives, parents and children, boyfriends and girlfriends, employees and bosses, and, in a lot of cartoons, owners and their pets. When you start casting your comic's characters, which you'll do in Chapter 24, "The Characters," think about the conflicts they could have with one another that you could exploit for gags. Those conflicts will become the foundations for the stories you create around those characters.

While conflict most often arises between two characters, that's not its only source. Conflict also occurs when a character is at odds with nature, the elements, or the world at large. In novels and movies, conflict with nature often produces the overblown disaster epic, with the hero battling a raging flood, an exploding volcano, or a monstrous shark. For your cartoon stories, think of the more mundane annoyances of life your characters might clash with: traffic jams, biting insects, sudden rainstorms, lines at the movie theater, and so on.

Creative Inkling

When you're brainstorming ideas, a good place to start is with conflict. Ask yourself: How are your characters irritating each other today?

Characters can also be in conflict with themselves, with essential parts of their personalities or their natures. Internal conflict is another rich source of gags. Look at Cathy's constant battle between her desire to be thin and her craving for chocolate, for instance. So when you search for conflicts to get your story moving, don't just stick with the obvious; conflict is everywhere.

Take Action

If plot is what happens in a story, action is how it happens—how the plot moves forward to the gag. Since we're trained by the movies, we tend to think of action as a lot of stuff going on: car chases, gun battles, explosions. But the action of a cartoon encompasses anything your characters *do*, from walking down the stairs to driving a car.

Moving Things Along

Dialog is the tried-and-true method for moving things along in the comic strip, and speaking is definitely a form of action—although perhaps not a very interesting one. The reader's eye hurries from one speech balloon to the next. The ongoing conversation propels the reader to the last panel, and the gag.

Don't fall into the trap of relying on dialog as the main action in all your cartoons, though. Have your characters do something when the situation calls for it. A story is always more interesting when you *show* what's happening, rather than *tell* the reader what's happening.

From the Pros _____

The syndicated newspaper strip *FoxTrot* is one of the more action-packed comics running, especially on Sundays. *FoxTrot* creator Bill Amend's first career goal was to become a movie director, and it shows in his action-packed drawings, unusual points of view, and constant references to science-fiction flicks. In fact, one of Amend's early jobs was at a movie production facility "until he met a visiting Leonard Nimoy and figured the job could only go downhill from there," according to his bio at www.ucomics.com/foxtrot/bio.htm. Study Amend's example to learn how action can enliven your strip.

Since cartooning is a visual medium, you will hold your readers' attention better if you give them characters that are more active than a series of talking heads. Even if the primary action of the cartoon is dialog, pay some attention to what the characters are doing while they're talking. Are they making dinner, walking down the sidewalk, or doing yard work? Often a very simple action is all you need to add energy to a scene. Characters seem more like your readers and become easier to identify with when they do things your readers do—particularly things they may do in secret, like raiding the fridge at midnight or juggling a cup of coffee and a cell phone while driving.

Some of the liveliest and fastest-paced strips are the ones that are all action, with no dialog at all—or none until the gag comes in the final panel. Action in cartoons is fun to look at and makes a nice change of pace for your readers. It also makes your life easier, because you don't have to write anything. The longer Sunday strip is the perfect vehicle for such action-packed stories. Study cartoons that employ a lot of action to see how action alone can be used to tell a complete story. (*Calvin and Hobbes* comes to mind, as does *FoxTrot*.)

Remember that people read from left to right, and they'll absorb visual action in the same way. Take advantage of this and help your readers more quickly grasp the situation by putting the character initiating the action on the left side of the panel and the character reacting to the action on the right side.

Don't overwhelm your story—and your reader—with too much action, though. Each panel should have only one action in it, and that action should flow naturally to the action in the next panel. That's why plotting out your story first—deciding what happens, when it happens, and in which panel it happens—is a good idea before you sit down to draw your strip.

Playing with Panels

In a multi-panel strip, each frame plays a part in the action of the story. Typically, the first panel sets the scene, showing the reader what the situation is and which characters are involved in the story. The next panel initiates the action, which flows into the following frame. The third panel provides the setup line, and the last frame delivers the punch line.

One simple way to enhance the action in a strip cartoon is to play with the size and shape of panels. Panel size often determines the rhythm and pace of the strip. Readers tend to move quickly through small panels and linger on longer ones. By mixing the two, you can create a more dramatic story while adding visual interest to your strip.

Long panels are useful for "establishing" shots, such as when you need to set up a scene. Or you can use them when you need to pull back and reveal something that was previously hidden to the reader—to show the gag in the last panel, for instance. Short panels, on the other hand, help to convey moments of high drama and suspense.

Changing the size of the panels can also change the reader's sense of time. A short panel indicates a brief moment of time. Sometimes you need to stretch out the action or give a sense of a longer passage of time; stretching out the panel is an effective way of doing that.

When the sequence doesn't change location and there aren't any time jumps, you can show all the action in one long open panel. This technique stands out on the newspaper page and imparts a feeling of freedom and energy to your story. This type of panel effect almost always employs a visual gag.

You can also vary the shapes of frames to add to the. A panel packed with explosive action can be bordered with a jagged frame, while a cloudlike frame might indicate a dream sequence. Don't be afraid to play around—that's part of the fun of telling the story! How you use panel size and shape will probably become an essential part of your cartooning style.

Red Ink Alert

Playing around is fun, but always remember that communicating the idea quickly to the reader is your primary goal. The art should enhance the story, not get in the way of it. Only use unusual panel shapes and other special effects if they are needed to get the idea across. Otherwise, your best bet is to keep things simple.

Continuity

Continuity in a multi-panel strip creates a flow that naturally moves the reader's eye along to the last panel. The overall effect is that the strip is a cohesive whole, a complete story with a beginning, middle, and end. It's that quality of a comic strip that makes it a cohesive whole, enabling it to flow uninterrupted from the first panel to the last. Continuity is achieved through a uniform style of drawing, as well as through providing constants in each panel that tie the entire story together.

The easiest way to achieve continuity in a multi-panel strip is to introduce a constant that appears in each frame. Typically, the constant is an image, such as a character that is participating in the story. While the images need not be identical in each panel—the character can change facial expressions or body positions, for instance—they remain essentially the same. For example, if you start out with one character standing on the left, you should keep that character on the left in each panel. That constant links each panel in a very simple way. You might also repeat a background image or prop from panel to panel or use one particular color throughout to achieve the same effect.

You also have to ensure that you don't unintentionally disrupt the continuity and thus distract the reader. For instance, if you draw a doorknob on the left side of the door in the first panel, you have to be careful not to accidentally move it to the right side of the door in the last panel. After finishing a cartoon, look it over carefully to check for errors in continuity. It may help to put the cartoon away for a day or two before rechecking it, so that you can come back to it with a fresh eye.

You don't have to show the same exact thing in every panel, though. You can vary the rhythm and pace of the strip by varying what you show in the panels. For instance, cutting to an exterior shot in the second or third panel gives the reader a sense of breathing room in a dialog-packed strip. But don't cut away from the main scene more than once. That makes the panels look unconnected and destroys the continuity.

Creative Inkling

To keep your characters consistent, it's helpful to write biographies about them for your own use, noting details like their birthdays, middle names, educational backgrounds, typical costumes, hobbies, habits, and relationships to other characters. Include sketches of them from all angles in their biographies, too.

Over the life of a strip, paying attention to continuity ensures that your characters remain essentially themselves, even if that means they wear the same thing every day for 50 years (like Charlie Brown and his shirt with the zigzag stripe). Your characters should look pretty much the same on day 1,000 as they did on day one. Although the "look" of your characters may change slightly as your style evolves, they will retain the same basic hairstyle, way of dressing, and so on. This maintains the continuity of the strip as a whole and helps retain your readers' loyalty.

Just as important, your characters will continue to act in the same way, to retain the basic characteristics that endeared them to your readers in the first place. Cartoon characters rarely change significantly: Children don't grow up, adults don't get old, and pets don't die. Day in and day out, they're still magically exactly the same. Your readers grow to expect that level of continuity, so if you find yourself lucky enough to produce a long-running, popular strip, you need to give it to them.

The Least You Need to Know

- Plot is everything that happens in a story; it's a good idea to rough out the plot and break it down into panels before you draw.
- Conflict adds drama to a story; conflict can occur between two characters, between a character and the world at large, or between a character and his or her essential nature.
- Action is how things happen in a story; as a visual medium, cartoons should contain lots of lively action.
- Continuity ensures that the story flows smoothly from beginning to end; you can achieve continuity with constant characters, props, backgrounds, and/or colors.

The Characters

In This Chapter

- Creating a cast of characters for your cartoon world
- Using stereotypes as the basis for characters
- Fleshing out your characters with character traits
- How repetitive gags can help define your characters

Characters are the people (and animals and anthropomorphic objects) that appear in your cartoons. If you primarily produce single-panel gag cartoons, your characters may be different every time, depending on the needs of the gag. A newspaper strip demands a common cast of characters, though, who will—if you're successful—populate your cartoon world for years to come.

Nothing is more important than your characters for making your cartoons come alive and become meaningful to your readers. Every successful strip running in the newspaper today works because its characters and its situations are so appealing. You should spend a lot of time thinking about and refining your characters, particularly if you intend to develop a regular cast.

Casting Call

Characters are the essential ingredients for creating a successful comic strip. Your task when developing a new strip is to come up with a cast of characters that your audience will want to read about every day. Your characters must be interesting, lovable, and appealing to the largest possible readership. They must have familiar traits that readers can instantly recognize, and they must have clear, simple personalities that remain essentially the same from day to day, year to year.

A cartoon character's essential personality can generally be summed up in one or two words: Charlie Brown is a loser; Beetle Bailey is a goof-off; Cathy is a neurotic. Readers don't expect cartoon characters to have complex, multilayered characterization like characters in novels do. They expect cartoon characters to be familiar, quick to identify, and easy to relate to.

Finding a Star

The first character you should concern yourself with is your main character, around which the strip will rotate. Some strips have an ensemble cast, but when you're just starting out, it's easier to focus on just one principal character. This character should have a strong personality and well-developed traits. The character's desires, goals, concerns, and problems should set the theme for the strip as a whole.

'Toon Talk

A **character** is a person, animal, or anthropomorphic object that acts in the cartoon. Cartoon characters are always of very specific personality types that can usually be summed up in one or two words.

When thinking about your main character, look for a personality type that has universal appeal and that your readers can connect with on a personal level. The subjects of strip cartoons are usually the subjects of everyday life that concern most people: childhood (*Peanuts, Calvin and Hobbes*); family (*FoxTrot, Baby Blues*, and innumerable others); the single life (*Cathy*); and work (*Dilbert*)—to name a few. You might want to target a specific market when creating your strip, such as parents, young professionals, college students, singles, women, or specific ethnic groups. It's a good idea to stay away from subjects that require special knowledge or very specific character types in order to avoid alienating your readers.

When choosing a main character, consider the potential for longevity, as well. Your theme should be broad enough so that you have plenty of subjects to explore and ideas for gags if the strip becomes popular and runs for years and years.

From the Pros

For proof of the power of family as a subject of cartoons, look at *Blondie*, originally created by Chic Young and now written by his son, Dean, with several artistic collaborators. The strip appears in more than 2,000 newspapers in 55 countries and has been running continuously for 72 years. Fans consistently rate it among their top five "most popular comics." This may inspire you to create your own strip about family life; on the other hand, it may convince you that the subject has been done to death and lead you looking for other subjects that haven't yet been thoroughly explored.

The best subjects and the most enduring characters are the ones that are closest to the cartoonist's heart and soul, though. Characters who develop directly out of your personal passions, interests, and life experiences, rather than from what you guess a reader or editor wants to see, will come to life on the page. That's what will capture the editor's attention and win your audience's loyalty for years to come.

So when you're looking for new characters, the first place to look is inside yourself. What subjects are most meaningful to you? Who are the people (and animals) in your life? What kinds of characters touch your heart and fire off your imagination? That's who you should be writing about.

Rounding Out the Cast

Every strong main character must have a good supporting cast. It's best to keep that cast small, so readers don't get confused and so you can keep track of everybody. Calvin has Hobbes, his parents, Miss Wormwood (his teacher), Susie (the annoying little girl at school), Moe (the bully), and Rosalyn (the terrifying babysitter); with the exception of occasional cameos, that's the bulk of the cast. Most newspaper strips have similarly manageable casts, with only a handful of recurring characters.

If you've already produced a number of one-off gag cartoons, going back over them can help you to develop a cast of characters for a strip. Look back through your gags—you may find that you've returned to certain subjects and kinds of characters again and again, without even being aware of it. The majority of your gags

may deal with lawyers and courtroom humor, for instance, or with a cast of singles hanging out in the dance clubs. Because that subject and those people obviously already interest you, that's a good place to start when creating a cast.

To cast your strip, hold "auditions" just as if you were casting a movie. Keep sketching faces until you find exactly the right one for each character in your cast; some cartoonists discard 30 or more faces before they create the perfect one.

Each character should have a unique "look" and should be easily identifiable, but that doesn't mean the drawings of them have to be complex. For every character that makes it into your final cast, you'll have to draw them thousands of times from every possible angle, and they'll always have to look essentially the same. Make things easy on yourself. Keep your drawings simple, and distinguish one character from another with one or two unique traits.

Creative Inkling

Practice drawing your characters from all angles. You won't always want to show them staring straight out of the frame. Once you've visualized your characters from every side, you'll find that your drawings of them will become livelier. This exercise will also keep you from unconsciously favoring easy-to-draw angles, thus staging scenes less effectively.

As for personality, a helpful shortcut is to model each character on someone (or a combination of someones) you know well, even if the cartoon version metamorphoses into something completely different like, say, a penguin. (Just don't pick a model who's likely to sue you for defamation of character!) Don't leave yourself out when you're looking for real-life models for your characters. Knowing your characters well means you already know how they will react to the various situations you'll put them in, and they will suggest even more situations to you, helping with that always tricky problem of where to get ideas.

Stereotype Shortcuts

In a cartoon, you don't have a lot of room to develop your characters and give them well-rounded personalities like you do in a novel or screenplay, for instance. Instead, you only have a few seconds to communicate who your characters are to your audience. Readers have to instantly recognize your characters so that they can get the gag.

Because of these limitations, cartoon characters have to be very specific "types." Readers must be able to immediately recognize who they are, what they do, and their significance in the situation. That means that the cartoonist often has to resort to stereotypes to get the gag across as quickly as possible.

Red Ink Alert

By character stereotypes, we don't mean the negative racial, ethnic, gender, and religious stereotypes that (unfortunately) we're all so familiar with. Relying on those stereotypes will just offend and alienate readers. Indeed, your work will probably never get published in the first place.

Using stereotypes means that your characters have to conform to the universal idea of who that person is, rather than accurately reflect real life. At a glance, the reader must be able to tell a bank robber from a doctor, a business tycoon from a taxi driver. So your taxi driver, businessman, doctor, or crook must resemble everyone's universal idea of what that type of person looks like.

Think about how to dress your characters, what they are carrying, and any other clues you can provide that will tip your readers off as to who these people are, what they do for a living, what their personalities are like, and what their relationships are to the other characters in the situation. Tie a black mask around your bank robber's face and put a bag with a dollar sign on it in his hands. Give the business tycoon a three-piece suit, a briefcase, and a fat cigar. Don't hesitate to rely on these widely held stereotypes to show who your characters are—they work.

Once again, you're using the cliché to give the reader something familiar before twisting that around for the gag. In cartoons, stereotypes are shortcuts to communicating with your readers, just like other clichés. Your

cartoon doctor isn't supposed to look like a real doctor; he should look like everyone's most basic idea of what a doctor is. So he wears a white coat and has a stethoscope around his neck. Perhaps he wears glasses to convey intelligence and has thinning hair to make him look older and fatherly.

As an exercise, draw an ordinary guy—your regular average Joe. Now turn him into a chef, a cop, a gym coach, and a college professor, just by changing his clothes and props. See if an objective observer can immediately identify each character. Getting the hang of it?

Stereotypes are a good place to start when assembling your cartoon's cast. You'll want to have representatives from several different character types, because that naturally creates conflict between the various characters.

From the Pros _____

Online cartooning is an entirely new medium that cartoonists can explore, thanks to the popularity and accessibility of the web, and new trends arise quickly. One recent trend is comics that use characters (called "sprites") from well-known video games. The humor of these cartoons relies on readers being familiar with sprites' personality types and the story lines of the games, as well as with video game stereotypes in general. Visit oldskooled.disflux.net/links.html and www.gamerswave.com/comics.htm for links to online sprite comics.

Here's a selection of stereotypes to start with; think of how you might twist any of these into interesting characters or add your own stereotypes to the list:

- Airhead (male or female)
- Beauty queen
- Tomboy
- Troublemaker
- Trendsetter
- Athlete
- Brainy student
- Fat-cat businessman
- Socialite
- Career woman
- Stuffy accountant
- Absent-minded professor
- Computer geek

- Crotchety old man
- Couch potato
- Downtrodden husband
- Single dad
- Working mom
- Terrible toddler
- Bratty kid
- Lazy teenager
- College student
- Love-struck guy
- Young activist
- Hippie
- Yuppie

Think of stereotypes as a kind of shorthand to help communicate your gag and to tell your readers who your characters are. But be careful not to use stereotypes as a crutch—as the basis for old, tired gags, for instance. Don't let a reliance on stereotypes keep you from developing lovable, interesting, unique characters for your strip.

Character Traits: Making Your Characters Real

So far, you've got a cast of general character types. You probably know very little about each character: their ages, their genders, their professions, their relationships to one another, and possibly a general idea of what they look like.

Now you should spend some time making your characters real. You've started with a stereotype, but you want to finish with a real person, one whom your readers can both easily recognize and yet grow to love for who they are. The best way to turn general characters into individuals is to give them unique character traits.

Character traits encompass everything that belongs to that character and that character alone. They help to quickly define who that character is. By examining a character's traits, your readers can make assumptions about that character's personality. Once your characters have several identifiable traits, they must keep them; your readers will expect to see them whenever you bring that character onstage.

Consider all of the following when assigning traits to your characters: physical attributes, costumes, props, personality traits, occupation, hobbies and interests, how they talk, and repetitive gags.

Red Ink Alert

Male or female? Unless you need to show a bodybuilder or Marilyn Monroe–type for the purposes of the gag, you don't need to emphasize the obvious differences between men and women. In fact, you probably shouldn't, because you risk offending readers by relying on tired gender stereotypes. Study most cartoons —what distinguish men from women are usually hairstyles, clothing, and jewelry (not T&A).

Physical Attributes

How your characters look is a very important part of who they are, especially in such a visual medium as comics, where you need to communicate quickly to your readers your characters' personalities through their appearances. For each character, make a list of their distinguishing physical attributes. You might pick one characteristic and exaggerate it to create a visual "signature" for that character.

Think about the following:

◆ **Facial features**—noses, lips, chins, wrinkles, facial hair, beard stubble, freckles, and acne all contribute to characterization.

◆ **Hairstyle**—how a character wears their hair can tell you instantly their age and personality type; a hippie's hair will look very different from a businessman's, for instance.

◆ **Body type**—short or tall, fat or skinny, voluptuous or athletic, stooped or straight? They all contribute to characterization.

Costumes

How your characters dress, including the styles of clothing (sloppy, neat, sexy, cute, formal, fashionable, etc.) and types of clothing (jeans and a T-shirt, business suit, miniskirt, etc.) they wear can tell your readers a lot about who they are. From characters' costumes, readers will learn what they do for a living, how much money they make, whether they are vain about their appearance, what their personalities are like, and other important details. Many cartoonists make their characters' costumes a defining characteristic and dress them in the same outfit, day in and day out, for the entire run of the strip (such as Charlie Brown and the rest of the gang in *Peanuts*).

Clothing can also provide important clues about what is going on in that day's story, communicating succinctly to your readers what the situation is. For instance, people dress very differently when they're going to work out than when they're going to work. They change their clothes depending on whether it's raining, snowing, or warm and sunny. So costumes show your readers what your characters are doing, what the weather is like, and what time of year it is.

Creative Inkling

As a general rule, draw your settings in the same style and tone as your characters, so that everything is in the same "voice."

Props

As you learned in Chapter 10, "Express Yourself," props are an important part of defining a character, and include everything that your characters habitually carry or have around them. Props you can use to help define your characters include glasses and sunglasses, pipes and cigarettes, beer cans and wineglasses, purses and briefcases, dolls and sports equipment, canes and wheelchairs, and so on. Don't forget to pay attention to a character's props when decorating their home or office, too. And when they have to get in a car, be sure to give them one that matches their personality type.

Personality Traits

Personality traits are essential attributes of your characters' natures. Are your characters smart, funny, sly, naive, lazy, ambitious, neurotic, confident, shy, loud, fun, spontaneous, practical …? The list of potential personality traits goes on and on. Each character should have at least one overwhelming personality trait that sums up who that person essentially is.

Occupations

Every one of your characters must *do* something all day, and usually that occupation is part of your character's essential personality. Do your characters go to an office or stay at home with the kids? Are they professionals or working class? Are they entrepreneurs or underlings, scientists or creative types? Are they successful or struggling, happy or unhappy with their jobs? Even children go to school, and each child is a different type of student with different interests: brainy, popular, athletic, artistic, and so on.

Hobbies and Interests

Giving your characters passionate interests makes their personalities three-dimensional and also provides another rich source of gags. Think of Charlie Brown's determination to become a good baseball pitcher, for instance, or Jason's (of *FoxTrot*) obsession with video games and science-fiction movies. When coming up with your characters' hobbies and interests, try to come up with activities that relate to their essential personalities. An outgoing airhead type probably wouldn't collect stamps, for example.

Red Ink Alert

Names are also important clues to characterization. However, avoid the temptation to give your characters cutesy names or overused clichés for describing certain personalities. Don't go for the obvious; your readers won't forgive you for it. Better name choices are natural, accurate, and unobtrusive.

How They Talk

One often-overlooked aspect of characterization is how a character talks. Each character will have a particular way of talking peculiar to his or her personality. A character's vocabulary helps define their age, class, educational background, where they live, and their occupation. Characters in particular lines of work will use some technical jargon, for instance, while teenagers will employ slang that adults don't use (or even understand, most of the time). So pay attention to how your characters talk, and make sure that they don't all talk the same way.

One tried-and-true method of defining characters is to give them a catchphrase that they repeat in certain situations. Think of Bart Simpson's "Cowabunga, dude!" or Homer's "D'oh!" Your readers will quickly associate that phrase with one particular character, so you can twist that cliché you've established to create new gags.

Repetitive Gags

Try giving each character one joke that is reserved for that person alone. Over time, your readers will come to associate the gag with the character. They will anticipate it and appreciate new twists on it. The classic example is Charlie Brown trying to kick that darn football; no matter how many times he tries, we know that Lucy will always pull it away. But think of all the other repetitive gags in *Peanuts*—each character has at least one. Snoopy is always trying to write that bad novel, Lucy is always dispensing psychiatric advice, and Sally is always trying to get Linus to be her boyfriend.

Regardless of how many characters you create and what traits you give them, they will all look similar to one another. How you draw your characters—how you draw eyes or noses or feet, for instance—should be an important part of your personal style. Some cartoonists help to establish a style by making all of their characters animals (*Shoe*), children (*Peanuts*), or a mix of animals and people (*Bloom County*).

The Least You Need to Know

- Your characters are the most important part of your cartoon world, so cast them carefully.
- Using character stereotypes is a helpful shortcut for quickly communicating to your readers who your characters are and what their relationships are to each other.
- Each character should be defined by several character traits, including physical appearance, personality traits, and likes and dislikes, all of which provide clues as to who your characters are.
- Using repetitive gags in your cartoons can help define your characters.

Polishing the Gems

In This Chapter

♦ Reading your captions and dialog aloud for rhythm and pacing
♦ Changing viewpoint to add a different perspective to a scene
♦ Paring your drawing down to its essence using identifiable elements
♦ "Aging" cartoons before declaring them finished

Now that you've got a finished cartoon with all the elements of story, characterization, and the gag in place, you still must go through one final step before submitting it for publication. That's the polishing step: that crucial period of time when you make sure the cartoon is as good as it absolutely can be. During this stage, you make certain that your captions and dialog deliver the gag with a punch; that the camera angle and point of view you have chosen contribute most effectively to the idea without overwhelming it; that you have eliminated all unnecessary and irrelevant details; and that there is nothing out of place, inconsistent, incorrect, or confusing in your drawing.

It may often seem like this step is unnecessary and a huge waste of time, but don't skip it! Professional cartoonists take the time to revise, rework, and rewrite until the drawing is perfect and the gag is just right. If you haven't yet published your cartoons, this step is even more crucial; polished cartoons are much more likely to snag an editor's attention and get sold.

Rework Captions by Reading Aloud

There is only one sure way to make certain the captions and dialog in your cartoons sound natural, are well paced, and deliver the gag in the funniest way possible: reading them aloud. You may feel silly at first, but reading every word of your cartoons out loud to yourself is an invaluable way to catch imprecise language and poor timing. You will discover whether the dialog needs an extra beat and whether the punch line—the funny part—comes at the right place.

When you're reading your captions and dialog aloud, pay particular attention to the following details:

◆ Your word choices are precise and mean exactly what you intend to say.

◆ You have kept your captions and dialog as brief as possible.

◆ You have chosen active, descriptive language.

◆ Your dialog sounds natural in your characters' mouths.

◆ Your word choices match the personality, age, and background of the person speaking.

◆ Nothing in the drawing is repeated unnecessarily in the dialog or caption.

◆ Nothing is said in the caption or dialog that would be more effective if shown in the drawing.

◆ Your dialog creates a flow that naturally carries the story along.

◆ The punch line falls on a natural beat or is otherwise emphasized.

◆ The punch line and the key words in the setup come at the end of a line and aren't lost in unnecessary words.

Creative Inkling

If you're testing dialog, try acting it out when you read aloud, as if you actually were the characters in your strip. This will not only help you determine that the dialog is exactly right, but will also help you to decide if you have chosen the best facial expressions and body language for your characters.

Changing Your Viewpoint

Changing the viewpoint can dramatically affect how readers perceive a gag. Think of yourself as a movie director. How can you move the "camera" to more effectively or dramatically show the situation of your cartoon? Who should be in the foreground of each panel? What and how much of the background should you show to best communicate the idea you're trying to get across? In cartoons, there are no limitations—you can put the camera anywhere.

Most cartoons and strips use a straight-on, medium shot—imagine that you're watching a television sitcom—which is fine for many gags. A static camera keeps from overwhelming quiet or verbal humor, such as in *Peanuts* or *Doonesbury*. Because it's the expected camera angle, the medium, head-on camera angle doesn't confuse the reader, either.

Don't get stuck in that mode, though. Always look for fresh, new ways to present your drawings. As we discussed in Chapter 11, "Getting Perspective," some gags, particularly visual ones, will be enhanced by showing the scene from below (a worm's-eye view) or from above (a bird's-eye view). Others benefit from moving the camera in tighter or pulling back for a wide shot. You might also show the characters themselves from different angles, such as from the side or even from behind.

'Toon Talk

In cartooning, **camera angle** encompasses the angle from which you choose to show the scene and the width of the shot. Different camera angles include straight on, from an angle, from above, and from below. Different kinds of shots include the standard medium shot, the wide shot, the long shot, and close-ups.

Certain *camera angle* conventions have long been established by cartoonists:

◆ A medium shot—the most commonly used camera angle in cartoons—focuses on the characters, showing only a little background detail.

◆ A long shot—also called a panoramic view or establishing shot—shows a great deal of information, usually about the background of the scene. It is often used in the first panel to set the location of a situation, particularly if the setting is important for the gag.

◆ A close-up zooms in on a character's face or an important object; extreme close-up is so tight that you may only see the character's eyes. Close-ups are usually employed to show important details of an object or a character's face.

♦ A worm's-eye view is a camera angle from below, or from the ground, looking up. It can show the bottoms of objects.

♦ A bird's-eye view is a camera angle from high in the sky or the very top of a building looking down. It can show the tops of objects.

Be aware of how changing the point of view in your strip disrupts continuity. You will have to find other links to maintain the flow from frame to frame. For instance, you could keep to one character's viewpoint to avoid confusing the reader. You could also put only one unusual camera angle in a strip and stick to the expected straight-on angle in the other panels.

These are some other moods or feelings that can be conveyed simply by changing the camera angle:

♦ High, tight camera angles suggest suspense or drama.

♦ Looking up into a scene gives the scene a more dramatic mood and makes the viewer feel small, suggesting a powerful character.

♦ Long shots communicate emotional distance or provide a feeling of open space.

♦ Close-ups emphasize important panels, such as the setup frame.

♦ Extreme close-ups emphasize the emotion expressed in the scene or an important object.

♦ Wide shots visually punctuate the gag. Going wide in the last panel also enables you to reestablish the scene and show character reactions.

Varying your camera angles enables you to "film" your cartoon from different points of view. *FoxTrot* often experiments with point of view, showing the scene from the viewpoint of Jason's pet iguana, for instance, or a model car zooming through the house. You can also use different points of view to show what one character is seeing, which gives insight into what the character is thinking or imagining; that helps readers "get" the gag.

The choice of camera angle should also be guided by how much of the scene the reader needs to see in order to "get" the gag. You might position your camera closer to focus on the characters and their facial expressions, or you might choose a long shot to show relevant background details. Suddenly pulling back to reveal a detail previously hidden from the reader can make a good visual gag, for example.

After roughing out your strip, use the polishing phase to experiment with viewpoints and try to find a more effective shot for a particular panel or scene. Don't be afraid to try something new! Not only does this give your readers a different perspective on the gag, but it also adds visual interest and excitement to your cartoons. Even a slightly off-center camera angle energizes and animates an otherwise static scene.

Just be careful not to let avant-garde camera angles overwhelm the ideas of your cartoons. Always choose viewpoints with the gag in mind. Only change the camera angle when it's necessary to get the idea across or to emphasize your point.

> **Creative Inkling**
>
> Next time you watch a movie, pay particular attention to the choice of camera angles. Notice how different camera angles change the mood and emphasis of a scene. Carry what you have observed with you into your studio—you will probably start producing more visually interesting comics!

Using Identifiable Elements

As we've said, the key rule in drawing cartoons is "keep it simple!" Too many irrelevant details and elaborately drawn backgrounds will clutter your drawing, distracting the reader from the gag. The polishing stage is often an editing stage. Give yourself some time to study your drawings carefully and remove extraneous artwork.

One effective way to keep your cartoons simple is to reduce familiar objects in your drawings to their most readily identifiable details. You don't have to draw every line of an object that your readers will recognize right away.

Red Ink Alert

In most cases, your cartoons will be reduced in size for publication. In reduction, lines become thinner, and small details that have been painstakingly drawn can be lost entirely. The simpler your drawing, the better it will reduce, and the cleaner it will look on the printed page.

Consider the everyday telephone, for instance. In real life, telephones come in all sizes and shapes. There are phones with dials and touch-tone phones, cordless phones and phones with cords, complex office phones that look like mini-computers, and small, efficient cellular phones.

If a phone is needed as a prop in one of your cartoons, you should draw a "cartoon" phone, not a realistic rendering of a telephone. What do most people think of when they visualize a telephone? Generally, they imagine a dial (even in these days of touch-tone phones), a handset, and a cord. All you have to do is draw the bare minimum of these details: a circle for the dial, a simple handset resting on a base, and perhaps a bit of a curly cord that abruptly ends in midair. You don't have to render the phone to its tiniest detail. Give your audience a stylized, simplified phone, showing only the most essential components, and they'll fill in the details for you.

The same principle applies to backgrounds. If your characters are standing in front of a brick wall, you don't need to draw in every brick. Just put in a sample corner of the wall, and your readers will fill in the rest in their own imaginations. The same with grass, bookcases, fences, sidewalks, wallpaper, or any repetitive image in the background. Unless the setting is vitally important to the gag, provide just enough of it to set the scene. Let your characters dominate the drawing.

In the case of both props and backgrounds, always strive to capture the basic essence of what you want to show. Your readers should see at first glance everything that's in the picture. You achieve that by providing only the most identifiable elements of an object, and nothing more. Overwhelming the drawing with details can actually prevent that instant communication.

From the Pros

According to Mort Gerberg in *Cartooning: The Art and the Business* (see Appendix B, "Bibliography"), *New Yorker* cartoonist Charles Saxon believes in reworking a cartoon until it's just right, but he strives to retain the original spontaneity of the drawing. He does this by using lightweight, see-through paper and drawing revisions on overlays of the previous version. Thus, his final drawing incorporates the best elements from each version. After finishing a cartoon, he takes several days to search for ways to improve it more. His credo is this: "Good is the mortal enemy of excellent."

The key when editing your drawings is to include just enough details to quickly communicate to your readers the idea you're trying to get across, but not so much as to overwhelm them or clutter the drawing. When in doubt, leave it out—the rule applies to your drawings as well as to your captions and dialog.

Aging

You've slaved away, revising and editing and refining your cartoon down to its essence. Every detail is perfect and necessary. The caption delivers the gag with the right emphasis and rhythm. Your cartoon is finished!

But is it really finished? Here's a trick that most professional cartoonists use, and you should, too: Put your "finished" cartoon in a drawer and forget about it. A couple of days or a couple of weeks later (whatever works for you), pull it out and look at it again. This process is called *aging*.

Aging takes the finished cartoon out of sight and out of mind. When you've been working on something, you focus all your attention on it; this can actually prevent you from really *seeing* the drawing after a while. When you put the cartoon away, you relegate it from your conscious mind to your subconscious. Then, when you take it out again, you'll regard it with a fresh eye.

This final look gives you one last opportunity to make edits. First, take in the cartoon as a whole. Does the idea still work? Is the gag still as funny as when you first conceived it? Unfortunately, after aging, many cartoonists find that what at first seemed to be a great gag doesn't work as well as they thought, and either needs to be reworked or discarded.

'Toon Talk

Aging is the process of letting a piece of artwork sit for a short while after you have finished it, and then taking it out and giving it a final once-over. This enables you to reapproach the drawing with a fresh eye, making it easier to catch errors and make final revisions.

If the basic idea is strong, good—that's most of the battle. Now take a closer look at the details and see if anything else can be improved. Perhaps an unnecessary detail can be removed. Perhaps something is missing and needs to be added. Perhaps a character's expression, body language, or costume is wrong for the situation. Perhaps the caption or dialog can be rewritten one more time.

Now is the time to check for errors and inconsistencies. You wouldn't believe how many silly mistakes can sneak by you when you're in the throes of creation. Check for six-fingered hands, continuity errors, inaccurate drawings of props, mistakes in perspective and proportion, and other minor problems. Also look for lines that are too heavy or too light, confusing or unclear areas of the drawing, and anything else that might distract readers or keep them from "getting" the gag. Finally, check the printability of your work. Are there any smudges or spots? Is the background clean?

During the finishing stage, it's a good idea to show your cartoons to someone. Pick reviewers who aren't afraid of hurting your feelings and will give you honest reactions. Don't be afraid to seek out criticism and don't take negative comments personally. Instead, use them to learn and make your cartoons even better.

Finally, your cartoon is finished! Now comes the time that causes both excitement and dread for many cartoonists: submitting your creations for publication.

The Least You Need to Know

- ◆ When rewriting your captions, read them aloud; that's the best way to determine if the rhythm is right and the dialog sounds natural.

- ◆ The finishing stage is a good time to consider different camera angles and points of view; changing these can dramatically affect the mood and emphasis of the cartoon.

- ◆ Editing props and backgrounds down to their essence, or most easily identifiable elements, produces simpler drawings and helps readers instantly grasp a situation.

- ◆ Aging is the process of letting a drawing sit for a while and then taking a fresh look—an essential step in editing a cartoon.

Part Getting into the Swing

As an aspiring cartoonist or comics artist, some burning questions are probably uppermost in your mind: "How can I get published?" "How can I get paid for my work?" and "How can I get paid more?"

This section will help the fledgling freelancer set up a professional cartooning business. First, you'll find out who might be interested in buying your artwork—not just the traditional outlets, but also the more lucrative markets that you might not have considered. Next, you'll discover how to get your foot in the door with the *right* way to prepare submissions, put together a portfolio, and mail samples. Finally, we'll delve into the crucial but confusing world of copyrights, licensing deals, and contracts. Following the advice given in this section will help you cross the line from amateur cartoonist to professional.

Breaking into the Business

In This Chapter

- ◆ Submitting gags to magazines
- ◆ Submitting strips to syndicates
- ◆ Other markets to consider
- ◆ Working on comic books
- ◆ Working in an animation studio

Coming up with ideas, evolving a personal style, and actually drawing the cartoons are only part of the battle. You can't really call yourself a professional cartoonist until your work gets published, and you get paid for it.

Here's a dose of reality for you: When you're just starting out, you'll get enough rejection slips to wallpaper your studio. Rejection is simply part of the business, so you'd better get used to the idea now. Here are some other unfortunate realities of the business. Editors change often; the editor who loved your work disappears one day, only to be replaced by someone who can't stand you. Magazines will hold your work forever—sometimes six months or more—and then reject it without explanation. The money isn't very good, it trickles in slowly, and sometimes it doesn't come at all, since magazines fold often and without warning. For most cartoonists, the aggravation is worth getting to do what they love. This chapter will help you negotiate the pitfalls of actually making a living in this business.

Selling Your Gag Cartoons

The traditional way to break in is to publish your cartoons in magazines, although this market is rapidly shrinking. Still, nothing says you've made it as a cartoonist like seeing your piece in *The New Yorker*.

In the magazine world, freelance cartoonists work on *spec:* They produce unsolicited material first and then submit it, hoping an editor will buy it. That means you'll probably end up doing a lot of hard work without a lot of reward, at least not at first. (The good news is that a cartoon never expires; once you've got a finished piece, you can keep trying to sell it for years, if need be.)

Unfortunately, the few magazines that still buy cartoons reject most of the submissions they receive. Every month tens of thousands of cartoons are competing for only a few hundred spaces. *The New Yorker* receives 3,000 submissions every week and only buys 25 to 30 cartoons—that's a 99 percent rejection rate, and you're competing with the top professionals working in the field. Even the lower-paying markets receive more submissions than they could possibly ever use.

So the chances of selling even one cartoon are small—you might as well accept that now. You'll fare a lot better if you learn not to take rejection personally. Cartoons are rejected for a lot of reasons, and many of them have nothing to do with how good you are. You just don't know, so you have to keep trying. Sooner or later some editor is going to think your cartoons are funny.

'Toon Talk

Spec is short for "speculation." It means that you do the work first in the hopes that you can sell it later and then get paid for it. Even the most well-established and well-known gag cartoonists submit their work on spec.

Creative Inkling

A lot of cartoon editors buy solely based on size. They want to make their jobs easier by purchasing cartoons that will fit the spaces they have. When studying potential markets, make a note of the sizes of cartoons they typically publish and tailor your submissions accordingly.

The best way to break into magazine cartooning is to know your market. Very few general-interest magazines have survived the magazine slump. Successful magazines now serve specialized, or niche, audiences. These markets—especially trade journals—can be easier to crack because they're not as well known and so they don't receive as many submissions. But you'll only sell them cartoons that will appeal to their narrow audience. In other words, a boating magazine will like boating-related cartoons, but not cartoons having to do with planes.

Before sending out a batch of cartoons for submission, take a trip to the library and/or newsstand. Study some issues of each magazine where you want to submit. What is their target audience? What kinds of cartoons do they typically publish? What styles do they favor? You'll have a leg up on the competition if you carefully select submissions that best fit each magazine.

Since the competition at the top is the toughest, you'll have an easier time breaking in by first approaching the smaller, lower-paying publications. To get started, pick several markets (12 to 20) ranging from your dream sale (*Playboy*, *The New Yorker*) to a good assortment of smaller publications. A book like *Artist's & Graphic Designer's Market* (see Appendix C, "Publications," for details) will be a big help. Start circulating new cartoons every week. The key is persistence: Keep producing new work and diligently submit it everywhere you can. (Chapter 27, "Self-Promotion," tells you how to prepare a batch of cartoons for submission.)

Selling to the Syndicates

All strip cartoonists dream of selling their strip to a syndicate. After that, they imagine, every newspaper in the country will pick them up, and the licensing and television deals will just roll in. Unfortunately, getting your strip bought by a syndicate is one of the toughest sells there is. And even after that happens, fame and fortune are not automatically guaranteed.

A *syndicate* is like an agent. It distributes your strip to as many newspapers and magazines as it can and takes a cut of the profits, usually 50 percent. Because the syndicate employs a large sales and marketing force, it can promote your cartoons more effectively than you probably can yourself.

There are seven major syndicates for cartoons:

◆ Creators Syndicate (www.creators.com)

◆ King Features (www.kingfeatures.com)

- *Los Angeles Times* Syndicate (www.lats.com)
- Tribune Media Services (www.comicspage.com)
- United Media Syndicate (www.unitedmedia.com)
- Universal Press Syndicate (www.uexpress.com)
- Washington Post Writers Group (www.postwritersgroup.com/writersgroup.htm)

Each one has different submission policies and procedures, and it's best to strictly follow each syndicate's rules when submitting strips (Chapter 27 provides more guidance on this). You can write directly to the syndicates to request submission guidelines, or check their websites.

'Toon Talk

A **syndicate** is an agent that sells comic strips, single-panel cartoons, and editorial cartoons, along with other creative material, to newspapers and magazines. The syndicate packages, promotes, and distributes features in exchange for a share in the profits.

It's tough for even a high-quality strip to sell to a syndicate, though. There just aren't that many spots for new strips. The number of newspapers is shrinking every year as they fold or get bought by large media conglomerates. Those that survive have to slash budgets and space, and cartoons are frequent victims. If a newspaper wants to bring in a new strip, it usually has to kick out a long-established one that has already won a loyal following. Fortunately, syndicates are actively looking for new markets beyond the traditional newspaper outlets, such as alternative newspapers, magazines, and websites, as well as merchandising.

You're probably going to have to submit and resubmit your strip proposal several times before you'll find success, refining it each time. Syndicates receive several hundred submissions a month, and each only launches two or three new strips a year. The most promising cartoonists are often invited to rework and resubmit their proposals or try new ideas. It's not unusual for cartoonists to submit strip proposals for years before they capture an editor's interest.

From the Pros

If you have a savvy business sense, a talent for marketing, and a lot of energy, you can go the self-syndication route like Tim Jackson, creator of the self-syndicated panel, *Things That Make You Go Hmm* Self-syndicated cartoonists keep all the rights to their work (and all the profits), but self-syndication requires a lot of hard work. Weekly newspapers are your best bet, because the dailies rarely buy from self-syndicated cartoonists. The good news is that once you build a loyal following, you have a better shot of selling your strip to one of the major syndicates.

If you're lucky enough to get picked up by a syndicate, how much money you make depends on how many newspapers and magazines pick up your strip. Each publication pays a different fee to publish the strip, depending on the publication's circulation and the popularity of the strip. So getting your strip into 50 large newspapers might make you more money than being in 150 small ones. Many strips don't earn as much as you might imagine, when you consider that a small newspaper might only pay $15 a week for a daily strip. Chances are slim that you'll produce a breakout strip, but you could be fortunate enough to ensure yourself a regular income that enables you to work as a cartoonist full-time.

Exploring Other Markets

As you've surely already figured out, you probably won't be able to make a living solely from selling gag cartoons. Freelance cartoonists always have to be on the lookout for new places to peddle their talents.

Selling Illustrations to Art Directors

One avenue is selling illustrations to art directors of magazines, publishing companies, advertising agencies, and corporations. Art directors buy illustrations to enhance or interpret the editorial content in the publications and advertisements their companies produce. They typically purchase spots: small, captionless drawings used in magazines to break up the text and lead readers from one feature to the next. They also might need more targeted illustrations for a story, advertising campaign, brochure, or other document. The gag cartoonist is perfectly suited to producing humorous, imaginative, and eye-catching illustrations and spots.

The tough part of producing good illustrations is that you have to illustrate someone else's ideas; you can't express your own in the drawing. Your job is to provide a visual element that will hook readers into reading the story or ad. Study the cartoon-like illustrations in your favorite magazines. Notice how cartoons are used to set the tone for a humorous article, dress up a feature about a celebrity with a caricature, and otherwise spiff up plain vanilla text.

As with gag cartoons, you must carefully tailor your submissions to art directors to fit the market's "personality." *Rolling Stone* has an edgier style than *Reader's Digest*, naturally. Before preparing a submission of samples for an art director (see Chapter 27), study the market carefully. Match the style and tone of your submissions to the market's overall personality to improve your chances for a sale. But don't clone other cartoonists' work. Art directors like to present a great deal of diversity in their publications' artwork, even within the same issue.

To start finding markets, check your local Yellow Pages for ad agencies and companies that might buy illustrations, as well as for newspapers that publish spots; these outlets usually prefer to work with local artists, and you can meet with the art director personally to show your portfolio. *Artist's & Graphic Designer's Market* and *Literary Market Place* are good sources of magazine and book publisher markets, as are trade magazines and professional organizations.

There may not be as much glamour in illustrating articles and advertisements, but the work is definitely steadier and often the pay is better (especially in advertising). Once you develop relationships with art directors who know and like your style, you should receive plenty of assignments.

Creative Inkling

The children's market is easy to approach and uses lots of art. Frequently, children's magazines will become regular clients. It's tougher to break into children's book illustration because there is so much competition, but your marketing efforts should also target publishers of children's books and CD-ROMs. *Children's Writer's & Illustrator's Market* is a handy guide to this field.

Red Ink Alert

Before signing anything, read the fine print and know what rights you are signing away. For greeting card sales, try to sell greeting card rights only; you never know where else you might be able to sell that image, so you don't want to sign away all rights to it. Chapter 26, "Legal Stuff," will help you negotiate the tricky business of selling rights to your work.

Greeting Cards and Novelties

The greeting card market is a rapidly expanding one for cartoonists, and a great place to get your foot in the door while making some money. Once dominated by a few giant companies, there are now hundreds of small, medium, and large businesses producing cards, and they all need fresh art and ideas. Another large market are companies that produce novelty items, such as T-shirts, calendars, posters, diaries, notepads, party favors, stationary, mugs, and the like. Most of these companies are open to submissions from freelancers. *Artist's & Graphic Designer's Market* and the Greeting Card Association (see Appendix C) are good sources of markets.

Before you tackle this field, though, spend some time in your local card shop. See what kinds of humorous cards are being marketed. A chat with the shop owner or manager may help you determine which cards are the top sellers. Make notes of the names of card companies producing cards in styles similar to your own and target these companies with your marketing efforts. You can do the same in gift and novelty shops.

Freelance rates will vary depending on the company, your experience, and your previous sales records (if any). Most companies offer standard rates. If you can produce a line of cards around a central theme, you stand to make more, but most cartoonists break in by selling individual card ideas.

Stock Illustrations and Clip Art

You're probably familiar with stock illustrations and clip art. These pieces are brokered through agencies, which sell the artwork to publishers, corporations, advertising agencies, and website designers through catalogs and on CD-ROMs.

Generally, stock illustrations are more sophisticated and polished art pieces, so this might not be the best market for cartoonists (or it might be yet another outlet for your artistic talents). Clip art, on the other hand, is often more humorous and cartoon-like. When most people think of clip art, they picture the copyright-free images used in church bulletins and high school newsletters. But with the popularity of desktop and Internet publishing, the demand for more polished, original, businesslike clip art is growing.

Another difference between the two concerns how you'll be paid for your work. Stock illustration firms typically license the right to reprint illustrations on a "pay per use" basis; they pay you royalties—a percentage of the sale—every time your artwork is used. Clip art firms grant buyers the right to use the artwork as much as they like, in any way they see fit; you are usually only paid a one-time fee for your work.

Selling your illustrations to these brokers gives you the opportunity to "recycle" your work. That spot or gag you sold once before can be sold again (as long as you've retained the right to resell it—see Chapter 28), producing more income for you. Another option is to create artwork that meets the market's specific needs and sell it to brokers directly.

When you sign up with a stock illustration or clip art firm, you generally sign an artist-exclusive contract. This means that you can only sell your artwork to that firm within the clip art industry (you're still free to sell to magazines, etc.). Check market directories for firms to target with samples.

> **Creative Inkling**
>
> To maximize your income, learn how to take an idea used in one form and reshape it for another. A single-panel gag might also make a good greeting card. A spot illustration could be a successful offering to a clip art firm. Recycling doesn't just work for newspapers and aluminum cans—it works for cartoonists, too.

Breaking into Comic Books

The comic book has finally come into its own. No longer relegated to the kiddie market, comics are a booming business producing high-quality collectible books targeted at adults with deeper pockets. Rejuvenated by a new distribution system and a growing fan base, comics are now sold at specialty shops, traditional bookstores, conventions, and through direct mail. The creator of a breakout comic book stands a chance of making handsome royalties and even signing a movie deal.

But get those dollar signs out of your eyes. It's not easy to break in. While there are more comic book publishers than ever, the market is volatile, and publishers frequently go under or sell out to bigger companies. The "big two" are Marvel and DC, but getting a job with either means competing against the best in the business. Still, the field depends on freelancers and is fairly open to newcomers—provided you have talent and can prove it, that is.

Most newcomers to the industry don't realize that each comic book is a collaboration among a team of creative types, which includes the writer, penciler, inker, colorist, letterer, and editor. Teamwork is the only way

'Toon Talk

In the comic book industry, the **page rate** is the price paid for each page of an issue that an artist produces.

Red Ink Alert

Don't try to land freelance comic book work by submitting a pin-up: a single sheet showing a character in a flashy pose. Comic book editors want to know if you can tell a story as well as draw. They need to see consecutive pages to judge your sense of pacing, drama, and layout.

to meet the strict deadlines and produce a new issue every month. Each artist is paid by the page, which is called, appropriately enough, the *page rate*. Page rates vary considerably, starting at the low end for letterers and colorists, midrange for pencil and ink artists, and top dollar for cover artists.

To break in, you generally take one of these jobs on an established comic book. You'll probably have to prove yourself as a colorist or letterer before you can move up to a penciling or inking position. After you've worked in the field for a while, you might try creating an original comic, but that's the subject for another book altogether (see Appendix B, "Bibliography," for some books on the subject).

You apply for a job by submitting samples of your work to the comic book's editor. Different publishers have their own guidelines for how they like to receive samples; visit each publisher's website or write them directly to request these guidelines, and follow them to the letter. Don't forget the small press and independent comics when you're trying to land your first job—they're often easier to break into.

Only submit samples of the type of the work you'd like to do. If you want to be a penciler, don't send in inked work. If you want to be a letterer, send in lettered pages. Don't try to do every job, but submit only your strongest work, whatever that might be.

Here are some guidelines for each type of artist:

- **Penciler.** The penciler lays down the initial artwork in pencil. Submit at least four consecutive pages to show the quality of your artwork and your storytelling ability. Create your samples from a professionally written script, if possible. Or find a previously published story that you thought wasn't drawn very well and redo a few pages.

- **Inker.** The inker traces over the penciler's drawing with black ink. Contact the publisher and request photocopies of penciled pages that you can ink (you might have to pay a small fee for postage). If the photocopies are in black and white, lay a sheet of vellum over them and ink on the vellum. You can ink right on top of blue lines. Make copies to submit; don't send the original ink work.

- **Colorist.** The colorist adds color to the inked drawings. You'll need inked samples for coloring. Be sure to make copies so that you can show the finished colored work next to the inked originals.

- **Letterer.** The letterer fills in all the dialog and other text. Your samples should demonstrate that you're able to create several different styles of special-effects lettering as well as standard dialog. Include a variety of balloons.

Chances are that your first submissions won't land you a job, but they may merit encouraging feedback from the editor. Take any personal criticism you get as a positive sign; most aspiring comic book artists receive only form letter rejections. Your work might even be filed for consideration for future jobs. Keep developing your style and improving, and keep submitting. Persistence is the name of the game.

Finally, if you can't break into the established publishers but know you have a winning idea, you can self-publish. Self-publishing is not for the faint of heart, though. It requires business sense, marketing savvy, a lot of legwork, an ironclad ego, and a considerable financial investment for risky returns. If you decide to go this route, there are some books that can help you; turn to Appendix B and check the "Comic Books" section.

Breaking into Animation

Animation is no longer limited to Saturday-morning cartoons and Disney features. It's an expanding industry that encompasses prime-time and cable television, film, advertising, and the Internet, with lots of opportunities for artists. Computer animation in particular is growing in popularity, with the advent of blockbusters like *Toy Story*, special effects work in live-action films, and the gigantic video game industry.

Before you can get a job in an animation studio, though, you need to develop some technical skills on top of your cartooning talent. Do this by enrolling in animation courses at film schools, getting accepted to a training program at an animation studio, or training yourself with computer animation software.

It's also a good idea to attend animation festivals and take advantage of recruiting opportunities there. Many festivals offer recruitment centers that give you a chance to make personal contact with a studio and show your portfolio. The World Animation Festival held in Pasadena, California, every January is a good bet, but a variety of festivals are held around the country all year long.

> **Creative Inkling**
>
> As an aspiring comic book artist, you should attend conventions as often as you can, and always take your portfolio with you. Conventions are prime places to meet editors face-to-face and maybe even arrange an interview. At the least, you can slip an editor your business card and follow up with a mailing of samples while you're still fresh in that editor's mind.

When you apply for a job with an animation studio, you'll need a sample to show. That means you'll need to dub a three-minute VHS reel showcasing your best hand-drawn or computer work. To make the best impression, have your tape dubbed professionally on a three-minute VHS tape (save money by having a dozen or so dubbed at one time). Try to show original characters that you have created, with a soundtrack, if possible. You can also showcase your demo on a personal website for the instant gratification of interested parties.

Animation studios prefer to hire on-staff animators rather than to work with freelancers, which means a steady paycheck doing what you love. However, doing freelance work is one way to break in. Indicate on your job application that you're willing to work freelance until a staff job comes open. Another way to break in is to accept a job as a production assistant, runner or administrative assistant, or doing clean-up work. Once you're on board, you'll have the opportunity to make contacts and showcase your ideas.

The Least You Need to Know

- Magazines are the traditional outlet for selling one-off gags, but that market is shrinking.
- Being accepted by a syndicate is the best way to get your comic strip into newspapers, but competition is fierce.
- Other markets to consider include selling illustrations to art directors, breaking into the greeting card market, or selling your work to stock illustration or clip art firms.
- A team of artists work on each comic book; you can break in as a penciler, inker, colorist, or letterer by submitting samples to publishers.
- Before you can get work at an animation studio, you have to get experience through classes, training programs, self-education, or taking less glamorous jobs lower down on the ladder.

Chapter 27

Self-Promotion

In This Chapter

◆ Preparing submission packages for magazines and syndicates

◆ Selling yourself with samples

◆ Putting together a professional portfolio

◆ Promoting yourself on the web

Making it as a freelance cartoonist requires two qualities besides a talent for cartooning: discipline and persistence. Having discipline means that you sit down in your studio and produce every day, whether you feel like working or not. And you must run your freelance business like a business, keeping everything organized, meeting deadlines when you receive assignments, and always producing high-quality, professional work.

Persistence is the key to making it in this business, though. You must continue to refine and submit your work, despite rejection. You must get out there and knock on doors, show your portfolio to everyone who's willing to take a look, give your business card to every new contact, and do everything you can to sell yourself and your talents. If you keep working at it and keep promoting yourself, you're bound to start making sales.

Preparing Your Cartoons for Submission

When trying to sell your gags or strip to magazines and syndicates, you need to pay careful attention to how you submit your work. (That goes for comic book artists, too.) Following the guidelines and preparing a professional submission package can determine whether an editor even bothers to look at your work.

The first and most important rule is to know your markets. Study the market first and only submit work that matches the general tone and style of other cartoons or comics that market publishes. Don't waste the editor's time (or indeed your own) by submitting inappropriate work.

The second crucial rule is to follow the publisher's guidelines. Every publisher is very particular about how they like to receive submissions. Some publishers prefer cartoons to be submitted at a particular size or on a particular type of paper. Some specify exactly how many submissions you

can send at a time. All publishers make their guidelines readily available to aspiring cartoonists. Simply check the publisher's website or send the publisher a letter requesting the guidelines. If you go the postal route, be sure to include a self-addressed, stamped envelope (SASE). SASEs make editors' lives easier and ensure that you get a reply. Be sure to attach the correct amount of postage.

Finally, when you submit your work, prepare a professional presentation. Nothing says "amateur" like sloppy submissions. Here are some other general guidelines to follow:

- Submissions should be clean, with no stains, folds, or tears.
- Leave plenty of white space around the drawings for the editor's notes.
- Make certain that all lettering doesn't contain any misspellings or grammar errors. Write captions underneath the drawing in pencil and place them inside quotation marks.

Creative Inkling

Cartoonists often resubmit their work many times to different markets or even to the same market. Some cartoons are sold years after the gag was first conceived. Don't give up! Keep circulating every idea you think is worthwhile.

- Stamp the back of each drawing with your name, address, and phone number. Loose sheets often get separated, especially when passed around from editor to editor.
- Never send originals! Only send copies that you don't mind getting lost in the mail or at the publisher's offices.
- Always include a SASE with unsolicited work for a reply and the return of your materials.

Besides these general rules, you need to follow some specific guidelines depending on whether you're submitting gags to magazines or a strip idea to a syndicate.

Submitting a Batch of Gags

Don't bother submitting a single cartoon but don't flood the editor with a huge pile, either. Submit a batch of cartoons to each magazine at a time, between 6 and 15 cartoons per batch (but check the magazine's guidelines for specific requirements).

Established cartoonists often send *roughs* in order to sell their ideas before producing the finished work. They can do this because editors already know their style and so they have a good idea of what the finished work will look like. As a beginner, you should probably go ahead and submit finished cartoons. You don't want to give the editor another reason to reject you.

'Toon Talk

A **rough** is a semi-finished sketch of a cartoon that you produce first in order to get the gag down on paper. Some cartoonists submit their roughs to editors before producing finished work. Many cartoonists draw what are known as "finished roughs" in order to preserve the spontaneity of the original cartoon.

Generally, submit copies of your gags on separate sheets of white 8½-by-11-inch paper, at least 16-pound weight. Heavy typing paper is a good choice, because it's a standard size that's easy to mail, file, and handle. Mail the cartoons flat in a 9-by-12-inch manila envelope with a heavy cardboard stiffener to protect them. Always address the envelope to the cartoon editor by name; get the name from the magazine's masthead or website. Don't forget to enclose a SASE of the same size with the same number of stamps.

You don't have to send a long cover letter with your submission, since it's obvious that you're offering cartoons for sale; a short note should be sufficient. Never send a letter that tells your life story or why you've always wanted to be a cartoonist—editors don't have time to read it, and it screams "unprofessional!" When you're trying to make your first sale to a particular market, you could include a clip or two of previously published work, but that's not necessary (follow the guidelines).

Now is the time to set up a system for keeping track of submitted cartoons. Remember the rule about running your business like a business—that means getting organized. Without some kind of system, you'll lose track of which cartoons you've submitted to each market, which ones the magazine accepted and rejected, when accepted cartoons will be published, and whether you've been paid for them.

A standard system used by many cartoonists is to number each cartoon and track submissions by number in a ledger or spreadsheet software program. What's nice about this system is that you can number the back of the original and each copy you make, as well as all related correspondence. Alternatively, you can make a photocopy of each rough, store it in a file folder or notebook, and record all submission efforts on that copy. It's not really important exactly what your system is, as long as you have a system that works for you. You should also keep some kind of record of all likely markets, noting editors' names, mailing addresses, and important details from the market's submission guidelines.

Red Ink Alert

Don't submit the same gag idea to more than one magazine at a time—what is known as a "simultaneous submission." Nothing is more irritating to an editor than to offer to buy a cartoon only to find out it has been sold somewhere else.

You should also get on a regular submission schedule now. You'll make a better impression by submitting a new batch of cartoons every week or two, rather than just a few times a year. Generally, you'll receive an answer within two or three weeks. If that answer is a rejection, send the cartoons right back out to the next market on your list.

Submitting a Strip Idea to the Syndicates

Above all—and we can't emphasize this enough—follow the syndicate's guidelines when preparing submissions. That being said, here are some general rules to keep in mind.

The first page in the submission package is a very brief cover letter (one or two paragraphs—certainly no more than a page), summarizing your idea. Be sure to provide any other information that might help sell your strip. For example, if your strip already appears in some newspapers and/or magazines, say so. It's also a good idea to mention relevant professional qualifications and experience, if you have any.

Next comes the character sheet. This page shows sketches of each of your major characters, along with their names and very brief descriptions. Ideally, these sketches depict the characters' entire bodies in active poses, preferably interacting with other characters. This is your first chance to show what you can do, so make the most of it: Be visual, be clever, be funny.

Follow the character sheet with 24 of your best strips on 8½-by-11-inch paper, 6 daily strips per page. Sending a month's worth of strips shows that you can consistently produce good artwork and funny gags, and that your idea has long-lasting potential. Be sure to put the strongest jokes first; editors will remember the first strips best, and they may never even read the later ones. Mail everything in a 9-by-12-inch manila envelope with a cardboard stiffener and a SASE.

From the Pros

Scott Adams of *Dilbert* fame received rejections from five major syndicates before he sold his strip to United Media. He was one of the lucky ones, though; his strip sold on his first simultaneous submission attempt. *Dilbert* now runs in more than 2,000 newspapers worldwide. Adams has posted his original submission package in its entirety and all the responses he received from the syndicates—ranging from form letters to personal critiques—on his website at www.dilbert.com. Studying his example can help you figure out how to put together a submission package that will (eventually) sell.

Unlike with magazine submissions, simultaneous submissions are acceptable when dealing with the syndicates. That's because syndicates can take so long to respond, often several months. And if you're lucky enough to receive two offers, you're in a better position to negotiate. (More on that in Chapter 28, "Legal Stuff.")

Marketing Yourself with Mailers

The best way to approach a new market—an art director at a magazine or publishing house, an ad agency or business, a clip art or stock illustration broker, or a comic book publisher—is by mailing samples that showcase your work and your general style.

A mailer usually consists of a single page of several samples of your work or even a professionally printed brochure. You might choose to enclose *tearsheets* showing your previously published work. Also include a brief cover letter (typed on your own personal stationery) that outlines your qualifications and previous experience. Be sure to clearly state that you are available for freelance work. Mail the samples flat in a 9-by-12-inch manila envelope. You might choose to include a preprinted response card (with postcard postage attached, of course), so that the art director can easily get back to you.

'Toon Talk

A **tearsheet** is an actual copy of a published work. Tearsheets impress art directors because they are proof that you have professional experience and that you can complete assignments to specification by the deadline. When you finish an assignment, be sure to ask for copies of the printed pages on which your illustrations appear for your files.

Creative Inkling

Art directors like to work with illustrators who own fax machines or who are connected to the Internet, or both. This enables them to quickly send assignments and exchange roughs with editing suggestions. Be sure to invest in both of these vital pieces of office equipment.

The trend today, though, is for more streamlined sample submissions. You can save the art director some time (and yourself some money on postage) by preparing postcards showing two or three well-chosen samples. Include contact information so that interested art directors can get in touch with you. It's a simple matter to have professional-looking postcards printed these days; copy centers like Kinko's provide this service for a relatively low cost.

Regardless of which method you choose, you should send samples out to as many art directors as your budget allows. Be sure to address your mailings to art directors by name; checking the magazine's masthead or calling the company directly will usually yield the art director's name.

Don't rely on one mailing to win assignments. Every few months, mail out a new batch of samples to each art director on your list, and add additional names to your mailing list as you come across them. As a general rule, it takes about three mailings for your name to register with art directors. Also, follow up any personal meetings with a sample mailing to keep your name fresh in their minds.

If you want to be a successful freelancer, you have to be proactive. Always be on the lookout for new markets, particularly unusual ones where you won't face a lot of competition. Get your name in sourcebooks, creative directories listing freelancers that art directors consult when searching for new talent. Enter competitions and contests; if you win, the exposure you'll get can be invaluable. Join professional organizations (see Appendix D, "Professional Organizations"), and attend conventions and trade shows regularly. Have business cards handy to give out to new contacts when you meet them. Don't forget to include a sample on your business card, as well—that's yet another place to showcase your work.

The Portfolio: The Artist's Main Marketing Tool

A *portfolio* is an essential tool for presenting your work to art directors, ad agencies, corporations, comic book publishers, animation studios, and anyone else to whom you want to sell your talents. In fact, you'll probably

have to put together several portfolios that showcase different types and styles of your work for different kinds of markets.

Neatness and careful organization are the keys to a professional portfolio. You don't have to have an expensive carrying case; a binder is usually sufficient and much more portable. Above all, your portfolio should showcase your best work, demonstrate a consistent drawing style, and provide samples that are applicable to the market you're approaching.

Generally, your portfolio should consist of no more than three to five double-sided pages, showcasing six to ten strong samples. Stick to a consistent style within one portfolio. Using loose-leaf binders enables you to easily rotate samples in and out, depending on the market you're approaching.

Keep the following rules in mind when assembling your portfolio:

- ◆ Label your portfolio on the outside with your name, address, and phone number. It's a good idea to stick a few business cards inside to hand out to everyone you meet.

- ◆ Choose a size that can be handled easily and is inexpensive to mail.

- ◆ Select your best, most current work for display. Begin and finish the portfolio with your strongest pieces.

- ◆ Organize interior pieces; for example, group all black-and-white drawings on one page and color on a separate page.

- ◆ Anchor all artwork and protect it with transparent plastic sleeves.

- ◆ Make at least one copy of every portfolio so that you'll still have one on hand in case you need to mail or leave one with a potential client.

Often you'll make an appointment with an art director to show your portfolio in person. Some magazines and ad agencies have drop-off policies: They accept portfolios one or two days a week, review them for a week, and then return them to artists. Only include originals in your portfolio if you're going to actually be present for the review.

'Toon Talk

A **portfolio** is an organized collection of sample artwork, published and unpublished. Many portfolios show artwork in different stages—roughs, comps, and finished projects—to demonstrate how you complete assignments.

Your Very Own Website

The rapid growth of the web has given the freelancer a powerful new marketing tool. In fact, it's rare for any business not to have an online presence these days. Setting up a website is easy and cheap, so there's no excuse not to do it. At a minimum, your site should showcase plenty of samples of your work and provide several user-friendly ways to contact you. Sites that offer some free content—a weekly cartoon, for instance, or a few pieces of free clip art—are more attractive to casual browsers.

Entire books have been written on how to design and maintain websites, so we won't get into the nitty-gritty details of that here. Here's one vital tip, though: Get your own domain name. (The domain name is the dot-com part of a website address.) It won't cost you much, and it makes your site look like a "real" business, rather than an amateur home page. Much has been made of the scarcity of good domain names, but if you're creative, you can find one that's still available. Your own name or a variation of it is a good bet. Some new companies pick their names solely based on available domain names.

Red Ink Alert

Unfortunately, the web makes it all too easy for others to steal your work simply by copying it to their computers. One way to prevent this is to write copyright notices directly on all the artwork you publish on your site (Chapter 28 tells you how to compose a copyright notice). Also, don't publish artwork that you hope to sell somewhere else on your site.

Once your website is up, don't expect the crowds to beat down your door. But it is useful to have a web address where you can direct potential clients to see examples of your work. Put your website address anywhere and everywhere: on your stationery, business cards, and even inside your cartoons themselves. (Website addresses go in the corner of a single-panel gag or in the gutter between panels.)

The Least You Need to Know

- The keys to selling your cartoons to magazines and syndicates are carefully preparing professional submission packages, following guidelines to the letter, and submitting consistently until you break through.

- Sending samples is a proven way to win assignments from art directors and ad agencies; cumulative mailings garner the best results.

- Your portfolio is your most essential marketing tool, so make sure it's organized and professional-looking, and that it showcases only your very best work.

- More cartoonists are turning to the web as a promotional tool; promote your unique website address at every opportunity.

Chapter 28

Legal Stuff

In This Chapter

- ◆ Deciphering copyright and putting it to work for you
- ◆ Figuring out which rights to sell when you sell your artwork
- ◆ How does work for hire work?
- ◆ Understanding and negotiating contracts

Artists and other creators frequently misunderstand copyright, and no wonder—copyright law is complex and cumbersome, and there's a lot of misinformation out there. What exactly are your rights when it comes to the cartoons and other artwork you create? What rights do you keep and what do you give away when you sell that artwork to a publisher? How can you protect your rights when signing contracts and negotiating licensing deals?

This chapter will answer those basic questions. The most important thing to understand is that, as a creator of an artwork, you possess certain inherent rights over your work, and you have control over how that work is used—until you sell or give away those rights, that is. It's up to you to protect your rights, though, which is why it's in your best interest to understand exactly how copyright works and how you can put it to work for you.

The Lowdown on Copyright

What exactly is *copyright*, anyway? At its essence, copyright encompasses all the ownership rights you have to an original artwork or any other creative work you create. That means that as soon as you put pen to paper, you possess very specific rights to the drawing that results. You can choose to sell or give away those rights as you see fit.

For a work to be protected by copyright, it must satisfy three fundamental requirements:

- ◆ It must be original; it can't be a copy or an alteration of someone else's work.
- ◆ It must demonstrate minimal creativity; basic facts and listings (like a list of telephone numbers) are not protected by copyright.
- ◆ It must be fixed to a tangible medium; it has to be put on paper, canvas, CD, videotape, computer disk, or some other physical medium.

'Toon Talk

Copyright is a legal right that protects an original creative work, such as a drawing or a piece of writing, from unauthorized use, publication, alteration, or copying by parties other than the creator of the work. The creator of the work is its legal owner until he or she sells the rights to the work or places it in the public domain.

Copyright enables you to maintain control over your own creations. As long as you hold the copyright, you are the one who determines where your cartoons are published. Only you can grant permission to others to make copies of your work. Only you can decide whether someone can create derivative works based on yours or adapt your work for some other use, like a movie or TV show. Only you can decide whether your cartoon character appears on a T-shirt or in a calendar or on any other product.

Copyright protects only the unique expression of an original idea; it doesn't protect titles or character names. Trademarks protect any word, name, or symbol used in business to distinguish one product, service, or company from another—a brand name. For more information, visit the U.S. Trademark and Patent Office's website at www.uspto.gov/main/trademarks.htm.

Myths and Misunderstandings About Copyright

Many people hold mistaken ideas about what copyright is and what it isn't. The following are some widely held copyright myths and the facts you should know:

- **Myth: You can copyright ideas.** Copyright doesn't protect individual ideas, just the unique way you express those ideas. If you have an idea for a comic strip that's about—for example—a young child and his invisible friend, you can't prevent any other cartoonist from also drawing a strip about that general idea. You can prevent other cartoonists from drawing strips about a young boy and his invisible friend who's really a stuffed tiger, though (or you could if you were Bill Watterson, creator of *Calvin and Hobbes*).

- **Myth: You can copyright titles and names of characters.** You can't legally copyright a title of a comic strip, short catchphrases, the names of characters, or those characters' basic traits. You may be able to trademark these, though.

- **Myth: You can't copyright work on your computer; it has to be on paper.** Copyright applies to any work that is fixed in a tangible medium—that includes bits and bytes, according to the law. So if your artwork resides only on your hard drive, a floppy disk, or CD-ROM, it's still copyright-protected.

- **Myth: All works on the Internet are in the public domain.** Copyright applies equally to original works published on the Internet, including on websites, in e-mail, and in postings to discussion groups. Just because a work is easy to copy doesn't mean it's legal to copy it.

- **Myth: You can copy whatever you like; it's "fair use."** According to copyright law, fair use is using a copyright-protected work only for very specific purposes: criticism, news reporting, teaching, or research. Fair use is generally more applicable to factual works than creative works.

Red Ink Alert

Never offer for sale a cartoon that was published first by another cartoonist—that's called plagiarism. Cartooning is a small field; everybody sees everything, so you will get caught, and that will pretty much put an end to your cartooning career.

- **Myth: Copyright lasts forever.** Once registered, copyright only lasts for the life of the creator plus 70 years. After that, the work enters the public domain.

- **Myth: To copyright a work, you have to register it with the Copyright Office.** An original work is copyright-protected from the moment of its creation; no formal notice or official registration is required. However, copyright notices and registering your copyrights offer legal protections, as explained in the next section.

Copyrighting Your Cartoons

As soon as you produce an original cartoon or other artwork, it belongs to you, and you own its copyright (the exception is artwork created under work-for-hire arrangements, explained later in this chapter). You don't have to take any steps to copyright that image; it's automatically protected.

It's a good idea to put a copyright notice on all your original drawings to tell everyone who the owner of the copyright is and when the work was created or first published. Though a notice isn't required for you to legally assert your copyright, it does keep someone from claiming that they didn't know the work was copyright-protected. A copyright notice simply consists of the word *Copyright* or the equivalent symbol ©, followed by the date and the creator's full name: © 2002 John Smith. You must put this notice where it can easily be seen, such as in the corner of your cartoons or in the gutter between panels. It's also acceptable to put the copyright notice on the backs of drawings when submitting them for publication.

A further step is registering your copyright with the Copyright Office at the Library of Congress. This isn't necessary, though, unless the work is going to be published. Generally, when you publish a cartoon in a magazine, newspaper, or book, the publisher will register the copyright for you in your name (this should be spelled out in your contract). If you plan to self-publish in print or on the Internet, you should register the copyright yourself.

Registering a copyright is a fairly simple process. Call the Copyright Form Hotline at 202-707-9100, and ask for Package 111 and Circular 44. Or write to the Copyright Office, Library of Congress, 101 Independence Avenue S.E., Washington, DC 20559-6000. You can also download the forms from the Copyright Office's website at www.loc.gov/copyright.

In return, you'll receive a copyright registration form. Fill it out and return it to the Copyright Office along with the registration fee and one copy of the work for unpublished works or two copies for published works. Typically, the registration process takes four to five months.

It's important to officially register your copyrights (or make certain they're registered for you) within 90 days of publication of your work. This enables you to enforce your rights against infringers, people who use your work in an unauthorized way. Even if you don't register the copyright, you can still sue people who copy or misuse your work, as long as you can prove the work is original to you. But you can only collect statutory damages and legal fees if you have registered the copyright.

> **Creative Inkling**
>
> You don't have to register copyrights before shopping your work around to editors. Newcomers often have a fear that unscrupulous editors will steal their ideas, but this rarely—if ever—happens. If you feel you have to put a copyright notice on your unpublished cartoons, make it small and unobtrusive. You don't want to risk offending an editor who might buy your work.

Selling Your Copyright

Copyright actually refers to a whole group of rights. These rights specify the media in which a work can be published, the geographic areas and languages where it can be published, and for how long the publisher can distribute that work. As owner of these rights, you can sell them to publishers and licensers as a complete package or sell each right off individually.

Even when you sell a cartoon to a magazine or another publication, the publisher should return the original artwork to you after the cartoon has been published. They are buying the rights to *reproduce* the cartoon, not original artwork (unless that's specified in the contract). Sometimes you can resell an original—yet another way to make extra money off one cartoon.

Each one of your rights has value in the form of potential income for you. So the more rights you sell, the more you should be paid for them. But it's in your best interest to maintain control over as many of your rights as possible. You just don't know when a particular artwork is going to be the breakout idea with the potential for earning you a fortune.

Your Rights and How to Sell Them

The following is a typical list of the rights to one cartoon that you can sell:

◆ **One-time rights.** The cartoon is "leased" for one use: one appearance in a magazine, for instance. The buyer has no guarantee that they are the first to publish the piece. After the piece is published, all rights revert to the artist. This is the best deal for you, so it's rare that a publisher will agree to buy one-time rights.

◆ **First rights.** This is the same as one-time rights, except that the buyer is purchasing the right to publish the cartoon for the first time anywhere (and possibly paying slightly more for the privilege). Still, the buyer can only use the cartoon once, and then all rights revert to the artist.

◆ **Second or reprint rights.** This gives a publication the right to reprint your work for one use after it has already appeared in another publication. You'll probably be paid much less for reprint rights.

◆ **Exclusive rights.** This guarantees the buyer's exclusive rights to use the cartoon in one market or for a specific product. If you sell exclusive rights to a greeting card company, then you can't turn around and resell the cartoon to a competing company for use on greeting cards, but you can resell it to noncompeting markets.

◆ **Subsidiary rights.** This covers any additional rights that the buyer purchases. Each separate right must be specified in the contract. For example, a book publisher might want to reserve the right to use your cartoon in a paperback or book club edition of the book. Subsidiary rights can also refer to movie and television deals, merchandising, and other potentially moneymaking licenses.

◆ **Electronic rights.** This grants the buyer the right to publish the work in electronic format, usually on the Internet. Electronic rights have become a standard part of most publishing contracts, but since the term is so vague, it's a good idea not to sell these away if you can help it. At least try to negotiate a separate fee for electronic rights.

> **Creative Inkling**
>
> While we're on the subject of money, keep in mind that freelancers can deduct any legitimate business expenses from their income taxes. That includes studio rent or the expenses of keeping a home office, art supplies, advertising and printing costs, books, subscriptions, and dues. To prove you are a professional, you'll need to demonstrate efforts to sell your work, so keep those rejection slips.

◆ **Geographic rights.** This specifies where in the world the cartoon can be published, including the languages it can be published in. Typical divisions are "world rights," "North American rights," and "English-language rights." If the publisher intends to sell your cartoon to an international market, you should get paid more. Geographic rights are often combined with other rights. For example, most U.S. magazines ask for "first North American serial rights," which gives them the right to publish the cartoon for the first time in a magazine (serial) in North America.

◆ **Promotion rights.** This allows the publisher to use your work for the promotion of a publication in which the cartoon has appeared.

◆ **All rights.** Just as it sounds, this involves selling all your rights to a particular artwork for a specified piece of time. During that time, the publisher can do whatever they like with the artwork. It's never a good idea to sell all rights.

In addition to selling kinds of rights, you must specify in the contract for how long the publisher gets to keep those rights. So a better analogy is that you are "leasing" your rights for a particular period of time. One-use rights, for instance, restrict the publisher to a one-time use of the artwork. Exclusive rights, on the other hand, may be good for years.

It's best to restrict the period for which you sell the rights as much as you can; that way, if the cartoon becomes popular, you can negotiate a better deal when the terms of the contract expire. Some publishers try to buy rights "in perpetuity," which means forever. Avoid that clause at all costs!

Recycling Your Cartoons Through Reprints

If you have sold first rights for a cartoon, there's nothing to prevent you from selling that same piece again and again, as many times as you can. This is how a lot of cartoonists make their money. If you have retained the rights to your cartoon, you can sell reprints for publication in other magazines, book collections, textbooks, foreign journals, ads, greeting cards, newsletters, bulletins, websites, and anywhere else you can think of.

Reprint fees are often lower than first-use fees, but they are fairly negotiable. The type of use determines the fee; advertising typically pays more than small magazines, for instance.

If you offer a cartoon for resale, you must tell the potential publisher that the cartoon has been published elsewhere and, thus, first rights are no longer available. Some magazines won't even consider reprints or offer a significantly lower fee for them, but don't let that stop you from being honest. If you're caught, you probably won't make any more sales to that market.

The additional income that can come from reprints underlines how important it is to keep reprint rights when you sell your cartoons. If you retain control over your work, then only you can grant permission to others to reuse that cartoon, and only you will get paid for the reprint—not the original publisher. When you sell a cartoon for the first time, get it in writing that you are selling first rights only. Most magazines automatically follow this practice, but it doesn't hurt to make it clear.

Making More Money Through Licensing

When you retain ownership of your copyright, you also retain creator rights. That means you control the character or concept you created. Creator rights give you a big stake in any merchandising sales, derivative movies, and television shows, and the like, that result from your creation.

Given the huge sales gained from the licensing of well-known characters from strips like *Peanuts*, *Garfield*, and *Bloom County*, or the movie deals that can arise out of popular comic books, retaining creator rights can mean big bucks for the cartoonist. Keeping creator rights may seem much more crucial to the strip cartoonist or comic book artist than to the gag cartoonist, but you never know what might make a big splash. Don't forget Charles Addams, whose gag cartoons inspired a television show and two movies.

Licensing refers to any sale you make that allows a company to reproduce your artwork for a limited time and/or for a specific purpose. In exchange, you receive a one-time fee or better yet, a share of the profits. After the term of the licensing agreement expires, the rights revert to you, the creator.

Syndicates and comic book publishers are particularly notorious for purchasing all creator rights and then making big bucks on licensing deals, while the cartoonist doesn't see a dime. In the old days, cartoonists often didn't have a choice but to sign all rights away. Now syndicates and publishers are much more willing to negotiate contracts and give cartoonists a stake in the profits from their creations.

When you think of licensing, you probably think of stuffed Snoopys, *Far Side* calendars, and Opus T-shirts. But good licensing deals don't always result from popular comic strips. You might license an image that you originally sold for a greeting card to a toy company to produce a stuffed animal, to an art publisher to make posters, or to a novelty manufacturer for use on coffee mugs. You never know when one of your cartoons will generate income through licensing.

That's why it's so crucial to read and understand every part of your contracts when you sell your work (we'll talk about contracts in more detail in the next section). Some publishers try to buy all rights, which includes creator rights, outright or for exceedingly long terms for a one-time fee. It's much more to your advantage to negotiate *royalties*, or a percentage of all future sales. You also want to limit the time period of

the contract, so that you can renegotiate for better terms if your idea proves to be popular.

If you receive a licensing offer, you may jump at it without careful thought, convinced you've hit the big time at last. Every deal is negotiable, though. Research the potential licensee before you sign anything. Does that company generally produce high-quality products? Will you be proud to have your creation appear on their products? Are the people you'll be doing business with willing to listen to your ideas and suggestions?

Even if you like and trust the company, try to keep control over as many rights as you can. Limit the term of the contract, preferably to five years or less. Try to retain the right to license the same image to other companies, as long as it is used for different products. If the licensee is particularly hot to make a deal, you might be able to have some say over the quality of the materials used to manufacture the product or the venues where the product is sold.

No Rights at All: Work for Hire

When you are just starting out, you may choose to sell your artwork under a work-for-hire agreement. This means that you are selling the artwork outright to the buyer. Work for hire is different from selling all rights because you don't even get to keep authorship of the work. After you get paid, the buyer is the legal author. The buyer can use that image in any way they like, reuse it again and again without further compensation to you, and keep all the profits from future sales of the image.

If that sounds like a bad deal, it is. But going the work-for-hire route may be the only way to break into a particular field. If you work as a freelance artist on an established comic book, for instance, you'll probably have no choice. Also, if you become an employee of a company, such as an animation studio, then all the work you produce while doing your job belongs to the company, not to you.

From the Pros

The classic cautionary tale about work-for-hire agreements concerns Jerry Siegel and Joe Shuster. As young artists in the 1930s, they created a little character named Superman. They sold the concept to DC Comics, signed a customary form that relinquished all their rights to the character, and missed out on a fortune. In 1947, Siegel and Shuster went to court but were denied their claim to ownership of Superman. In the 1970s, with a multimillion-dollar film coming out and young cartoonists actively campaigning for Siegel and Shuster's rights, DC tried to avoid negative publicity by offering the two a lifetime pension of $20,000 per year. If they had kept their creator rights, though, they would have been millionaires.

Fortunately, you can't accidentally give away your rights. You have to sign your rights away. Unless you are an employee of the company, you must sign a contract that specifically states that the agreement is a work-for-hire arrangement. The lesson is to read everything before you sign, understand every word, and get legal advice when you don't.

Contracts: Friend and Foe

Contracts can be scary. They're long, they're convoluted, and they're full of legalese. When you're excited about making a sale, who wants to take the time to read a contract? It often seems so much easier just to sign the thing and worry about what it says later.

You'll do better if you think of your contract as a handy way of making certain that you and the licensee are in complete agreement. Until a contract is signed, it's completely negotiable. Everything in a contract can be changed, as long as both parties agree.

Every time you license a piece of artwork, you need to get a contract. That may seem like a big pain, especially if you're just selling a single gag to a magazine, but you'll save yourself a lot of headaches in the long run if you take the time to put the terms of the sale in writing.

You don't need a team of lawyers to produce a contract. It can be as simple as a one-page letter specifying that you are selling the magazine the cartoon for first or one-use North American rights and giving the amount of the sale. You can draw this up yourself and send it to the editor for his or her signature.

For bigger deals, you're going to need a more thorough contract. Usually, the publisher or licensee provides the contract. Read it carefully. Make sure the terms are as specific as you can make them: The contract should spell out what the licensee is buying your cartoon for, what rights you are selling, how much you're getting paid, when you get paid, and how long the agreement lasts. Understand every word of every clause.

If you have questions, it's worth it to hire a lawyer to look over the contract. Look for one who deals specifically with artists' contracts (fellow cartoonists and professional associations are good sources of referrals).

Don't be afraid to negotiate your contract; too many creators make this mistake, afraid that the publisher or licensee will just walk away from the deal. Companies understand that this is a business arrangement, and most are willing to work out an agreement that's fair to both parties. If you don't ask, though, the licensee will naturally craft an agreement that benefits the company, not the artist.

If someone is interested enough in your work to want to license it, then your work is valuable. As creator of that work, you deserve to share in its value. You have to stand up for your rights as a creator. Not only do you stand to gain more from your creative work, but you are also fighting for the rights of creators who come after you.

Red Ink Alert

Magazines should always pay on acceptance, not on publication. When you sell a cartoon to a magazine that pays on publication, you run the risk of not getting paid: The magazine may go out of business; the artwork may get lost; a new editor may arrive and hate your cartoon. Make payment on acceptance part of your contract terms.

Creative Inkling

An agent can be a creator's best friend. Sure, you have to hand over a commission of between 15 and 25 percent, but the agent handles all the scary negotiations for you. Agents are often instrumental in opening new markets for your work, as well. Check *Artist's & Graphic Designer's Market* (see Appendix C, "Publications") for a list of artists' agents.

The Least You Need to Know

◆ Copyright is the right you have as a creator to the original work you create; as soon as you commit the work to a fixed medium, that work is copyright-protected.

◆ You can sell your copyright as one or more rights; when you sell rights, you specify where the work can be used, how it can be used, and for how long it can be used.

◆ Under a work-for-hire agreement, you relinquish all your rights to a work you created, including authorship of the work—not a good deal for the creator.

◆ Contracts may seem complicated at first, but remember that everything is negotiable and you're entitled to sufficient payment for your work; don't be afraid to get legal help if you need it.

Glossary

accent To place emphasis on an element of a drawing by converging lines (as in perspective), making it the largest element in the drawing, using spot color or thick lines, or implementing some combination of these.

accessory Any element of a drawing that isn't part of the primary idea or necessary to the premise but in some way supports it.

acetate Plastic material that comes in sheets or rolls, and is usually transparent or translucent. Acetate is used as a support for art or as an overlay, especially in animation.

acrylic A paint or ink in which the pigment is bound with a polymer; most are water-soluble.

additive colors Hues made with light rays, where all hues mixed together in equal amounts make white. Colors on the computer screen are additive colors. The primary additive colors are red, blue, and green.

advancing colors *See* warm colors.

agate A unit of measure in newspapers. One column inch equals 14 agate lines.

aging The process of letting a piece of artwork sit for a short while after it is finished before making final revisions.

airbrush A mechanical painting tool that produces a very fine spray of paint or ink.

all rights Signing away all rights of the creator to his or her creation for a specific period of time.

angular perspective *See* two-point perspective.

animation The process of linking slightly different drawings to simulate movement.

anime Japanese animation.

anthropomorphism The attribution of human appearances or traits to nonhuman objects or beings. Technically, it applies to gods, animals, and inanimate objects, but in the cartooning world, it is most often applied to animals.

art director The person who buys illustrations for a magazine, publishing company, advertising agency, or other business.

artist's pencil A pencil made of a mixture of graphite and clay encased in wood. The higher the ratio of clay to graphite, the harder the pencil; hardness is indicated by grade, with 9H being the hardest and 9B being the softest.

atmospheric perspective The illusion of distance as shown by detail, color, and contrast rather than by line.

automatic pencil A pencil that doesn't need sharpening.

balloons Shapes, typically circular, surrounding dialog in comic strips, with pointers indicating the person speaking.

basis weight The weight in pounds of a ream of paper cut to standard, or basis, size. Basis size varies depending on the grade of the paper.

benday tint *See* mechanical tint.

bird's-eye view A point of view of a scene looking down as if from a great height.

bite The tooth of paper or another drawing surface. A surface too smooth will not grab and hold dry pigments like graphite or chalk.

bitmapped graphic A graphic file on the computer that creates the picture one pixel at a time. This can result in detailed photographic images, but if expanded, they will begin to show jagged edges.

bleed To print a design beyond the borders of where it will be trimmed, so that there is no margin on one or more sides. Also refers to pigments that spread from one area into another or through a support like paper.

blocking-in Light, simple lines suggesting the basic masses of a subject with no details. It indicates the simplest form and plan of the composition.

book paper A standard grade of paper in printing, along with pulp and newsprint.

border The outer edge of an element marked in a visual manner, such as dots, dashes, a box, or some sort of decorative pattern.

break down The process of splitting the events of a strip's or comic book's story into separate panels.

Bristol board A high-quality, fine-calendered pasteboard used for pen and wash techniques.

camera angle The angle and width of a panel's viewpoint.

caption The dialog below a single-panel cartoon.

caricature A drawing of a person in which characteristic features are exaggerated for comic or satirical effect.

cartoon Originally large drawings on paper used as patterns for large paintings, frescos, or tapestries. The term became connected to humorous or satirical drawings due to an 1840s satire in the English comic weekly *Punch*.

cel Short for "cellulose acetate." A plastic sheet that comes in several degrees of translucence, texture, and color, and is used as a support for art, especially in animation, or as an overlay.

center of gravity The point where a vertical line is drawn with equal amounts of mass on both sides of the line.

center of vision The point in a drawing where the artist's vision is focused, or the center of interest.

character A person, animal, or anthropomorphic object that acts in the cartoon. Cartoon characters are of very specific personality types that can usually be summed up in one or two words.

charcoal A powdery substance made from charred wood and available in pencil or hard, pressed form.

chiaroscuro The technique of using the contrast between dark and light for dramatic effect.

cliché A readily identifiable situation or phrase that has become a part of our shared culture.

clip art Stock illustrations, usually sold in books or on CD-ROMs, that the buyers can use in any way they like for as long as they like.

colorist In the comic book industry, the artist who colors inked artwork.

colors *See* additive; cool; complementary; primary; secondary; subtractive; and warm.

comic book A story told with sequential pictures. Comic books are typically released as monthly issues, with the story continuing from one issue to the next. Originally the domain of superheroes and kiddie characters, comic books have evolved to encompass all genres and adult story lines.

comic strip A series of three or four small drawings, divided into panels, that tells a story or delivers a gag. Comic strips are most often found in newspapers.

compass A tool for drawing circles or arcs. Compasses come in a variety of types: A bow compass is used for smaller circles, a bar compass for larger ones. They may have a pencil arm, an ink pen arm, or a cutting arm.

complementary colors Pairs of colors directly opposite each other on the color wheel. The three sets of complementary colors are blue and orange, violet and yellow, and green and red.

composition The arrangement of elements, forms, and color in a picture to create a specific reaction.

computer animation Animation created entirely on the computer, rather than hand-drawn. Computer animation is generally three-dimensional in appearance.

continuity The quality of a comic strip that makes it a cohesive whole. Continuity is achieved through a uniform style of drawing, as well as through providing constants in each panel that tie the entire story together.

continuity-adventure strip A comic strip that tells a story that continues from one day to the next.

conventionalize To express the spirit or basic truth of an object by subordinating its less important features.

cool colors The section of the color spectrum in which blue and green are the dominant hues.

copyright The legal right of ownership that a creator has to an original creative work, such as a drawing or a piece of writing. For a work to be copyright-protected, it must be original, demonstrate minimal creativity, and be fixed in a tangible medium. Copyright prevents unauthorized use or copying by parties other than the creator of the work.

copyright notice A visible notice on a copyright-protected work that consists of the word *copyright* or the symbol ©, the date of creation or publication, and the full name of the copyright holder.

crayon Originally a fine chalk medium, as in pastels; now more often a wax-based medium.

creator rights The right of a creator to control his or her character or concept and to share in any profits gained from licensing that character or concept.

cross-hatching A shading technique where lines crossing each other are used to produce light and shadow effects.

cyan Process blue.

dry brush A brush with very little moisture or wet media, and a technique mostly used with watercolor or India ink.

Duotone A drawing board made by Grafix imprinted with two shading textures, which can be developed by brushing on a developer.

editorial cartoon A cartoon that comments on politics, current events, or society, usually in a satirical way.

electronic ink A technology that uses electronic capsules that can either be turned off (made the same color as the background) or turned on (made a different color). This enables images and printing to easily be changed with the push of a button.

electronic rights The right to publish a creative work in electronic format—on the Internet, for instance.

exclusive rights The right to reproduce a creative work in one market or for one use for a specified period of time.

fair use The legal use of copyright-protected material for research, news protection, criticism, or education.

ferrule The metal section of a brush that attaches the bristles to the handle.

first rights The right to publish a creative work for the first time.

fixative A clear varnish sprayed over artwork to protect it without altering it.

foreshortening The appearance of being short due to the angle of the perspective. An arm pointing directly toward you at or near eye level will be extremely foreshortened.

freelance To work for yourself rather than for an employer. Freelancers are generally paid by the hour, by the page, or by the project, and don't receive benefits or have taxes withheld from their paychecks.

gag cartoon A humorous situation, action, or comment shown in a single panel.

gag-a-day strip A comic strip that delivers a standalone gag each day, rather than telling an ongoing story.

geographic rights The right to publish a creative work in a particular part of the world or a specific language.

golden section A proportion frequently used in art and architecture that rounds out to 3:5. Also called *golden mean* and *divine proportion*.

graphic novel A book-length comic book containing a complete story. Graphic novels often have higher production values than comic books.

graphite A mineral form of carbon also known as *plumbago*. Graphite is the chief ingredient in pencils.

grylli Heads with limbs but no bodies. In extreme cases, they are simply a nose or eyeballs with limbs.

gum arabic A water-soluble gum made from the sap of the acacia tree and used as a binder in watercolor and pastel.

gutter The space between panels. Also called the *alley*.

hatching A shading technique using lines of varying strength and width from each other. Compare with *cross-hatching*.

hologram A three-dimensional image created with photographic projection.

horizon line A horizontal line at eye level.

house organ A magazine published by a company or an organization for their employees, stockholders, clients, or the press.

India ink Originally sticks made of fine lampblack and gelatin or other mild binders in China and Japan. A liquid form is sold in bottles in the West and comes in numerous variations for special uses. It may contain shellac, glues, acrylics, or other additives.

inker In the comic book industry, the artist who applies ink to the penciler's drawings, making them ready for printing.

letterer In the comic book industry, the artist who draws all the lettering and speech balloons.

lettering In cartooning, the process of writing in dialog, usually contained in balloons.

letterpress A printing process in which ink is transferred from a raised printing surface.

licensing An agreement granting a company the right to reproduce artwork for a limited time and/or for a specific purpose.

litho crayon A greasy crayon used on kid or rough pebble-like surfaces that comes in cake, liquid, and stick form.

lithography A printing process that relies on the fact that water and oil repel each other.

magenta Process red.

manga A Japanese comic book.

mechanical tint A tint consisting of a dot or line pattern that can be laid down on artwork before or during processing for reproduction.

morgue Refers to the cartoonist's library of pictures and photos of people and things that may be of use as references when drawing.

nonphoto blue pencil A pencil that draws light blue, a color that won't be picked up by cameras. Often used to draw roughs because the pencil lines don't need to be erased from the final drawing.

nutgall A nutlike growth on some trees or plants near the leaf stem caused by an insect laying its eggs there. Nutgall is rich in tannic acid. The quality varies depending on the plant; the Oriental oak is generally considered the best.

one-point perspective Perspective where two elements of a drawing are parallel to the picture plane, usually a horizontal line and a vertical line. The receding parallels meet at a single point on the horizon.

one-time rights The right to publish a creative work one time only.

overlay A transparent sheet of paper or film used in the preparation of colored artwork or to indicate instructions for reproduction.

page rate In the comic book industry, the price paid for each page of an issue that an artist produces.

panel A boxed-in cartoon; a strip is composed of multiple panels.

penciler In the comic book industry, the artist who lays down the initial artwork in pencil.

persistence of vision The ability of your eye and brain to retain a visual image for a short period of time (about $1/30$ of a second).

perspective The illusion of depth and three dimensions on a flat surface.

pica A printing measure made up of 12 points. There are six picas to an inch.

picture plane In perspective, the imaginary plane between the artist and the object that represents the paper or surface on which the object will be drawn.

pigment The coloring matter of paints and dyes.

pin-up A single page showing a comic book character in a flashy pose.

plagiarism Passing off another creator's work as your own.

point A printing measurement. For all practical purposes, there are 72 points per inch, or 12 points per pica. Technically, a point is 0.01383 inch.

portfolio An organized collection of sample artwork, published and unpublished.

primary colors Pure colors from which all other colors can be mixed. In subtractive color, the primary colors are red, blue, and yellow; in additive color, they are red, blue, and green.

print on demand A form of self-publishing that prints single copies of an artwork or book upon its sale, reducing printing costs and enabling works to stay in print indefinitely.

process colors The breakdown of colors by camera filters for duplicating colored artwork in print. Generally stated as CMYK, C being cyan, or blue; M being magenta, or red; Y being yellow; and K being black.

promotion rights The right to use a piece to promote the publication in which it appears.

props Any inanimate objects needed in the drawing to enhance, clarify, or act as a vital element in the concept. Anything can be a prop, but it should be vital to the gag or story.

protractor A semicircular instrument divided into 180 degrees for the measurement of angles.

query A letter, no more than one page, sent to a publisher or licenser to gauge interest in unsolicited ideas before sending artwork or samples.

rough A semi-finished sketch of the final cartoon.

royalty The percentage of the profits that the creator earns every time a publication or product featuring that person's artwork is sold.

ruling pen A drafting tool used to draw straight lines.

SASE Stands for "self-addressed, stamped envelope." A requirement when submitting unsolicited material to any publisher if you want the material returned.

second rights The right to reprint a previously published creative work.

secondary colors The colors that result from mixing primary colors.

self-publishing Publishing, marketing, and distributing a creative work, such as a book or comic book, yourself instead of through the traditional publisher.

self-syndication Promoting and distributing an ongoing strip to newspapers and magazines yourself rather than through a syndicate.

sight gag A cartoon without a caption. The humor is conveyed entirely through the artwork.

slant The subject matter of a collection of cartoons.

spec Short for "speculation." Working on spec means doing the work first in the hopes of selling it later.

splash page The first page of a comic book, with a large introductory image.

spot A small, captionless illustration used in magazines, newspapers, and books to break up the text and lead readers from one feature to the next. Spots are essentially decorative or conceptual, but not necessarily humorous.

station point In perspective, the position from which the object is being viewed.

stereotype A character that fits the general idea of what that person is like; a basic personality "type."

stippling A freehand shading technique using dots.

stock illustration An illustration licensed for reprinting through a broker on a "pay-per-use" basis.

subsidiary rights Additional rights to sell or use a creative work specified in a contract.

subtractive colors Pigment-based colors where, if the primary colors are mixed, they produce black, and an absence of color is white. The opposite of *additive colors*. The primary colors are red, blue, and yellow.

syndicate An agent that sells comic strips, single-panel cartoons, and editorial cartoons, along with other creative material, to newspapers and magazines. The syndicate packages, promotes, and distributes features in exchange for a share in the profits.

tearsheet An actual copy of a published cartoon or illustration.

thumbnail A small, quickly done sketch used to explore layout and composition before beginning the actual drawing. Also refers to a small version of a computer graphic file.

tone The measure of light and dark in a drawing.

trade journal (TJ) A magazine aimed at a particular trade or profession. TJs only buy cartoons that will appeal to their target audience.

trademark Legal protection of a name, title, or slogan that is used as a brand name for selling goods or services.

triangle A drawing tool, usually made from a transparent material. Triangles typically come in 30-, 45-, 60-, and 90-degree forms.

T-square A straightedge attached at right angles to a head.

two-point perspective Only one dimension is parallel to the picture plane, usually a vertical one. Two vanishing points are needed for an object. No surface faces the picture plane; the objects are at an angle to it. Also called *angular perspective*.

vanishing point In perspective, the point at which parallel lines appear to meet in the distance. The vanishing point is most often at eye level, but not always.

vector graphic A computer graphic file that describes shapes by mathematics. There are no jagged edges, no matter how much the images are enlarged, and the files are smaller.

warm colors The hues in which red and yellow predominate. Also called *advancing colors*.

wash A tone applied to a drawing using a diluted media like watercolor or ink, resulting in a transparent tone.

watercolor Finely powdered pigment mixed with gum arabic, a water-soluble resin.

woodcut A drawing cut into the side of a plank.

work for hire An agreement in which the buyer purchases creative work outright from the creator. The buyer then becomes the official author of the work.

worm's-eye view A point of view of a scene looking up as if from the ground.

yellow journalism Refers to sensationalistic, melodramatic newspaper reporting. The term was spawned by the character of the Yellow Kid, the subject of competing cartoons in the *New York World* and the *New York Journal*, and came to be associated with the papers' journalistic style.

Bibliography

The following is a well-rounded collection of books for every aspiring cartoonist's library, broken down by subject. You don't have to run right out and buy every book listed here, but you should probably get one or two from each subject category—more on the genre(s) you're most interested in working in.

History and Study of Comics

Blackbeard, Bill, and David Crain. *The Comic Strip Century: Celebrating 100 Years of an American Art Form*. Northampton, MA: Kitchen Sink Press, 1995.

Eisner, Will. *Comics and Sequential Art*. Tamarac, FL: Poorhouse Press, 1994.

———. *Graphic Storytelling and Visual Narrative*. Tamarac, FL: Poorhouse Press, 1996.

Harvey, Robert C. *The Art of the Funnies: An Aesthetic History*. Jackson: The University Press of Mississippi, 1994.

Hess, Stephen. *Drawn and Quartered: The History of American Political Cartoons*. Montgomery, AL: Elliott and Clark, 1996.

Horn, Maurice, ed. *The World Encyclopedia of Cartoons*. New York: Chelsea House, 1999.

———. *The World Encyclopedia of Comics*. New York: Chelsea House, 1998.

McCloud, Scott. *Reinventing Comics*. New York: Paradox Press, 2000.

———. *Understanding Comics: The Invisible Art*. New York: Paradox Press, 1993.

Nyberg, Amy Kiste. *Seal of Approval: The History of the Comics Code*. Jackson: University Press of Mississippi, 1998.

Robbins, Trina, and Catherine Yronwode. *Women and the Comics*. New York: Eclipse Books, 1985.

Schodt, Frederik L. *Manga! Manga! The World of Japanese Comics*. Tokyo: Kodansha International, 1988.

Thompson, Don. *The Comic-Book Book*. Iola, WI: Krause Publications, 1998.

General Art and Cartooning Techniques

Bridgman, George Brant. *Constructive Anatomy*. New York: Dover, 1976.

Bruno, Michael H., ed. *Pocket Pal: A Graphic Arts Production Handbook*. Stamford, CT: International Paper, 1997.

Cole, Rex Vicat. *Perspective for Artists*. New York: Dover, 1976.

Edwards, Betty. *The New Drawing on the Right Side of the Brain*. Los Angeles: J. P. Tarcher, 1999.

Faigin, Gary. *The Artist's Complete Guide to Facial Expression*. New York: Watson-Guptill, 1990.

Farris, Edmond J. *Art Students' Anatomy*. New York: Dover, 1961.

Gautier, Dick. *Drawing and Cartooning 1,001 Faces*. New York: Perigee, 1993.

Glasbergen, Randy. *Toons! How to Draw Wild and Lively Characters for All Kinds of Cartoons*. Cincinnati: North Light Books, 1997.

Hamm, Jack. *Cartooning the Head and Figure*. New York: Perigee, 1982.

———. *How to Draw Animals*. New York: Perigee, 1982.

Hart, Christopher. *How to Draw Cartoon Animals*. New York: Watson-Guptill, 1995.

Hogarth, Burne. *Drawing Dynamic Hands*. New York: Watson-Guptill, 1988.

———. *Dynamic Figure Drawing*. New York: Watson-Guptill, 1996.

———. *Dynamic Wrinkles and Drapery*. New York: Watson-Guptill, 1995.

Nicolaides, Kimon. *The Natural Way to Draw: A Working Plan for Art Study*. New York: Mariner Books, 1990.

Peck, Stephen Rogers. *Atlas of Human Anatomy for the Artist*. New York: Oxford University Press, 1990.

Redman, Lenn. *How to Draw Caricatures*. New York: McGraw-Hill, 1984.

Whitaker, Steve. *The Encyclopedia of Cartooning Techniques*. Philadelphia: Running Press, 1994.

Comic Strips and Magazine Cartooning

Hart, Christopher. *Drawing on the Funny Side of the Brain: How to Come Up with Jokes for Cartoons and Comic Strips*. New York: Watson-Guptill, 1998.

———. *Everything You Ever Wanted to Know About Cartooning but Were Afraid to Draw*. New York: Watson-Guptill, 1994.

———. *How to Draw Cartoons for Comic Strips*. New York: Watson-Guptill, 1988.

McKenzie, Alan. *How to Draw and Sell Comic Strips for Newspapers and Comic Books*. Cincinnati: North Light Books, 1998.

Richter, Mischa, and Harald Bakken. *The Cartoonist's Muse: A Guide to Generating and Developing Ideas*. New York: Contemporary Books, 1992.

Thomson, Ross, and Bill Hewison. *How to Draw and Sell Cartoons*. Cincinnati: North Light Books, 1992.

Walker, Mort. *Backstage at the Strips*. New York: A&W Visual Library, 1975.

Comic Books

Alvarez, Tom. *How to Create Action, Fantasy and Adventure Comics*. Cincinnati: North Light Books, 1996.

Caputo, Tony C. *How to Self-Publish Your Own Comic Book*. New York: Watson-Guptill, 1997.

Chelsea, David. *Perspective! for Comic Book Artists: How to Achieve a Professional Look in Your Artwork*. New York: Watson-Guptill, 1997.

Daniels, Les. *DC Comics: Sixty Years of the World's Favorite Comic Book Heroes*. New York: Bulfinch Press, 1995.

Gammill, Kerry. *Kerry Gammill's Drawing Monsters and Heroes for Film and Comics*. Lebanon, NJ: Vanguard Productions, 2001.

Haines, Lurene. *The Business of Comics: Everything a Comic Book Artist Needs to Make It in the Business*. New York: Watson-Guptill, 1998.

Janson, Klaus. *DC Comics Guide to Pencilling Comics*. New York: Watson-Guptill, 2002.

Kubert, Joe. *Superheroes: Joe Kubert's Wonderful World of Comics*. New York: Watson-Guptill, 1999.

Lee, Stan, and John Buscema. *How to Draw Comics the Marvel Way*. New York: Simon & Schuster, 1984.

Mallory, Michael. *Marvel: The Characters and Their Universe*. Southport, CT: Levin Associates, 2001.

Martin, Gary. *The Art of Comic-Book Inking*. Milwaukie, OR: Dark Horse Comics, 1997.

O'Neil, Dennis. *The DC Comics Guide to Writing Comics*. Lebanon, NJ: Vanguard Productions, 2001.

Tinsley, Kevin. *Digital Prepress for Comic Books: The Definitive Desktop Production Guide*. New York: Stickman Graphics, 1999.

Animation

Blair, Preston. *Cartoon Animation*. Laguna Hills, CA: Walter Foster Publishing, 1995.

Culhane, Shamus. *Animation from Script to Screen*. New York: St. Martin's Press, 1990.

———. *Talking Animals and Other People*. Cambridge, MA: De Capo Press, 1998.

Hart, Christopher. *How to Draw Animation: Learn the Art of Animation from Character Design to Storyboards and Layout*. New York: Watson-Guptill, 1997.

Kerlow, Victor Isaac. *The Art of 3-D: Computer Animation and Imaging*. New York: John Wiley and Sons, 2000.

Laybourne, Kit. *The Animation Book: A Complete Guide to Animated Filmmaking*. New York: Three Rivers Press, 1998.

Maestri, George. *Digital Character Animation 2: Essential Techniques*. New York: New Riders Publishing, 1999.

Maltin, Leonard. *Of Mice and Magic: A History of American Animated Cartoons*. New York: New American Library, 1990.

Myers, Dale K. *Computer Animation: Expert Advice on Breaking Into the Business*. Milford, MI: Oak Cliff Press, 1999.

Taylor, Richard. *The Encyclopedia of Animation Techniques*. Philadelphia, PA: Running Press, 1996.

White, Tony. *The Animator's Workbook*. New York: Watson-Guptill, 1988.

Williams, Richard. *The Animator's Survival Kit*. New York: Faber and Faber, 2002.

The Business of Cartooning

Crawford, Tad. *Business and Legal Forms for Illustrators*. New York: Allworth Press, 1999.

———. *A Legal Guide for the Visual Artist*. New York: Allworth Press, 1999.

Foote, Cameron S. *The Business Side of Creativity: The Complete Guide for Running a Graphic Design or Communications Business*. New York: W. W. Norton, 1999.

Gerberg, Mort. *Cartooning: The Art and the Business*. New York: William, Morrow and Co., 1989.

Glasbergen, Randy. *How to Be a Successful Cartoonist.* Cincinnati: North Light Books, 1996.

Graphic Artists Guild. *Graphic Artists Guild Handbook: Pricing and Ethical Guidelines.* Cincinnati: North Light Books, 2001.

Heller, Stephen, and Marshall Arisman, eds. *The Education of an Illustrator.* New York: Allworth Press, 2000.

Nordling, Lee. *Your Career in the Comics.* Kansas City, MO: Andrews McMeel: 1995.

Sedge, Michael H. *Successful Syndication: A Guide for Writers and Cartoonists.* New York: Allworth Press, 2000.

Publications

The following is a selection of magazines, newsletters, directories, and other periodicals related to the art and business of cartooning. Some are must-haves for every professional cartoonist; others are intended for creators working in a particular genre. Addresses and websites are provided where available so that you can contact the magazines for subscription information. At the end of the appendix, you'll find a selection of websites you should definitely have in your bookmarks.

Periodicals

Animation Blast
PO Box 260491
Encino, CA 91426-0491
www.animationblast.com

Published sporadically. Independent magazine covering animation.

Animation Magazine
30101 Agoura Court, Suite 110
Agoura Hills, CA 91301
www.animationmagazine.net

Published monthly. Industry magazine covering animation in television, film, advertising, and the Internet.

Art Business News
One Park Avenue, Second Floor
New York, NY 10016-5802
www.artbusinessnews.com

Published monthly. Covers the business of producing and selling art.

Artist's & Graphic Designer's Market
www.writersdigest.com/catalog/index.htm

Published annually. Lists markets where you can sell your art, including submission guidelines and pay rates. Available in all major bookstores and your local library.

The Artist's Magazine
1507 Dana Avenue
Cincinnati, OH 45207-1005
www.artistsmagazine.com

Published monthly. Teaches artists how to paint and draw better and how to sell their work.

Cartoonist PROfiles
PO Box 325
Fairfield, CT 06430
www.comicspage.com/cp

Published quarterly. Profiles successful syndicated cartoonists.

Children's Writer's & Illustrator's Market
www.writersdigest.com/catalog/index.htm

Published annually. Lists markets for children's book illustrators. Available in all major bookstores and your local library.

Comic Shop News
www.csnsider.com

Published weekly. Usually available for free in comic shops.

Comics Buyer's Guide
Krause Publications
700 E. State Street
Iola, WI 54990-0001
www.collect.com

Published weekly. Covers comics for collectors, fans, and professionals.

The Comics Journal
7563 Lake City Way N.E.
Seattle, WA 98115
www.tcj.com

Published monthly. Covers the comics medium from an arts-first perspective.

Communication Arts
www.commarts.com

Published bimonthly. Industry magazine for the graphic design field.

Editor & Publisher Syndicate Directory
770 Broadway
New York, NY 10003-9595
www.editorandpublisher.com/editorandpublisher/business_resources/syndicate.jsp

Published annually. The definitive directory of North American syndicates.

Encouraging Rejection
Noforehead Press
Box 55
Kearsage, NH 03847
www.reuben.org/heath/newindex.asp

Published bimonthly. A fun newsletter offering support and advice to aspiring cartoonists.

GAG Recap
GAG Recap Publications
12 Hedden Place
New Providence, NJ 07974-1724

Published monthly. Reviews recently published cartoons and lists cartoon markets.

Greetings etc.
Greeting Card Association
1156 15th Street N.W., Suite 900
Washington, DC 20005
www.greetingsmagazine.com

The official publication of the Greeting Card Association.

Hogan's Alley
Bull Moose Publishing
PO Box 47684
Atlanta, GA 30362
www.cagle.com/hogan

Published monthly. The magazine of the cartoon arts.

HOW
1507 Dana Avenue
Cincinnati, OH 45207
www.howdesign.com

Published bimonthly. The business, creativity, and technology magazine for graphic designers.

indy Magazine
www.indymagazine.com

Published online. Guide to alternative comics.

Literary Market Place
www.literarymarketplace.com

Published annually. The directory for the publishing industry. Lists publishers, agents, trade associations, and more. Expensive publication that is usually available in your local library.

ProTooner
PO Box 2270
Daly City, CA 94017-2270
protooner.lookscool.com

Published monthly. Newsletter for professional and amateur cartoonists and gag writers.

Websites

Akemi's Anime World:
animeworld.com

Animation on About.com:
cartooning.about.com

Animation World Network:
www.awn.com

Cartoon Art Museum of San Francisco:
www.cartoonart.org

CartoonCommunity.com:
www.cartooncommunity.com/index.shtml

Cartoon Crossroads:
www.cartooncrossroads.com

Cartooning on About.com:
drawsketch.about.com/cs/cartooning

Cartoon Over-Analyzations:
members.aol.com/TheGriffon/cartoon.html

Cartoon Research Library:
www.lib.ohio-state.edu/OSU_profile/cgaweb

Comic Book Legal Defense Fund:
www.cbldf.org

Comic Book Resources:
comicbookresources.com

Comics Media Archives:
www.chebucto.ns.ca/Recreation/CMA

Creators Syndicate:
www.creators.com

Daryl Cagle's Professional Cartoonists Index:
www.cagle.com

Don Markstein's Toonopedia:
www.toonopedia.com

EX: The Online World of Anime & Manga:
www.ex.org

Grand Comic Book Database:
www.comics.org

iCOMICS: www.icomics.com

International Museum of Cartoon Art:
www.cartoon.org

Joe Kubert's World of Cartooning:
www.kubertsworld.com

Ka-Boom! A Dictionary of Comic Book Words
on Historical Principles:
collection.nlc-bnc.ca/100/200/300/ktaylor/
kaboom/index.htm

King Features Syndicate:
www.kingfeatures.com

Looney Tunes:
looneytunes.warnerbros.com/web/home.jsp

Los Angeles Times Syndicate:
www.lats.com

New Comic Book Releases List:
www.comiclist.com

Origins of American Animation:
lcweb2.loc.gov/ ammem/oahtml/oahome.html

Pioneering Cartoonists of Color:
www.clstoons. com/paoc/paocopen.htm

Rants & Raves by R. C. Harvey (a comics
scholar):
www.rcharvey.com/rantsraves.html

School of Visual Arts:
www.schoolofvisualarts.edu/sva.html

Sequential Tart:
www.sequentialtart.com

So You Wanna Be a Comic Book Artist?:
www.soyouwanna.com/site/syws/comics/comics
FULL.html

Starving Artists Law (legal help for artists):
www.StarvingArtistsLaw.com

Tribune Media Services Syndicate:
www.comicspage.com

United Media Syndicate (comics.com):
www.unitedmedia.com

Universal Press Syndicate:
www.uexpress.com

Washington Post Writers Group Syndicate:
www.postwritersgroup.com/writersgroup.htm

Words and Pictures Museum:
www.wordsandpictures.org

Professional Organizations

Joining an artists' organization enables you to network with fellow cartoonists as well as with the people who might buy your work, such as editors, art directors, and licensees. You might also reap benefits intended for the freelance artist, like group health insurance or legal representation in case of a copyright infringement or contract violation.

American Institute of Graphic Artists
164 Fifth Avenue
New York, NY 10012
www.aiga.org

Association of American Editorial Cartoonists
1221 Stoneferry Lane
Raleigh, NC 27606
pc99.detnews.com/aaec

Graphic Artist's Guild
90 John Street, Suite 403
New York, NY 10038-3202
www.gag.org

Greeting Card Association
1156 15th Street N.W., Suite 900
Washington, DC 20005
www.greetingcard.org

International Animated Film Society
ASIFA—Hollywood
721 S. Victory Boulevard
Burbank, CA 91502
www.asifa-hollywood.org

National Cartoonists Society
PO Box 713
Suffield, CT 06078
www.reuben.org

National Writers Union Cartoonists Association
113 University Place, Sixth Floor
New York, NY 10003
www.cartoonistsassociation.com

Society of Children's Book Writers and Illustrators
8271 Beverly Boulevard
Los Angeles, CA 90048
www.scbwi.org

Society of Illustrators
Museum of American Illustration
128 E. 63rd Street
New York, NY 10021-7303
www.societyillustrators.org

Women in Animation
PO Box 17706
Encino, CA 91416
www.womeninanimation.org

Index

A

A. Mutt, 24
A. Piker Clerk, 24
accessories, 83
acid content (paper), 53
acid-free plastic bags, 53
acrylic inks, 49
action, 84-85
 atmosphere, 107
 multi-panel strips, 184-185
 stories, 183-184
Action Comics, 29
Adams, Scott, 213
Addams, Charles, 176
adhesives, 44
Adobe Illustrator, 51
Adobe PageMaker, 51
Adobe PhotoShop, 51
adventure strips, 113
agents, illustrators, 164
aging, drawings, 198-199
all rights, 220
Ally Sloper's Half Holiday, 28
Amend, Bill, 184
anatomy, 69
 dynamic, 68
 feet, 75
 female figures, 69-70
 Greeks, 67
 guidelines, 69
 hands, 73-75
 heads, 71-72
 expressions, 81
 eyes, 79-80
 mouths, 80-81
 heroic, 68
 male figures, 69-70
 realism, 68
 types, 70
 children, 70-71
 grylli, 71
Anderson, Carl, 7
aniline inks, 49
animals
 anthropomorphic animals, 150
 drawing, 76-77

animation, 24-26, 141
 cels, 110
 computer animation, 142, 145-146
 computer games, 146
 education, 142-143
 features, 143-144
 Internet, 34-35, 142
 jobs, 143, 209
 online, 146
 Out of the Inkwell, 144
 persistence of vision, 25
 rotoscoping, 144-145
 styles, 110, 144
 techniques, 144
 vaudeville, 26
Animation from Script to Screen, 143
Animation Magazine, 146
animators, 143
Anthony, Norman, 21
anthropomorphic cartooning
 animals, 150
 characters, 111
 figures, drawing, 76-77
 objects, 10
Apple, Mary, 126
Arctic atmosphere, 106
Arno, Peter, 7, 114
art directors, selling illustrations to, 206
Artist's & Graphic Designer's Market, 170, 204-206
assembly-line model (comic books), 135-136
assistants, 143
Astroboy, 152
asymmetrical composition, 98-100
atmosphere
 action, 107
 Arctic, 106
 creating, 106-107
 curved lines, 107
 desert, 106
 diagonals, 107
 perspective, 95-96

B

B.C., anatomical proportions of characters, 71
Baby Blues, 41
 anatomical proportions of characters, 71
 characters, 127
background artists, 143
backgrounds (comics), 198
backing cardboard, 53
balance, 76, 97
 asymmetrical composition, 98-100
 golden section, 97-98
 symmetrical composition, 98-100
ballpoint pens, 42
Ballyhoo, 21-23
Batman, compared to *Superman*, 106
Beetle Bailey, 56, 84
Benday sheets, 50
Benday tint, 50-51
Benzine, 41
Berenstain, Stan, 7
Bigot, George, 151
bird's-eye view, 94, 197
bitmapped graphics, 146
black-and-white cartoons, 95
black watercolor, 49
Blackton, James Stuart, 26
Blair, Preston, 143
Blondie and Dagwood
 anatomical proportions of characters, 71
 character development based on family theme, 188
blood flow, facial expressions, 81
Bloodworth, Alvin, 119
bodies
 characters, 191
 drawing. *See* drawing
 gestures, 81-82
 heads in proportion to length of, 67-69
books. *See* comic books; graphic novels; sketching

Brady, Pat, 94
Bray, J. R., 26
break downs, 182
Breger, Dave, 7
Briggs, Clare, 23
brushes, 42
 Japanese hake brushes, 42
 numbering system, 43
 Oriental brushes, 42
 Red Kolinsky sable, 42
 Sumi brushes, 42
Budget of Fun, 20
Bull, John, 19
burnishers, dry-transfer process, 50
Busch, Wilhelm, 23
bust lines, drawing, 70
Buzz Sawyer, 51

C

calendered paper, 52
calligraphy, 159-160
Calvin and Hobbes
 anatomical proportions of char-
 acters, 71
 characters, 127
 perspective, 94
cameras, 39-40, 196-197
Campbell, E. Sims, 71
Caniff, Milton, 106, 154
 anatomy, 68
 style influences, 112
Capp, Al, grylli, 71
The Captain and the Kids, 23
captions
 captionless cartoons. *See* sight
 gags
 gag cartoons, 121, 176-177
 punch lines, 176
 reading, 195-196
 writing, 121, 195-196
carbon pencils, 41
cardboard, backing, 53
careers
 animation, 143, 209
 comic book publishing, 138
 comic books, 207-208
 editorial cartoonists, 129-130
 greeting card freelancers,
 167-168
 illustrators, 162-163
caricatures, 3-4, 110
Carracci, Annibale, 4
Cartoon Animation, 143

*Cartooning: The Art and the
 Business*, 176, 198
cartoonists
 editorial, 17-18, 129
 American, 19-20
 careers, 129-130
 drawing, 131-132
 editorial policies, 132-133
 humor, 131
 proportions, 130
 symbols, 130-131
 education, 6-7
 gag, 117
 necessities, 55-56
 practice, 7-8
 studios, 56-58
 style influences, 112
 syndicates, 123
 web, 32-33
cartoons
 definition of cartoon, 4
 future considerations, 31
 electronic ink, 33-34
 holographic technology,
 34-35
 Internet, 32-33
 Internet animation, 34-35
 print on demand, 34
 programmable paper, 33-34
 gag. *See* gag cartoons
 history of, 9-10
 American editorial cartoon-
 ists, 19-20
 animation, 24-26
 comic books, 27-29
 early editorial cartoonists,
 17-18
 Egyptians, 10
 Greeks, 10
 Hogarth versus Töpffer,
 13-14
 humor magazines, 20-23
 newspapers, 23-24
 prints, 12-13
 Romans, 11
CD labels, 171
cels, 110
center of gravity, 76
center of vision (CV), 91
characters, 127, 187
 A. Mutt, 24
 A. Piker Clerk, 24
 action, 84-85

Andy Capp proportions, 71
anthropomorphic characters,
 111
B.C., 71
Baby Blues, 127, 71
Beetle Bailey, 84
Blondie and Dagwood, 71
Calvin and Hobbes, 71, 127
costumes, 82-84, 191
Dennis the Menace, 71
designers, 143
dialog, 192
drawings, 3
Elmer Woggon, 126
Grog, 71
hobbies, 192
interests, 192
KoKo, 144
lettering, 127-128
main, developing, 188
occupations, 192
Peanuts, 71, 127
personality traits, 192
physical attributes, 191
props, 192
realism, 190-191
repetitive gags, 193
stereotypes, 189-190
support characters, 188-189
tobacco use, 84
The Wizard of Id, 71
Yellow Kid (*Hogan's Alley*), 23
charcoal, 50
Charlie Brown, costumes, 191
children
 anatomical proportions, 70-71
 drawing illustrations for,
 164-165
China, India ink, 48
Chips, 28
Christmas drawings, 20
circles, 93-94
circular proportional scale tool, 43
clavicles, drawing, 70
clichés, gag cartoons, 177-179
clip art, selling, 207
close-up zooms, 196-197
clothing, 82-84
coated paper, 52
coding cartoons, 120
Cohl, Emile, animation, 26
College Humor, 23
Colliers, 23
colored inks, 49
colored pencils, 50

colorists, 208
colors
 black and white, 95
 contrast, 105
 perspective, 95-96
comic books, 27-29, 135. *See also* comic strips
 Action Comics, 29
 Ally Sloper's Half Holiday, 28
 assembly-line model, 135-136
 Chips, 28
 Comic Cuts, 28
 Comics Code Authority, 136
 compared to Eastern manga, 152
 conventions, 137
 covers, 136
 Famous Funnies, 29, 135
 genres, 136-137
 graphic novels. *See* graphic novels
 jobs, 207-208
 page rates, 207-208
 publishers, 138
 self-publishing, 138-139
 size, 138
 The Spirit, 139
 splash pages, 136
 styles, 111
 Tired Tim, 28
 title pages, 136
 Weary Willie, 28
Comic Cuts, 28
comic strips, 123. *See also* comic books
 Andy Capp, 71
 Apple Mary, 126
 B.C., 71
 Baby Blues, 71
 characters, 127
 Batman, 106
 Beetle Bailey, 56, 84
 Big Chief Wahoo, 126
 Blondie, 188
 Blondie and Dagwood, 71
 Calvin and Hobbes
 anatomical proportions of chracters, 71
 characters, 127
 perspective, 94
 characters. *See* characters
 continuity-adventure strips, 126
 Curtis, 126
 Dennis the Menace, 71
 Dick Tracy, 112
 Dilbert, 213

For Better or for Worse, 126
FoxTrot, 184, 197
Funky Winkerbean, 126
gag-a-day strips, 125
Judge Parker, 126
Little Nemo, 94
Luann, 126
manga. *See* manga
panel syndicates, 126-127
Peanuts
 anatomical proportions of characters, 71
 characters, 127
 costumes, 191
 repetitive gags, 193
Rex Morgan, M.D., 126
Rose Is Rose, 94
Roy Crane, 51
soap opera strips, 126
Steve Canyon, 68
Steve Roper, 126
submitting strips, 124, 213-214
Sunday strips, 124
Superman, 106, 222
Tarzan, 68
Terry and the Pirates, 68
The Wizard of Id, 71
Comics and Sequential Art, 139
Comics Code Authority, 136
compasses, 44
composition, 97
 asymmetrical, 98-100
 symmetrical, 98-100
computers, 51-52
 animation, 142-146
 games, 146
cone of vision, 89
conflicts, 182-183
continuity,
 adventure strips, 126
 multi-panel strips, 185-186
contracts, 223
contrast, 104-105
conventions, comic books, 137
copies, submitting to publications, 118
copyrights, 217-219
 Copyright Form Hotline, 219
 myths, 218-219
 selling, 219-220
 licensing, 221-222
 reprints, 221
The Corrector, 20
costumes, 82-84, 191
covers, comic books, 136

Cowpokes, 34
craft knives, 44
crayons
 Crayola, 41
 lithographic, 41, 132
Creators Syndicate, 204
Culhane, Shamus, 143
Curtis, 126
curves, atmosphere, 107
cutting
 mats, 44
 tools, 44
CV (center of vision), 91

D

da Vinci, Leonardo, 5, 99
Daedalum, 25
Daumier, Honoré, 18
 crayons, 41
 lithography, 131
Davenport, Homer, 20, 131
Day, Ben, 50
DC Comics, 222
Dennis the Menace, 71
deserts, 106
designing
 CD labels, 171
 greeting cards, 169
 music posters, 171
desktop publishing, 31
diagonals
 atmosphere, 107
 proportioning, 124
dialog
 characters, 192
 lettering, 127-128
 reading, 195-196
 single-panel gag cartoons, 100-103, 176-177
 writing, 195-196
Dick Tracy, 112
digital publishing, 32-33
Dilbert, 213
dip pens, 41-42
directories, illustrators, 164
directors, 143
Disney, Walt, animation, 26
dividers, 44
doodles, 63
Doyle, Richard, 15
Doyle, Sir Arthur Conan, 14
drafting supplies, 44

drawing. *See also* sketching
 aging stage, 198-199
 animals, 76-77
 anthropomorphic figures, 76-77
 basic shapes, 64-65
 bodies, 157-158
 brushes, 42
 Japanese hake brushes, 42
 numbering system, 43
 Oriental brushes, 42
 Red Kolinsky sable, 42
 Sumi brushes, 42
 bust lines, 70
 circular proportional scale tool, 43
 clavicles, 70
 crayons, litho, 132
 cutting tools, 44
 editing stage, 197-198
 editorial cartoonists, 131-132
 expressions, 81
 eyebrows, 80
 eyes, 72, 79-80
 faces, 72
 expressions, 81
 eyes, 79-80
 manga, 155
 mouths, 80-81
 feet, 75
 gag cartoons, 120-121
 gestures, 81-82
 hair, 72, 156-157
 hands, 73-75
 heads, 71-72, 154-157
 illustrations for juveniles, 164-165
 mouths, 80-81
 necks, 70
 noses, 72
 pelvises, 70
 pencils
 carbon, 41
 colored, 50
 grades, 40
 graphite, 40
 nonphoto blue, 39
 Prismacolor black, 41
 sharpeners, 44
 pens, 41
 ballpoint, 42
 dip, 41-42
 fountain, 42
 globe-bowl, 42
 India ink, 41
 quill, 41

 reed, 41
 ruling, 44
 Speedball points, 41
 practice, 7-8
 proportions. *See* anatomy
 rulers, 43
 T-squares, 43
 waists, 70
DreamWeaver, 164
dry media
 charcoal, 50
 colored pencils, 50
dry-transfer process, 50
Duoshade, 51, 132
dyes. *See* inks
dynamic anatomy, 68
Dynamic Figure Drawing, 137

E

e-cards, 169
e-comics, 32
ears, drawing, 72
Eastern Color Printing, 29
Eastern manga, 149
 anthropomorphic animals, 150
 calligraphy, 159-160
 compared to Western comic
 books, 152
 drawing
 bodies, 157-158
 faces, 155
 hair, 156-157
 heads, 154-157
 history, 149-152
 sound effects, 159-160
 style, 153-154
Ed, Carl, 7
Edison, Thomas, animation, 26
editing drawings, 197-198
Editor & Publisher, 130
editorial cartoonists, 129
 careers, 129-130
 drawing, 131-132
 editorial policies, 132-133
 humor, 131
 proportions, 130
 symbols, 130-131
editorial cartoons, 17
 American cartoonists, 19-20
 early cartoonists, 17-18
education
 animation, 142-143
 cartoonishts, 6-7

Egypt
 history of cartoons, 10
 India ink, 47
 reed pens, 41
Eisner, Will, 139, 154
EL (eye level), 91
electronic greeting cards, 32, 169
electronic ink, 33-34
electronic rights, 220
elink website, 33
Elmer Woggon, 126
embossed paper, 52
emphasis, 104-106
erasers
 gum, 44
 ink, 44
 Magic Rub, 44
 Pink Pearl, 44
Escher, M. C., 89
Esquire, 23
exclusive rights, 220
exercises, relaxation, 63-64
expressions, drawing, 81
extreme cartoons, 113
eyes
 controlling in sequences, 101-102
 drawing, 72, 79-80
eye level (EL), 91
eyebrows, drawing, 80

F

faces, drawing, 72
 expressions, 81
 eyes, 79-80
 manga, 155
 mouths, 80-81
facial features, characters, 191
Fairholt, Frederick W., 10-12
Family Circle, 14
Famous Funnies, 29, 135
Fantasmagorie, 25
Fantoscope, 25
feet, drawing, 75
female figures, 69-70
first rights, 220
Fisher, Bud, 24
Fitzpatrick, Daniel, 131
Fleischer, Max, 144
flip books, 26
For Better or for Worse, 126
Foster, Hal, 68

fountain pens, 42
FoxTrot, 184, 197
Franklin, Benjamin, 19
freelancing
 greeting cards, 167-168, 207
 marketing, 214
 tax deductions, 220
Funky Winkerbean, 126
future of cartooning, 31
 electronic ink, 33-34
 holographic technology, 34-35
 Internet, 32-33
 Internet animation, 34-35
 print on demand, 34
 programmable paper, 33-34

G

gag cartoonists, 117
gag cartoons, 117, 175-176
 captions, 121, 176
 changing viewpoints, 196-197
 clichés, 177-179
 coding, 120
 creating, 178-179
 drawing, 120-121
 house organs, 119
 presentation, 117-118
 repetitive, 193
 selling, 203-204
 sight gags, 175-176
 slants, 121-122
 submissions, 212-213
 trade journals, 119
gag-a-day strips, 125
Gaines, M. C., 29
Gallagher, John, 114
games, 146
Gately, George, 114
genres
 comic books, 136-137
 styles, 113
geographic rights, 220
Gerberg, Mort, 176, 198
The Gerrymander, 19
Gertie the Dinosaur, 26
gestures, drawing, 81-82
Gibson, Charles Dana, 3, 22
Glarco, Coquille, 132
Glasbergen, Randy, 122
globe-bowl pens, 42
glue sticks, 44
Goff, Ted, 122
golden section, 97-98

Gould, Chester, style influences, 112
grades, pencils, 40
Grafix, 50
graphic novels, 32, 139
Graphic Storytelling and Visual Narrative, 139
graphics,
 bitmapped, 146
 programs, 51-52
graphite pencils, 40
Graphix, 51
gravity, center of gravity, 76
Gray, Harold, 106
gray tones, mechanical tints, 50-51
Greeks
 anatomy, 67
 asymmetrical design, 98
 history of cartoons, 10
 perspective, 87
greeting cards, 167
 designing, 169
 e-cards, 169
 electronic, 32
 freelancing, 167-168
 selling, 206-207
 submitting, 169
 types, 168-169
Greetings Etc., 168
Grog *(B.C.)*, 71
grotesques, 3
grylli
 anatomical proportions, 71
 Grog *(B.C.)*, 71
gum erasers, 44
gutters, 102-103, 136

H

hair
 as costumes, 83
 characters, 191
 drawing, 72, 156-157
Hamli, V. T., 7
hands, drawing, 73-75
A Harlot's Progress, 12
Harman, Fred, 106
Harper's Weekly, 19-20
hats, 82-83
heads
 drawing, 71-72, 154-157
 proportion to bodies, 67-69
Hearst, William Randolph, 23
heroic anatomy, 68

history, 9-10
 American editorial cartoonists, 19-20
 animation, 24-26
 comic books, 27-29
 early editorial cartoonists, 17-18
 Egyptians, 10
 Greeks, 10
 Hogarth versus Töpffer, 13-14
 humor magazines, 20-23
 newspapers, 23-24
 perspective, 87-89
 prints, 12-13
 Romans, 11
HL (horizontal line), 91
hobbies, characters, 192
Hogan's Alley, 23
Hogarth, Burne, 68, 137
Hogarth, William, 3-4, 12, 17, 88
Holbrook, Bill, 32
holograms, 34-35
horizon line (HL), 91
house organs, 119
humor, 127
 editorial cartoonists, 131
 gag cartoons, 177-179
 humor magazines, 20-23
Hunt Manufacturing Company, 41

I

illustrations, 161
 drawing for juveniles, 164-165
 illustrators
 agents, 164
 directories, 164
 jobs, 162-163
 media, 163-164
 selling
 stock illustrations, 207
 to art directors, 206
 styles, 161-162
in-betweeners, 143
inclined planes, 92
Independent Balance, 20
India ink, 41, 47-48
inks, 47
 acrylic, 49
 aniline, 49
 colored, 49
 electronic, 33-34
 erasers, 44
 India, 41, 47-48

inkers, 208
iron and nutgall, 48
Sumi, 48
inorganic pigments, 49-50
Internet
 animation, 34-35, 142, 146
 future of cartooning, 32-33
iron and nutgall ink, 48
Irvin, Rea, 14

J

Jackson, Tim, 205
Japan
 animation, 110
 hake brushes, 42
 India ink, 48
 manga, 27, 149
 anthropomorphic animals,
 150
 calligraphy, 159-160
 compared to Western comic
 books, 152
 drawing bodies, 157-158
 drawing faces, 155
 drawing hair, 156-157
 drawing heads, 154-157
 history, 149-152
 sound effects, 159-160
 style, 153-154
Japan Punch, 150-151
jobs
 animation, 143, 209
 CD labels, 171
 of characters, 192
 comic books, 207-208
 editorial cartoonists, 129-130
 greeting card freelancers,
 167-168
 illustrators, 162-163
 music posters, 171
 novelties, 171
 publishing, 138
 wrapping paper, 170
Jolly Joker, 20
Judge, 21-22
Judge Parker, 126
juveniles, drawing illustrations for,
 164-165

K

Katzenjammer Kids, 23
Keane, Bil, 14

Keppler, Joseph, 21
Kevin and Kell, 32
kineographs, 26
King Features, 204
Kircher, Athanasius, 25
Kirkman, Rick, 41
Knerr, Harold, 23
knives, craft, 44
KoKo, 144

L

La Caricature, 18-20
labels (cartoon terminology), 3-4, 6
Larson, Gary, style influences, 112
The Last Supper, 99
layout artists, 143
Le Charivari, 20
Leech, John, 4
Leslie's, 19-20
Letraset, 50
lettering, 127-128
 guides, 44
 letterers, 208
letters (query), 170
Liberty, 23
licensing, 221-222
Life, 22
light tables, 56
lighting, 57
lines, atmosphere, 107
Linkert, Lo, 104
Literary Market Place, 206
lithography, 18, 131
 lithographic crayons, 41, 132
Little Nemo, 26, 94
London Illustrated News, 150
long shots, 196-197
Look, 23
Lord of the Rings, 145
Los Angeles Times Syndicate, 205
Luann, 126
Lucent website, 33
Lysippus (Greek sculptor), 67

M

Macromedia DreamWeaver, 164
Macromedia Flash, 146
magazines. *See also* publications
 Animation Magazine, 146
 Ballyhoo, 21, 23
 Budget of Fun, 20
 College Humor, 23

Colliers, 23
The Corrector, 20
Esquire, 23
Harper's Weekly, 20
house organs, gag cartoons, 119
humor, 20-23
Independent Balance, 20
Jolly Joker, 20
Judge, 21-22
La Caricature, 20
Le Charivari, 20
Leslie's, 19-20
Liberty, 23
Life, 22
Look, 23
National Geographic, 34
New Yorker, 21, 23
Phunny Phellow, 20
publishing gag cartoons,
 203-204
Puck, 21
Punch, 4, 20
Reader's Digest, 206
Rolling Stone, 206
The Saturday Evening Post, 23
The Scourge, 20
The Tickler, 20
Vanity Fair, 23
The Wasp, 20
Wild Oats, 20
Yankee Notions, 20
Magic Rub, 44
mailers, 214
main characters
 developing, 188
 support characters, 188-189
male figures, 69-70
manga, 27
 Eastern, 149
 anthropomorphic animals,
 150
 calligraphy, 159-160
 compared to Western comic
 books, 152
 drawing bodies, 157-158
 drawing faces, 155
 drawing hair, 156-157
 drawing heads, 154-157
 history, 149-152
 sound effects, 159-160
 style, 153-154
 United States, 150
 Western, 149, 152
marketing, 214-216
Mauldin, Bill, 106

Max, Peter, illustrations, 162
Max und Moritz picture stories, 23
McCarthy, Fred, 7
McCay, Winsor, 26, 35, 94
mechanical tints, 50-51
media
 computers, 51-52
 dry, 50
 illustrations, 163-164
 oil, 52
 plastic, 52
 styles, 110, 113
medium shots, 196
Michelangelo, 67
Middle Ages, history of cartoons, 11
minimalists, 111
Minor, Robert, 131
Monroe, Marilyn, 191
morgues, 57-58
mouths, drawing, 80-81
movies
 Lord of the Rings, 145
 Steamboat Willie, 26
multi-panel cartoons, 118
multi-panel strips
 action, 184-185
 continuity, 185-186
music posters, 171
Mutoscopes, 26
Mutt and Jeff strip, 24

N

names, watercolors, 49
Naphtha, 41
Nast, Thomas, 19, 131
 Christmas drawings, 20
 reform campaigns, 19
National Geographic, holograms, 34
necessities, 55-56
necks, drawing, 70
New York Illustrated News, 19
New York Journal, 23
New York World, 23
New Yorker, 21-23
newsletters, house organs, 119
newspapers, 23-24
 The Captain and the Kids, 23
 Katzenjammer Kids, 23
 New York Journal, 23
 New York World, 23

nonphoto blue pencils, 39
noses, drawing, 72
novelties, 171, 206-207
numbering system (brushes), 43
nutgall ink, 48

O

Obadiah Oldbuck, 14
occupations. *See* jobs
oil, as media, 52
Oliphant, Patrick, 131-132
On the Fast Track, 32
one-point perspective, 90-91
one-time rights, 220
online animation, 146
onomatopoeia, 159
Opper, Frederick Burr, 131
organic pigments, 49-50
Oriental brushes, 42
Out of the Inkwell, 144
Outcault, R. F., 23

P

page rates, comic books, 207-208
panels
 gag cartoons
 captions, 176-177
 dialog, 176-177
 gutters, 102-103
 multi-panel cartoons, 118
 single-panel sequences, 100
 dialog balloons, 103
 dialogs, 100-101
 eye control, 101-102
 syndicates, 126-127
paper, 52, 170
 calendered, 52
 coated, 52
 embossed, 52
 gutters, 136
 programmable, 33-34
 protection, 53
 supercalendered, 52
 transfer sheets, 41
 uncalendered, 52
 weight, 52
papier-mâché, 52
Parc website, 33
Parolini, Elmer, 118
Partch, Virgil, 75, 114
Party & Paper Retailer, 168

Peanuts
 anatomical proportions of characters, 71
 characters, 127
 costumes, 191
 repetitive gags, 193
pelvises, drawing, 70
pencilers, 208
pencils
 carbon, 41
 colored, 50
 grades, 40
 graphite, 40
 nonphoto blue, 39
 Prismacolor black, 41
 sharpeners, 44
pens, 41
 ballpoint, 42
 dip pens, 41-42
 fountain, 42
 globe-bowl, 42
 India ink, 41
 quill, 41
 reed, 41
 ruling, 44
 Speedball points, 41
Perry, Admiral Matthew, 150
persistence of vision, 25
personality traits (characters), 192
perspective, 87
 atmospheric, 95-96
 bird's-eye view, 94
 circles, 93-94
 color, 95-96
 cone of vision, 89
 history, 87-89
 measuring, 89
 one-point, 90-91
 shadows, 93-94
 two-point, 90-91
 vanishing point, 64, 91, 99
 worm's-eye view, 94
pH factor (paper), 53
Phantasmagoria, 25
Phenakistoscope, 25
phi, 98
Philipon, Charles, 18, 20
Phunny Phellow, 20
physical attributes (characters), 191
picas, 124
picture plane, 90
picture stories, *Max und Moritz*, 23

pigments
 inorganic, 49-50
 organic, 49-50
 watercolors, 49-50
Pink Pearl, 44
planes
 inclined, 92
 picture, 90
plastic mediums, 52
plots, 181-182
Polycleitus (Greek sculptor), 67
portfolios, 214-215
portraits, caricatures, 3-4
posters, music, 171
Praxinoscope, 25
Price, George, 106
print on demand, 34
prints
 A Harlot's Progress, 12
 history, 12-13
 lithography, 18
 media, cameras, 39-40
Prismacolor black pencils, 41
profits, royalties, 222
programmable paper, 33-34
promotion rights, 220
proportional scales, 124
proportions, 69
 anatomy types, 70
 children, 70-71
 grylli, 71
 balance. *See* balance
 dynamic anatomy, 68
 editorial cartoonists, 130
 feet, 75
 female figures, 69-70
 Greeks, 67
 guidelines, 69
 hands, 73-75
 heads, 71-72
 expressions, 81
 eyes, 79-80
 mouths, 80-81
 heroic, 68
 male figures, 69-70
 perspective. *See* perspective
 realism, 68
props, 82-84, 198
 Beetle Bailey's cap, 84
 characters, 192
protection of work, 53
protractors, 44
pseudonyms, 114

publications. *See also* Appendix B;
 magazines
 Animation from Script to Screen,
 143
 *Artist's & Graphic Designer's
 Market*, 170, 204, 206
 Cartoon Animation, 143
 *Cartooning: The Art and the
 Business*, 176, 198
 comic books. *See* comic books
 Comics and Sequential Art, 139
 Cowpokes, 34
 Dynamic Figure Drawing, 137
 Editor & Publisher, 130
 *Graphic Storytelling and Visual
 Narrative*, 139
 Greetings Etc., 168
 Harper's Weekly, 19
 house organs, 119
 Japan Punch, 150-151
 Leslie's, 19-20
 Literary Market Place, 206
 London Illustrated News, 150
 New York Illustrated News, 19
 Obadiah Oldbuck, 14
 Party & Paper Retailer, 168
 Punch, 4
 Tôbaé, 151
 trade journals, 119
publishing. *See also* submissions
 comic books
 page rates, 207-208
 self-publishing, 138-139
 contracts, 223
 copyrights, 217-219
 licensing, 221-222
 myths, 218-219
 selling, 219-221
 desktop, 31
 gag cartoons, 203-204
 graphic novels. *See* graphic nov-
 els
 print on demand, 34
 publishers
 comic books, 138
 illustration media, 163-164
 syndicates, 204-205
Puck, 21
Pulitzer, Joseph, 23
Punch, 4, 20
punch lines, 176

Q-R

queries, 170
quill pens, 41

Raymond, Alex, genre, 113
Rea, Gardner, 7
Reader's Digest, 206
reading
 captions, 195-196
 dialog, 195-196
realism
 characters, 190-191
 proportions, 68
Red Kolinsky sable, 42
reed pens, 41
Reid, Ace, 34
relaxation, sketching exercises,
 63-64
Renaissance
 history of cartoons, 11
 perspective, 88
repetitive gags, 193
reprint rights, 220
reprints, 221
Rex Morgan, M.D., 126
Reynaud, Emile, 25
rights. *See* copyrights
Robinson, Boardman, 131
Roget, Peter Mark, 25
Rolling Stone, 206
Romans
 history of cartoons, 11
 perspective, 87
Rose Is Rose, perspective, 94
Ross, Harold, 21, 101
rotoscoping, 144-145
roughs, 212
royalties, 222
rulers, 43
ruling pens, 44

S

Safe Havens, 32
SASE (self-addressed, stamped
 envelope), 212
Satire on False Perspective, 88
satiric art. *See* manga
The Saturday Evening Post, 23
Saunders, Allen, 126

Schmidt, Jack, eye control in sequences, 101
Scourge, 20
Searle, Ronald, 40
second rights, 220-221
secondary characters, 188-189
self-addressed, stamped envelope (SASE), 212
self-publishing comic books, 138-139
self-syndicates, 205
selling
 cartoons 121-122
 clip art, 207
 contracts, 223
 copyrights, 219-220
 licensing, 221-222
 reprints, 221
 gag cartoons, 203-204
 greeting cards, 206-207
 novelties, 206-207
 stock illustrations, 207
 to syndicates, 204-205
sequences, 100
 contrast, 104-105
 emphasis, 104-105
 single panel, 100
 dialogs, 100-101, 103
 eye control, 101-102
 gutters, 102-103
shadows, perspective, 93-94
shapes, drawing basic shapes, 64-65
sharpeners, 44
Sherlock Holmes, 14
showgirls, Campbell, E. Sims, 71
Shuster, Joe, 222
Siegel, Jerry, 222
sight gags, 175-176
signatures, 114
silhouettes, 106
simultaneous submissions, 213
single-panel gag cartoons
 captions, 176-177
 dialog, 176-177
single-panel sequences, 100
 dialogs, 100-101, 103
 eye control, 101-102
 gutters, 102-103
sketching. *See also* drawing
 doodles, 63
 relaxation exercises, 63-64
 roughs, 212
 sketch books, 61-63
 while watching television, 62

slants, gag cartoons, 121-122
Sloper, Ally, 28
Smolderen, Thierry, 13-14
soap opera strips, 126
software, graphics programs, 51-52
solvents, 41
 Benzine, 41
 Naphtha, 41
sound effects, manga, 159-160
SP (station point), 91
space, between panels in sequences, 102-103
specs, 204
speech balloons, 103
speedball pen points, 41
The Spirit, 139
splash pages, comic books, 136
spray adhesives, 44
spreads, 118
station point (SP), 91
Steamboat Willie, 26
stereotypes (characters), 189-190
Steve Canyon, 68
Steve Roper, 126
stock illustrations, selling, 207
storage, 53
stories
 action, 183-185
 break downs, 182
 conflicts, 182-183
 plots, 181-182
storyboard artists, 143
strips. *See* comic strips
Stuart, Gilbert, 19
studios, 56-58. *See also* work spaces
styles, 109-110
 animation, 110, 144
 art tools, 111
 caricatures, 110
 comic books, 111
 extremes, 113
 genres, 113
 illustrations, 161-162
 influences, 112
 "less is more" method, 112
 media, 110, 113
 minimalists, 111
 signatures, 114
submissions, 211. *See also* publishing
 gag cartoons, 212-213
 guidelines, 212
 simultaneous submissions, 213
 syndicates, 213-214
subsidiary rights, 220

Sumi
 brushes, 42
 ink, 48
Sunday strips, 124
supercalendered paper, 52
Superman, 29, 106, 222
support characters, 188-189
symbolism, manga, 153-154
symbols, editorial cartoonists, 130-131
symmetrical composition, 98-100
syndicates, 123
 cartoonists, 123
 characters, 127-128
 continuity-adventure strips, 126
 Creators Syndicate, 204
 gag-a-day strips, 125
 King Features, 204
 Los Angeles Times, 205
 panels, 126-127
 self-syndicates, 205
 selling to, 204-205
 submissions, 213-214
 submitting, 124
 Sunday strips, 124
 Things That Make You Go Hmm, 205
 Tribune Media Services, 205
 United Media, 205
 Universal Press, 205
 Washington Post Writers Group, 205

T

T-squares, 43
tables, light tables, 56
tapes, 44
Tarzan, 68
taxes, freelancers, 220
tearsheets, 214
teenagers, drawing illustrations for, 165
television watching, sketching, 62
Terry and the Pirates, 68
Tetsuwan-Atom, 152
Tezuka, Osamu, 152-153
Thaumatrope, 25
Thaves, Bob, 7
Théâtre Optique, 26
Things That Make You Go Hmm, 205
three-dimensional shapes, drawing, 65

thumb-and-pencil technique, 89
The Tickler, 20
Tired Tim, 28
Tisdale, Elkanah, 19
title pages, comic books, 136
TJs (trade journals), 119
Toba, Bishop, 150
tobacco use (characters), 84
Tobae, 151
toys, 171
 kineograph, 26
 Praxinoscope, 25
 Thaumatrope, 25
 Zoetrope, 25
Töpffer, Rodolphe, 13-14
trade journals (TJs), 119
trademarks, 218
transfer sheets, 41
triangles, 44
Tribune Media Services, 205
Trogdon, Ted, eye control in
 sequences, 101-102
two-point perspective, 90-91

U

U.S. Trademark and Patent Office,
 218
uncalendered paper, 52
uniforms, 82-84
Unishade, 51, 132
United Media Syndicate, 205
United States
 editorial cartoonists, 19-20
 manga, 150
Universal Press Syndicate, 205

V

van Musschenbroek, Pieter, 25
vanishing point, 64, 91, 99
Vanity Fair, 23
vaudeville, animation, 26
viewpoints, changing, 196-197
Vitagraph Company, animation, 26

W

waists, drawing, 70
Walker, Mort, 56
Walt Disney, animation, 26
Ward, Jay, 141
Washington Post Writers Group, 205

The Wasp, 20
watercolors, 49
 black, 49
 names, 49
 pigments, 49-50
Watterson, Bill, 94
Weary Willie, 28
web cartoonists, 32-33
websites
 creating, 215-216
 design, 164
 elink, 33
 Lucent, 33
 Parc, 33
weight, paper, 52
Western manga, 149, 152
Wheel of Life, 25
Wheel of the Devil, 25
Where's Waldo?, 14
wide shots, 197
Wild Oats, 20
Wildenberg, H. I., 29
Williams, Gluyas, 14
Wirgman, Charles, 150
The Wizard of Id, 71
wood engraving, 131
work for hire, 222
work spaces, 55-56. *See also* studios
worm's-eye view, 94, 197
wrapping paper, 170
writers, 143
writing
 captions, 121, 176-177, 195-196
 dialog, 176-177, 195-196

X-Y-Z

X-Acto blades, 44

Yankee Notions, 20
yellow journalism, 23
Yellow Kid (*Hogan's Alley*), 23
Young, Chic, 188
Young, Dean, 188

Zen Buddhism, 150
Zoetrope, 25

A Little Knowledge Goes a Long Way ...

Check Out These Best-Selling COMPLETE IDIOT'S GUIDES®

0-02-863639-2
$16.95

0-02-862743-1
$16.95

0-02-862728-8
$16.95

0-02-864339-9
$18.95

0-02-864244-9
$21.95 w/CD-ROM

0-02-862415-7
$18.95

0-02-864316-X
$24.95 w/CD-ROM

0-02-864235-X
$24.95 w/CD-ROM

0-02-864232-5
$19.95